anthony caro

This exhibition is dedicated to
Sheila Girling Caro

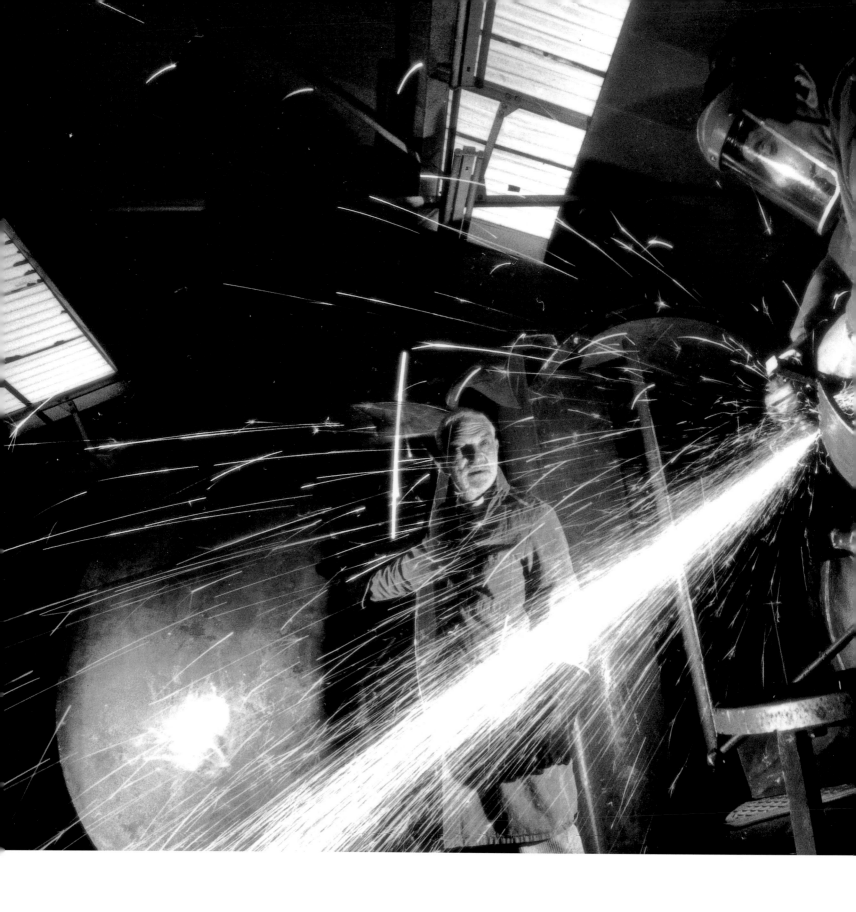

anthony caro

edited by Paul Moorhouse
with essays by Michael Fried and Dave Hickey

Tate Publishing

First published 2005 by order of the Tate Trustees
by Tate Publishing, a division of Tate Enterprises Ltd,
Millbank, London SW1P 4RG
www.tate.org.uk/publishing

on the occasion of the exhibition at
Tate Britain, London
26 January – 17 April 2005

Supported by

**The Anthony Caro
Exhibition Supporters Group**

with additional support from the Henry Moore Foundation

British Library Cataloguing in Publication Data
A catalogue record for this book is available from the British Library

ISBN 1-85437-509-1

Distributed in the United States and Canada by Harry N. Abrams, Inc.,
New York

Library of Congress Cataloging in Publication Data
Library of Congress Control Number: 2044111330

Designed by Kate Stephens
Printed in Italy by Conti Tipocolor

Cover: Early One Morning 1962
Photographed by Dave Lambert, Tate Photography
Frontispiece: Anthony Caro in his studio, *c.*1997

Measurements of artworks are given in centimetres, height before width

Millbank Steps has been fabricated and constructed by
William Hare Limited

Contents

Foreword

Anthony Caro is Britain's most celebrated living sculptor, an artist of the highest international renown, and a figure of unquestionable significance in the history of modern Western art. His innovations and his influential teaching – which suggested that sculpture could be made of literally anything – effectively reinvented the language of the medium itself. His influence – for example in eliminating the plinth and placing the sculpture in the viewer's own space, now a convention – has been profound. And the presence and resonance today of his work from across six decades is, as this exhibition bears witness, extraordinary.

This exhibition follows the retrospectives of Lucian Freud (2002) and Bridget Riley (2003) as the third in Tate Britain's series devoted to major artists whose sustained impact on the course and reputation of modern British art has seemed to us worthy of complete exploration and committed presentation to a new contemporary public. Unusually, but unapologetically, we have devoted not only the standard exhibition space in our upper floor galleries at Millbank, but the whole of our central Duveen galleries to the show as well. This has enabled us to trace in some depth the evolution of Caro's art from the early figurative bronzes, through the landmark abstract works of the middle period, to the monumental, figurative and architectural works of more recent years. It is the first exhibition in the world to survey over fifty years of his work, and, supported by the scholarship of those who have prepared this accompanying catalogue – Paul Moorhouse, Michael Fried and Dave Hickey – I believe it may reveal for the first time the true extent of his achievement, both aesthetically and art-historically.

The curator of the exhibition was Paul Moorhouse, who led the project with great clarity and authority. He worked closely with the artist in shaping and selecting the show, a process in which Nicholas Serota, despite one or two other commitments, also took a unfailingly close and sustained part. I would like to express my thanks to Paul, to Anthony and to Nick, and also to Judith Nesbitt, Head of Exhibitions and Displays, and her marvellous team, in particular Rachel Tant, for giving their all to bring about a complex project of which we are exceptionally proud. Paul's own acknowledgments emphasise the full extent of the collaboration required and given by many other parties and individuals, but I would like to note particular thanks to all those who lent works of art to the show – especially, perhaps, Museum Würth for parting with *The Last Judgement* – and to the Anthony Caro Exhibition Supporters Group, whose financial contributions, co-ordinated by John Botts, made an extremely ambitious exhibition possible.

Stephen Deuchar, Director, Tate Britain

Acknowledgements

Few artists succeed in redefining the standards by which art is judged. Anthony Caro belongs to that select few. There is sculpture before the astonishing constructions that he began to make in 1960, and there is sculpture made in the wake of those works. The difference between these two eras constitutes nothing less than a revolution in the way we understand and appreciate sculpture.

It has been an enormous privilege, as well as a great pleasure, to work with Anthony Caro on this exhibition. The product of three years planning, it attempts the impossible – to give an indication of the scope and scale of his achievement as a sculptor. It is, perhaps, simply a glimpse – numerous other exhibitions would have been possible and, during the course of our conversations, we imagined many of them. I am deeply indebted to the artist for his advice and extraordinary energy, and also to Sheila Girling Caro for her unfailing support and astute insights throughout.

Many others have played an part in bringing the exhibition to fruition. As ever, Nicholas Serota and Stephen Deuchar have been a welcome source of support and advice. Patrick Cunningham, the artist's studio director, provided a bedrock of sound judgement on innumerable issues. In the show's organisation, I have greatly benefited from the calm efficiency and professionalism of Rachel Tant, Assistant Curator. John Miller and Deborah Denner gave valuable advice on the exhibition design, and Kate Stephens worked wonders on the catalogue design, the production of which was ably overseen by Mary Richards and Sarah Tucker.

The exhibition would have been impossible without the generous support of the many loans from public and private collections, and to these lenders I extend warm thanks. I would like to pay a special tribute to William Hare for their sponsorship of *Millbanks Steps*, the major commissioned work which is being seen for the first time in this exhibition, and in particular to Nick Day, Richard Branford and Andrew Thompson for their support. Generous financial assistance has been provided by the Anthony Caro Exhibition Supporters Group and by The Henry Moore Foundation.

The following individuals have helped and guided the exhibition in various ways: Dennis Ahern, Leigh Amor, Ian Barker, Christina Bagatavicius, Paola Barbarino, Alex Beard, Rosey Blackmore, Erica Bolton, John Botts, Gillian Buttimer, David Dance, Laura Davies, Gary Doherty, Mark Edwards, Matthew Flintham, Jaana Fowler, Fiona Fouhy, Siri Fischer Hansen, Edward Goolden, Kenneth Graham, Mikei Hall, Benna Harper, Jackie Heuman, Sarah Hyde, David Lambert, Mike Lawson, Hywel Livingstone, Katharine Lockett, Ben Luke, Siobhan McCracken, Philip Miles, Ellie Oliver, Jo Oliver, John Riddy, Andy Shiel, Cynthia Wainwright, Piers Warner, Sylvia Weber, Dave Williams and Reinhold Würth.

Finally, my special thanks go to Rosemary Harris, who was there all the way.

Paul Moorhouse

'The forms of things unknown':
Anthony Caro's sculpture Paul Moorhouse

Caro with *Man Holding his Foot* and *Woman in Pregnancy* in his garden in Hampstead, 1955

And, as imagination bodies forth
The forms of things unknown, the poet's pen
Turns them into shapes, and gives to airy nothing
A local habitation and a name.
(William Shakespeare, A Midsummer Night's Dream*)*

By the time he reached his mid-thirties in 1959, Anthony Caro had secured a reputation as a sculptor with a highly original outlook. During the preceding five years he had made over thirty sculptures: strange lumpen figures and distorted heads, impressed with rocks, pebbles and a burgeoning sense of their own material presence. This substantial body of work signalled the emergence of a distinctive and commanding vision. Indeed, Caro's first solo exhibition, held in London in 1957, was described by Andrew Forge, writing in *The Listener*, as a 'tour de force'.[1]

Yet, Caro has observed: 'I was thirty-five before I started to make original work.'[2] How is this apparent dismissal of his early art to be understood? The answer lies in the huge significance of his subsequent decisive break with figurative sculpture, and in the far-reaching importance of the constructed, abstract sculptures in painted steel which he began to make in 1960. Quite simply, Caro's achievement, in his late thirties, is to have created, in a relatively short space of time, a body of work so radical in its implications, and so yet so completely authoritative in its means of expression, as to have changed the course of sculpture. There are obvious precedents in the work of earlier artists making constructed sculpture, notably Pablo Picasso, Julio González and, latterly, David Smith. But Caro's breakthrough in 1960 so effectively builds on the insights contained in these earlier artists' work, and then *extends* those insights in such original and unexpected directions, as to constitute a redefinition of the premises of sculpture. As a result of Caro's innovations, within a short period conventional ideas about subject,

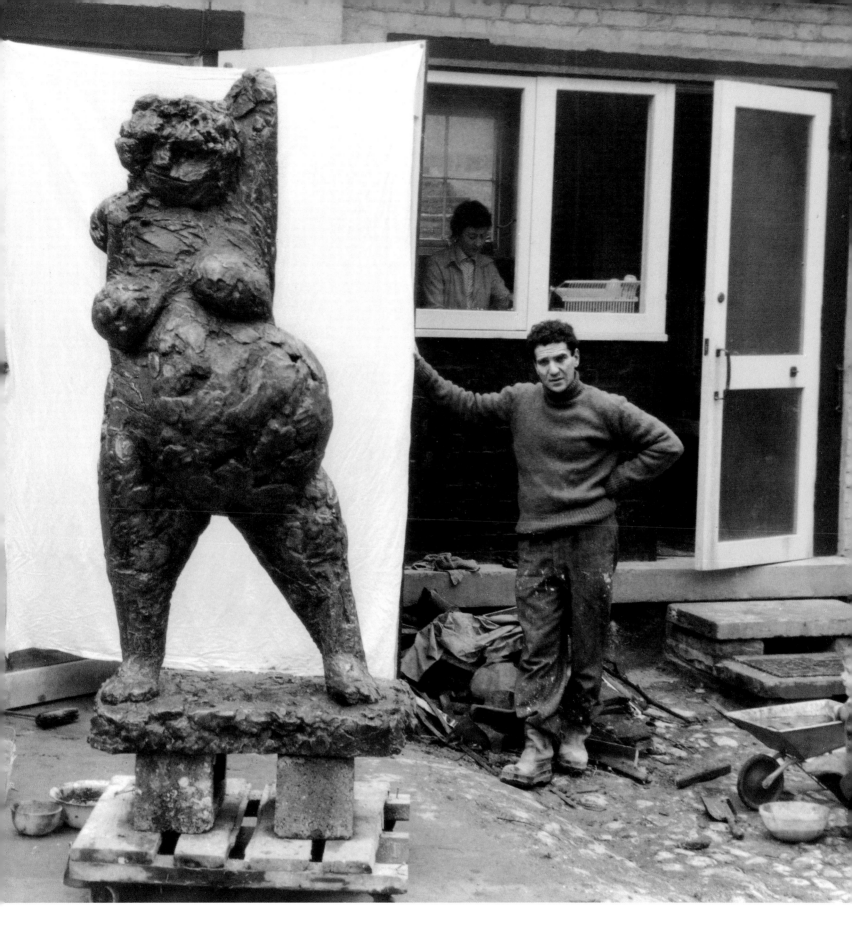

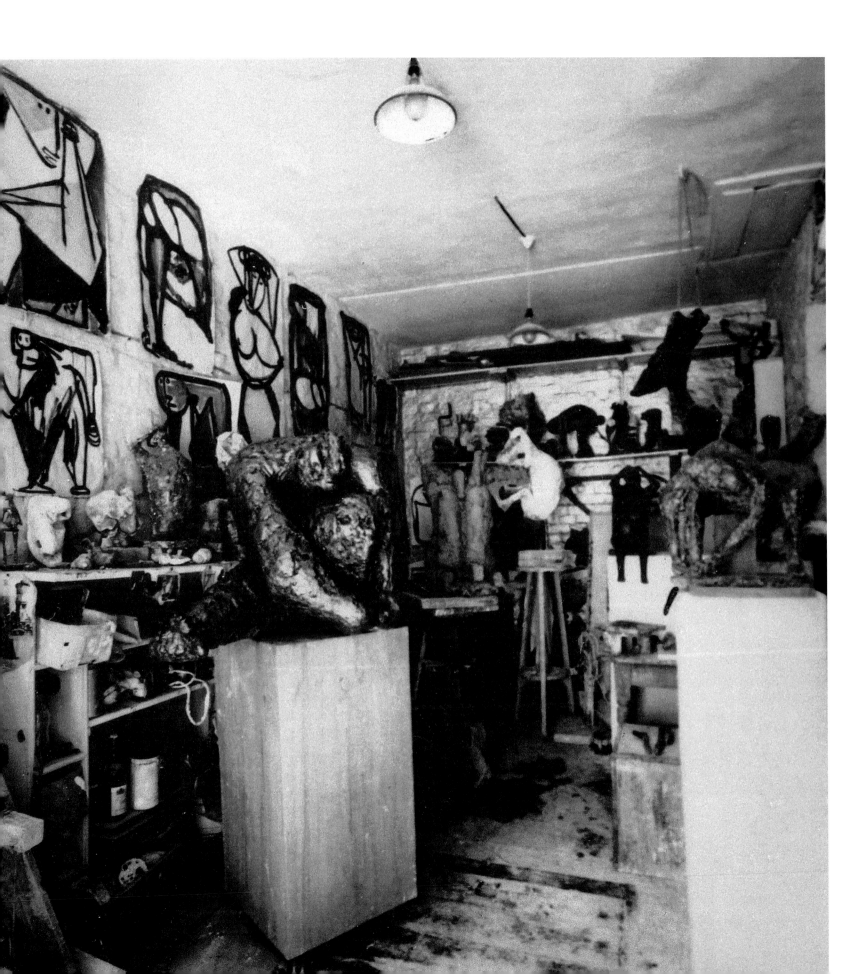

Caro's garage studio
in Hampstead, 1955

appearance, materials and methods were overturned. The effects of that revolution continue to resonate.

This is not to say that Caro was alone in forging a radical, new abstract sculptural language. Since 1953 he had been teaching part-time on the sculpture course at St Martin's School of Art, London, and from the outset his approach was unorthodox. 'I made it clear', he recalled, 'that we were all engaged on an adventure, to push sculpture where it never has been. We are explorers, equals.'[3] Eschewing the literal imitation of observed reality, Caro sought to provoke a fresh understanding of whatever subject was being addressed. In a striking departure from conventional life-drawing, the students would study the model and would then be asked to make a drawing after moving to an entirely different space. The impetus was towards a more subjective and intuitive way of working – a view of the world digested by the intellect and illuminated by feeling. The resulting, highly charged atmosphere of experiment and exploration drew upon the presence of younger men studying under, and later teaching alongside Caro, notably: David Annesley, Michael Bolus, Phillip King, Tim Scott and William Tucker. With Caro, all were questioning and probing the tradition of figure-based sculpture, which they felt had fallen into decorative impotence, drained of expressive potential. Collectively, there was an imperative to try to find new ways for sculpture to carry and convey feeling, and to explore the potential of unconventional materials and ways of working. But at the centre of this activity and discussion, it was Caro's willingness to dispense with familiar methods and assumptions, and then to lead the discussion into uncharted territory, that are the hallmarks of his originality. 'I had come to the conclusion', he later observed, 'that it was no longer desirable for a sculpture to be a single object, a kind of metaphor for the human body'.[4]

It is this radical critique of the very foundations of sculpture, this deep interrogation of the tradition of closed monolithic form, that created the necessary conditions for the influential innovations he effected. Among these changes, the most celebrated – and arguably the most significant – was Caro's elimination of pedestal-based sculpture so that the work of art was placed directly on the ground. A plinth is to sculpture what a frame is to a picture. It defines an imaginary or virtual space in which we are

Figure
1955–6 (no.5)
Brush and ink on paper
85 x 54 cm
Private collection, UK

Man Walking
1955 (no.4)
Brush and ink on paper
157.2 x 53.1 cm
The British Museum, London

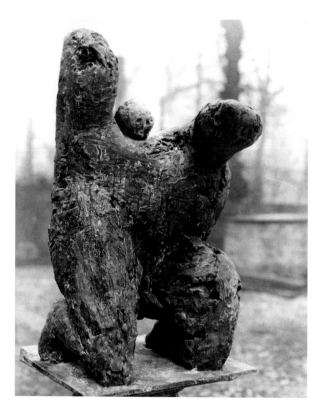

Man Taking Off his Shirt
1955–6 (no.7)
Bronze
78 x 46 x 47 cm
Collection Professor and Mrs King

Woman's Body
1959
Plaster
188 cm high
Destroyed

able to view the work of art as a representation of some other thing. Qualities of scale and materials that the sculpture itself may not actually possess may be suggested. Plinth-based sculpture constitutes a virtual experience – one thing is recognised as evoking or simulating another. The reason that taking sculpture off the plinth and placing it on the ground is so significant is because it situates the sculpture in the viewer's space: in the real world of people and objects. It redefines the relationship between the viewer and the sculpture, making the experience of the sculpture more immediate.

Eliminating the plinth was, in physical terms, a small step. As was immediately recognised, however, its ramifications were enormous. It was seen, rightly, as breaking down a long-standing barrier around the experience of sculpture, and consequently this advance was immediately and widely imitated. Indeed, it has since become a convention for most contemporary sculpture. The imperative driving it was, as Caro later commented, the desire 'to give my sculpture the immediacy one feels talking one-to-one with another person'.[5] Contrary to the popular view, however, placing his sculpture on the ground did not coincide with Caro's breakthrough into a language of abstract form. Rather, it immediately preceded it. In suggesting that he was thirty-five before he made an original work of art, he is alluding to this achievement. He reached this age in 1959: the year in which, for the first time, one of his figurative sculptures, *Woman's Body*, occupies the space of the real world. This imposing figure, somewhat larger than life-size, is seated on a bench – a real object – her legs jutting out and her feet directly in contact with the ground.

A clue to understanding Caro's thinking at this vital juncture is contained in his statement: 'My goal was always to make sculpture more real, more felt.'[6] In other words, the literal immediacy of sculpture and its expressive force are intimately connected. *Woman's Body* is therefore

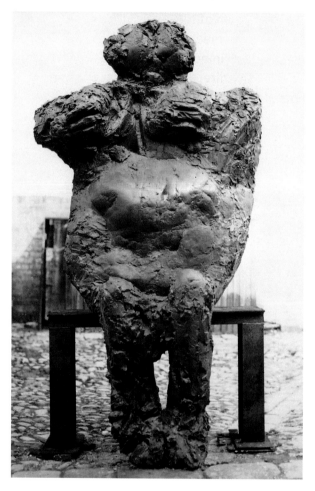

a decisive move, but incomplete. Bringing the sculpture into the real space occupied by the viewer makes its physical presence more tangible, but in itself it is still representational, non-literal and non-real. As a sculpture, it remains rooted in virtual experience: an illustration of another object, in this case a person. Its expressive force is strengthened by its newly won occupation of literal space, yet as an expression of feeling it is simultaneously qualified by its continued mediation of those feelings through representational imagery. We are not able to experience the sculpture directly: as a real thing in itself, with its own expressive characteristics. Instead, we infer those expressive characteristics indirectly, through their figurative representation. The will to make his sculpture more *real* – as an object in its own right, which we experience directly – is therefore the key to Caro's breakthrough into abstraction. He observed: 'I felt the figure was getting in the way … I had no alternative but to make my sculpture abstract if it was to be expressive.'[7]

Radical though it is, Caro's creation of abstract sculpture situated in the real world of objects does not completely dissolve the barriers between art and life. This confusion, and the initial difficulty in 'reading' his sculpture when it first appeared, is well captured in the following account by the critic and curator David Sylvester:

> The Horse, *of 1961, had been the dominant piece in the second* Situation *group show organised by Lawrence Alloway. I had visited the exhibition on a Saturday morning with my two year old daughter, and when I encouraged her, in the presence of other visitors I knew, to climb onto the Caro and walk up and down the slope, it had not only been to show the pretty child off and keep her entertained; it had been a deliberate act of provocation directed against my friend and enemy Alloway: I treated the piece as a piece of playground apparatus to imply that it was an object rather than a sculpture.*[8]

Positioning a Caro sculpture in literal space would, as Sylvester's account suggests, seem to imply that the work of art takes its place alongside other objects: functional things such as tables, chairs and, on a larger scale, buildings and engineered and fabricated things. Like an abstract sculpture, a chair is a thing in itself, with its own defining physical characteristics, occupying the same space as that which we occupy. This, however, is precisely why Caro insisted that his early abstract sculpture should be for looking at only. Despite their physical proximity, we are not intended to touch or otherwise physically interact with the works. Such contact would imply some degree of functionality. While the viewer walks around the sculpture and experiences its scale and presence in relation to their own physical movements, that interaction remains visual. The sculpture occupies the same space but, as Caro stated, 'it is something outside which we are'.[9] This is an important distinction and – surprising though it may seem for an artist whose work is so rooted in material fact – a conceptual one. The very abstractness of the sculpture, and its essentially non-functional nature, define it as art – a purely aesthetic object that is also a real thing, but which nevertheless stands at a remove from other things within the world. Its purpose is purely expressive.

Caro's early abstract sculpture thus has a double aspect: it is *in* the world but not *of* it. He has put it another way: 'art thrives on the discrepancy between its territory and the real world, and it exploits the tensions between these frontiers.'[10] In effect, therefore, when Caro placed sculpture in the real world, rather than dissolving boundaries, he was pushing back but, nevertheless, sustaining the limits of sculpture. This testing of boundaries would be a fertile, defining characteristic of the development of his work – a sustained expansion of the envelope and context of sculpture through probing its relation to other areas of human experience and creativity.

Testing the boundaries

The desire to make his work more real, and more directly expressive, led Caro into the unfamiliar territory of abstract form. The momentum for change had been confirmed in 1959, following a visit by the influential American art critic Clement Greenberg to Caro's studio in Hampstead, north London. Greenberg was critical of Caro's figurative work, criticism which was nevertheless intended in a constructive, positive and friendly way. Caro sensed the value of Greenberg's insights, in particular his advice: 'If you want to change your art, change your habits.'[11] Caro was stimulated to rethink his ways of working but, as yet, had little idea how to proceed.

Towards the end of that year Caro visited the United States for the first time. He spent two months travelling, during which time he met the painter Kenneth Noland in Washington. Later in the trip, he spent some time in New York and was able to see, at French & Co., an exhibition of Noland's circle paintings and a single sculpture by Smith. Caro was impressed and intrigued by Noland's work, responding to its freshness, clarity and abstract, expressive directness. Around the same time, he renewed his acquaintance with Greenberg. At a dinner given by Robert Motherwell and Helen Frankenthaler, Caro was introduced to Smith. He knew and admired Smith's work from photographs and the sculpture he had seen, and they later spent an evening together, going around Chinatown. However, Caro did not follow up Smith's invitation to visit his studio at Bolton Landing in upstate New York; indeed, it would be another three years before their relationship developed and Caro would have an opportunity to get to know Smith's work better. In terms of his breakthrough to abstraction, and especially the particular form it would take, of major significance was a second meeting with Noland in New York, when the two men spent an entire night joined in discussion. Noland spoke about abstract painting and he referred to his practice of

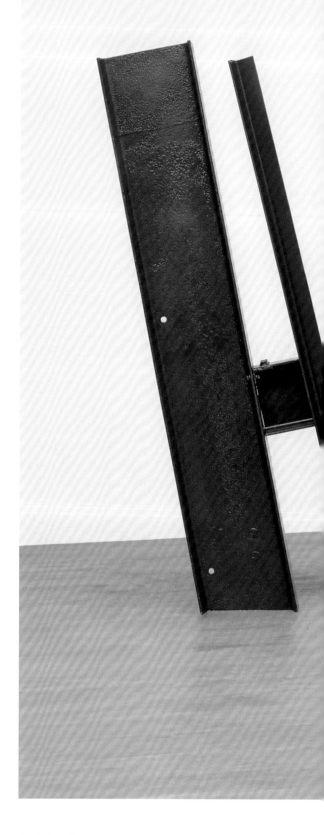

Sculpture Two
1962
Steel, painted green
208.5 x 361 x 259 cm
Tate. Lent by Mr and Mrs Donald Gomme 1992

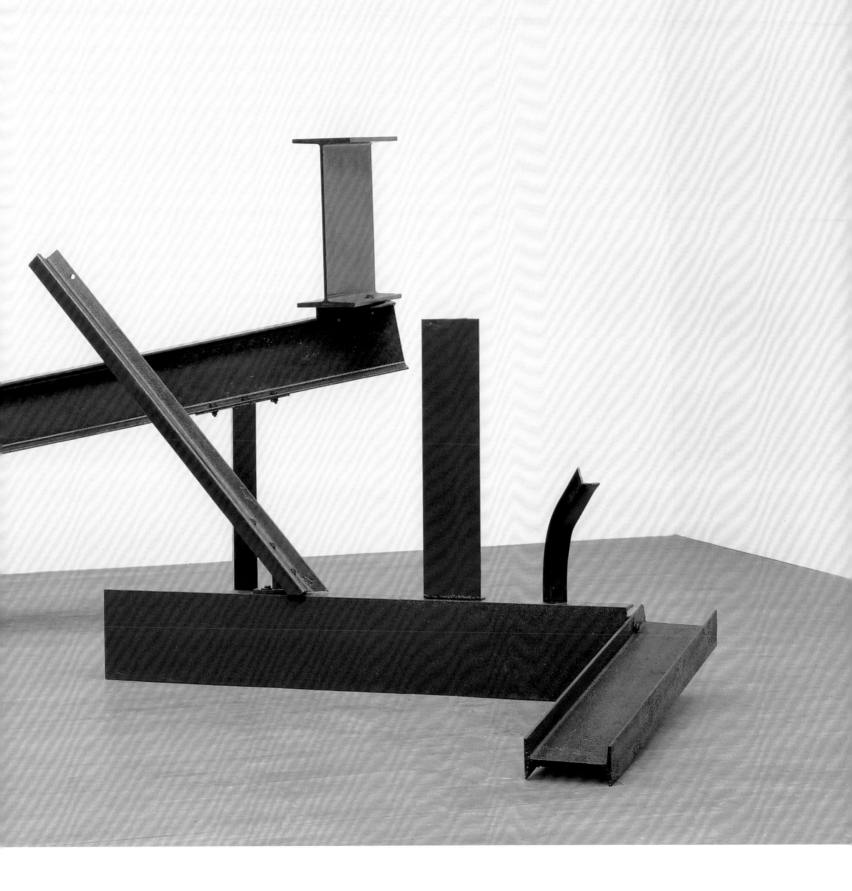

Kenneth Noland
Half
1959
Museum of Fine Arts, Houston

David Smith
Sentinel III
1957
Private collection

keeping the canvas flat while he was working on it, an approach calculated to prevent reliance on conventional principles of pictorial composition. The idea of working blind, as it were, fired Caro's interest and he came away determined to try 'to make a kind of Noland'.[12] On his return to London, he sought out scrap yards and docks where he was able to purchase various pieces of scrap steel, including girders and sheet metal, and he learnt how to use oxyacetylene welding equipment. The result was his first abstract steel sculpture: *Twenty Four Hours* 1960.

The speed and authority with which Caro stakes out his territory is – even now, and seen through the lens of familiarity – astonishing. Nothing like it had existed previously, certainly not in Smith's oeuvre, which might be expected to have provided a model. In the main, Smith's work is essentially totemic, the human figure never far from its range of allusive reference. In contrast, Caro immediately establishes a quite different formal grammar – one, arguably, that owes more to painting. Indeed, Caro seems positively to have denied any reference to the figure and, with it, the sculptural baggage of mass and vertical form. Any semblance of figural connotation would fall back into the language of representation – of mediated, indirect expression. In the pursuit of a purer, non-connotational language of abstract expression, such anthropomorphic references could be expunged. In their place a vocabulary of non-referential shapes is deployed: organised horizontally and structured solely in terms of internal relationships.

Unlike Smith's plinth-based sculpture, and continuing the advance made in Caro's figurative work in the previous year, *Twenty Four Hours* stands directly on the ground. From the outset, he appears to have recognised that presenting abstract sculpture in this way would lead the unwary spectator to view such works as objects. This consideration informed the work's striking – and highly unusual – open structure. The notion of sculpture as closed mass has been exploded. Instead, borrowing from the language of painting, he presents us with a sculpture that we tend to view from the front. This aspect of the work yields a surprising sense of spatial depth receding behind the front triangular shape, in which a disc shape, culled from Noland, appears to float; in turn, and further away still, a square form hovers at an oblique angle. With these

Twenty Four Hours
1960 (no.11)
Steel, painted dark brown
and black
138.4 x 223.5 x 83.8 cm
Tate. Purchased 1975

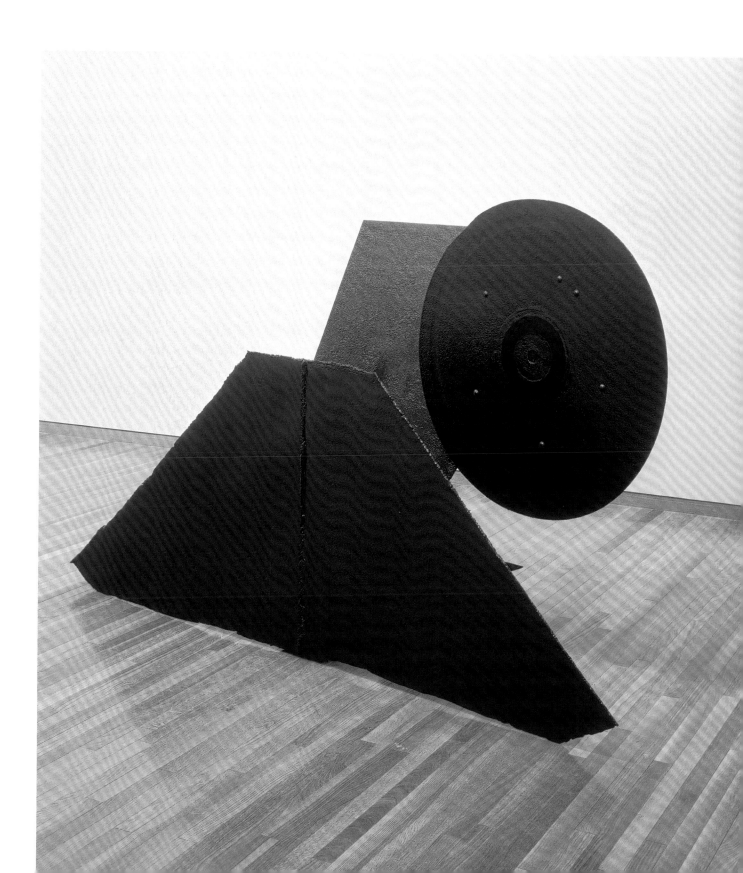

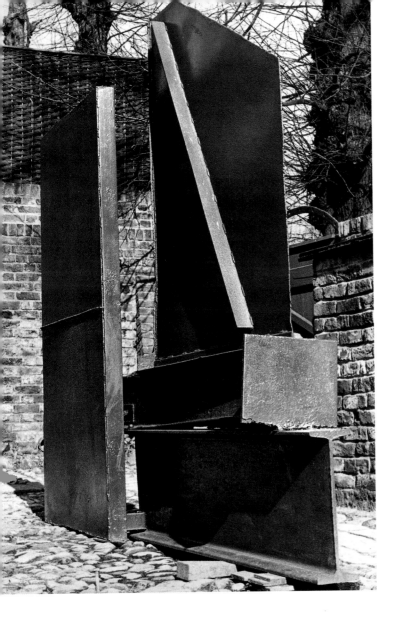

Second Sculpture
1960
Steel, painted dark brown
229 x 258 x 41 cm
Private collection, UK

means, Caro has begun to play a new, sophisticated game. Having emphasised the literal nature of the sculpture by placing it in real space, this advance is accompanied by a kind of pictorial illusion in the form of apparent, floating weightlessness. This sleight of hand is made clear in viewing the work from the side, where the structural supports are revealed. Material fact is married with the virtual – a theme that will run through Caro's work from this point onwards. Its effect is to assert the reality of the sculpture and simultaneously to remove it from the world of ordinary objects.

In 1991, Caro observed: 'I think the edges of subjects are interesting: where sculpture meets drawing, where sculpture meets architecture – these are borderlines which invite exploration.'[13] In the 1960s, his exploration of the connections between sculpture and drawing, and sculpture and architecture lay in the future. Nevertheless, the observation is germane to the notion of his seeking to expand the domain of sculpture by testing its boundaries with other art forms and areas of creativity. In the early 1960s there is evidence of Caro developing a dialogue between sculpture and painting, not least because a pictorial organisation of parts – open and layered – was such a potent antidote to the convention of closed, figural, sculptural form. These ideas were developed, for example, in the severe planar structure of *Second Sculpture* 1960, which can be seen as a response to the veil paintings of Morris Louis.

In the past, the interpretation of Caro's work has been characterised by a tendency for commentators to erect a single 'reading', which is then applied, without significant exception or variation. This approach underestimates the diversity of Caro's development, his fondness for working in contradictory ways at the same time, and his ability to marry contrasting impulses within a single work. In works such *Midday* 1960 (pp.22–3), *Sculpture Seven* 1961 (pp.20–1) and *Lock* 1962, we witness the development of a mature vision in which the internal relation of parts attains a remarkable degree of finesse and resolution. In contrast to the frontal nature of *Twenty Four Hours*, such later works are fully realised in terms of a complex sequence of formal relationships, which unfolds continuously as the viewer walks around the work. This visual experience involves the passage of time in that the changing display of

Lock
1962
Steel, painted blue
88 x 536 x 305 cm
Private collection, UK

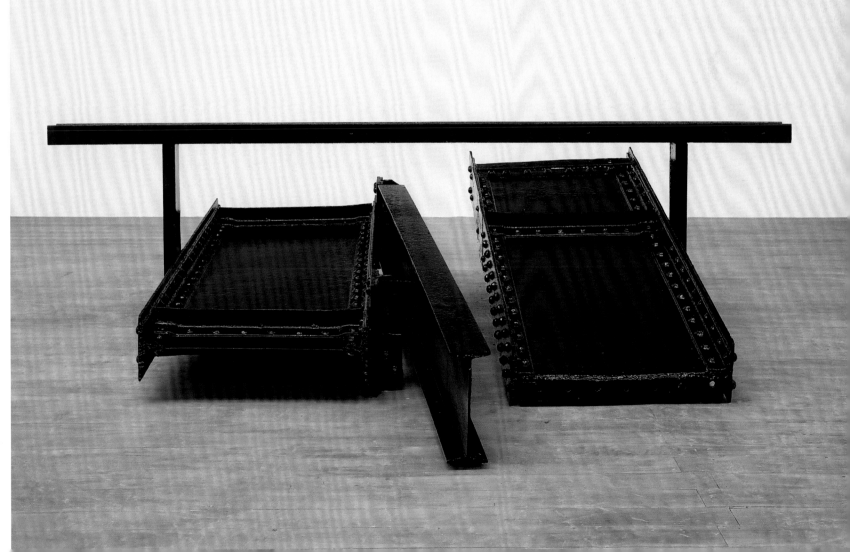

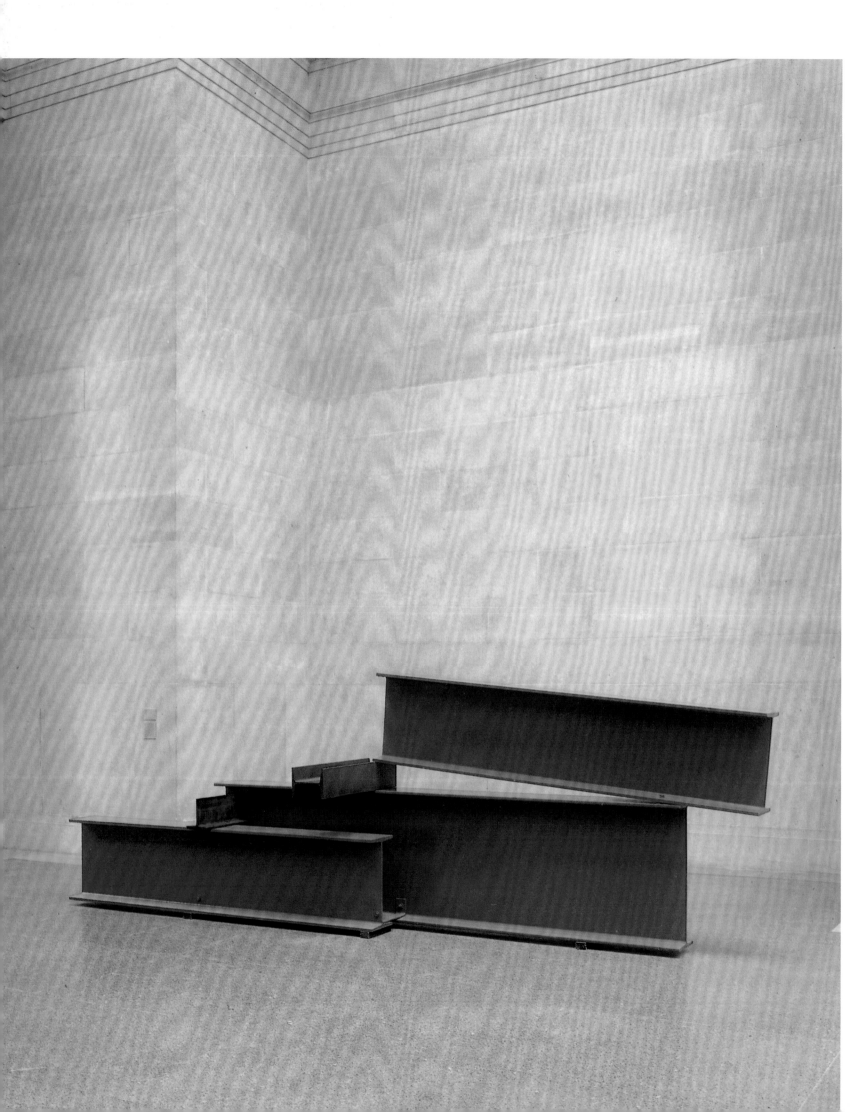

abstract shapes is sequential, and it is therefore analogous to experiencing the progress of a melody. Such works mark the emergence of Caro's interest in developing the language of abstract sculpture through the absorption of certain musical principles. Of these developments, Caro commented:

> I have been trying to eliminate references and make truly abstract sculpture, composing the parts of the pieces like notes in music. Just as a succession of these make up a melody or sonata, so I take anonymous units and try to make them cohere in an open way into a sculptural whole. Like music, I would like my sculpture to be the expression of feeling in terms of the material, and like music, I don't want the entirety of the experience to be given all at once.[14]

At this juncture, it is worth noting that Caro's use here of the word 'composing' is potentially misleading; elsewhere he has been at pains to point out that the idea of composition was far from his intentions. In the early 1960s he worked in a small garage space, which meant that he was forced to work close up to the sculpture, and was unable to see the work as a whole until it was taken outside. In a sense, therefore, he was working 'inside' the sculpture, determining its formal relationships in terms of their internal connections to each other, rather than to the overall structure. In this unpremeditated relationship with the evolving work from within, it is possible to see parallels with Jackson Pollock's assertion that while working he was 'in' the painting. For Caro, 'the advantage of making them where I couldn't stand back from them was … to prevent my falling back on my previous knowledge of balance and composition'.[15] This is not to say that the musical analogy does not hold. Rather, it tells us that Caro's sculpture unfolded during the process of its creation in a manner close to free improvisation, in which the element of surprise was ever present.

Working in extreme proximity to the evolving sculpture, for Caro, prevented – and guarded against – premature editing or organising. In this way of working, there is a clear sense of the close physical relationship between the artist and the work, a 'felt' connection that is reflected in the character of the sculptures themselves. *Lock*, for example, invites the viewer to approach and look

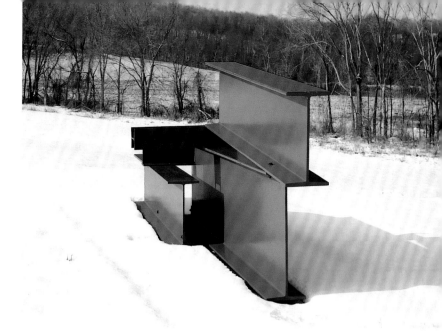

Sculpture Seven
1961 (no.13)
Steel, painted green,
blue and brown
178 x 537 x 105.5 cm
Private collection, UK

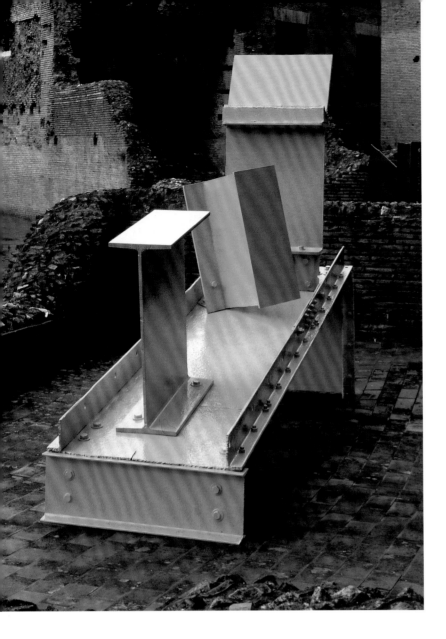

Midday
1960
Steel, painted yellow
240 x 96.5 x 366 cm
The Museum of Modern Art,
New York

down upon it. The configuration of its low-lying parts suggests the processes of arrangement – on the ground and viewed from above – that operated during its evolution. The scale of the piece, and its recumbent disposition, seem inescapably human: connected, intimately, to the proportions and movements of the human body. Having established direct contact between the sculpture and the ground, in *Lock* Caro now embraces this as a theme. The work declares its earthbound nature and, in the upward tilt of one of its parts, evokes movement in opposition to gravity. These characteristics are shared by *Midday* and *Sculpture Seven*, which also incorporate inclined elements that rise from the horizontal. Such sculptures are defiantly abstract, yet the sensations they evoke are familiar; indeed they are rooted in everyday experience.

The marriage of material fact and illusion, implied in *Twenty Four Hours*, is developed in these works. The physical weight of the steel, that we know to be present, is simultaneously belied by Caro's adoption of a bright livery

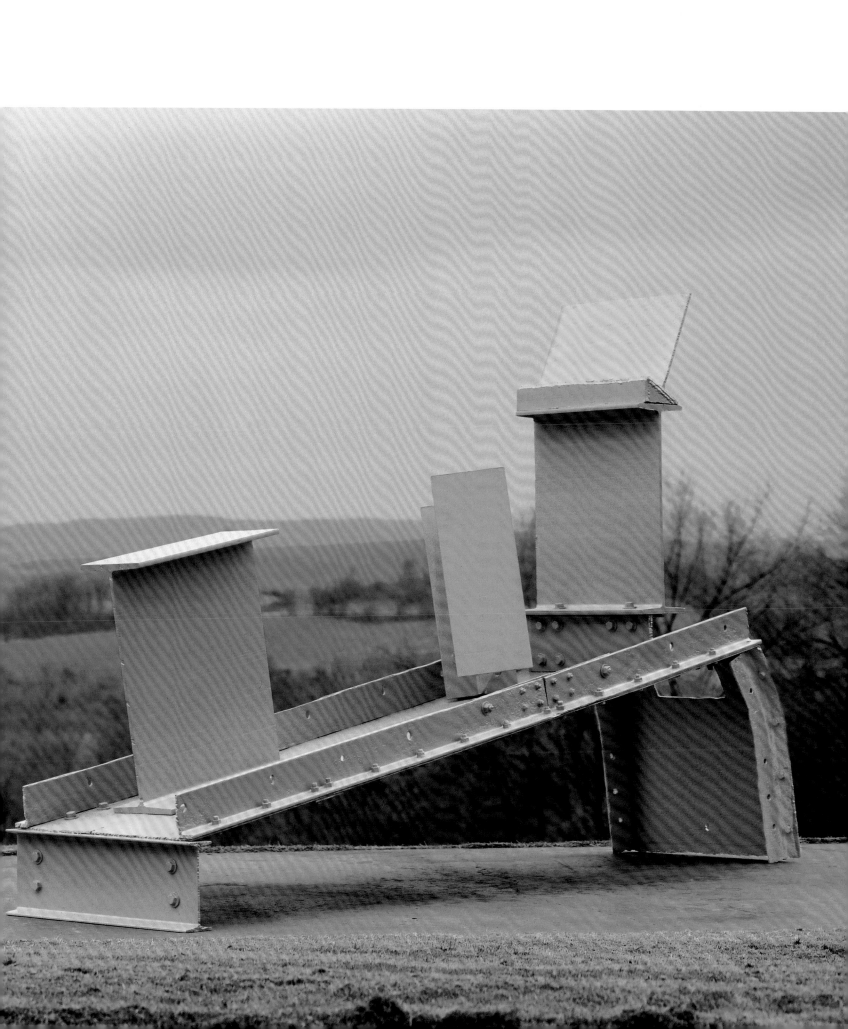

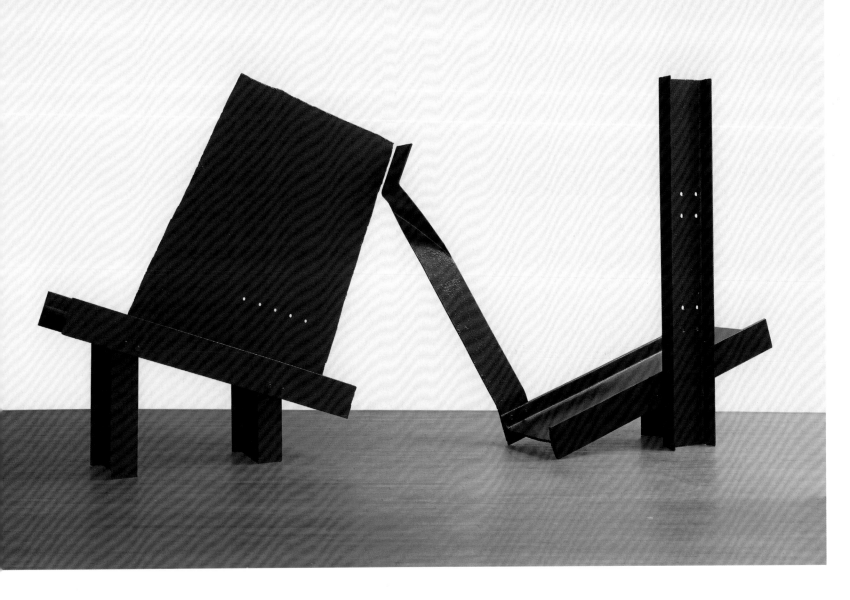

The Horse
1961 (no.12)
Steel, painted dark brown
203.5 x 96.5 x 427 cm
Audrey and David Mirvish,
Toronto

of colours – blue, yellow and green. Colour mitigates the austere, industrial character of the raw materials. The use of colour again borrows from the language of painting. But, even so, in *Midday*, *Sculpture Seven* and *Lock*, Caro's concerns seem to move beyond the conversation with painting he had begun in *Twenty Four Hours*. The implication of human scale and movement in these later works appears to echo ideas explored in Caro's earlier, figurative sculptures, which, as he has pointed out, 'were to do with what it's like to be inside the body'.[16]

The somatic – that is to say, body-related – character of Caro's abstract sculpture can be construed from the artist's own comments about the general nature of three-dimensional art. In a 1986 lecture on Degas, for example, he observed: 'all sculpture is to do with the physical – all sculpture takes its bearings from the fact that we live inside our bodies and that our size and stretch and strength is what it is.'[17] This approach is the theme of Michael Fried's early, enlightened interpretation of these works (see pp.114–25). Fried's essay appeared as the introduction to the catalogue of Caro's exhibition at the Whitechapel Art Gallery, London, in 1963, and the case it made for reading the works in terms of 'expressive gestures' has been widely influential. Fried argued that 'gesture is evoked, and at his best, liberated, through configurations made by assembling lengths of steel girder, aluminium piping, sheet steel and sheet aluminium'.[18] The implication is that Caro's sculpture may be understood and experienced in terms of human expressive gestures that are evoked, in a purely abstract way, through the disposition of shapes and the relationships between them. That is to say, we perceive or recognise these configurations, with their implication of mass and movement, as having expressive characteristics by reference to our own subjective experience of occupying a body, moving through the world, and encountering a range of attendant feelings and sensations.

Caro advanced this argument rapidly. *Sculpture Two* 1962 (pp.14–15), disposes of any lingering sense of mass; it works, instead, entirely in terms of linear elements configured along the ground and activating the surrounding space. Within Caro's oeuvre, this piece acts as a kind of manifesto for the principle of sculptural gesture. Composed almost entirely of beams, these parts extend, probe, stretch, reach and recline. This is not unconnected

with the notion of painterly gesture which implies the trace of the artist's own movements. But Caro develops this principle within the context of sculptural expression, defining and affirming 'gesture, the advance into, the occupation of space'.[19] The work asserts a complex 'presence' that builds on the achievements of the preceding two years. Significantly, this sense of presence is due not to an inflation of scale, nor to a concentration of physical mass. Rather, by developing a matrix of formal relationships, the piece offers an ever-changing flow of inflections as the viewer walks around it. The effect is that of animation, so that the structure appears charged with a sense of inner dynamism. Its presence is therefore intimately connected with the impression of immanent life that it conveys as the viewer observes its structure unfolding.

This consideration is vitally important, for it touches on the issue of expressiveness which lies at the heart of Caro's work. 'I believe', he has stated, 'that art is about what it is like to be alive'[20] and, arguably, this is the main artery that links his own endeavours as an artist. It is an explicit concern in the 1950s, when his figure sculpture evoked bodily sensation through representation of various physical states or actions. It would, however, be a mistake to view the non-figurative sculptures in the same light, as abstractions *from* the body. Caro's sculpture after 1960 originates as inert material which, through the intervention of the artist, finds a formal resolution whose expressive character we can sense by reference to our own bodies. *Lock*, for example, is not an image of lying down. Rather, it lies down. It is an abstract sculpture – a thing in itself – invested with the recognisable quality of recumbence. Caro's abstract sculptures may be understood in relation to physical experience. But their expressiveness arises from a fusion of somatic content *and* abstract form, of feeling *and* intellect: 'The art carries its content through the medium.' This is the reason why the development of Caro's work must be understood not only in relation to the body. The physical aspect is essential – but only as part of a wider imperative to deepen the expressive potential of sculpture by exploring and expanding the medium at all its boundaries.

Sculpture and its territories

From the early 1960s until the mid-1980s, the principal tributary of Caro's development is his exploration of *space*. Towards this central consideration, all other issues flow – from the role of the ground, the deployment of horizontality, the investigation of scale, the use of different materials and, most importantly, the dialogue with other areas of creativity. Establishing space as the grammar of the language he was developing effectively neutralised those figural connotations that were a link with sculpture's past. Thinking in spatial terms was liberating, enabling the new sculpture to proceed, unfettered by distracting references, in a purely abstract way. The ever-broadening range of Caro's work during this period attests to the extraordinary flexibility won through the adoption of this spatial premise, enabling the appropriation and cross-fertilisation of elements which, previously, had been extraneous to sculpture.

Among these advances, one of the most fruitful is the teasing, playful relationship re-established with painting. 'In pictorial sculpture the structural solidity of the object is evaporated',[21] Caro has explained. With *Twenty Four Hours*, he had opened up the space behind the foreground element. With *Early One Morning* 1961, sculpture as solid object has been consigned to history. Apparently weightless and without mass, the work defines and articulates space with extreme economy. A vertical rectangle of colour acts as a kind of picture plane, but Caro achieves a remarkable sensation of graduated spatial depth by positioning various other elements in front of this back plate. The impression is of pictorial space advancing *towards* the spectator, an experience without precedent in the language of sculpture. It is a surprise when the true depth of this space is revealed. A side view of the work reveals the dramatic length of the horizontal connecting element – which in its foreshortened view had been almost

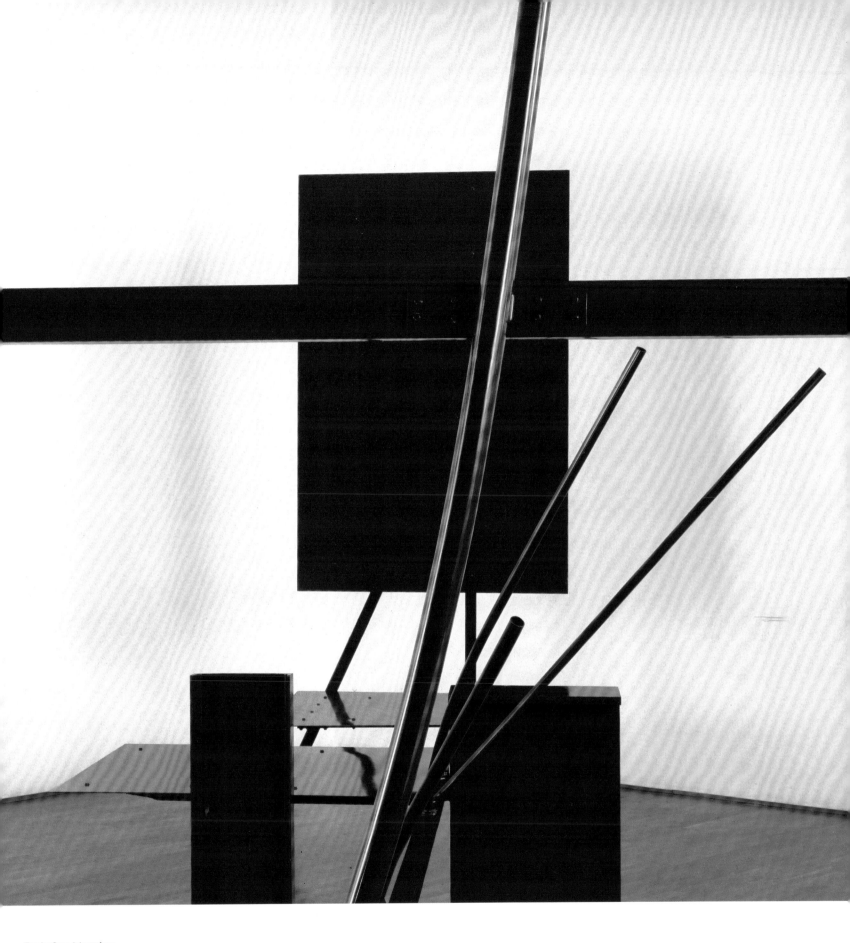

Early One Morning
1962 (no.14)
Steel and aluminium, painted
red
289.6 x 619.8 x 335.3 cm
Tate. Presented by the
Contemporary Art Society
1965

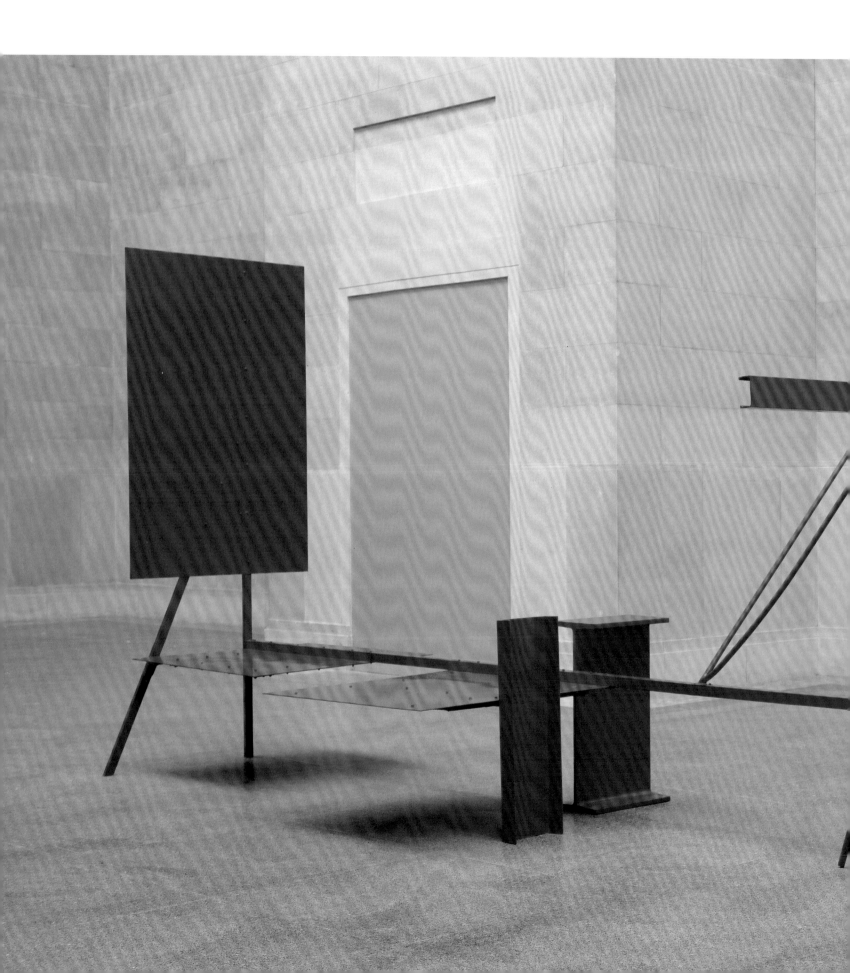

Early One Morning
1962 (no.14)
Steel and aluminium,
painted red
289.6 x 619.8 x 335.3 cm
Tate. Presented by the
Contemporary Art Society
1965

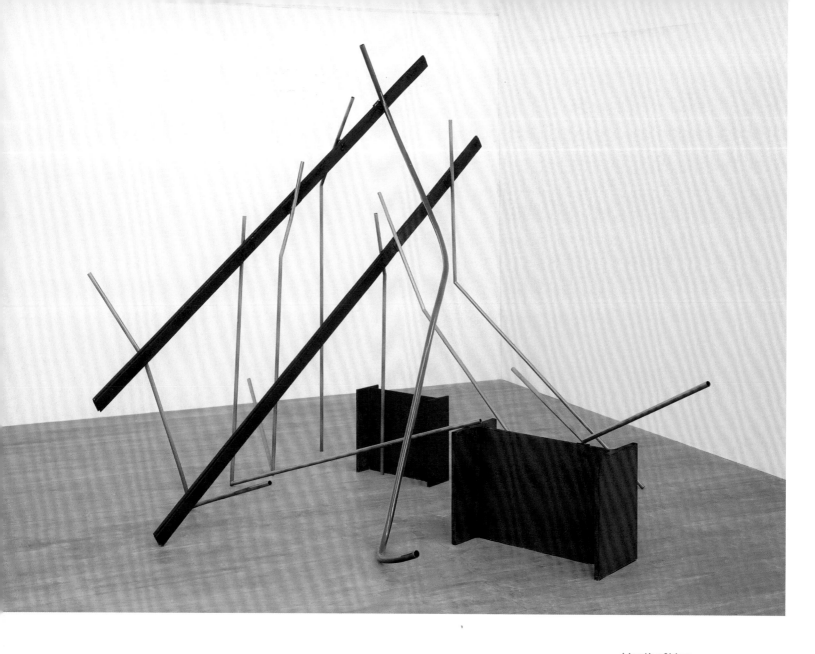

Month of May
1963 (no.15)
Steel and aluminium, painted
magenta, orange and green
279.5 x 305 x 358.5 cm
Private collection, UK

Hop Scotch
1962
Aluminium
250 x 213.5 x 475 cm
Private collection, UK

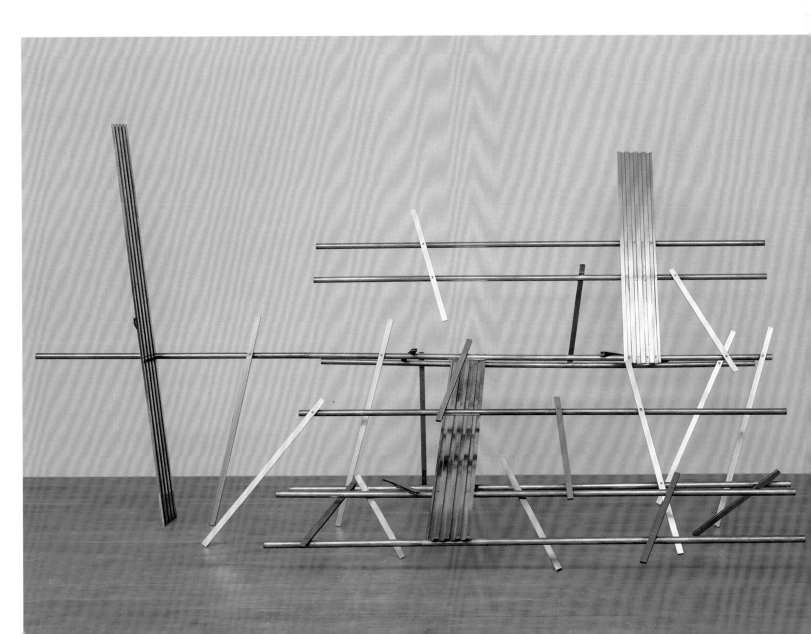

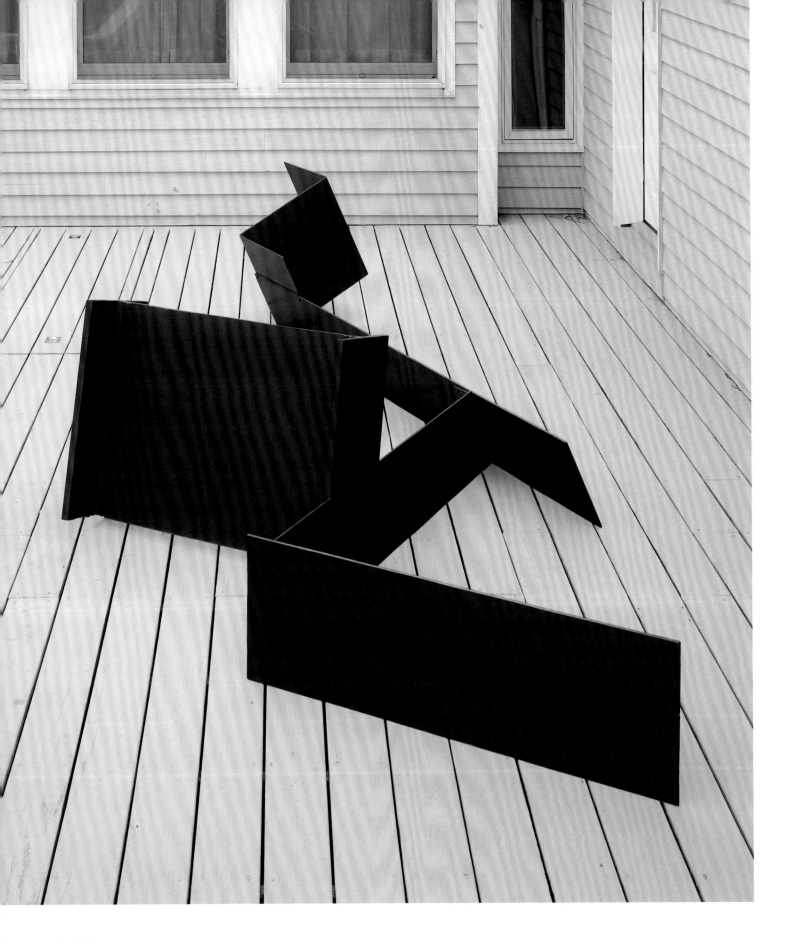

Shaftsbury
1965
Steel, painted purple
68.8 x 323 x 274.5 cm
Private collection, USA

invisible – becomes apparent. These two aspects – front and side – are seamlessly joined. Yet the discontinuity between them, the impossibility of inferring the side view from the frontal impression, lends the sculpture an enduring ability to fascinate and to delight. Rightly regarded as one of his greatest early abstract sculptures, the realm it occupies seems light-years away from the world of massive, scabrous figures which Caro had inhabited barely three years earlier.

The sense of elan conveyed in *Early One Morning* 1962 arises from a poetic association of excursions into several adjoining territories. Sculpture speaks to painting. But in its disposition of graceful, sinuous lines – exploring space and resting, almost balletically, against the horizontal bar – there is the implication of dance, gesture and, especially, drawing. The marriage of these different elements is continued in other works made around this time, notably *Hop Scotch* 1962 and *Month of May* 1963 (pp.30, 31). In the earlier work Caro forgoes colour, preferring to preserve the aluminium in its natural state. In *Month of May*, he goes in the opposite direction, differentiating the various elements through the use of several colours. Both works employ linear elements as vectors – as directional lines in space – though the works interpret that underlying theme differently. *Hop Scotch* moves towards music, the horizontal elements forming a kind of stave within which the sculpture dances to a syncopated rhythm. *Month of May* is slower, more fluid, and tends towards the calligraphic. The eye becomes a coloured pencil as it follows the sculpture in its inscription of space.

Titan
1964
Steel, painted blue
105.5 x 366 x 290 cm
Art Gallery of Ontario,
Toronto

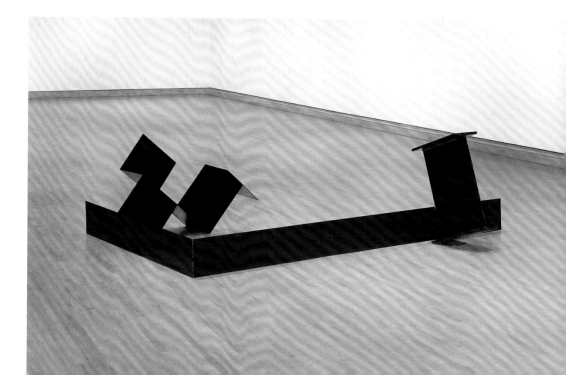

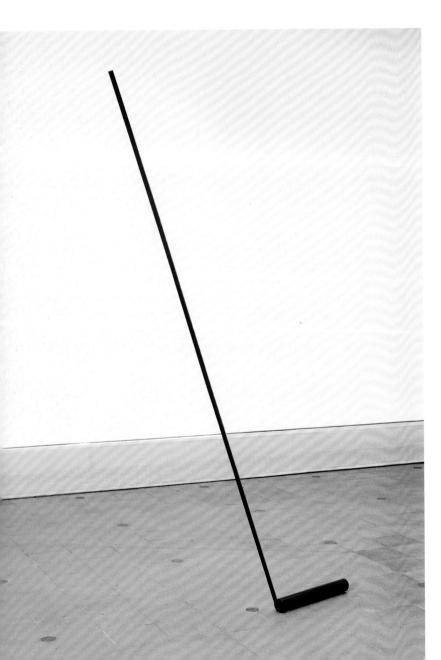

Eyelit
1965 (no.16)
Steel, painted blue
286 x 168 x 7.5 cm
Collection of William S.
Ehrlich

Linearity, the relationship with drawing, and an impetus towards leaner, more reductive means, are the defining characteristics of Caro's sculpture during the mid 1960s. Having set down the grammar of the language, these developments can be seen as a refining and clarifying process. It is as if Caro was probing the question of how much flesh can be taken away while retaining expression. In part, this direction seems to have been encouraged by Noland, with whom Caro continued to maintain a fruitful dialogue. The context for this renewed contact was Caro's acceptance, in 1963, of a teaching position at Bennington College in Vermont, an appointment which, with the exception of a break in the autumn of 1964, he continued as a visiting faculty member until 1965. 'I remember Ken saying to me', Caro recalled, '"The one objection I have to your English work is that it's too complicated. Why don't you work in series? Why don't you work simpler, and don't try to put so much into a single piece; make a whole series of pieces and you can put something of it into every one, and the series will grow?"'[22]

The works that Caro went on to make in America, *Bennington* 1964 and *Shaftsbury* 1965 (p.32) among them, evince the new spareness that Noland had espoused. The formal argument of the earlier works has been simplified. The sculptures snake along the ground, turning and pausing, evoking qualities of extension and expansion in a more disembodied way. Yet this aesthetic could be, and was, pushed further. Jules Olitski, who was also on the staff at Bennington, advocated even greater reductiveness. At this moment, Olitksi's paintings were tending to increasing emptiness and this asceticism crept into Caro's work. *Eyelit* 1965 and *Smoulder* 1965 commence a series of emphatically linear works that takes to an extreme the principle of a naked sculptural gesture: a line drawn in steel through the air or along the ground. Exploring the boundaries of sculpture and drawing, they explore how far an artistic statement in three-dimensions can be emptied out and still remain expressive: sculpture invested with feeling, but stripped to essentials.

Taking sculpture in this direction – opening it out, extending it and, in so doing, *exposing* it so that the work appears almost like an armature – continued Caro's progress away from the tradition of monolithic,

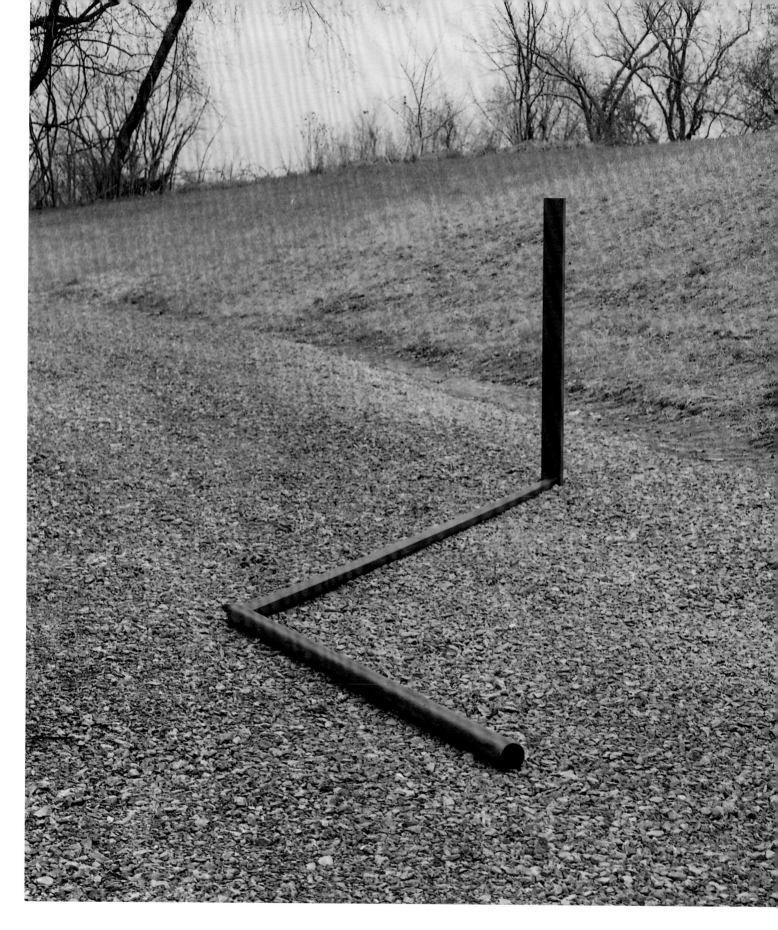

Smoulder
1965
Steel, painted purple
106.5 x 465 x 84 cm
Private collection, UK

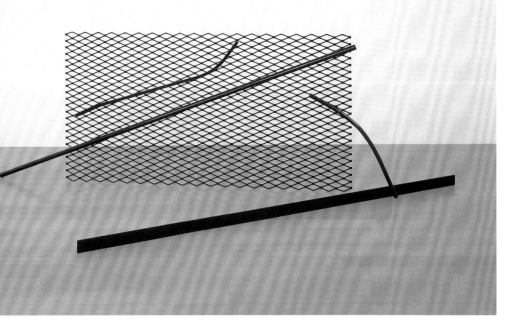

Aroma
1966
Steel, polished and
lacquered blue
96.5 x 294.5 x 147.5 cm
Collection of the artist

monumental form with its figural connotations. His purpose
was, as he explained, 'to make [sculpture] more fully
abstract … With sculpture this is difficult because
sculpture's materiality always tries to suck it back into the
world of things.'[23] The naked sculptures, as Caro sometimes
refers to them, approach the limits of immateriality and
abstractness. They exist, but only just: sculpture as pure
extension and direction. But, as he now recognised,
proceeding would entail re-clothing the work. This must
have presented something of a problem since, having
brought the articulation of space within the domain of
sculpture, a return to solid form was out of the question.
Caro's solution is both elegant and inspired. From 1966
a new formal element – the mesh panel – enters his
vocabulary. Making its first appearance in *Aroma* 1966, it
returns in a number of guises in several subsequent works,
before receiving authoritative treatment in a trio of related
sculptures: *The Window* 1966–7 (pp.38–9, 40), *Carriage*
1966 (p.41) and *Source* 1967.

 In *The Window*, for example, wire mesh is used as a
vertical, space-defining element, in much the same way
that, in architectural terms, a wall serves to contain or
define an area. In this sculpture it is used in conjunction
with a square panel of sheet steel and various other planar
and linear elements in order to enclose a central space.
The mesh functions structurally – as a plane and as a
connecting element – so that the work regains the formal
and spatial complexity that had been surrendered in the
purely linear sculptures. In formal terms, it puts flesh back

Source
1967
Steel and aluminium,
painted green
185.5 x 305 x 358 cm
The Museum of Modern Art,
New York

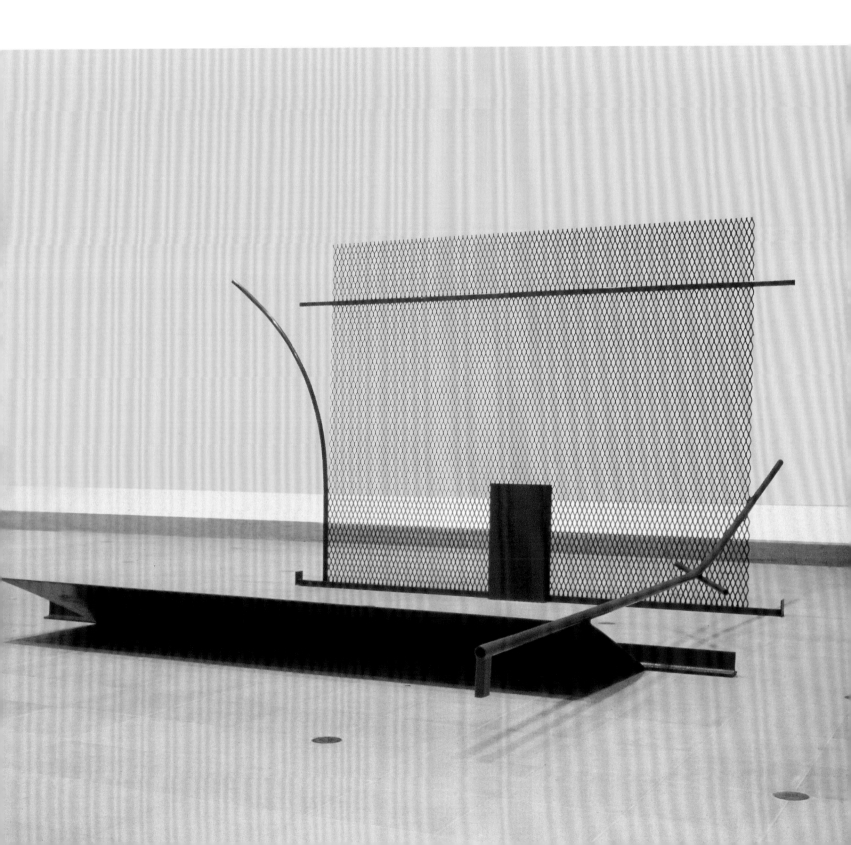

The Window
1966–7 (no.18)
Steel, painted green and olive
217 x 374 x 348 cm
Tate. Lent by a private collector
1994

on the sculpture. But its principal virtue is the way in which it achieves this without entailing heaviness. Indeed, being semi-transparent the mesh neatly avoids obscuring the rest of the sculpture, which can be glimpsed through it. Caro saw this as analogous to the presence of glass in a skyscraper. Although such architectural connotations were far from his thinking at the time, there is no doubt that Caro's treatment of space in *The Window* signals a growing engagement with concerns which hitherto had been the exclusive domain of architecture. For that reason, it signals the beginning of a dialogue between sculpture and architecture, an issue that would assume growing importance in Caro's work, particularly during the 1980s.

Caro's ambivalence about the relation of sculpture and architecture in his work at this early stage is evident in the following, later observation:

> Since the 60s, sculpture has not been so far away from architecture: sculpture extended itself so that it explored almost the same space as the architect's. Not quite the same space, because the sculptor's space, however open, demanded an invisible wall between the spectator and the work. But since we sculptors were absorbed with getting away from old-fashioned methods and modes, and with making a new vocabulary for sculpture, the

The Window
1966–7 (no.18)
Steel, painted green and olive
217 x 374 x 348 cm
Tate. Lent by a private collector
1994

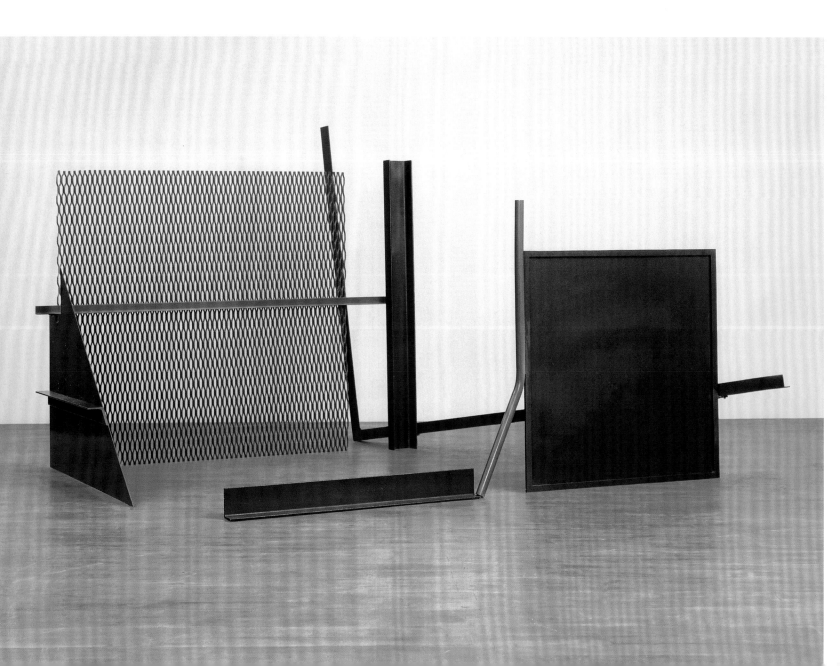

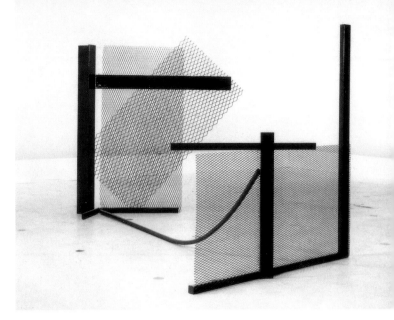

realisation of the closeness of what we were making to architecture would at the time have horrified us – taken away from our endeavour. Nevertheless we were using rods that felt like handrails even though they were not grasping, making intervals like doorways even though one couldn't go through them, enclosing space in works that felt like rooms even though one could explore them with the eyes only.[24]

This statement is highly significant, for it acknowledges the way in which sculpture's new concern with the interpretation of space had taken it close to the boundaries of architecture. Equally clear, however, is Caro's insistence on the essential difference between sculpture and architecture. Though sculpture now also explored and defined space in its pursuit of a more abstract language, the architect's endeavour is towards a functional object, whereas the sculptor's aim is purely expressive. The essential and absolute divide lies, at this stage, in the entirely visual nature of Caro's sculpture. *The Window* stands squarely on the ground, it contains space, and it even incorporates a point of entry at one of its corners. Its title hints at architecture, alluding to the sense of being able to look into a separate, defined place. Indeed, Caro has allowed that this work and its cousins 'felt like rooms'.[25] However, there the connection with architecture ceases. Physical contact with the work would be a breaching of the boundaries, taking sculpture fully into the real world. Instead, the space defined by the sculpture is one that, as Caro suggests, 'one could explore … with the eyes only'.[26] Though situated in the same physical space as the viewer, it also stands at a remove, situated precisely at that point where architectonic form and abstract, sculptural expression touch.

Carriage
1966
Steel, painted blue
195.5 x 203.5 x 396.5 cm
Nasher Sculpture Center, Dallas

Levels

Caro's achievement, by 1966, is to have positioned space at the heart of his endeavour as a sculptor. As seen, the intention driving this momentum was to repudiate – decisively and completely – the idea and tradition of the solid sculptural object; and, by liberating sculpture from its historic allegiance to the representation of the figure, to forge a new language for sculpture that speaks directly and expressively, like music, in purely abstract terms. *The Window* embodies Caro's authority in achieving these aims. It places space at the centre of the sculpture. And by drawing sculpture closer to the architect's language of forms that interpret and control space, Caro introduced a further radical development in terms of the relationship which the sculpture now established with the ground. Earlier in the decade he had situated abstract sculpture in the same physical space as the viewer, so that its physical presence is real and immediate. *The Window* not only occupies and explores the ground, it now also *interprets* the plane on which it stands, defining that space in terms of what in architectonic terms would be called a ground plan. The ground now becomes an integral element in the sculpture's disposition of abstract formal relationships.

Establishing a dynamic interaction with the plane supporting the sculpture is significant because it underpins and fosters the horizontal deployment of elements, permitting open, extended structures and the inflection of elements that move across, along and over. These were exciting developments which greatly opened up the range of possibilities. Previously, sculptural representations of the figure had confined the sculptor's expressive range to elements stacked vertically. While there might be a cantilevered element in the form of an extended arm or leg, in the main the potential for activating the space *around* the sculpture was circumscribed. Emphasising and incorporating a flat plane as a compositional element in itself was therefore new, fertile territory.

Prairie
1967 (no.21)
Steel, painted matt yellow
96.5 x 582 x 320 cm
Collection of Lois and
Georges de Menil

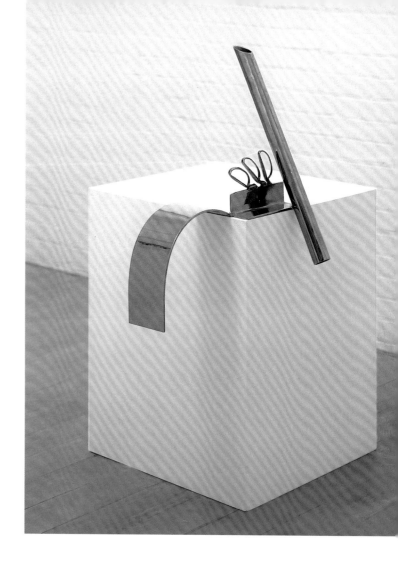

Table Piece VIII
1966 (no.17)
Steel, polished
68.5 x 33 x 50.8 cm
Private collection, UK

Table Piece XLII
1967 (no.20)
Steel, polished and
sprayed green
59.7 x 39.4 x 73.7 cm
Private collection, UK

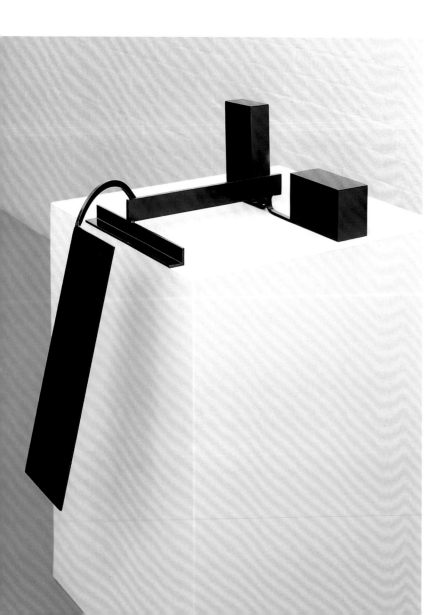

For that reason, these ideas were influential. Indeed, the principle of grounded sculpture achieved currency so swiftly that by the mid-1960s this newly won territory had already achieved a degree of orthodoxy. All advanced sculpture could be expected to work in terms of a direct physical relationship with the viewer's space.

Having pioneered the way, Caro now found the newly won ground becoming overcrowded. His recognition of this situation led to a further, singular innovation. The table sculpture, which dates from 1966, responds to the growing ubiquity of ground-based sculpture by taking the opposite course. Returning now to working on a smaller scale, he addressed the problem of how to place sculpture on a plinth without implying that such works were maquettes for larger sculptures. Underlying that issue was the familiar problem that placing any sculpture on a plinth segregated it from the real world, inviting the perception that such works existed within a virtual space as the representation of some other thing. His solution to these questions is inspired and utterly original, at once asserting the role and presence of the supporting plane and also situating sculpture, literally, at the edge.

Caro's earliest table pieces commence a numbered series which continues to the present day and, indeed, his fertility in this area has been prodigious. His agenda was clear from the outset. *Table Piece VIII* 1966, for example, incorporates the handles of scissors. These elements function in a purely abstract way, as ovals that trace a tiny curving movement through space. But they are also instantly recognisable as tool parts. As such, they establish a real scale which relates to the human hand. This banishes any implication of represented scale. They have a literal presence in that they are sensed as things in themselves and not as a simulation of any other object. This element is thus nicely poised: at once unmistakably real and functional in origin, but rendered abstract and expressive – yet no less real – by their new context.

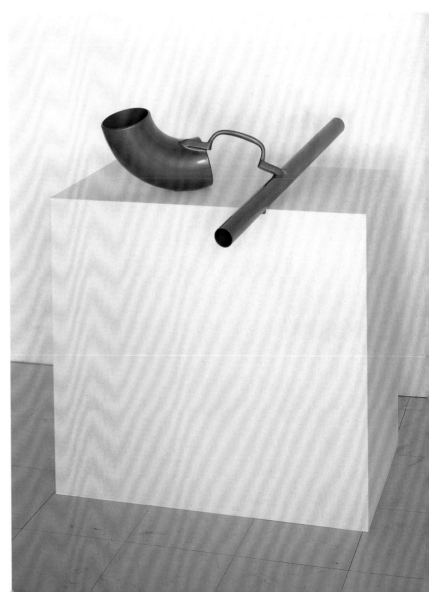

Table Piece XXII
1967 (no.19)
Steel, sprayed jewelescent green
25.4 x 80 x 68.6 cm
Private collection, UK

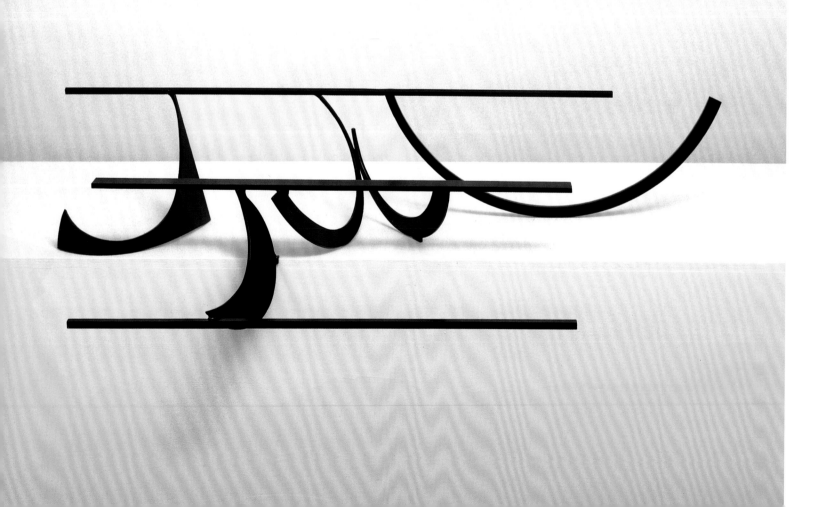

Table Piece LXXX
1969 (no.25)
Steel, painted deep blue
34.3 x 134.6 x 50.8 cm
Private collection, UK

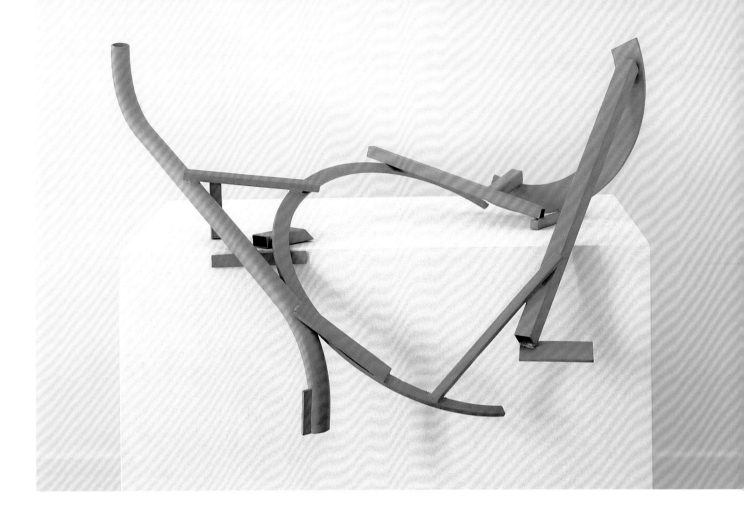

**Table Piece LXIV
– The Clock**
1968 (no.23)
Steel, painted yellow
76.2 x 129.5 x 81.3 cm
Private collection, Paris

However, Caro did not stop there. A connected tubular element is balanced against the table edge; also, a curved part springs forward from the edge, inscribing a movement which passes below the table top. With these simple means, the sculpture passes from the space of the table top, projecting outwards and spilling into the literal, surrounding space. The sculpture asserts the edge of the support and then extends beyond it, connecting with the real world. Consequently, we encounter the work directly, as is the case with Caro's ground-based sculpture. Indeed, the connection with the ground-based work is closer than might at first be apparent. A recurrent feature of the early table sculptures is the way in which they project not only into the surrounding space, but also below the table level. This is significant, for it is clear that these small works can *only* exist positioned on a table top and cannot be scaled up for siting on the ground. Like the larger sculptures which sit directly on the ground, the table sculptures assert their intimate, close connection with the literal plane that supports them. On both scales, the sculptures have a real, immediate presence. And in both cases, Caro achieves this immediacy by probing the boundary that exists between the viewer's space and the space inhabited by the sculpture.

In some ways Caro's table sculpture and his work on a large scale are generically distinct. From the start, he tended to work on the smaller pieces at weekends or in the evening, using the small garage space at his home in Hampstead. Parallel to this activity, the large sculptures were made in a basement space in Loudon Road, south Hampstead, and then, from 1969 onwards, in a large converted piano factory in Camden Town. In addition to this physical separation, the two lines of activity differ in appearance and feeling. Aside from the issue of scale, the

Table Piece LIX
1968 (no.22)
Steel, sprayed silver grey
29.2 x 43.2 x 48.3 cm
Private collection, UK

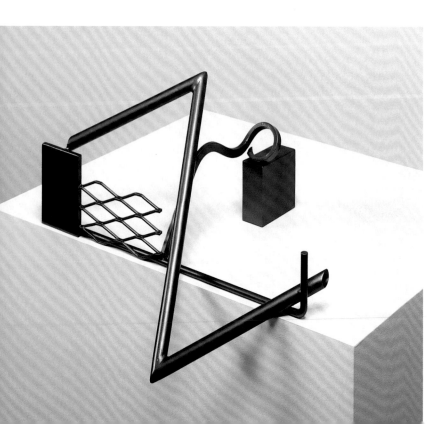

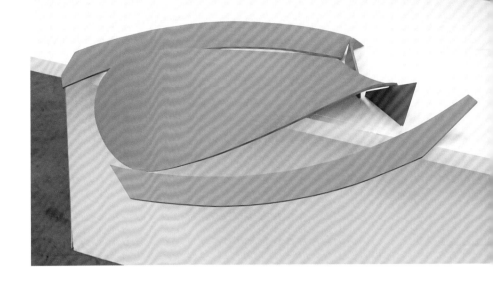

Table Piece LXXV
1969 (no.24)
Steel, sprayed matt tan
29.2 x 99.1 x 71.1 cm
Private collection, UK

table sculptures responded to the more intimate nature of the table top and, at first, Caro sprayed them with lacquer or gave them a polished, steel finish to emphasise their jewel-like character. This contrasts with the bolder, brighter, more assertive personality of the large works. Also, whereas the ground-based sculpture from the mid-1960s tends, in the main, to more complex structures and formal relationships, the table sculptures are more terse and economical, often comprising, as in *Table Piece XXII* 1967 (p.45), a simple conjunction of two elements. The table sculptures feel like drawings – though not in the sense of being preparatory sketches, for they are an end in themselves. But they have a spontaneity, and a surprising lightness of touch, that suggests the sculptor sketching in three dimensions.

This is not to imply that the two ways of working are unconnected. Rather, the interaction between them is indirect: they share similar concerns and provide different, though related, responses. A principal point of connection lies in a mutual engagement with the principle of *levels*. As seen, the table sculpture evolved in part as a reaction to the widespread involvement among sculptors with ground-based sculpture. The small works that Caro went on to make now suggested a line of development which fed back into his work on a larger scale. In particular, the theme of a raised level, below which elements of the composition are dropped or inflected, is now taken up in earnest in the larger sculptures. Undoubtedly, Caro sensed in this spatial arrangement a way of preserving the open, lateral dispersal of shapes while being freed from an adherence to situating the sculpture squarely on the ground.

Prairie 1967 (p.43), announces this innovation and, within Caro's oeuvre, this sculpture must be regarded as

one of his most remarkable. A perfect marriage of material fact and visual illusion, the sculpture introduces an invention that is without precedent in the language of sculpture. An implied plane, comprising cantilevered horizontal rods in series, appears to float above the ground. Beneath this, other structural elements are deployed, effecting a transition between the plane and the ground. The work embodies everything that, previously, had been denied to sculpture: it is open, expansive, weightless and transparent. It is difficult to say which of these qualities makes the greatest impression. Within the language of sculpture, each signals an advance in terms at once unfamiliar yet completely convincing. The singular character of *Prairie* arises from the way in which it so effectively advances into these several territories simultaneously. The work's openness is a revelation, evoking the flat distance of landscape, and the American prairie in particular. Hitherto, this was a range of experience and reference that lay beyond sculpture's boundaries. At the same time, the work's flatness is pure pictorial illusion, an impression conveyed by the repetition of several surprisingly elongated rods. Despite *Prairie*'s emphatic horizontality, once again, painting – and Noland in particular – seems to have been in Caro's thoughts. Parallels can be drawn between his use of repeated, highly attenuated lines, and Noland's concurrent paintings in which he was deploying ambitiously extended lateral stripes. Noland's aim in those works was to explore repetition as an alternative to conventional composition and, significantly, *Prairie* is not a work that seems overtly composed. Moving beyond an analysable relationship of individual parts, the *fact* of the work – its incontrovertible and completely resolved character – makes the dominant impression.

This is an important advance. Hitherto, there was a sense that Caro's primary concern had been to identify and establish the grammar of the sculpture that he was

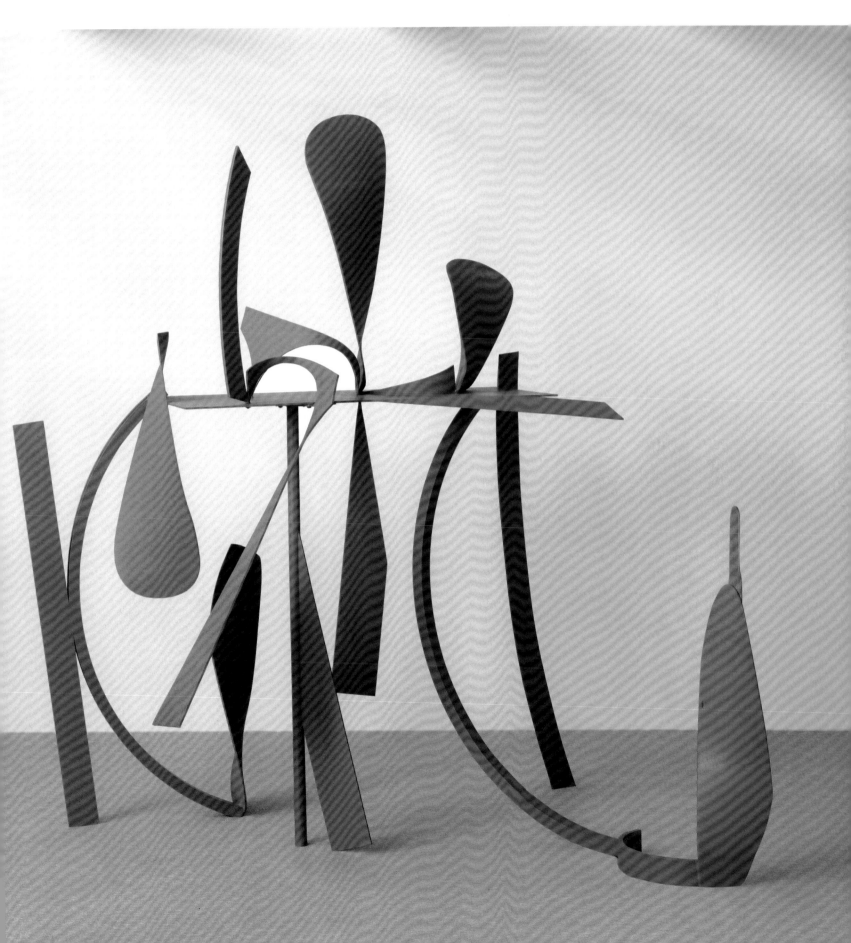

Orangerie
1969 (no.26)
Steel, painted Venetian red
225 x 162.5 x 231 cm
Kenneth Noland

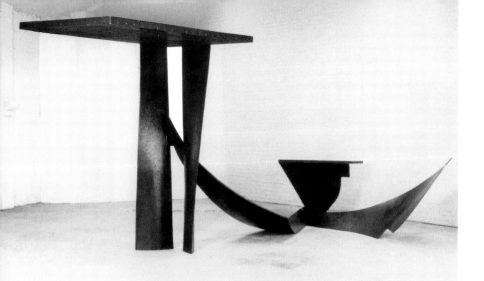

Deep North
1969–70
Steel, cadmium steel and
aluminium, painted green
244 x 579 x 289.5 cm
Kenneth Noland

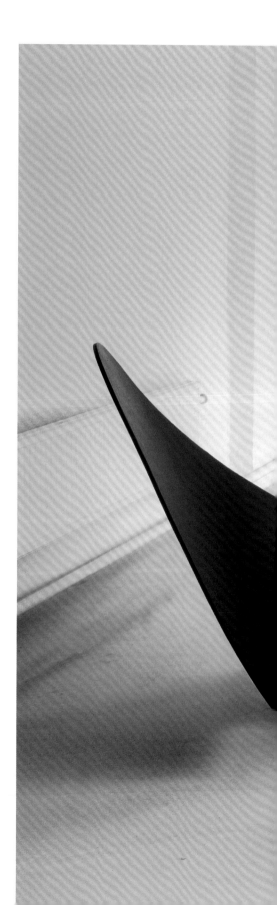

evolving. It is for this reason that issues of syntax – the joining and relation of different elements – commands attention. Increasingly, however, towards the end of the 1960s, this formal analysis gives way to works such as *Prairie*, but also *Orangerie* 1969 (p.51), *Sun Feast* 1969 (pp.54–5), *Garland* 1969–70 and *Deep North* 1969 – all masterly sculptures – that are invested with a greater sense of poetry. This is not to suggest that in these works Caro foregoes issues of formal relation. If anything, the reverse is true. But now form and feeling are wedded so completely that neither obtrudes, and each contributes equally to the work's nature as sculpture. This authority enables Caro's art to draw closer to the world of objects, confident of its purely expressive role and able to explore a range of forms, echoes of which can be recognised in everyday experience. Among these developments, the issue of level planes is a central theme. *Orangerie*, for example, continues the table idea. Here, however, the level is an integral part of the fabric of the sculpture itself. Then, in a significant extension of table sculpture, various curved forms, some of them ploughshares, are inflected above and below the plane, connecting it to the ground. This theme is developed further in *Sun Feast* and *Georgiana* 1969–70, both of which sustain the illusion of a gravity-defying table-level in the midst of a chain of animated shapes. The table form situates these sculptures at the borders of the real, lending them immediacy. But the vivacious play of abstract form, and the illusion of weightlessness, demarcates the divide and defines their status as art.

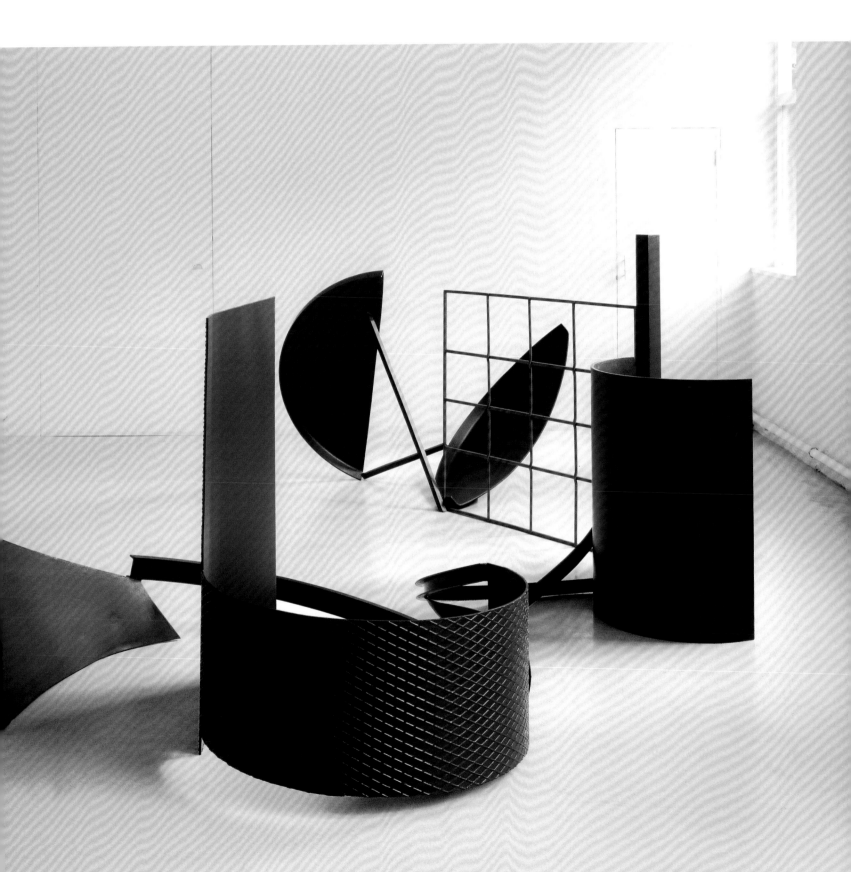

Garland
1970
Steel, painted green and red
140 x 429.5 x 376 cm
Private collection, USA

Deep North takes the theme of levels a step further, incorporating two horizontal elements and raising one of them to ceiling height. Once again, architecture is implied. As Caro has observed: 'the aesthetic concerns of contemporary sculptors and architects do match one another. The materials are the same or similar. Form and space are the subject of both disciplines; scale and how the viewer relates to the work is of vital importance to both.'[27] In this work there is a sense that Caro has deepened the architectonic dimension. The raised level defines a space beneath it, and the viewer can walk around the sculpture and occupy this space – if desired. The physical relationship between the sculpture and the viewer's body has drawn closer. However, physical occupation is not really the point. The viewer experiences the work in relation to his own height but the connection remains essentially visual. Moreover, the character of the work, with its great sweeping shapes, is assertively non-functional, uninhabitable and overtly expressive. In advancing sculpture towards those issues addressed by architecture, once again Caro simultaneously defines the boundary between the two activities: 'Architecture invites, sculpture is a thing in and of itself, architecture sits grounded, sculpture flies.'[28]

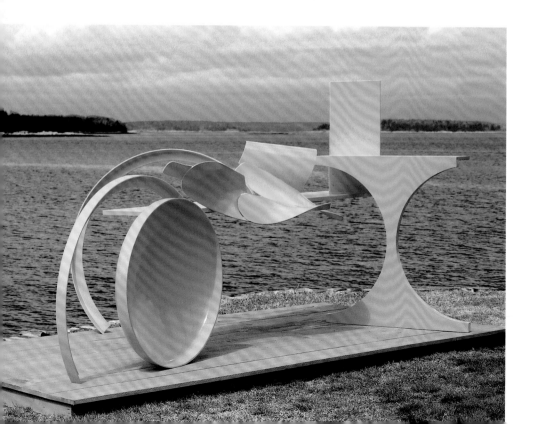

Sun Feast
1969–70 (no.27)
Steel, painted yellow
181.5 x 416.5 x 218.5 cm
Private collection

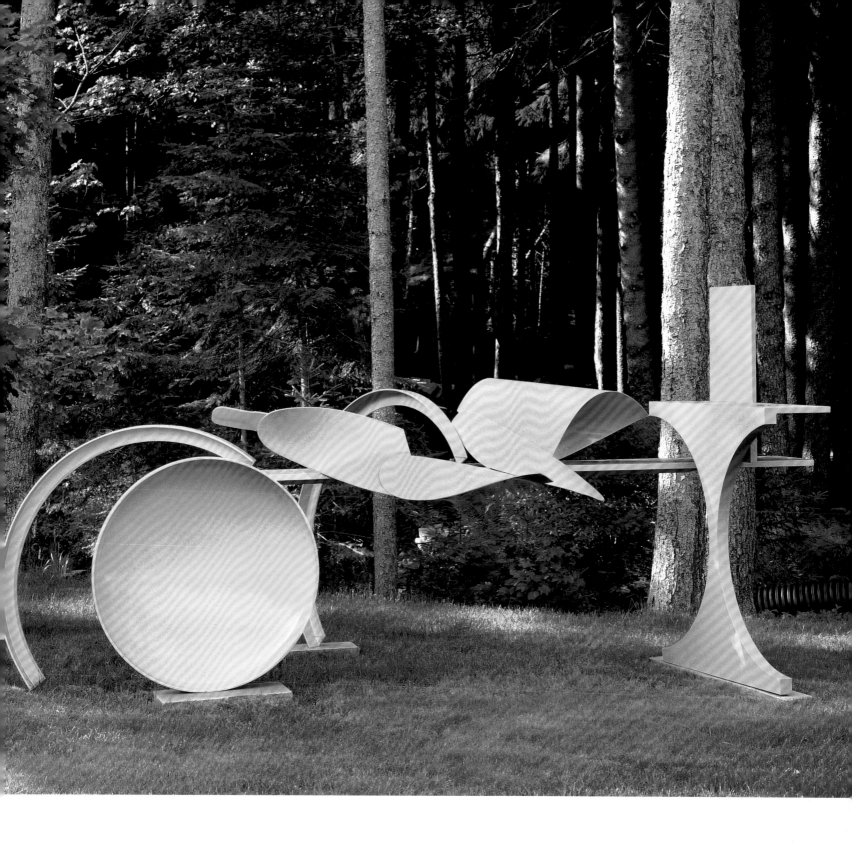

Thickening the argument

In 1970, on the occasion of Caro's solo exhibition at André Emmerich Gallery, New York, Hilton Kramer wrote the following review in the *New York Times*:

> *Mr Caro stands today all but unrivalled as the most accomplished sculptor of his generation. He is unquestionably the most important sculptor to have come out of England since Henry Moore … If he continues on his present course, adding distinction and eloquence to an already powerful oeuvre, he must certainly be counted among the great artists of his time … One has the impression of an artist who, having totally mastered a new and difficult area of sculptural syntax, is now permitting himself a freer margin of lyric improvisation.[29]*

The exhibition included *Orangerie*, *Sun Feast* and *Deep North*, and, as Kramer observes, there was a clear sense that with these sculptures Caro had attained an unprecedented mastery and resolution of the language that he had been developing in the preceding decade. Despite the commercial success of the show and the acclaim it received, Caro himself had doubts. With hindsight, he observed: 'it was as if I had been too successful … it was too much liked.'[30] In part, these misgivings possibly arose from his perception that in the 'lyric' character of the work, noted by Kramer, lay the incipient danger of over-refinement in the future. Perhaps there was a growing sense that the mood and atmosphere of the times was changing and he felt a concomitant need to respond to that shifting outlook. Whatever the reason, Caro resolved to do the very opposite of the course advised by Kramer. He later recalled feeling 'I've got to do something completely different, and almost opposed to it'.[31]

 The Bull 1970 (p.58) signals the new direction that Caro now took. In its radical dissimilarity to its immediate predecessors, there is the

Ordnance
1971 (no.28)
Steel, rusted and varnished
129.5 x 193 x 636 cm
Collection of the artist

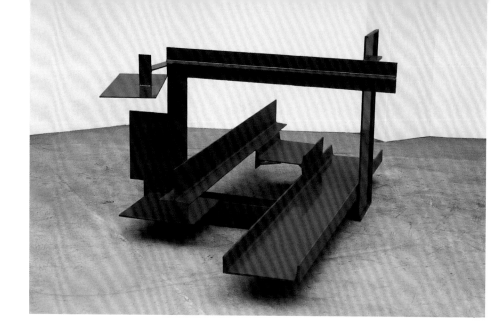

Bailey
1971
Steel, painted brown
113 x 181.5 x 226 cm
Private collection, USA

The Bull
1970
Steel, rusted
81.5 x 302.5 x 145 cm
Kenneth Noland

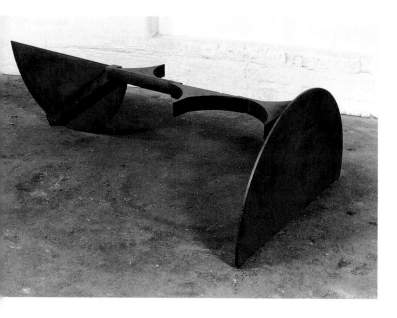

evidence of a determination to change, echoing the break with his previous practice forged exactly ten years earlier. Indeed, in some respects, *The Bull* resembles *Twenty Four Hours* 1960, the work that marked his breakthrough to pure abstraction. Both have a blunt, direct quality – a tough, uninflected character of abbreviation in which embellishment is excluded. *The Bull* takes this even further, comprising relatively few parts, each of which is heavier and more massive than had been the case hitherto. This denial of elaboration is continued in the work's finish. *The Bull* severs a more or less unbroken adherence to painted surfaces that, for Caro, had always been something of an addition, a kind of skin serving to unify a work and to underline its expressive character. Instead, he now retained the steel in its raw state, wanting to emphasise and expose the work's material reality.

Having put down this marker, the works that Caro made in the early 1970s are diverse in character and ways of working. In contrast to *The Bull*, colour as well as lighter, more delicate, linear elements make occasional reappearances and, viewed as a whole, there is a sense of uncertainty, and a corresponding willingness to experiment. Underpinning this exploratory phase, two themes do, however, gradually emerge with growing strength and conviction. The first is a renewed tendency towards greater complexity. However, unlike the lyrical refinement that delineates the works of the late 1960s, this

complexity is less to do with grace and subtlety. The sculpture is markedly less light in touch and is, in a sense, more like prose than poetry. Having established and clarified the terms of the language, the complexity to which Caro's work now aspires exists more in terms of a thickening of the argument. The work has greater substance and weight: both materially and in its expressive content. The second, connected theme is the growth of the work towards a greater, more insistent reality. Whereas previously, inflection and illusion had been elements in the formal argument, increasingly Caro's sculpture declares itself as a material fact, with nothing hidden or implied. The physical presence of the work is assertive. As such, the sculpture renews and intensifies its interrogation of the boundary with the world of real objects: simultaneously testing and maintaining the line of separation.

Bailey 1970, for example, returns to a painted finish and, in that sense, its material objectivity is qualified. In formal terms, however, the matter-of-fact way in which it simply asserts a succession of rising elements in a step-like

Straight Cut
1972
Steel, rusted and painted silver
132 x 157.5 x 129.5 cm
Private collection, UK

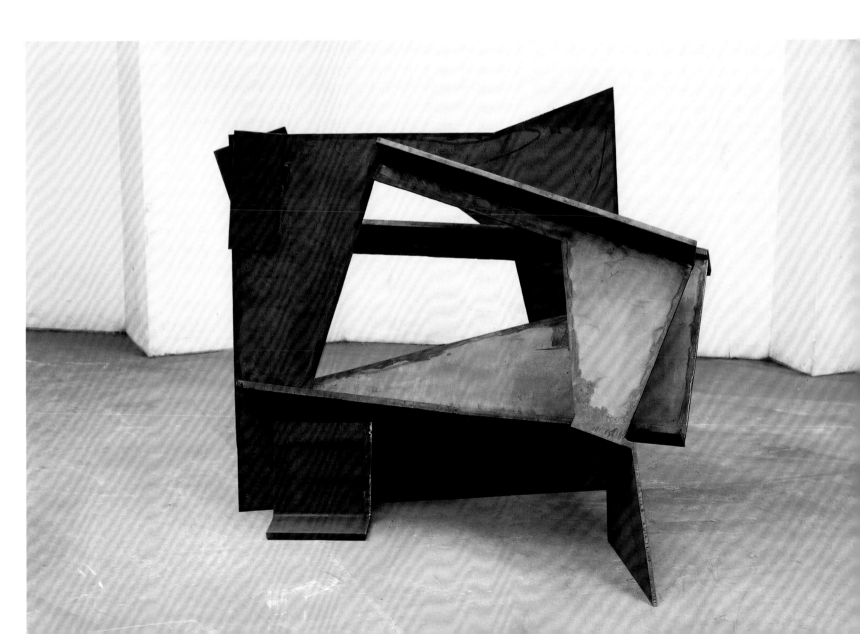

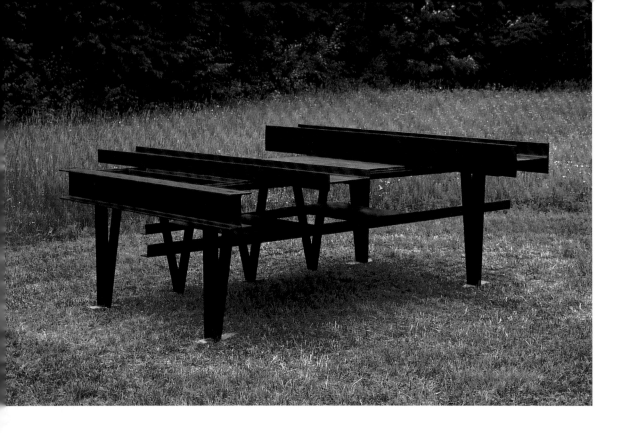

Focus
1971
Steel, rusted and varnished
117 x 264 x 305
Museum of Contemporary Art,
Los Angeles

formation is startlingly new in Caro's idiom. In these ascending progressions there is the continuation of Caro's earlier dialogue with architectonic elements, focusing now on steps. This is a theme that would assume much greater significance for Caro from the mid-1980s onwards, not least when stairs would form a primary element in the architectonic works that involve the physical involvement of the viewer. In this early appearance, the viewer's participation with the work remains visual, although there is a heightened psychological dimension in that the work expresses a sense of ascent, an experience that moves beyond the visual and invites an imaginative engagement.

Caro's use of stacked forms, frequently involving beams, is a principal line of argument around this time. The sculptures rise, vertically and, on occasion, with a playful precariousness. It is as if, having previously denied vertical configurations, Caro now relishes their reintroduction, confident that his command of space can accommodate these relationships without their entailing any figural implication. Caro's interest in these stacked compositions is coloured not only by architectonic considerations. In his pursuit of a sense of greater material reality, the paintings of Hans Hofmann, which had not much interested him previously, now exerted a relevance. In particular, Hofmann's use of stacked rectangular shapes – so that the paintings appear almost *built* – is germane to Caro's thinking.

The result is an emphasis on overt, raw construction, in which the complex assemblage of discrete parts – lateral and vertical – is noticeably more pronounced. The works

Ordnance
1971 (no.28)
Steel, rusted and varnished
129.5 x 193 x 636 cm
Collection of the artist

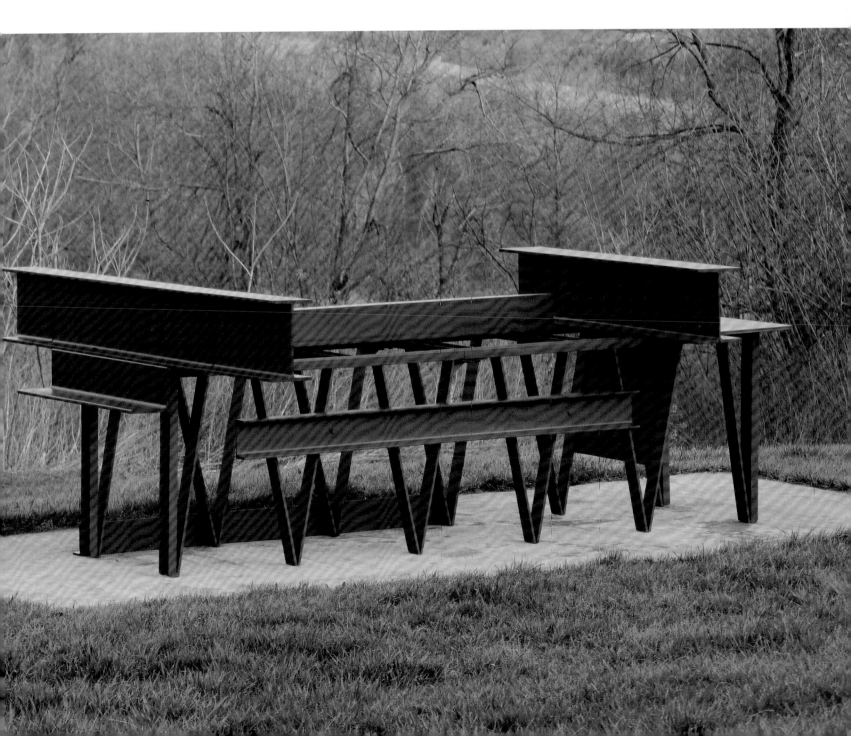

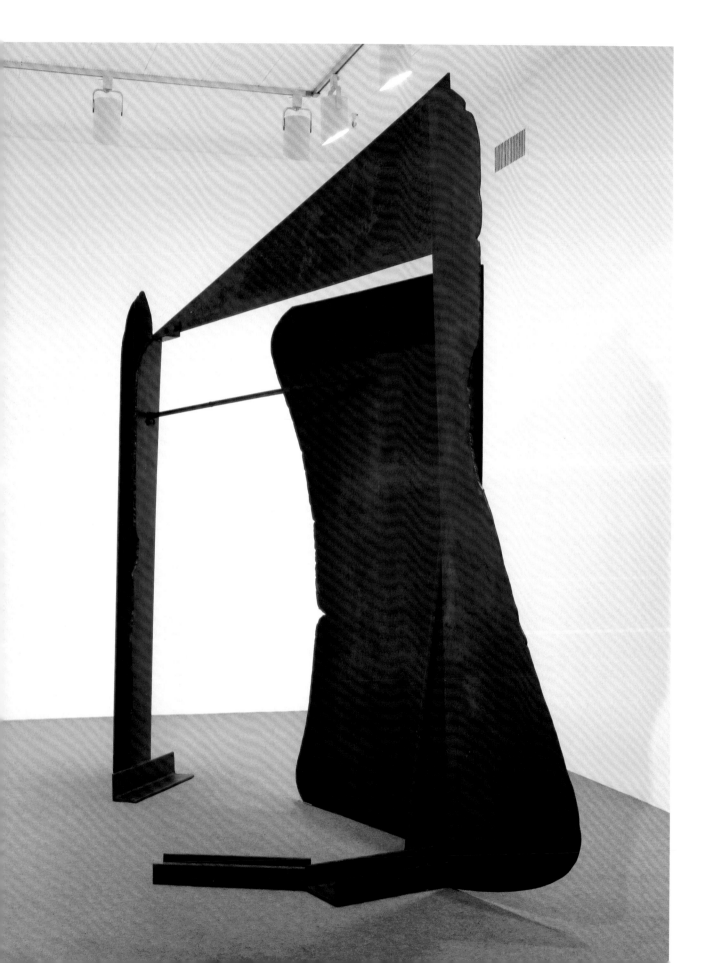

Veduggio Sun
1972–3
Steel, rusted and varnished
251.5 x 305 x 137 cm
Dallas Museum of Art

made at the beginning of the 1970s interpret this directness in a deliberately unrefined way, in defiance of elegant sensuality. These approaches – stacking, an emphasis on the built nature of the work, and an intentionally non-lyrical angularity – find magisterial expression in two works, *Ordnance* and *Focus* (pp.60–1), both 1971. These are persuasive statements of what amounts to a redefined aesthetic. Both make use of a new element, the saw-horse, a pre-fabricated tool-part that Caro found while staying with Kenneth Noland. This appropriated shape is an important compositional device, effectively allowing Caro to reprise the table idea. In complete contrast to its earlier incorporation in works such as *Sun Feast* and *Orangerie*, here it forms a supporting level on which are positioned a number of I-beams, laid horizontally. The effect is one of severity, clarity and open, contained space. The works' unpainted, literal quality advances sculpture towards the world of fabricated and engineered objects. At the same time, the entirely non-functional, indeed, musical, animation of space, effected by the repeated rhythm of the saw-horse legs, locates the works firmly within the domain of pure expression.

As the 1970s progressed, the thickening of the sculptural argument advanced by Caro led to increasing complexity, though this is not its only manifestation. The *Straight* series of 1972 (p.59), for example, is predicated on the principle of sections of I-beam, cut and shaped, and brought into angular, interlocking configurations of space and form. Making the works was demanding and complicated because as each work progressed, there was a sense of endless, proliferating possibilities that took each work in new directions as well as generating ideas for other, related works. However, concurrent with his work on the *Straight* series, the *Veduggio* sculptures reveal a parallel, contrasting tendency leading to extreme formal simplicity, almost a blankness, in which the relation of parts is comparatively understated. Significantly, there is a sense that these opposite tendencies arise from a common sensibility: the conviction that sculpture must be made more real, more literally a thing in itself. And, whether complex or not, the issue of central importance is that 'the fact' of the sculpture should, as Caro puts it, 'be more emphatic than their form'.[32]

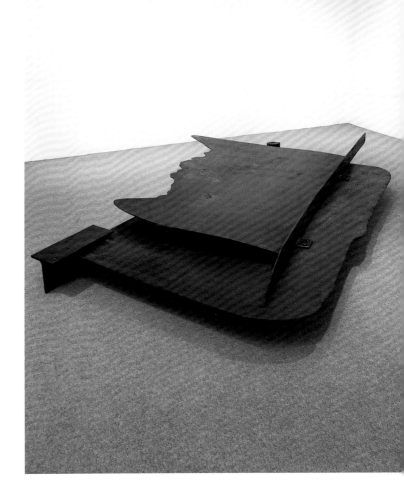

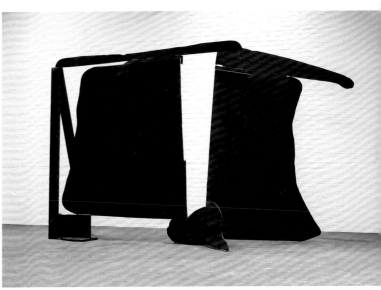

Veduggio Lago
1972–3
Steel, rusted and varnished
35.5 x 195.5 x 335.5 cm
Collection of the artist

Camden Street
1974
Steel, rusted and varnished
239 x 414 x 269.5 cm
Museum Moderner Kunst
Stiftung Ludwig, Vienna

The fourteen sculptures that comprise the *Veduggio* series came about as a result of three visits made by Caro to the Rigamonte steel factory at Veduggio, Brianza in Italy, during 1972 and 1973. Working with large sheets of steel coming straight from the rolling mills, Caro found a supply of material that seemed to require minimum intervention, and yet in whose imposing material characteristics he recognised great formal and expressive potential. In many ways, the works made at Veduggio are a complete reversal of his previous allegiances. With notable exceptions, in the main they achieve an impressive verticality, frequently towering about the viewer. Even in those works which are predominantly horizontal or flat, the overall impression is one of great scale. In some instances the works' proportions, and their sheer physical presence, tend towards the monumental, an expressive dimension that, hitherto, Caro had avoided. As if recognising that working with sheet steel was leading the argument into the territory of increased expansiveness, the sculptures accommodate this advance by favouring formal simplicity. The baroque, detailed complexity of the *Straight* series is supplanted by a breadth and generosity of statement.

In this respect, the dialogue of sculpture with painting and drawing is an underpinning consideration. 'In both painting and sculpture, drawing gives a kind of definition', Caro has observed. In the *Veduggio* series, the sculptures' edges – torn, ripped and irregular – acquire this significance, functioning as a raggedly drawn, defining boundary. A number of the works, notably *Veduggio Wash* 1972–3 and *Veduggio Lago* 1972–3 (p.63), take this further, asserting the surface of sheet steel as the centre of attention. As such, they move sculpture into the realm of the pictorial – eliminating solidity and introducing, as a new source of visual interest, the play of light across a plane of rich earthy reds and rust browns. In this there is an echo of Jules Olitski's paintings, which also offer an open

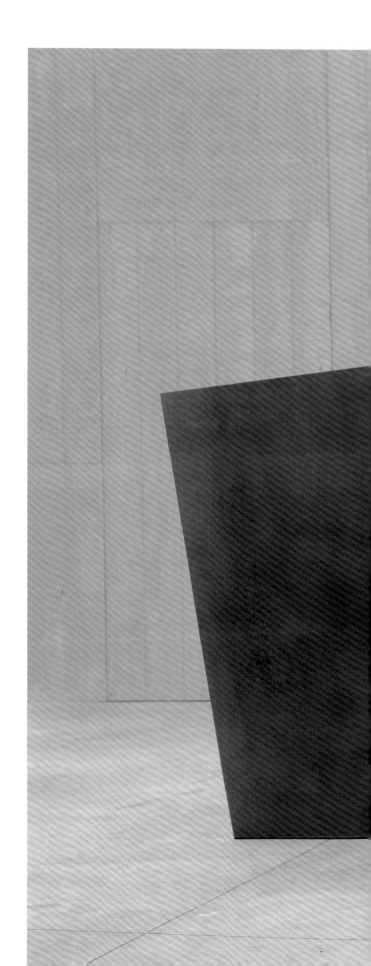

Cliff Song
1976
Steel, rusted and varnished
197 x 353 x 129.5 cm
Collection of the artist

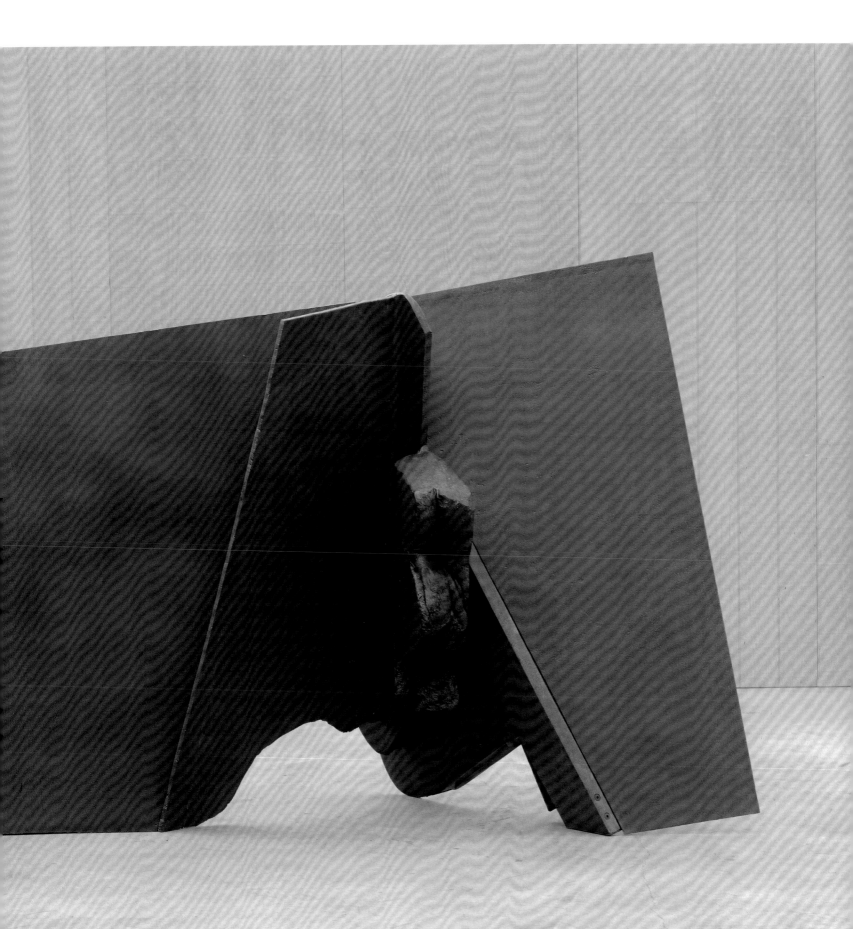

Tundra
1975 (no.31)
Steel, waxed
272 x 579 x 132 cm
Tate. Purchased 1982

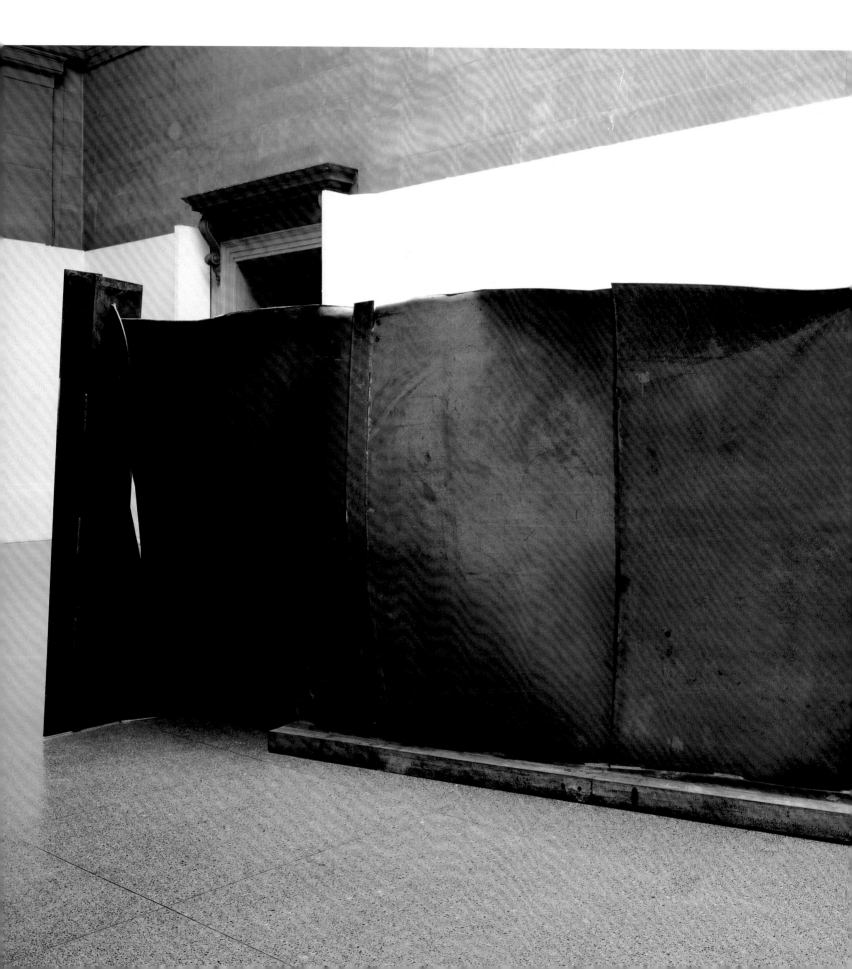

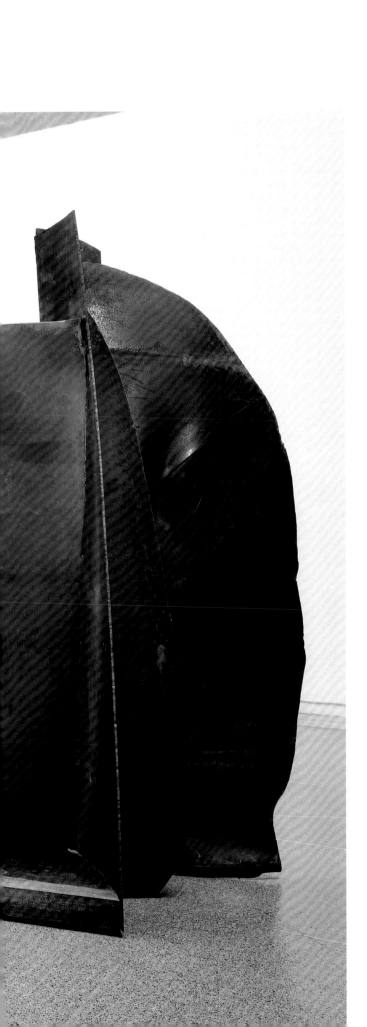

surface of colour events with drawing positioned at the edges. It is interesting to note, however, that while working on the series, Caro was relatively less engaged by issues of surface, and responded more to the silhouettes created by the sheet steel, seen in the intense, bright Italian light. In part, this may account for the works' formal clarity. Certain architectonic elements – walls, steps, gateways and arches are suggested – created by the combination and conjunction of shapes. But these arrangements, which Caro arrived at quickly, have a fundamental quality that now passes through and beyond architecture. The raw emotive power of the *Veduggio* works transcends conventional principles of composition, evoking ancient forms which stand at the beginning of human expression. Like Neolithic menhirs, their directness speaks simply but deeply.

Having opened up the terms of reference – notably sculpture's relationship with painting, drawing and architecture – increasingly Caro developed the argument by diversifying his means and ways of working. From this point onwards, the inspiration that he derives from working with an ever-expanding range of materials is evident. The line of development begun in the *Veduggio* series, for example, continued in a series of large-scale works made in 1974, also using soft-edge rolled steel, this time obtained from the Consett steel works in Durham, England. These sculptures develop the theme of verticality, admitting – in *Camden Street* 1974 (p.63) – a developing dialogue between flat planes of sheet steel and the intervals between them. This interaction between edge and interval, surface and negative, evokes drawing and painting in equal measure. The thirty-seven works made at the York Steel Company in Toronto in the same year advance towards a greater pictoriality. This is surprising given that they use thicker and heavier sheet steel. However, by overlapping and layering the steel, qualities of depth, surface relief, and the play of shadow sustain a satisfying tension between

monumentality and subtlety. The *Veduggio*, *Durham* and *York* series trace a path towards larger and simpler formal arrangements, a way of working which brought to Caro's art the sense of expansive gesture and weight that he had eschewed in the 1960s.

But alongside that line of development, a parallel route towards greater complexity, which began in the *Straight* series, was sustained in the late 1970s by Caro's use of bright steel: small pieces of machined scrap. *Midnight Gap* 1976–8, for example, is the sculptural equivalent of chamber music: an arresting structure built out of intricate detail, nuance and passages of expressive fancy. This is a striking instance of the principle of action and reaction which underpins his way of working. Having, as it were, emptied or, rather, blanked out the sculpture's centre in the *Veduggio*, *Durham* and *York* series, in *Midnight Gap* the centre is entirely animated by detail – indeed the sculpture seems *all* centre.

Henceforward, a sculpture's centre – the exploration of its interior – becomes a primary theme of Caro's work. It forms the starting point for the *Emma* sculptures, the last major series of works that he made in the 1970s. The product of a period spent in 1977 as artist in residence at the Emma Lake summer workshop under the auspices of the University of Saskatchewan, Canada, the fifteen sculptures that comprise the series were unlike anything that he had made previously. In a radical departure from the monumentality and detailed density of their predecessors, the *Emma* sculptures are entirely linear and open, almost cage-like. They do not so much contain space as inscribe it – with economy and brevity. Once again, Caro's choice of materials – mostly steel tubing in this instance – was an influence on the resulting character of the works. That said, in making the *Emma* sculptures he had a particular motive. He later recalled: 'I was interested in the possibility of feeling my way into sculptural space from within, instead of without.'[33]

Midnight Gap
1976–8
Steel, varnished and painted
180.5 x 361 x 279 cm
Private collection

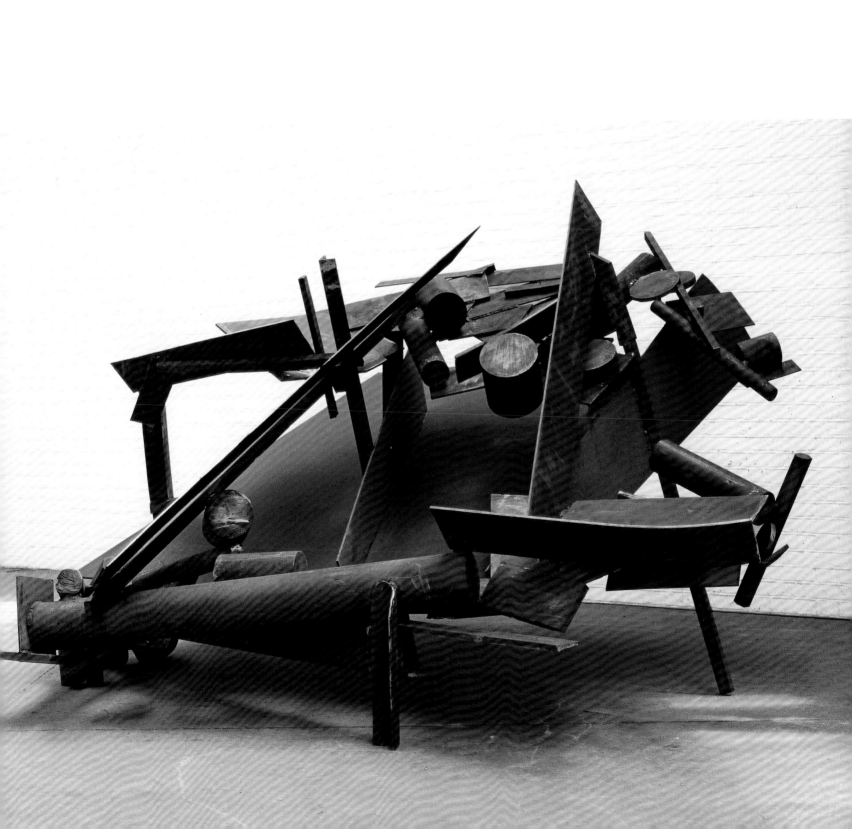

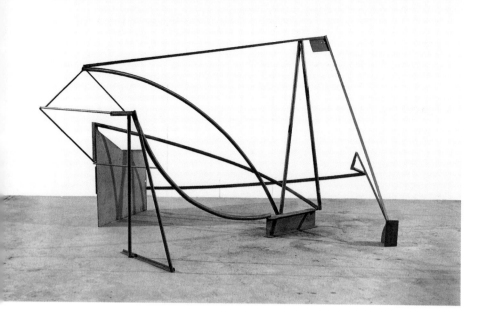

Emma Push Frame
1977–8
Steel, rusted, blacked and
painted green and yellow
213.5 x 274.5 x 343 cm
Collection Würth, Künzelsau,
Germany

This observation is highly significant, implying a new approach to making sculpture in which the interior is not simply exposed, but has equal, if not greater, importance than the surface or exterior characteristics. In *Emma Dipper* 1977, for example, the sculpture does not really have an exterior, nor for that matter any definable centre. It incorporates a square, window-like element, hinting that one looks through and into the work; but such devices are playful. The sculpture probes the division between interior and exterior, and dissolves these distinctions. It exists as a kind of line drawing in air, exploring and animating space. But, as Caro implies, the energy for this exploration comes from within the work, probing the surrounding space and simultaneously vacating the centre. In terms of his expansion of sculptural boundaries, this is an important advance, comparable to his elimination of closed, solid form as a premise for sculpture, and to his displacement of the figure through an engagement with space. The experience of sculpture now implies a simultaneous engagement with its exterior *and* interior characteristics. In the *Emma* sculptures this engagement is still entirely visual. But it prepares the way for Caro's investigation of the interior of sculpture, which, from the 1980s onwards, would proceed in ways that would not solely engage the eye.

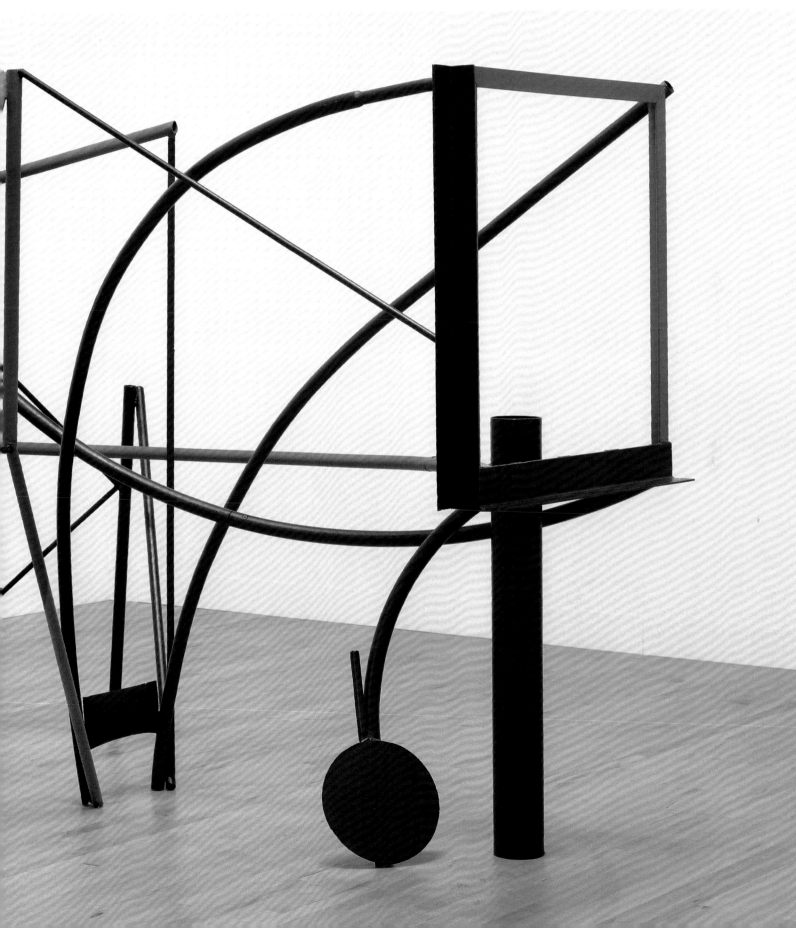

Emma Dipper
1977 (no.32)
Steel, rusted and painted
grey
213 x 170 x 320 cm
Tate. Presented by the artist
1982

Sheila's Song
1982
Steel, rusted and varnished
209.5 x 292 x 127 cm
Baltimore Museum of Art,
Baltimore

The figure in context

The story of the development of Caro's sculpture from the 1980s to the present is one of ever-increasing diversity. His work proceeds on a broad front, indeed several – often apparently contradictory – fronts simultaneously. It draws inspiration from painting, architecture, music and other creative fields. And, whereas previously steel was his principal avenue of expression, increasingly Caro has fed that main tributary through his related work in other media, notably bronze, lead, ceramic, stainless steel, silver, wood and paper. Such apparent contradictions have been a renewed source of energy. Unlike the position to which Caro committed himself in the 1970s, which, in his desire for change, was almost a willful denial of his previous achievements and ways of working, this new spirit of contradiction speaks more of confidence. There is a sense that this is an artist aware that many of the old battles no longer need to be fought. The language for abstract sculpture has been articulated, the case for its expressive power made. This is not to suggest that the imperative to push back its boundaries in any way diminished: Caro's advances into new areas of enquiry makes it clear that expanding the language of sculpture remains a central goal. But the breadth of his work of the last two decades is manifestly the product of an imagination which looks outward, capable of embracing manifold solutions. Caro summarised his position at the beginning of the 1980s as follows: 'I was willing to say, come on, let's open up and use it in every way we can without even feeling that we shouldn't do this. I felt much more freedom to experiment, freedom to try anything.'[34]

 At the heart of this new openness has been Caro's willingness to re-engage, in a more overt way, with issues relating to physical experience, and even to evoke – in a series of small sculptures of figures – representations of the body. This is not to suggest that sensation and feeling have not always been central to his art. Indeed, as seen, the experience of Caro's sculpture is inseparable from the viewer's somatic and emotional responses to it. But, from 1960, implications of the figure – as the subject of his sculpture – were

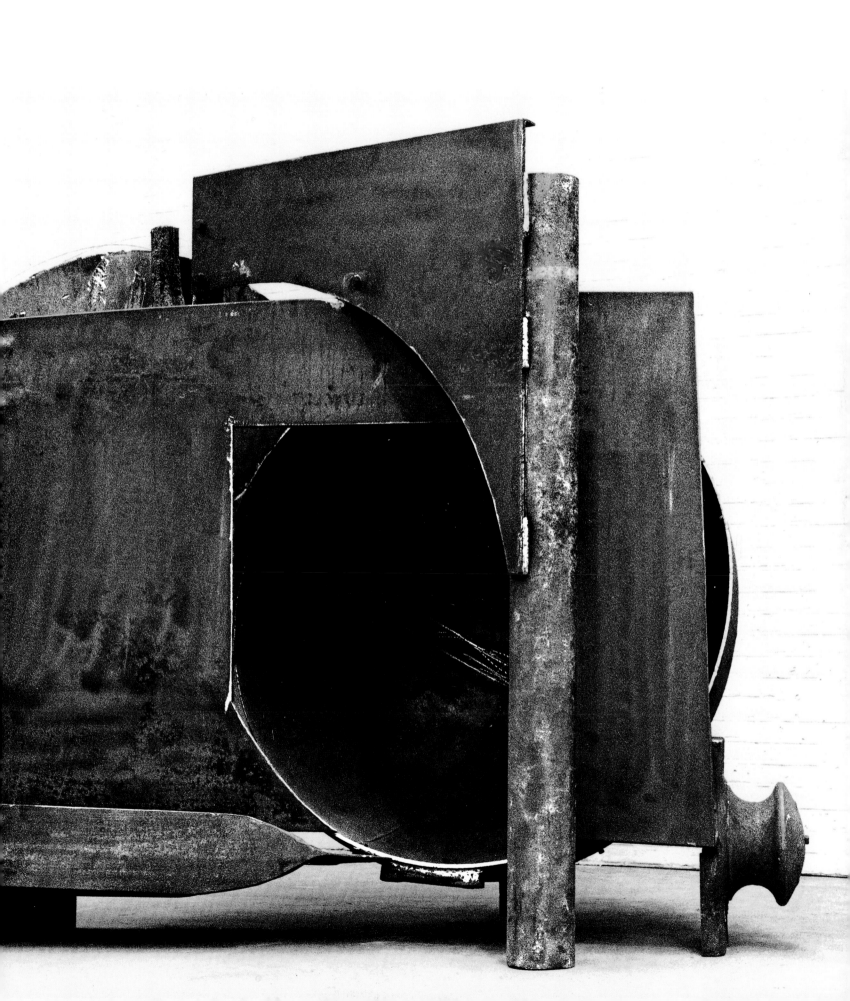

displaced by his engagement with making space the primary focus of expression. It is perhaps surprising, therefore, that the body should now re-enter Caro's field of enquiry. It is significant, however, that his re-engagement with the figure does not entail its reinstatement as his central subject. Rather, the body – as the site for experience – is brought into a creative dialogue with his investigation of space: as part of a continuing imperative to make sculpture more real, to lend the experience of it greater immediacy, and in order to deepen its expressive potential.

The seeds of this new approach can be glimpsed in the series of large sculptures using scrap steel found in shipyards, which Caro made between 1982 and 1984. In these works, a new vocabulary of heavy, maritime elements is deployed. Massive buoys, chain links and bollards are combined with sections of thick sheet steel, creating works that have a new weight, a revived complexity and an irrepressible physical presence. Most striking, however, is the way in which these characteristics are conveyed without recourse to solidity or mass. Continuing the implications contained in the *Emma* sculptures, the exterior of the works and their interior are held in suspension. The sculptures offer an exploded view of themselves. They advance surface and plane but, at the same time, they draw the eye to their internal recesses, chambers and cavities. A new element of mystery enters Caro's sculpture as the works declare – openly and sometimes partly – their inner character. A principal element, unifying the series, is a large half-buoy. In many of the works, notably *Sheila's Song* 1982 (p.73) and *The Soldier's Tale* 1983, this shape suggests an open mouth, accommodating and containing the viewer's gaze. The sculptures remain abstract, but as the musical connotations of these and other of their titles suggest, they allude to singing, songs and musical instruments. Interior space and somatic allusion are combined, admitting an intriguing metaphorical element.

These sculptures drew together two important strands – the body and interior space. In so doing, they prepared the ground for a reinvestigation and development of the relationship of sculpture to architecture. This is an issue with which Caro's work had engaged in the past and from

the early 1980s it became an increasingly fertile field of enquiry. Of this development, Caro observed: 'when the 70s and 80s came along, the architectural became more specific, more explicit.' And in a lecture titled 'Through The Window', given at the Tate Gallery, London, in 1991, he explained his growing interest in the relationship between sculpture and architecture by asserting that 'sculpture and architecture may be nourished by one another'.[35]

This is not, of course, to suggest a dissolution of the boundaries between the two activities. A fundamental difference remains. Though expressive, architecture is essentially functional and answers particular requirements. In contrast, the sculptor's endeavour is purely expressive and free. Clearly, however, Caro saw that in their shared concerns with form and space, and especially with the relationship of the body to space, the line of contact between sculpture and architecture is extensive. More importantly, by broadening that area of contact, he felt – and feels – that both sculpture and architecture can grow; and, by drawing together, in a wider social context form a more harmonious relationship. The importance of this issue for Caro as a sculptor should not be underestimated. As a young artist, he felt the service into which sculpture had been pressed – as a form of architectural decoration – had been largely responsible for its decline as an expressive art. That he should now re-engage with this important issue was therefore a return to first principles, though he was not unaware of the difficulties and dangers. Among these, the central question was how to nourish a communion between sculpture and architecture while maintaining the ground between them.

The beginning of an overt connection between Caro's sculpture and architecture was his participation, in 1982, in *A New Partnership – Art and Architecture*, an exhibition at the Institute of Contemporary Arts, London. Caro showed a model of a proposed walkway bridge for the City Library Building in Los Angeles. In effect, the proposal took sculpture into the realms of functional, engineered objects and, as such, blurred the boundaries. His next foray into this territory was more teasing: penetrating the principles of architecture, but maintaining a non-functional,

The Soldier's Tale
1983
Painted steel
183 x 208 x 134.5 cm
Tate. Purchased 1997

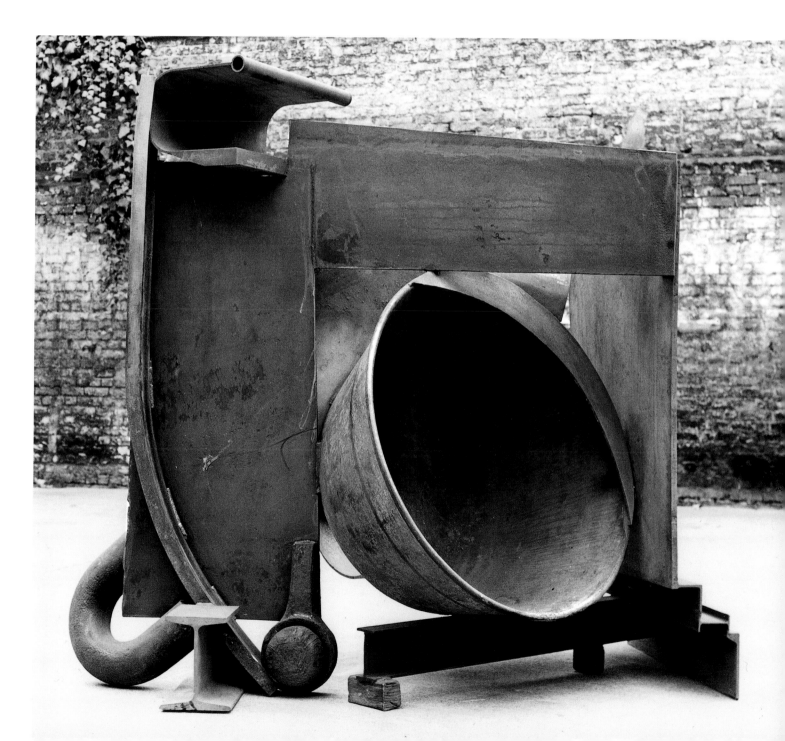

The Rape of the Sabines
1985–6
Steel, rusted and varnished
217 x 603 x 145 cm
Metropolitan Life Building,
Seattle

expressive distance. *The Child's Tower Room* 1983–4 (p.79) was created in wood for the *Four Rooms* exhibition, commissioned by the Arts Council of Great Britain in 1984. With this work, Caro advanced the idea of a sculpture which is conceived in spatial terms, but is no longer a purely visual experience. Continuing his earlier dialogue between exterior and interior, the sculpture can be read as a kind of tower, with steps that lead from the outside shell to a contained, interior space. None of these elements – an external skin, steps, a partially concealed inner chamber – were, in themselves, entirely new in Caro's language. The crucial difference is, however, that to experience them fully, the viewer enters the sculpture and responds physically to the interaction of these different shapes.

Caro's growing interest in the relationship between sculpture and architecture received crucial confirmation the following year. In 1985 he visited Greece for the first time, an experience he had always resisted. As a student at the Royal Academy Schools, he had been familiar with Greek sculpture in the form of the ubiquitous brown plaster casts that lined the School's passages and life-rooms. These fragmented figures, isolated from their original setting, were presented by his tutors as the pinnacle of artistic achievement; and, in a general way, Caro saw their quality. But, even so, he refused to conform to the injunction that to complete his education as an artist it was necessary to study classical art in situ. Finally seeing the great Greek temples, and those at Olympia and Aegina in particular, was a revelation. Caro recalled:

> *The light and the temples sited in their landscape made me see Greek art in a completely different way from studying photographs: the art and the history belong together. For me the most wonderful are the archaic sculptures, and also the pediments and metopes of Olympia. Instead of the sharded parts, that I know from*

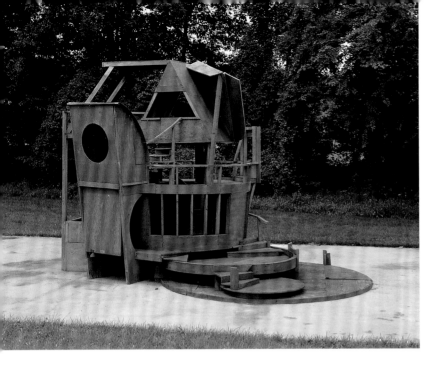

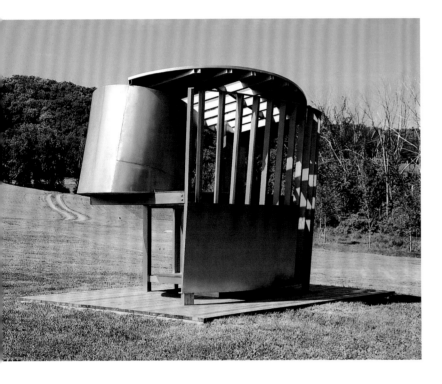

**Working Model for
Lakeside Folly**
1988
Plywood, painted red
460 x 660.5 x 452 cm
Destroyed

Pool
1988–91
Stainless steel
325 x 396 x 203 cm
Hyogo Prefectural Museum
of Art, Kobe

*my studies, I now saw the sculptures more as they were
originally conceived – sensual rolling forms and figures
contained and even forced into strict architectural
shapes. The contrast of the volumetric moving forms is
set against the crisp and geometric.*[36]

It is significant that Caro's response, in focusing on the
relation of sculpture to architecture, entails an engagement
with the connection of figure and space. This echoes
precisely those issues that he had already begun to address
in the *Child's Tower Room.* In that work, the viewer's body
responds directly to an architectonic space. The works he
now made, *The Rape of the Sabines* (p.76) and *Scamander*,
both 1985–6, are analogous. They respond to the
pedimental sculpture he admired, addressing in abstract
terms, but in a purely visual way, the theme of containing
rich, sensual, anthropomorphic shapes within an implied
geometric context.

In this way, Caro opened up two, separate lines of
development in which the relation of real or implied figures
to their context is a shared issue. Those sculptures that
invite physical occupation by the viewer (which he playfully
called 'sculpitecture') continued, in 1987, when he
constructed a 'village' with the architect Frank Gehry. This
was followed, in 1988, by two half-scale proposals for
larger works, namely the *Working Model for Lakeside Folly*
and the *Working Model for Pool House.* Like the *Child's
Tower Room*, all these works were made of wood and, in
common with that earlier piece, they occupy the territory
between architecture and sculpture: permitting physical
exploration but, in formal terms, built freely and
expressively. As such, they press architecture at its borders,
but step back, maintaining sculpture's adherence to
imagination over function.

Responding to these developments in Caro's work, in
1990 the Tate Gallery commissioned him to make a
sculpture that connected directly with a particular
architectural setting: the Sackler Octagon, which lies at the
centre of the gallery's sculpture halls. The circular space
and lofty height of the space drew a complex response,
originally conceived in wood but executed in steel: the
Tower of Discovery 1991. Larger than its predecessors, the
Tower brought together many of Caro's long-standing
preoccupations: exterior and interior space, steps, the idea
of levels and vertical ascent; and, crucially, the idea of

Child's Tower Room
1983–4
Japanese oak, varnished
381 x 274.5 x 274.5 cm
Private collection, UK

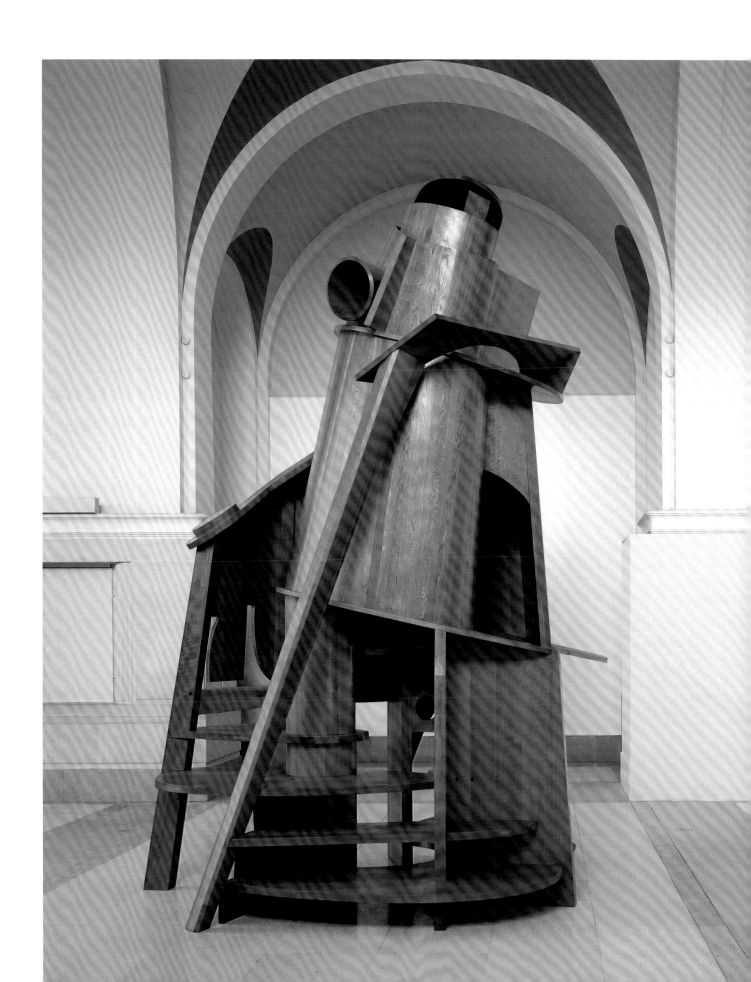

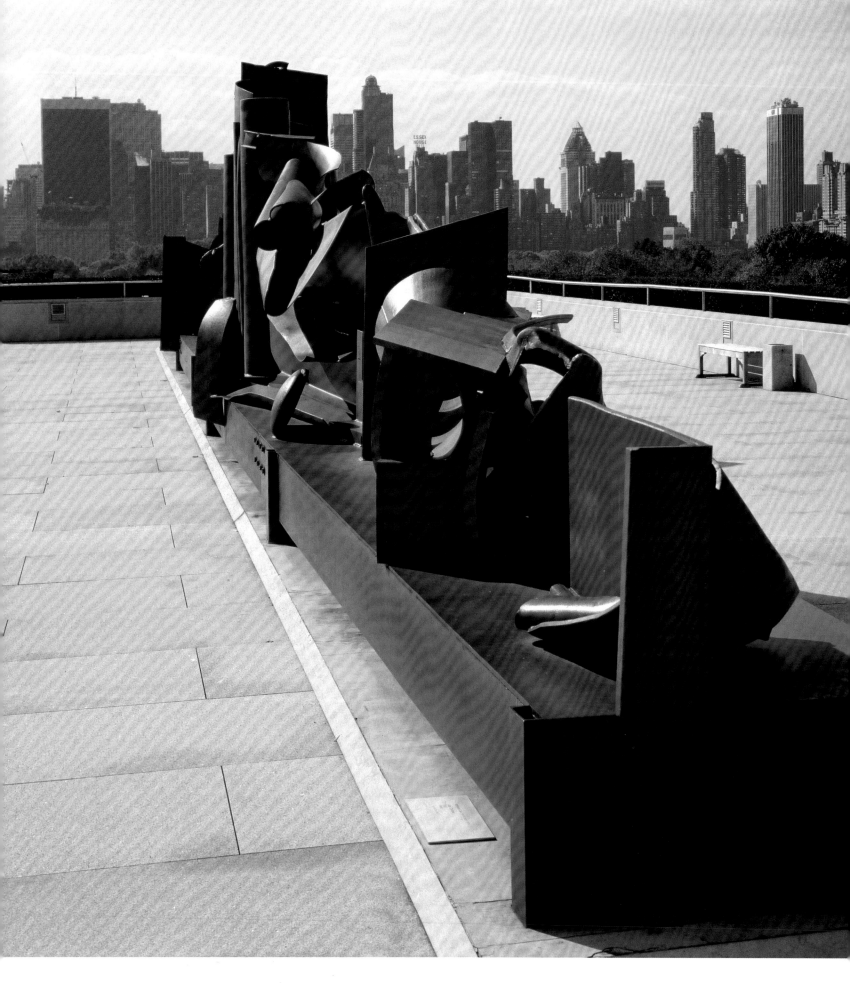

intensifying the experience of sculpture by drawing the viewer into a direct, physical relationship with its formal and spatial layout. Comprising five staircases that are accessible from the outside, and a sixth spiral staircase within a central spine, the viewer negotiates a journey within the sculpture, ascending and descending, inhabiting its various internal spaces, and occasionally emerging on one of its three levels. Throughout, moving forward through the work involves altering the shape of one's body according to the size and character of each internal space and passage. Though monumental, the sculpture is impressed with a sense of human occupation and proportion, drawing the body and space into an expressive dialogue.

Meanwhile, the purely visual aspect of Caro's investigation of this theme had been continued in 1987 with *After Olympia*, his largest work to date. Described by Caro as 'a kind of War and Peace sculpture'[37] – an allusion to its scale and ambitious complexity – it took a step further his interpretation of Greek pedimental sculpture. Inspired by the art and architecture of the Temple of Zeus at Olympia, the sculpture is an abstract meditation on the relation of soft, sensual forms contained within a suggested triangular space: the human and the geometric in opposition and harmony. The challenge to which it rises is that of arranging a succession of discrete abstract shapes over an extended space, and investing those separate elements – numerous found pieces of scrap steel – with a sense of unified life. Each individual piece has to maintain a feeling of relation to its neighbour while fitting into the overall context: a formal challenge that seems, at a deeper level, redolent with human experience.

After Olympia
1986–7
Installed on the sculpture terrace of the Metropolitan Museum of Art, New York
Steel, shot-blasted, rusted slightly and varnished
332.5 x 2342 x 170 cm
Etablissement public pour l'aménagement de la région de la Defense, Paris

After Olympia
1986–7
Installed at Barford North,
Ancram, New York

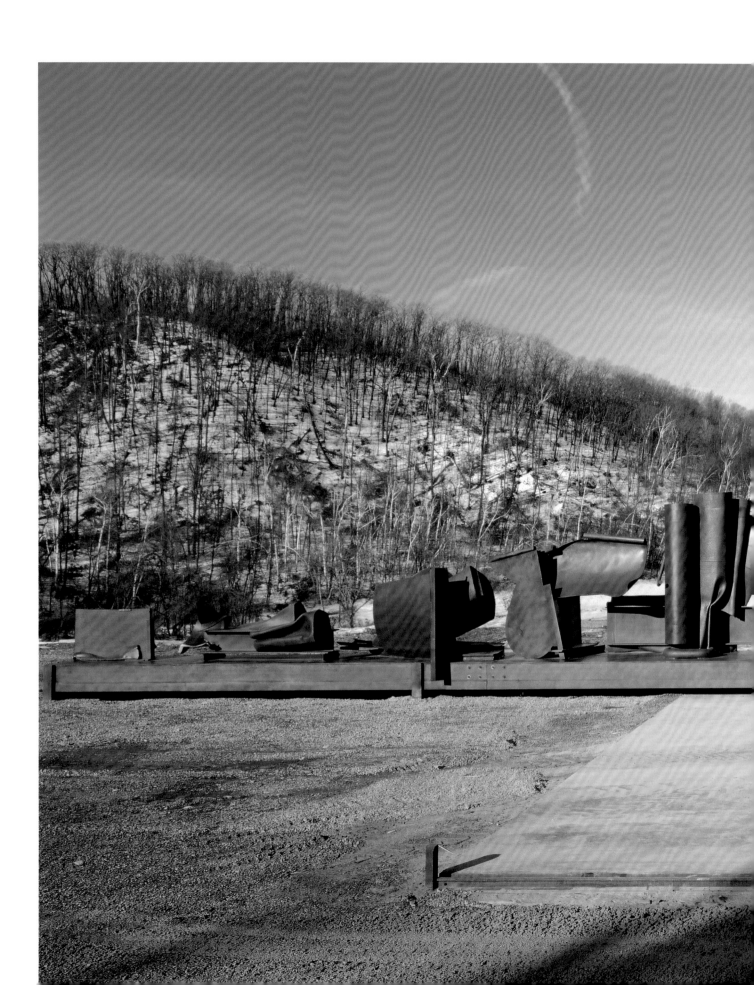

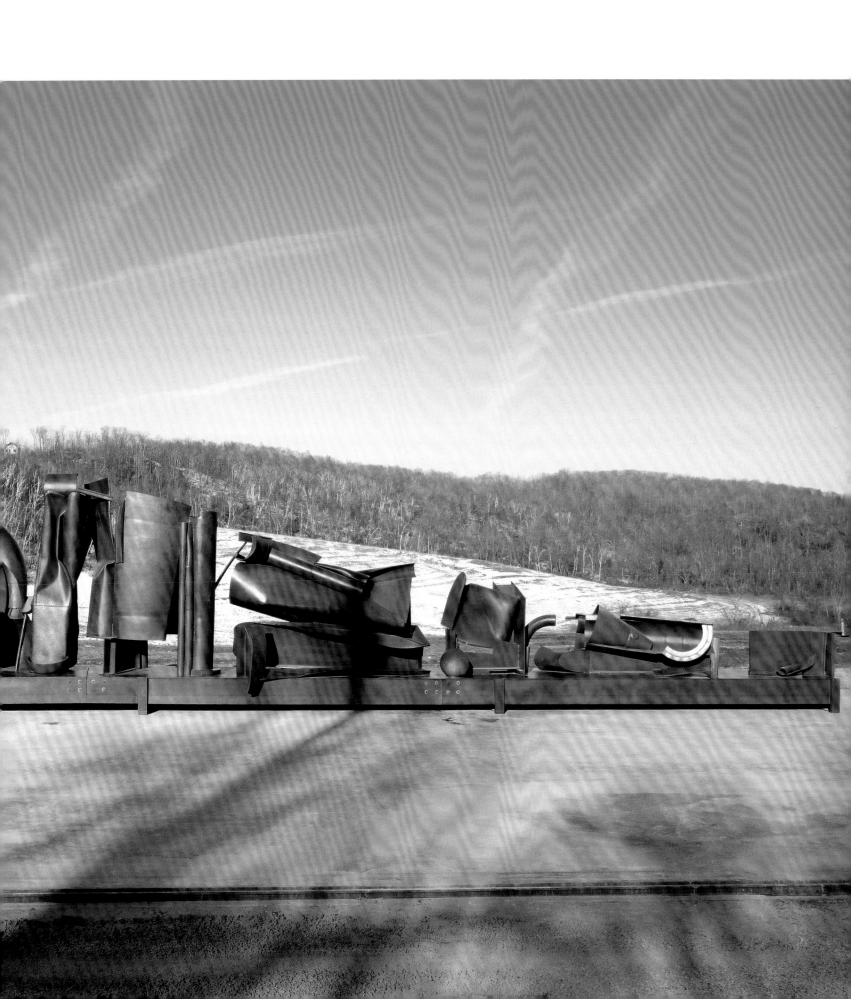

Sculpture and its sources

One of Caro's principal sources of inspiration has always been the specific materials he is using – the particular character of certain found pieces of scrap steel or, more recently, lumps of stone or ceramic or fragments of paper. As his work has developed, this dialogue with his materials has drawn increasingly on a range of other areas of creativity – painting, drawing, architecture – impregnating the process of his materials' transformation into art with ideas and possibilities that, hitherto, were thought alien to sculpture. If the early 1980s marked the onset of greater diversity in Caro's oeuvre, the late 1980s onwards has been a period of ever increasing cross-fertilisation. His art has not only opened itself to a range of new external influences, but has actively *married* those different ingredients, generating – almost from within itself – new possibilities and fresh challenges. As Caro has observed: 'the work itself takes over'.[38]

This process was evident, for example, in the creation of *Xanadu* 1986–8 (pp.86–7). This imposing sculpture was originally conceived as a complement to *After Olympia* – in that like the larger work it, too, was inspired by Greek pedimental sculpture. But at some point in its long evolution, it veered away from this line of thought and began to take on an entirely unexpected significance. Gradually *Xanadu* became associated with one of Caro's favourite paintings, Matisse's *Bathers by a Stream* 1916–17. Comparison of the two works reveals several points of resemblance. Like the painting, the sculpture has a strong internal vertical emphasis whose lines correspond with the positions of the bathers. That said, the link is not overt and there is no suggestion that the sculpture was in any precise sense abstracted from the Matisse. It remains non-representational and expressive in its own right. Indeed, its composition contains the vestiges of a pedimental arrangement in the way in which the elements rise from the right to what would have

Caro in his Camden Town studio, 1990

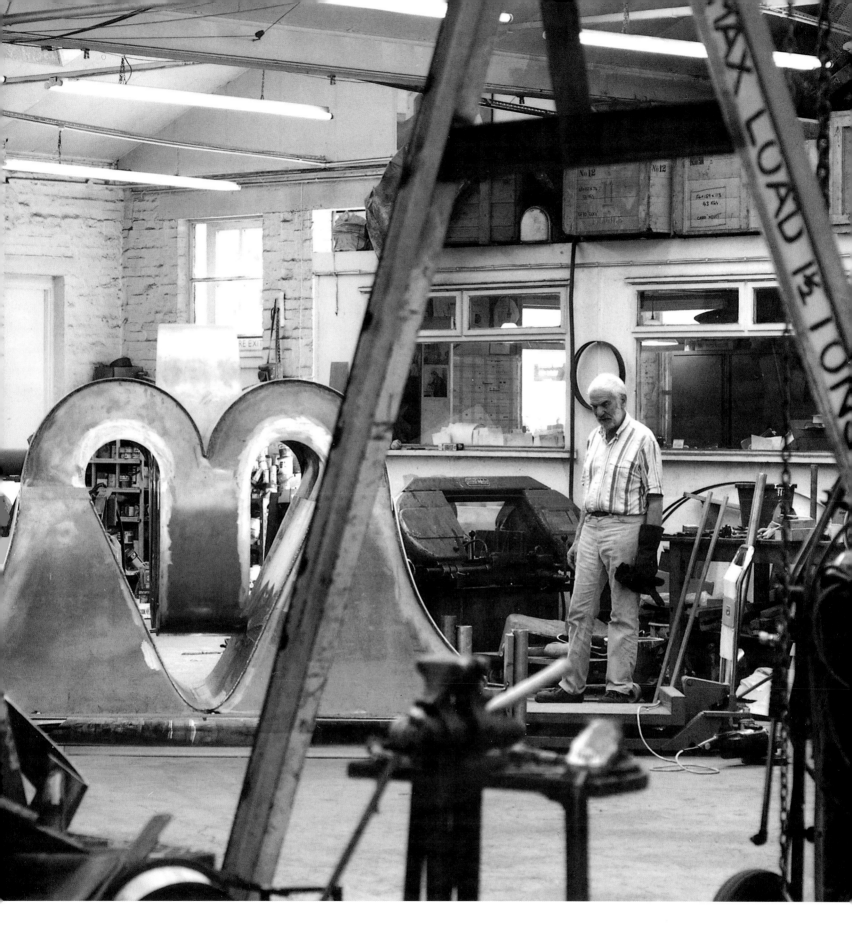

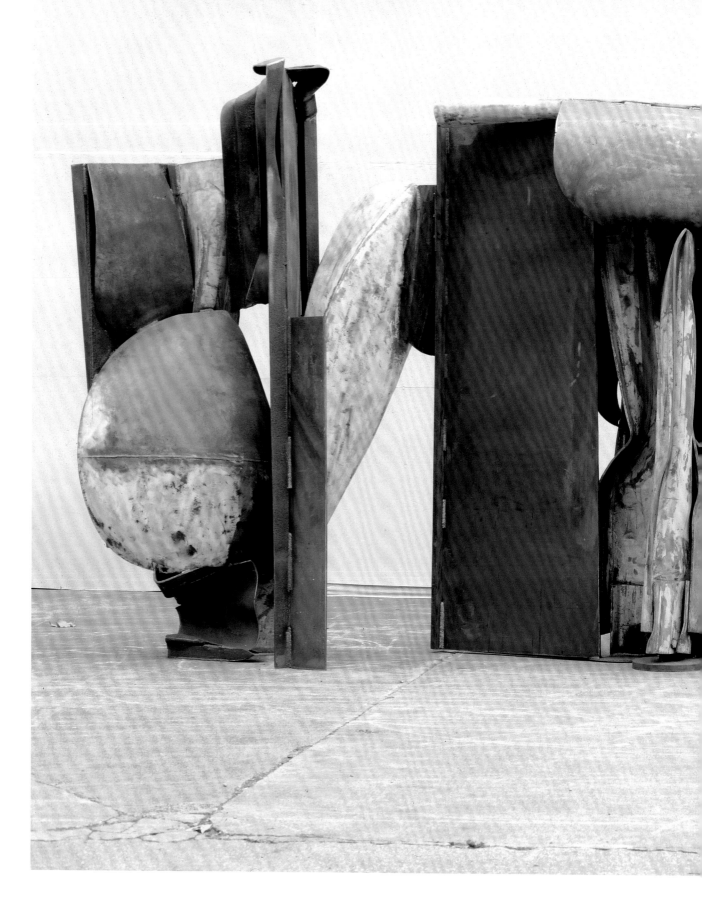

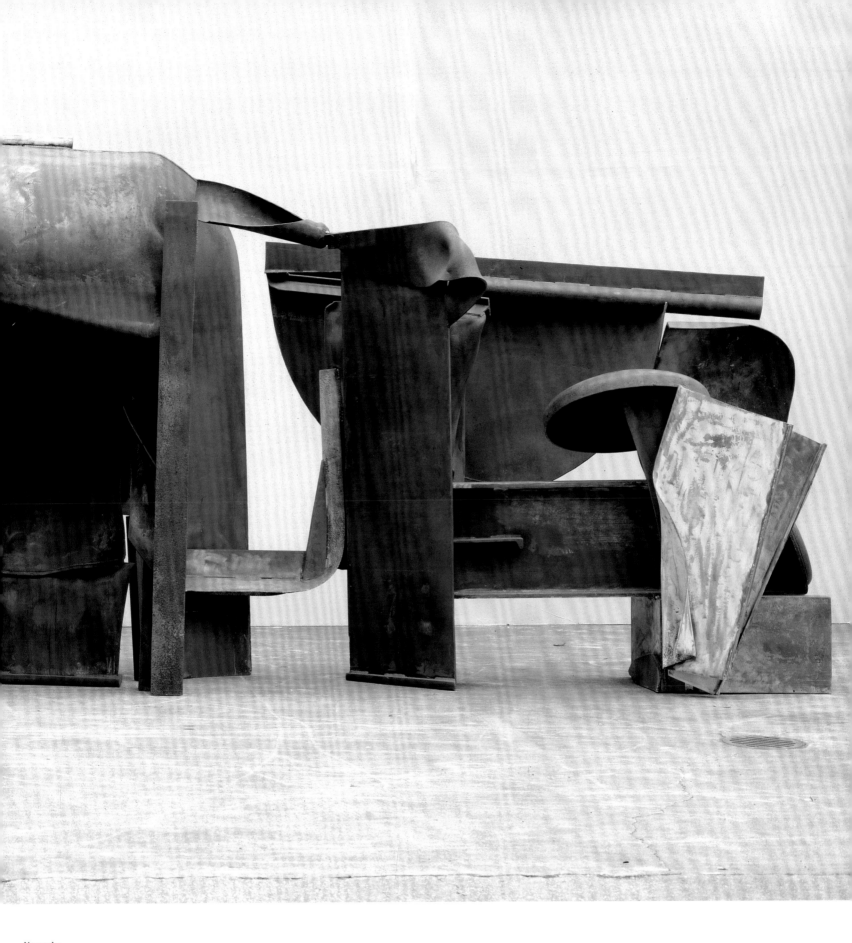

Xanadu
1986–8 (no.37)
Steel, rusted and waxed
240 x 622 x 160 cm
Tate. Lent by a private
collector 1994

Paper sculpture
No.48 – Bandit
1981 (no.34)
Pencil, chalk, acrylic, corrugated board,
handmade paper on Tycore in wooden box
83.2 x 68.6 x 12.7 cm
Collection of the artist

Paper Sculpture
No.19 – Inside Outside
1981
Pencil, acrylic, handmade paper
on Tycore
88.9 x 53.3 x 15.2 cm
Private collection, UK

Obama High
1990–2 (no.44)
Washi paper, tissue paper
and gouache
78.5 x 99 x 12.5 cm
Colección Marqués de la
Romana

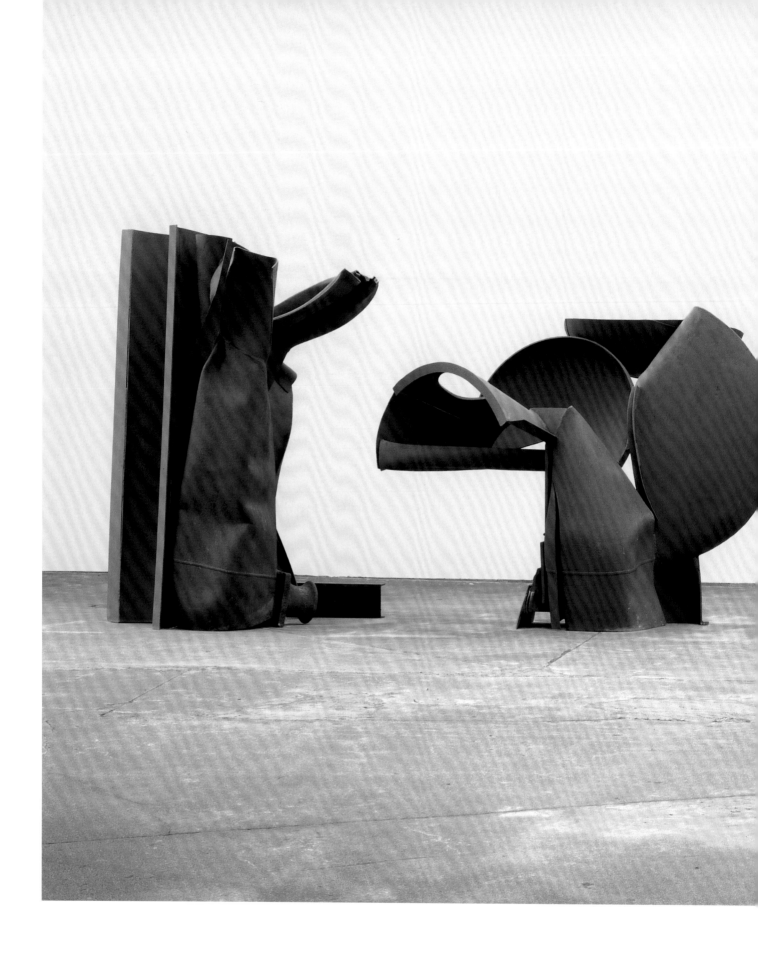

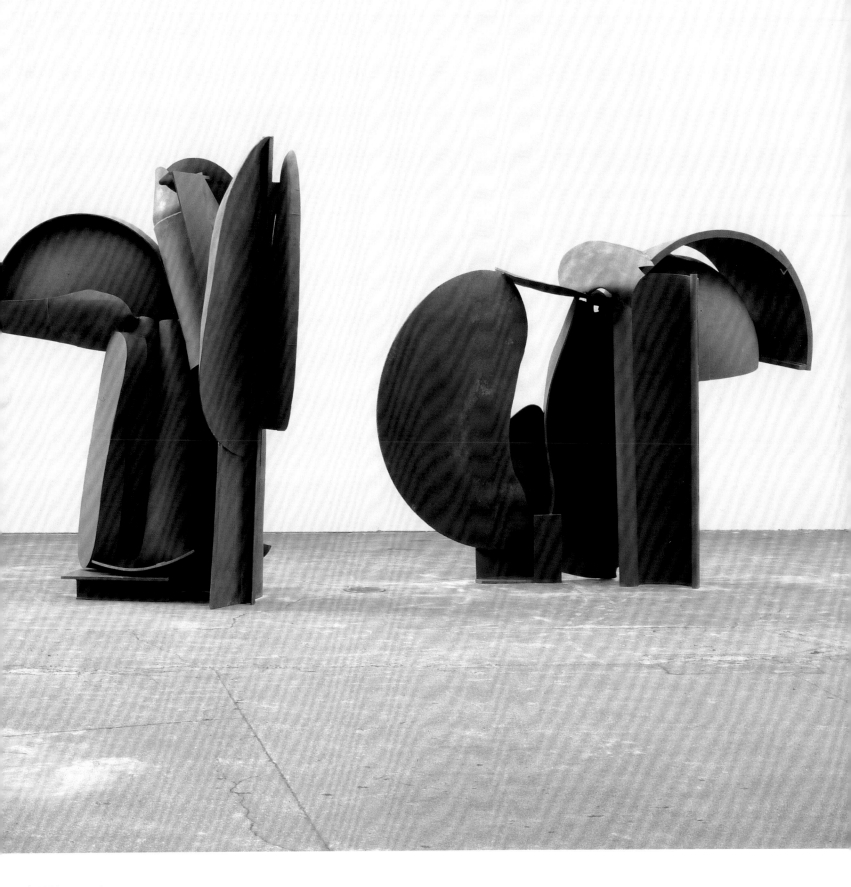

Night Movements
1987–90 (no.39)
Steel, stained green,
varnished and waxed
276 x 1077 x 335 cm
Tate. Purchased with funds
provided by the Kreitman
Foundation 1994

Henri Matisse
The Moroccans 1915–16
The Museum of Modern Art,
New York

The Moroccans
1984–7
Stoneware and earthenware
with stainless steel support
183 x 203 x 172.5 cm
Hakone Open Air Museum,
Tokyo

been the apex of the pediment at the opposite end of the sculpture. At the same time, however, *Xanadu* is inhabited by the ghost of its pictorial ancestor – though, in a wider sense, figures, space, abstract form, architecture and painting are all presiding spirits.

A similar confluence of different elements permeates *Night Movements* 1987–90 (pp.90–1). For once, Caro was not particularly inspired by the materials with which he began the piece. Over a long period, he cut pieces off, arranged and rearranged the parts, and struggled. Eventually, the bottoms of the individual parts were cut flat so that they stood up and, in an unexpected way, painting again entered the developing life of the sculpture, guiding and shaping its growth. Later, Caro recalled: 'I had become very excited by Courbet, and I looked at a lot of Courbet's paintings, as I had earlier been looking at Rubens. Courbet's heavy, weighty, art … was something I wanted to emulate.'[39] The steel suggested those qualities which Caro associated with Courbet's paintings, and the sculpture began to acquire independent characteristics – moving from plane, to skin, to volume. But, as an arrangement of four physically separate parts, the work also raised an issue more usually associated with architecture: that of how to relate and unify unconnected elements so that they cohere within an overall structure. In this respect, *Night Movements* can be seen as an intriguing variation on the theme of sculpture that the viewer occupies physically. By walking around and within the sculpture's open arrangement, the viewer experiences

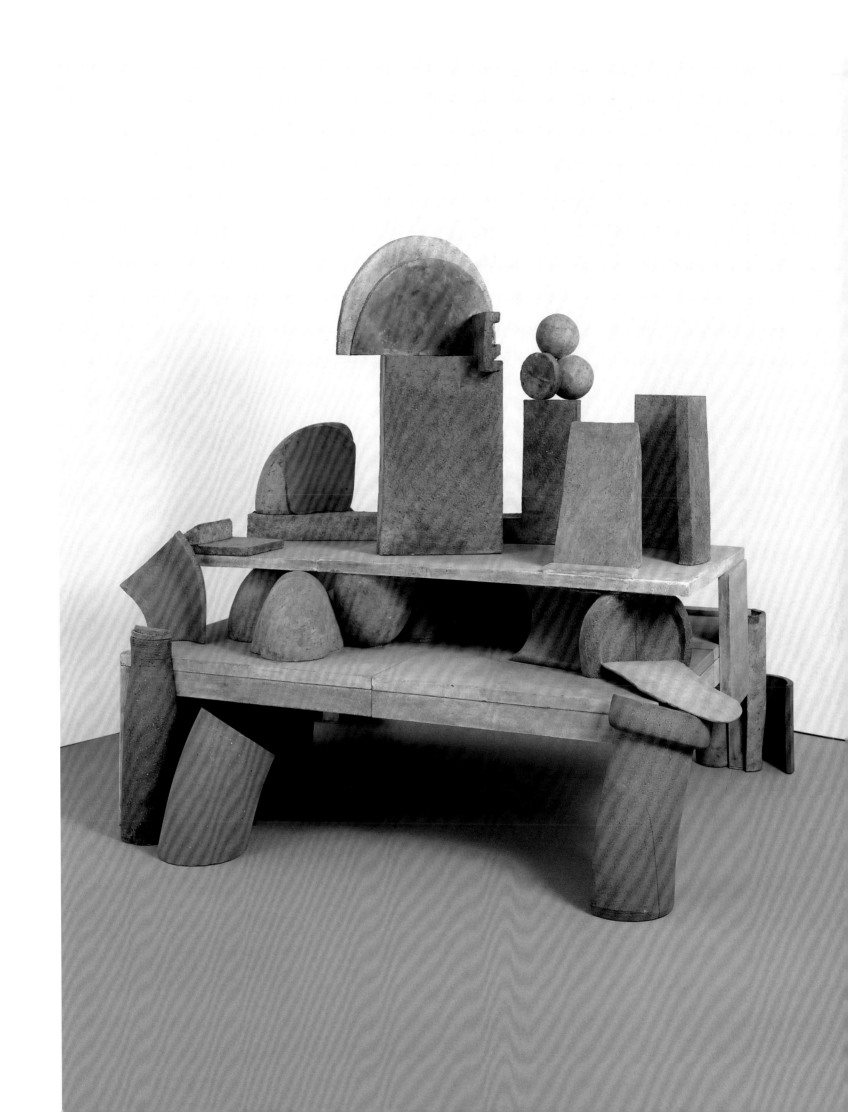

**Descent from the Cross I
– After Rubens**
1987–8
Steel, rusted and waxed
244 x 185.5 x 160 cm
Modern Art Museum,
Fort Worth

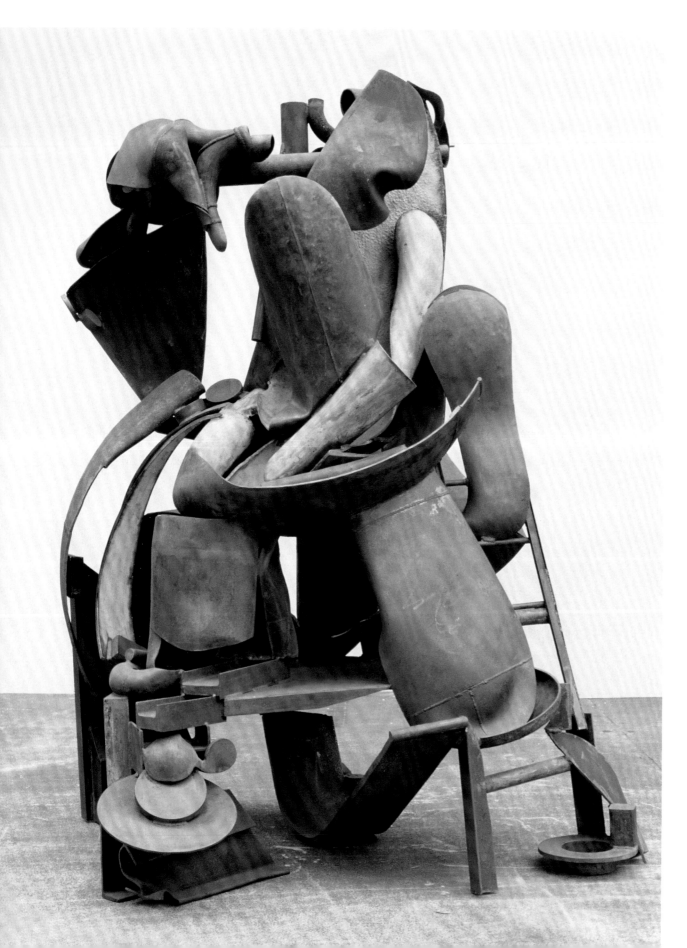

**Descent from the Cross III
– After Rembrandt**
1989–90 (no.42)
Brass and bronze, cast
and welded
221 x 119.5 x 111.5 cm
Musée d'art contemporain
Val-de-Marne/Vitry
Conseil général du Val-de-Marne

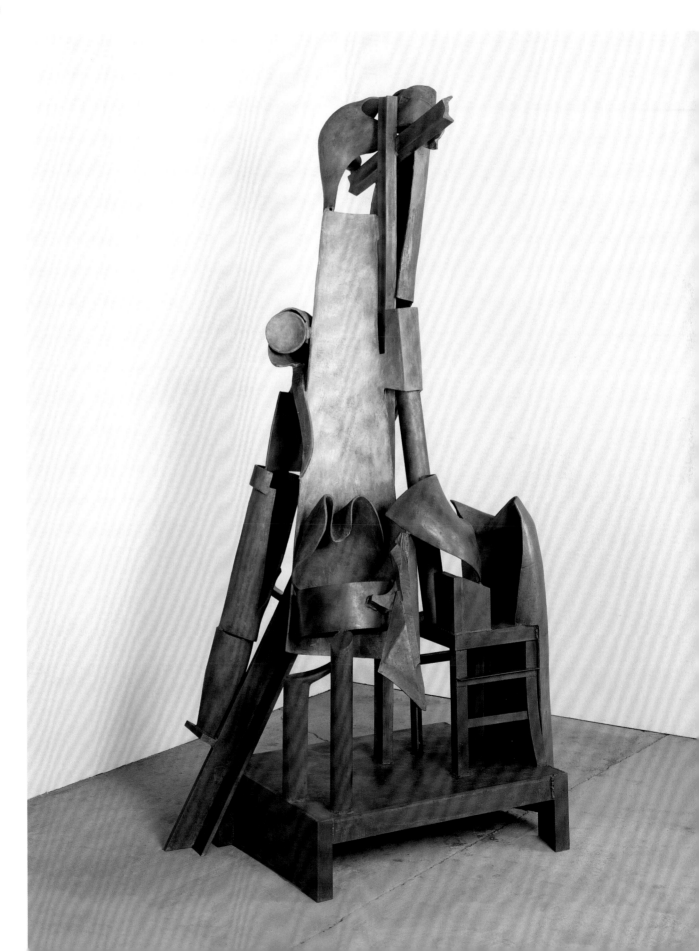

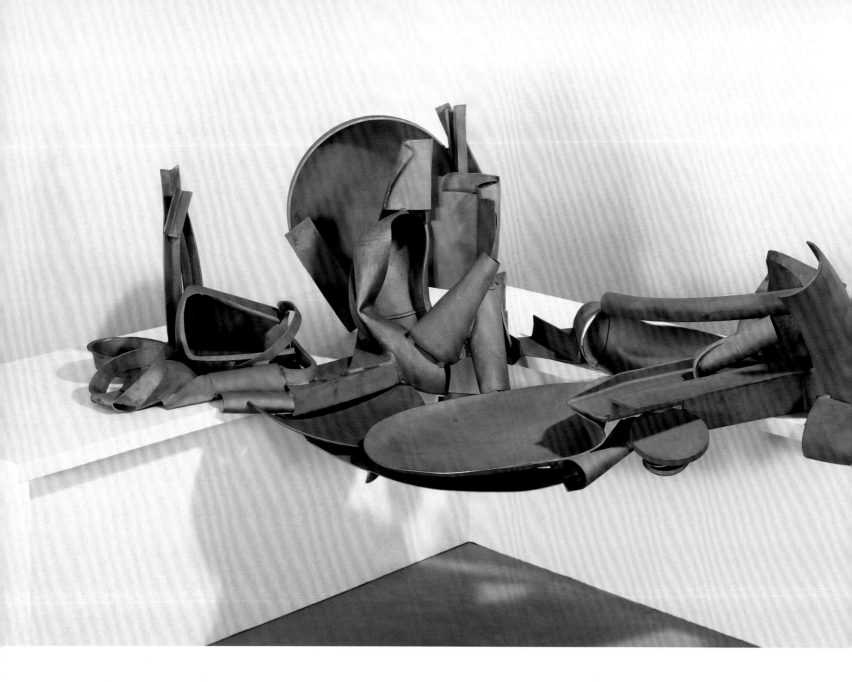

Déjeuner sur l'herbe II
1989 (no.40)
Steel
97 x 187 x 252 cm
Tate. Presented by the artist
2000

its exterior and interior as a *continuum* – sensing its scale and the proximity, relation and character of the individual forms. Through that physical – but purely visual – relationship with the work, the viewer becomes an active participant, drawing the sculpture into a connected whole.

In both *Xanadu* and *Night Movements*, painting was a vitalising element, combining with the suggestiveness of steel, so that the sculpture took on an unforeseen pattern of development. At the outset of Caro's abstract work, painting was a source of inspiration; and thereafter, notably in such works as *Early One Morning* (also connected with Matisse), it provided an occasional point of departure or reference. From the mid-1980s, Caro began to address painting more overtly as source material for particular sculptures. *The Moroccans* 1984–7, for example, responds to Matisse's 1916 painting of that title (pp.92–3). Between 1987 and 1989 he completed four sculptures after works by earlier masters, namely: *Descent from the Cross (after Rubens)* 1987–8 and *Descent from the Cross (after Rembrandt)* 1988–9 (pp.94–5), followed by two major table sculptures on a new, grander scale: *Déjeuner sur l'herbe I* 1989 (inspired by Monet's painting of that title) and *Déjeuner sur l'herbe II* 1989, after Manet (p.96). Contemporaneous with his large work related to Greek pedimental sculpture, Caro's pictorially inspired pieces are closer to their source. Rather than an abstract response to a pre-existing work of art, they abstract *from* a pre-existing image. In these works Caro runs close to painting, seeking in these Masters' solutions to particular pictorial problems new lines of attack for sculpture. The *Descent from the Cross* sculptures, for example, are about organising voluptuous forms *over* a geometric structure and, in this way, they relate to the connected issue of composing soft, organic shapes *within* a geometric surround, encountered in *After Olympia.* However, in both versions of *The Descent from the Cross*, a particular

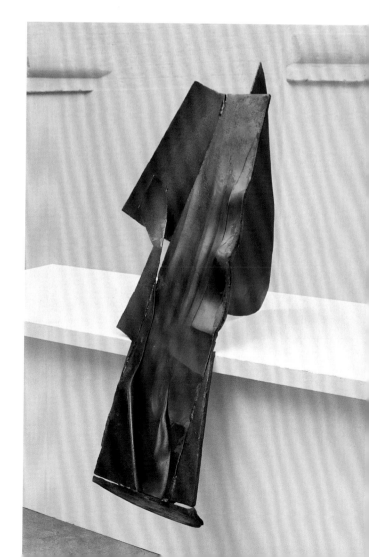

Table Piece CLXIII
1973 (no.29)
Steel, varnished
125.7 x 83.8 x 58.8 cm
Collection of the artist

Writing Piece 'Whence'
1978 (no.33)
Steel, rusted, painted
and blacked
31.7 x 86.4 x 16.5 cm
Private collection, UK

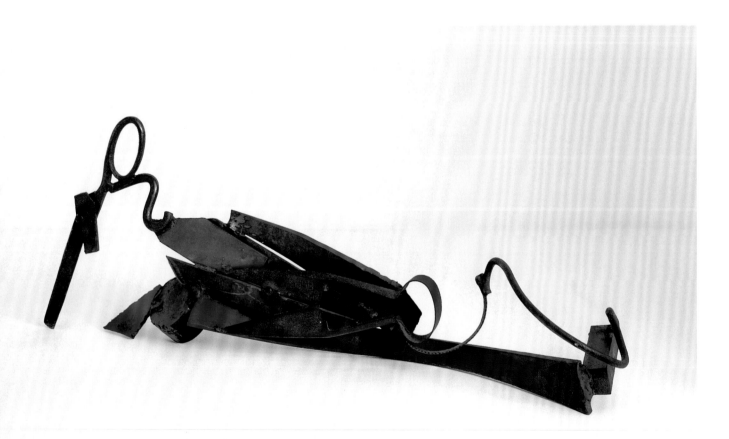

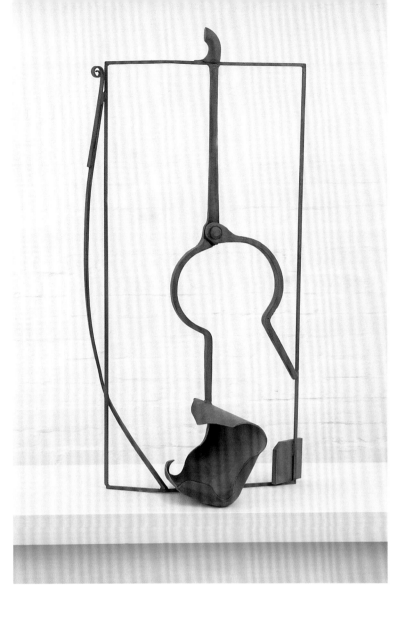

Table Piece Y–87
'Knave's Measure'
1987 (no.37)
Steel, waxed
118 x 99 x 40.5 cm
Mr and Mrs Eva and John
Usdan

Table Piece
'Catalan Maid'
1987–8 (no.38)
Steel, rusted and fixed
134.5 x 68.5 x 39.5 cm
Collection of the artist

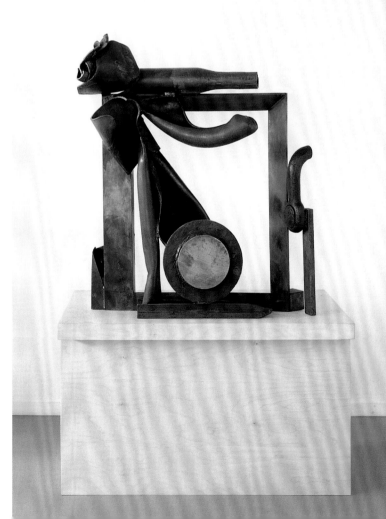

Gold Block I
1997 (no.47)
Stoneware, steel and tin,
rubbed with paint
57 x 64 x 23 cm
Private collection

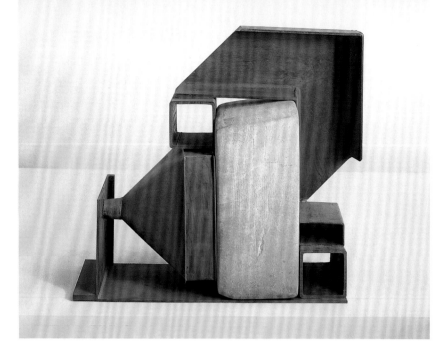

Arena Piece 'Beginning'
1995 (no.45)
Wood and steel, painted
black, red and viridian
72 x 54 x 38 cm
Michael Harris Spector and
Dr Joan Spector

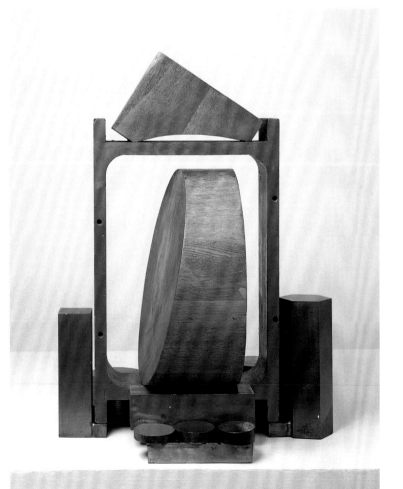

concern is with the problem of organising abstract shapes to suggest languid, downward, vertical movement. The table sculptures on the theme of *Déjeuner sur l'herbe*, address the opposite question: that of arranging reclining forms. In all these works, the evocation of flesh – mortal and sensuous – is tangible.

In recent years, the dialogue between Caro's sculpture and architecture has combined with his renewed interest in the human figure, achieving a remarkable, simultaneous communion with both these concerns. *Elephant Palace* 1989 (p.102), *Night and Dreams* 1990–1 (p.103) and *Requiem* 1993–6 manifest this multi-valent sculpture. They restore to Caro's art a sense of skin that is now partly architectonic and part body. As exteriors, they suggest objects or habitable places – a building, a table, even a mausoleum – and they have a real, tangible, insistent presence. But in each case, this physicality is offset by the implied containment of some strange, inner life or ineffable psychic energy. *Night and Dreams*, for example, stands four-square on the ground and its outer planes are left deliberately blank, almost impassive. The work's principal interest lies *within* – in its inner recessed spaces and labyrinthine forms. Caro recalls that 'I once saw a photograph of a sculptured head … I think it was Roman, that was broken, so that you could see inside the cranium … it has struck me that that's what sculpture's about. Sculpture's about the skin.'[40] Mystery and metaphor haunt these works, extending their expressive range into the realms of the animate and the psychological.

Making interior space an issue for sculpture is an abiding preoccupation of Caro's work and it is one of his most singular contributions to the recent development of that art. The idea of contained space can be traced back to *The Window* 1966, a work whose central area invited a kind of imaginative occupation. But as a theme in his work this kind of *psychological* engagement with the

Late Quarter
– Variation G
1981 (no.35)
Bronze and brass,
cast and welded
37 x 58.5 x 45.5cm
Private collection

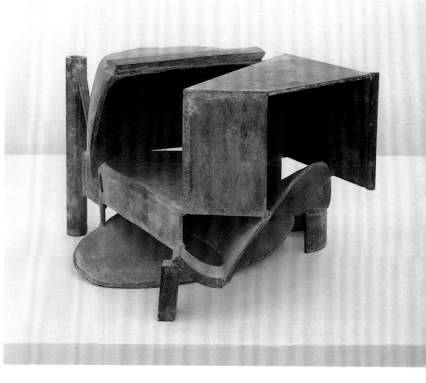

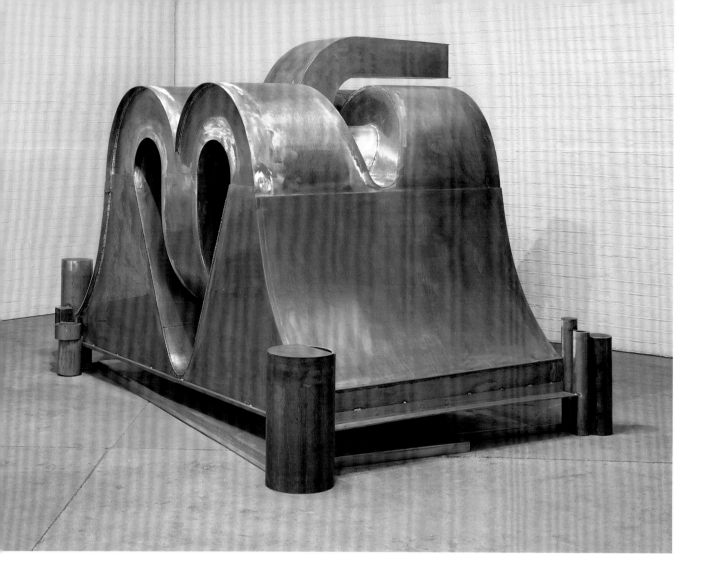

Elephant Palace
1989 (no.41)
Brass, welded
188 x 303.5 x 190.5 cm
Collection of the artist

interior of sculpture remained, until the 1990s, relatively undeveloped. Instead, his attention focused, from the 1980s, on interior spaces that the viewer could occupy physically. Between 1993 and 1994 he worked on a complex, multi-part work that, for the first time, began to bring together these ideas, creating a sculpture that worked in terms of a psychological and physical space. The work had its origins in a collaboration with the ceramicist Hans Spinner. Working with Spinner in Grasse on the Côte d'Azur, Caro created a body of stoneware pieces – his raw material – that formed the basis of what became thirty-eight individual sculptures on the subject of the Trojan War.

In an echo of his work in clay of the 1950s, Caro engaged in a very physical and free way with Spinner's high-density clay – beating and pushing, manipulating and dropping it – until, as Caro says, 'an image began to emerge'. In a fresh departure, wood and metal parts were combined with the fired stoneware, deepening and fixing the work's evolving character. In a final, further acknowledgement of his previous practice, a number of the pieces incorporate parts that function as pedestals, positioning the works in a space that sits somewhere

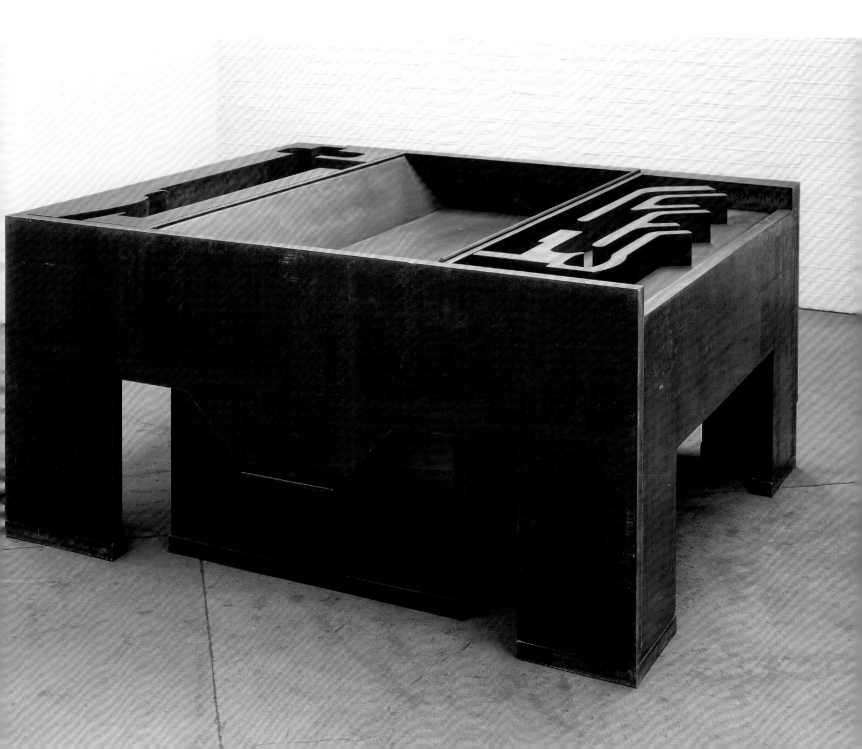

Night and Dreams
1990–1 (no.43)
Steel, bolted, welded
and waxed
104 x 223.5 x 188 cm
Collection of the artist

The Trojan Horse
1993–4
Stoneware, steel and
Jarrah wood
193 x 351 x 219 cm
Private collection

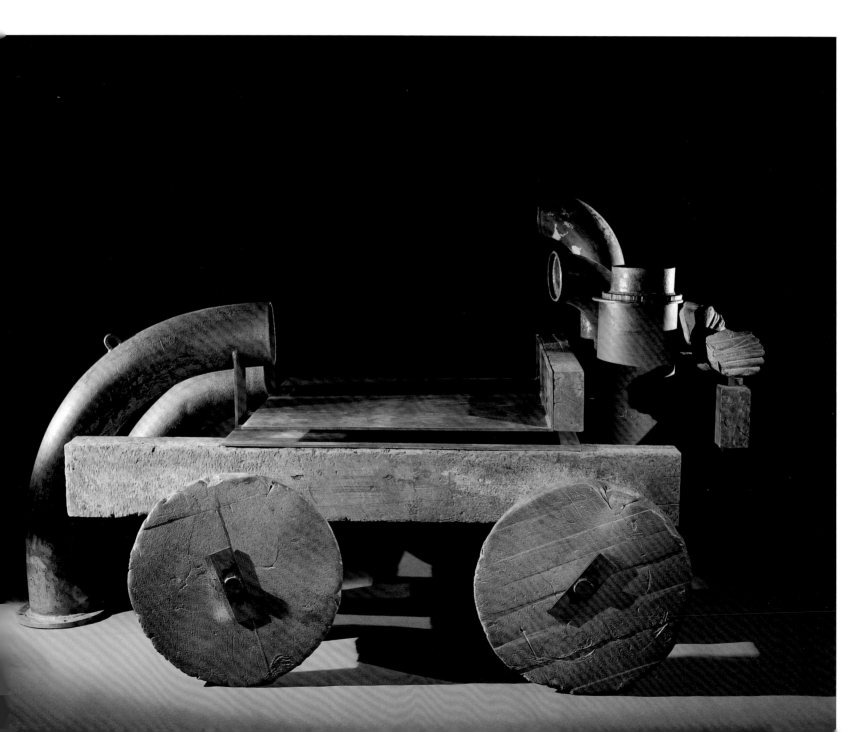

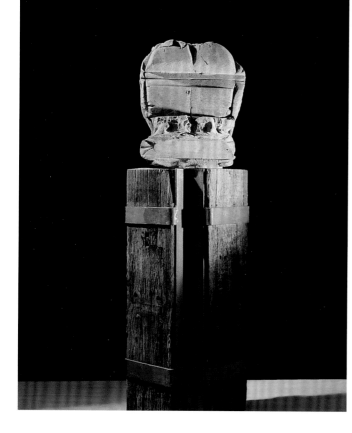

between the real and the imagined. The result marks an extraordinary development in Caro's art. Moving between the frankly figurative, the abstracted and the purely abstract, the individual parts are arranged as a kind of tableau. Each evokes one of the gods or heroes from Homer's *Iliad* – Caro's source – and collectively they form a visual epic. *The Trojan War* takes sculpture towards drama, in which the viewer is an active, implicated protagonist.

The Trojan War implied an expanded physical and psychological context for sculpture, implications that received magisterial expression in the even more ambitious multi-part sculpture that followed. *The Last Judgement* 1995–9 (pp.108–11) is one of Caro's most personal works: a sustained, emotive indictment of human cruelty and a tragic meditation on its effects. Whereas its forerunner derived from a literary source, Caro's point of departure in the later work is the world as it is now: a stage on which unfolds human catastrophe, unbelievable and indefensible suffering, a tragedy written in blood. Nothing is identified but the references are all too familiar, images ingrained from news footage of war, ethnic cleansing and devastation. Developing ideas contained in *The Trojan War*, the work comprises numerous individual parts – twenty-eight in all – many of which are fully developed as tableaux in their own right. *Civil War*, for example, is an evocation of numerous figures in an architectural setting. Others, such as *Flesh* and *Jacob's Ladder* (p.109), suggest human remains. Many of the

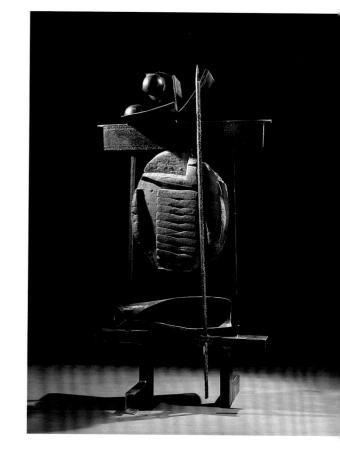

The Bell Tower
(The Last Judgement)
1995–9 (no.46)
Stoneware, Jarrah wood and
steel
384 x 617 x 122 cm
Collection Würth, Künzelsau,
Germany

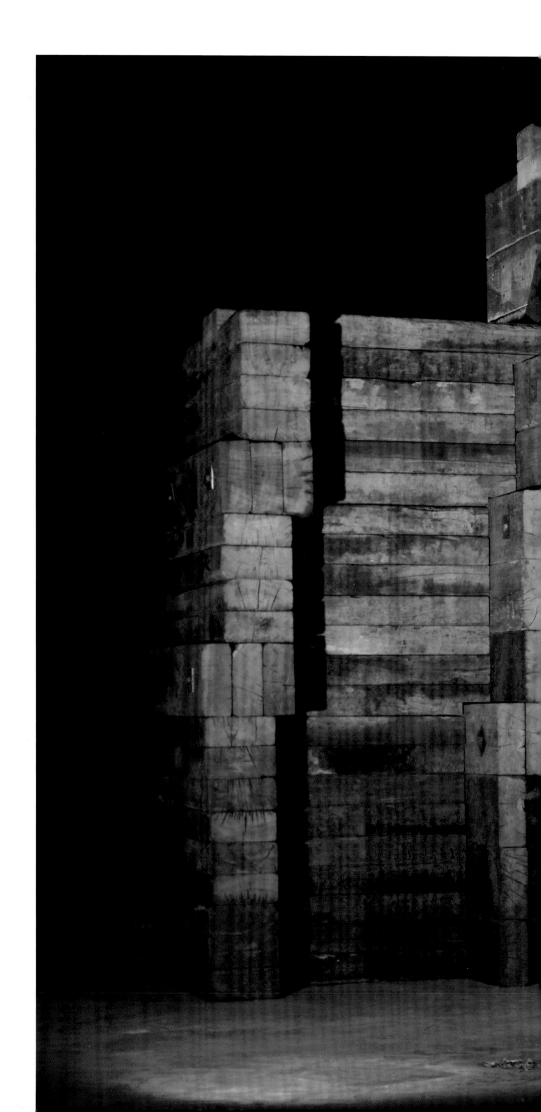

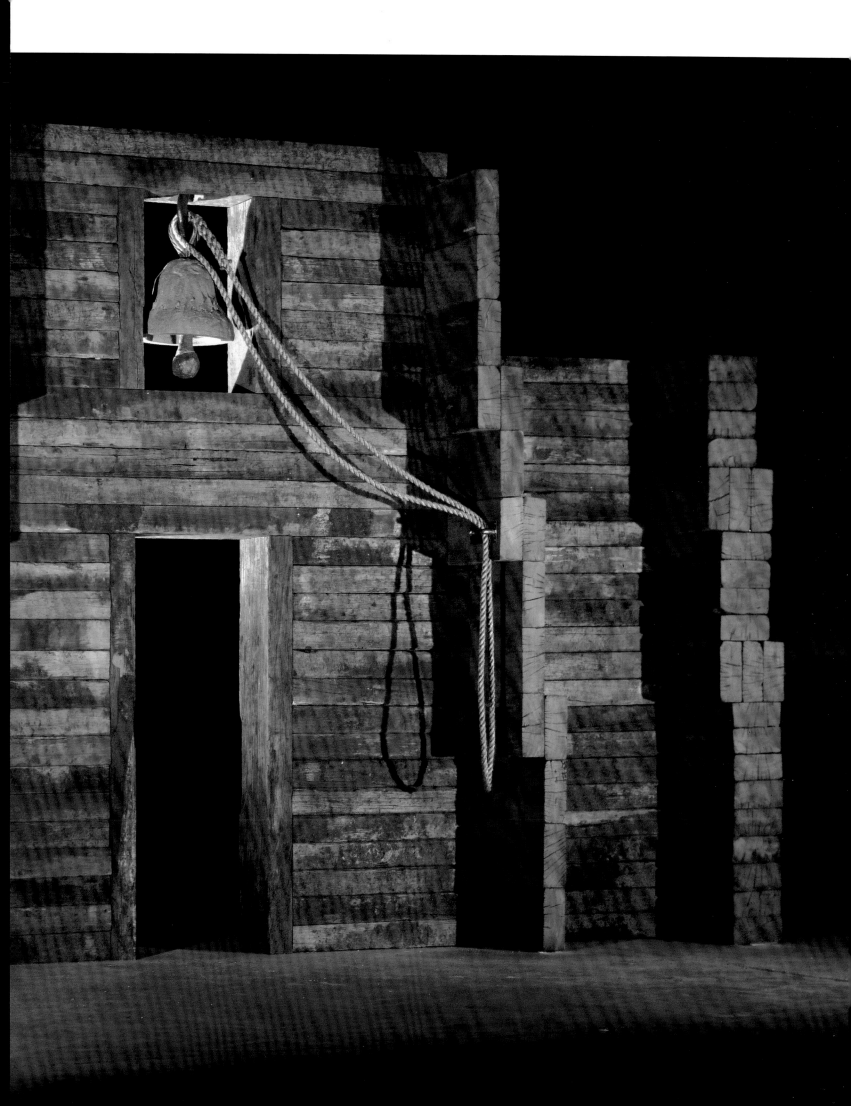

works are in confining boxes – no longer sensuality contained, but rather, hatred and suffering compressed. Wood, stone, steel, brass, ceramic and concrete take on a new connotation of bitterness; and his language – representational, abstracted and abstract – seems calculated in its dissonance, entirely at one with its subject. This is a complex and contradictory position for sculpture: dispersed elements that weave a psychologically charged space, through which the viewer moves. Involving the spectator in this way invests *The Last Judgement* with an inescapable pathos – events that seem disturbingly unreal are rendered by art with intensity and immediacy.

This dichotomy of the real and that which lies just beyond – occupying the territory of art – has always informed Caro's endeavour as a sculptor, and he continues to probe the line between the two. For example, his recent architectonic sculpture has assumed an even larger scale, taking it ever closer to architecture. Two such works, *Halifax Steps: Spirals* 1994 and *Babylon* 1997–2001 (p.110–11) – one in steel, the other in wood – both use steps as a basic, instantly recognisable element. However, it is equally clear that the context of sculpture places this feature beyond use. Caro's engagement is with the *idea* of steps. He deploys these elements freely and poetically, creating new structures that occupy the real space of the world but, at the same time, stand apart from it. Such sculptures infiltrate the principles of architecture in subtle ways. They suggest buildings, yet they respond to the architectural space within which they are seen. Caro's most recent work in this vein, *Millbank Steps* 2004 (see p.112), operates on precisely this double level. Its large internal spaces invite physical exploration, evoking a building; but it is itself contained by a building. In architectural terms, that which is real contains that which is implied.

Flesh
(The Last Judgement)
1995–9 (no.46)
Stoneware, steel
and jarrah wood
209 x 118 x 74 cm
Collection Würth,
Künzelsau, Germany

Jacob's Ladder
(The Last Judgement)
1995–9 (no.46)
Stoneware, steel
and jarrah wood
211 x 139.5 x 84.5 cm
Collection Würth,
Künzelsau, Germany

The Last Judgement
1995–9 (no.46)
Stoneware, wood, steel,
brass, bronze, concrete
and plaster
Collection Würth, Künzelsau,
Germany

Babylon
1997–2001
Jarrah wood railroad ties,
spiked and bolted together
380 x 1005 x 423 cm
Collection of the artist

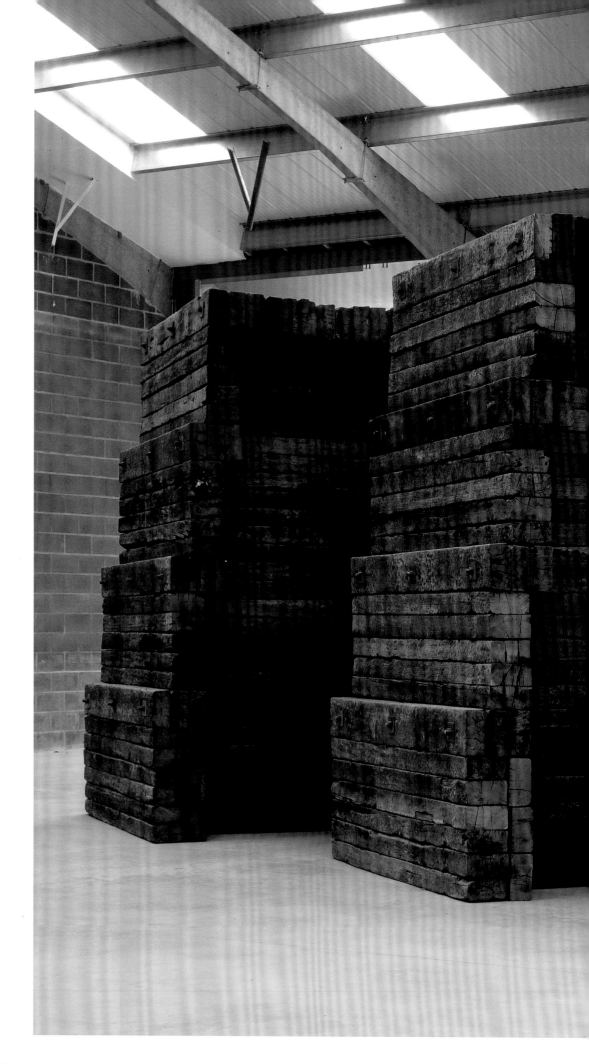

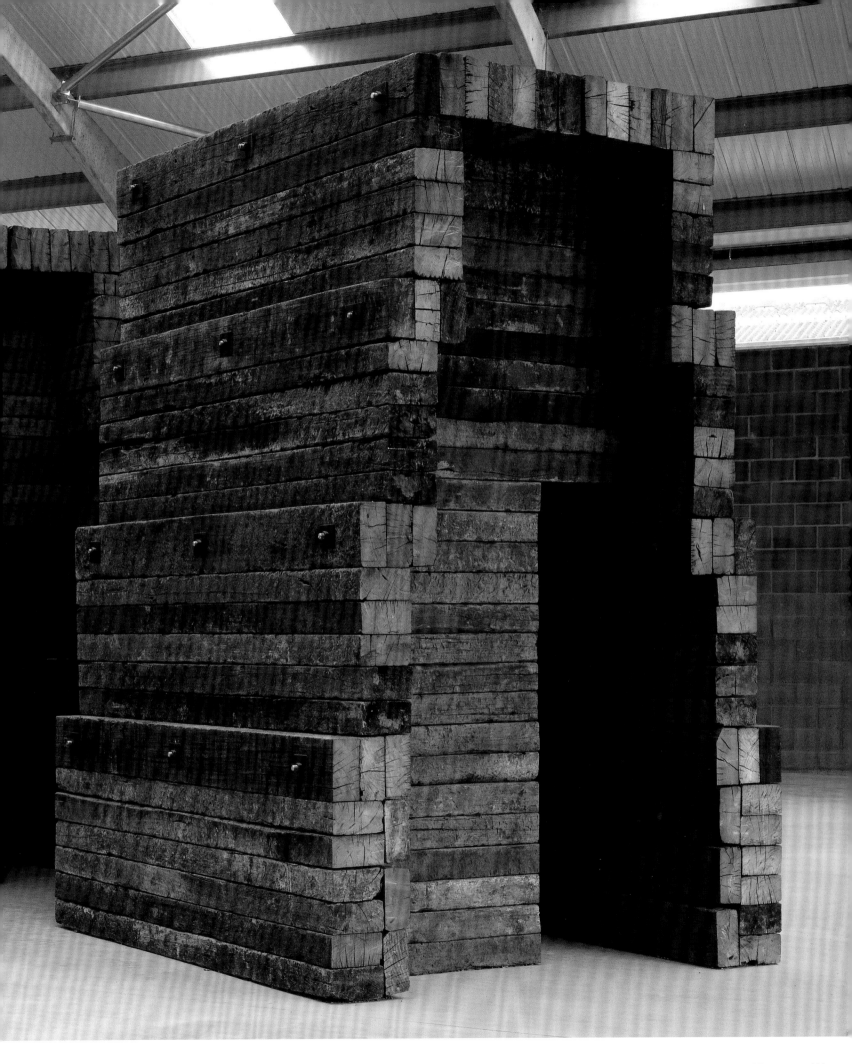

This is the essence of Caro's achievement: to have deepened the expressive potential of sculpture by carrying it closer to life, at the same time as reinvigorating its standing as art through a dialogue with architecture, painting and other areas of creativity. At the heart of that endeavour lies a profound adherence to the principle that life and art, though intimately connected, are essentially distinct. Caro has put this in the following way: 'Sculpture's space and our space are not the same … *separation* is the secret of sculpture's function as art.'[41] The real world must be approached and then absorbed, as it were, filtered through a sensibility; and its logic – its space, structures and the relation of living things to their surroundings – recast and illuminated according to the eye and mind. At the outset Caro addressed the question: what is sculpture? The answer he has given goes further. He has shown what sculpture can be.

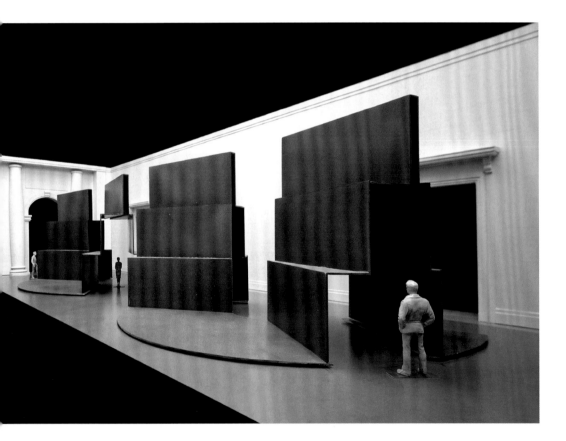

Model for *Millbank Steps*, 2004

Notes

1 Andrew Forge, 'Round the London Galleries, *The Listener*, 17 Jan. 1957, p.102.
2 Unpublished typescript of address by Anthony Caro, School of the Museum of Fine Arts, Boston, 23 May 1980, f.2.
3 Quoted in Andrew Dempsey (ed.), *Sculptors Talking: Anthony Caro, Eduardo Chillida*, Art of This Century 2000, p.46.
4 Unpublished typescript of lecture by Anthony Caro, 'Matisse and Some Others, Strictly a Personal View', Jan. 1994, f.9.
5 Unpublished typescript of lecture by Anthony Caro, Hartford Symposium, f.1.
6 Boston address, op. cit., f.2.
7 Hartford symposium lecture, op. cit., f.1.
8 David Sylvester, 'The Recent Sculpture of Anthony Caro – Bits of the Cat', *Artpost*, vol.5, no.1, Autumn 1987, p.14.
9 Hartford Symposium lecture, op. cit., f.4.
10 Quoted in Tim Hilton, 'On Caro's Later Work', essay in *Anthony Caro: Sculpture 1969–84*, exh. cat., Serpentine Gallery, London, 1984, p.71.
11 Quoted in conversation between Anthony Caro and Paul Moorhouse, 13 May 2004.
12 'Sir Anthony Caro interviewed by Paul Moorhouse 1993', National Life Story Collection (NLSC), unpublished transcript (closed access until 2023), f.168.
13 Anthony Caro, 'The Architecture of Sculpture', *Blueprint*, no.78, June 1991, p.36.
14 Quoted in William Rubin, *Anthony Caro*, exh. cat., Museum of Modern Art, New York 1975, p.99.
15 Phyllis Tuchman, 'An Interview with Anthony Caro', *Artforum*, vol.10, no.10, June 1972, p.58.
16 Ibid., p.56.
17 Unpublished typescript of lecture by Anthony Caro, 'Sculpture and Degas', f.21.
18 Michael Fried, 'Anthony Caro', introduction to *Anthony Caro: Sculpture 1960–1963*, exh. cat., Whitechapel Art Gallery, London 1963. The essay is reproduced, with a new Postscript, on pp.114–25 of this catalogue.
19 'Sculpture and Degas', op. cit., f.15.
20 Unpublished statement by the artist, noted in conversation with the author, Jan.2004.
21 'Sculpture and Degas', op. cit., f.14.
22 NLSC interview, op. cit., f.206.
23 Lecture by Anthony Caro, 'Through the Window', Tate Gallery, London, March 1990, reprinted in Dieter Blume, *Anthony Caro Catalogue Raisonné*, IX, p.23.
24 Ibid.
25 Ibid.
26 Ibid.
27 Ibid.
28 Ibid.
29 Hilton Kramer, 'A Promise of Greatness from Anthony Caro', *New York Times*, 17 May 1970.
30 NLSC interview, op. cit., f.217.
31 Ibid.
32 Hartford Symposium lecture, op. cit., f.1.
33 Unpublished typescript of lecture by Anthony Caro, Yale University, f.2.
34 NLSC interview, op. cit., f.282.
35 Letter from Anthony Caro to Paul Moorhouse containing answers to the author's questionnaire, 24 March 1991.
36 Anthony Caro, Foreword to *Anthony Caro – Major New Work*, exh. cat., Richard Gray Gallery, Chicago, April–May 1989.
37 Letter from Anthony Caro to Paul Moorhouse, 5 Feb. 1991.
38 Ibid.
39 Ibid.
40 NLSC interview, op. cit., f.319.
41 Unpublished typescript of lecture by Anthony Caro [Townsend lecture], 1982.

Anthony Caro: Sculpture 1960–1963
Michael Fried

This essay first appeared as the introduction to a catalogue accompanying the exhibition Anthony Caro: Sculpture 1960–1963, *held at the Whitechapel Art Gallery in London in 1963.*

The purpose of this introduction is to put forward a way of looking at Anthony Caro's sculptures that I hope will prove useful to those meeting his work for the first time. Let me begin as directly as I can, with the following analogy:

I want to suggest that our situation, or predicament, in the face of the present exhibition is roughly analogous to that of a small child, at most on the verge of speech, in the company of adults conversing among themselves. It is often clear enough, in such circumstances, that the child grasps something of what is going on around it – much as we ourselves may be moved by Caro's sculptures. Here the question arises, to what does the child respond, if it is still ignorant of the meaning of individual words? And the answer must be, to the abstract configurations in time made by the spoken words as they are joined to one another, and to the gestures, both of voice and body, that accompany, or better still, inhabit them. To the child the language he hears spoken around him is both *abstract* and *gestural*: here is the crux and the high-water mark of our analogy. Whatever eloquence, whatever capacity to move or excite him, or merely to command his attention, the language may possess resides solely in its character as configuration. But at this point our analogy starts to break down.

There are two important and obvious differences between our situation and the child's. The first is that we, the spectators, command a language and are at home in its conventions. The second is that Caro's sculptures are not compound signs in a conventional language, put together from individually meaningful elements according to known rules of grammar. They are, as has been implied, abstract and gestural. But their abstractness

Anthony Caro: Sculpture 1960–1963
Whitechapel Art Gallery, London

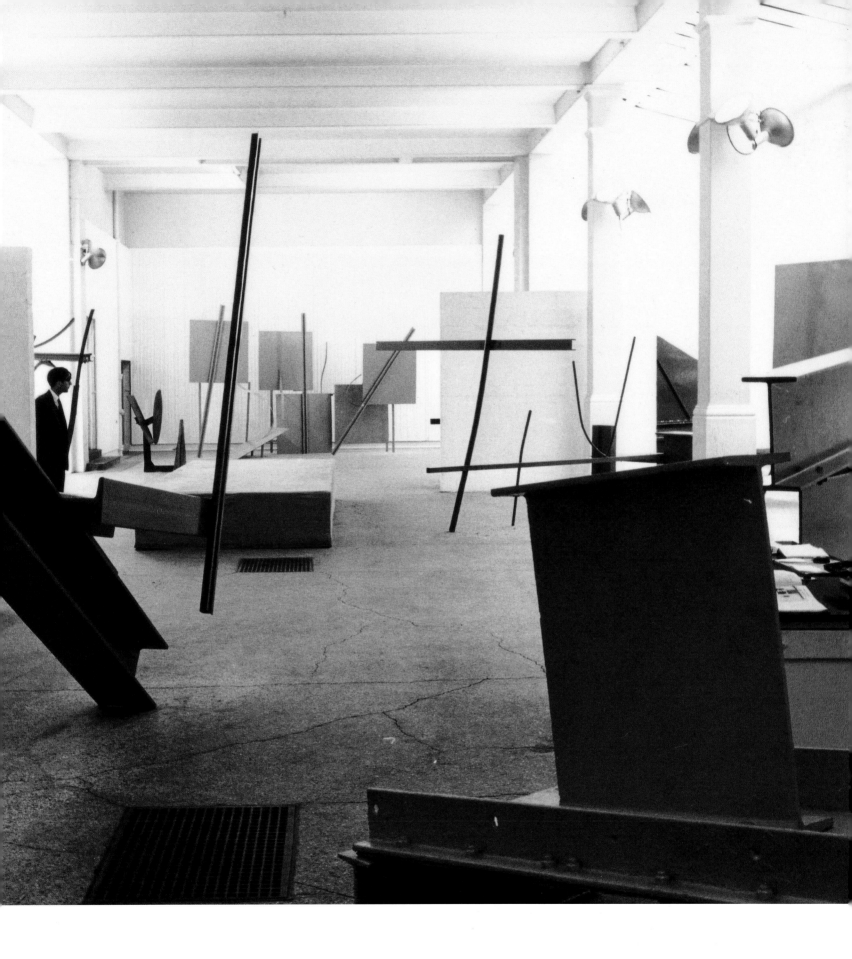

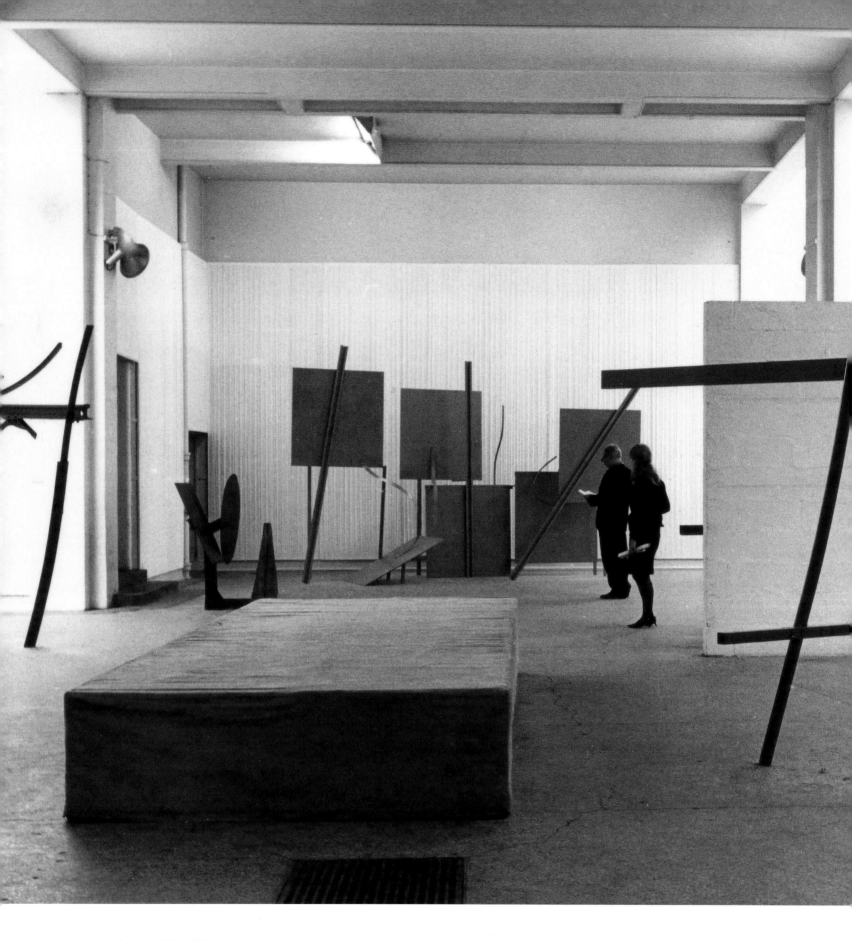

Anthony Caro: Sculpture 1960–1963
Whitechapel Art Gallery, London

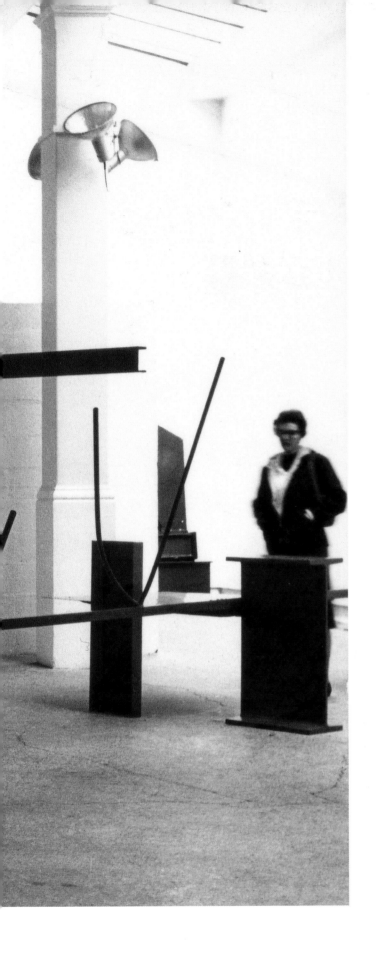

does not derive from a want of linguistic resource on our part. Rather, it is probably the most important objective fact about the works themselves, and has its roots in the artist's awareness of and way of looking at what has happened to sculpture since Auguste Rodin. I shall return to this later on.

As for the gestures bodied forth in Caro's sculptures, it is impossible to say whether they precede language and its related social institutions or whether they crown them. In one sense (the sense of our analogy) their trajectories have their place of origin in a realm of experience that is both primitive and prelingual; but there is another, no less important sense in which they presuppose all the conventions we have, all the civilisation of which we are the increasingly uneasy masters. This is true in regard to those of language itself: it was the labour of the late French philosopher Maurice Merleau-Ponty to show how the institution of language arises out of primitive gesture; and it is the special excruciation of the American critic R.P. Blackmur to demonstrate, in masterpieces of sympathetic analysis, how language that has been wrought to its uttermost in great poetry may reach the condition of consummate gesture.

It is, further, important to recognise that gestures such as those bodied forth in Caro's art cry out for something more than the appreciation of their merely formal properties, or, rather, that the cry is *in us* for something more and that works of art such as Caro's sculptures answer, or at least cry back to it. Stuart Hampshire has written, 'We have less and less need of poetry, fiction, and the visual arts for the exploration of social realities, as we have more and more need of them for questioning the advertised claims of those realities upon us, for indirectly revealing disavowed forms of experience that are in conflict with social roles.'[1] An art which presupposes all the conventions we have may not only crown, but may – however indirectly – challenge or undermine the validity of those conventions. In the face of the increasing specialisation of interests, standardisation of behavior, and banalisation of emotion imposed on us by modern civilisation, Hampshire argues, is nothing less that 'a condition of sanity that the unsocialised levels of the mind should be given some ordered, concrete embodiment, and thereby made accessible to intelligence and enjoyment.'

Sculpture Three
1961
Steel, painted green
297 x 439.5 x 140 cm
Nasher Sculpture Center,
Dallas

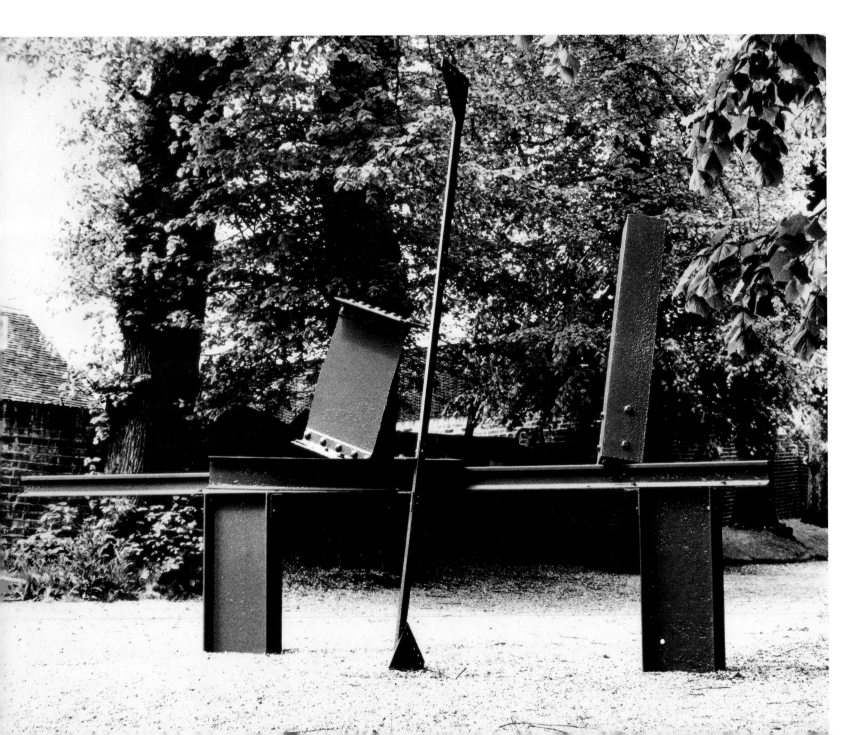

I suspect that this task came to be laid on art only fairly recently, but that is beside the point. What matters is that there have been artists working both in representational and abstract styles who have, with varying degrees of self-awareness, taken it up. It is in this respect that Caro has more in common with certain representational artists of the past – for example, Rodin – than he has with some of the finest abstract painters working now in the United States, whose paintings are more concerned with the solution of formal problems than with the making of expressive gestures. Rainer Maria Rilke's vast admiration for Rodin was largely founded on his recognition of the sculptor's power to make gestures that broke not only with the conventions of his art but with deeper, and more deeply imprisoning, conventions of thought and feeling. Hence Rilke's characterisation of one of Rodin's sculptures, perhaps the striding *Saint John,* as 'that walking figure, which stands like a new word for the action of walking in the vocabulary of [the spectator's] feeling.'[2] And it is in the first part of his *Rodin-Book* that Rilke writes, in connection with one of the master's armless figures, 'One recalls Duse, how in one of the D'Annunzio's plays, when left bitterly alone, she attempts to give an armless embrace, to hold without hands. This scene, in which her body learns a caress far beyond its natural scope, belongs to the unforgettable moments of her acting. It conveyed the impression that arms were a superfluous adornment, something for the rich and self-indulgent, something which those in the pursuit of poverty could easily cast aside. She looked in that moment not like a person lacking something important: but rather like someone who have given away his cup so that he may drink from the stream itself, like someone who is naked and a little helpless in his absolute nakedness.'[3]

In painting and sculpture our notions of what is important and what may be cast aside have undergone radical change since Rilke wrote the above words. This has come about through developments within those arts that may be described in purely formal terms, as is Clement Greenberg's collection of seminal essays, *Art and Culture.* His argument is very roughly that, starting with Edouard Manet, there has been a strong drive within each art toward the elimination of what does not strictly belong to it. This is the burden and meaning of modernism in painting and sculpture: 'to avoid dependence upon any order of

experience not given in the most essentially construed nature of its medium …The arts are to achieve concreteness, "purity," by acting solely in terms of their separate and irreducible selves.'[4] In painting this has entailed renouncing all illusion of the third dimension and throwing emphasis instead on the flatness and the shape of the canvas; while in sculpture it has led – by way of Rodin, Constantin Brancusi, Cubism and the Constructivist[5] tradition sparked off by Picasso and including Jacques Lipchitz, Julio González, the earlier Alberto Giacometti, and David Smith, to name only the major figures and a long and complex chain of events described by Greenberg in his essay 'The New Sculpture' – to the kind of abstract, open idiom one finds in Caro's work:

> *Space is there to be shaped, divided, enclosed, but not to be filled. The new sculpture tends to abandon stone, bronze, and clay for industrial materials like iron, steel, alloys, glass, plastics, celluloid, etc., etc., which are worked with the blacksmith's, the welder's and even the carpenter's tools. Unity of material and color is no longer required, and applied color is sanctioned, The distinction between carving and modelling becomes irrelevant: a work or its parts can be cast, wrought, cut or simply put together; it is not so much sculptured as constructed, built, assembled, arranged.*[6]

Greenberg maintains that this drive toward 'purity' in the visual arts – called by him the 'modernist "reduction"' – stems ultimately from the positivist ethos of modern civilisation, which, to his mind, demands the immediate, the concrete, the irreducible. I am not at all convinced that this explanation is right or that it goes deep enough; but again, in the context of the present essay, this hardly matters. It remains undeniable, I think, that the visual arts have, over the past century, performed upon themselves the 'modernist "reduction"' summarised in the outline above, and that Greenberg's writings dealing with it are by far the finest and most intelligent we have.

Caro accepts this 'reduction' as a fait accompli – an acceptance that would be shallow, and unlikely to issue in major art, if it were not founded upon his sure grasp, at once intuitive and intellectual, of the internal logic of the 'reduction.' But unlike some of the most important paintings in America today, his sculpture is in no sense a

solution to formal problems posed – with terrific urgency, it should be understood – by the art of the immediate past. It would be a mistake to think that one could adequately describe his work in formal terms, or to believe that because one had noted the formal structure of his pieces one had fully experienced them. In fact it may happen that one of Caro's pieces fails to 'carry its intentions' – his phrase in an interview with Lawrence Alloway[7] – even though it is flawlessly composed. This happens when the spectator is made to feel that a particular element in the sculpture, despite its formal integration within the whole, somehow obtrudes upon or gets in the way of the nascent emotion – when that element seems superfluous to the gesture which the work itself seeks to release. In the same interview Caro is quoted as saying, 'I know that when I work on a sculpture out of doors I have room to stand back and that only encourages me to worry about the balance and that sort of thing; and that invariably ruins it. Working indoors in a restricted space and close up all the time my decisions don't bear on the thing's all-round appearance. They're not compositional decisions.'[8] Similarly, when Rodin struck the staff out of the left hand of the original figure later called *The Age of Bronze* it was not a compositional decision, but it marked, as Rilke saw, the first appearance of nonconventional expressive gesture in his work.

Caro's sculptures, then, if I am right, are the result of an attempt to use the materials and techniques arrived at by the 'modernist "reduction"' as basic elements in the construction of expressive gestures. Herein lies the major difference between his art and that of Rodin: for the latter, the language of gesture was the human body; while in Caro's work gesture is evoked, and at his best liberated, through configurations made by assembling lengths of steel girder, aluminium piping, sheet steel, and sheet aluminium, and through the colours these are often painted. There is another difference worth remarking on as well. In Caro's sculptures, unlike Rodin's, the spectator is not made to feel that the artist has been closely or passionately involved with his materials. Where Rodin in his bronzes makes one aware of what must have been the texture of clay between his powerful fingers, and in his marble alerts one to the subtlest nuances of light and surface which that material could be made to yield, in Caro's sculptures one's attention is made to bear only upon

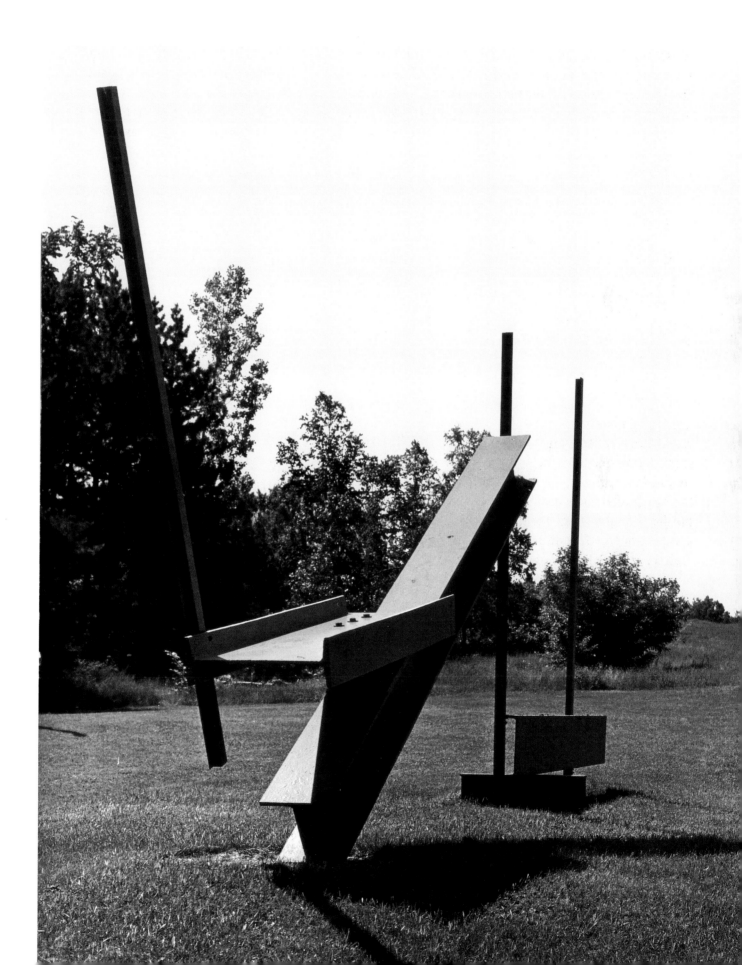

Atlantic
1961
Steel and aluminium,
painted blue
320 x 755 x 91.5 cm
Private collection, USA

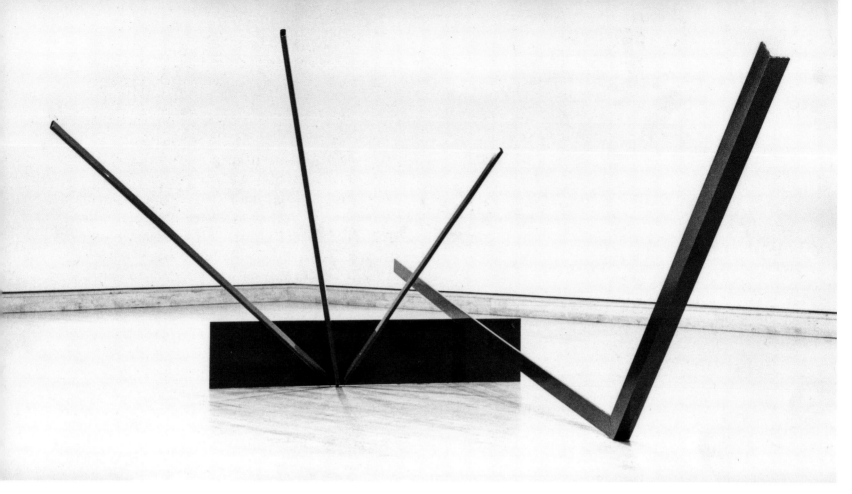

Wide
1964
Steel and aluminium, painted
burgandy
149.5 x 152.5 x 406.5 cm
Private collection, UK

the gesture itself. Everything in Caro's art that is worth looking at – except the colour – is in its syntax. That this is not the case with regard to the autumn of 1959 makes his subsequent achievements all the more remarkable. It is as if in his first abstract sculptures Caro deliberately rejected as beside the point – or worse, as a potential distraction – the kind of involvement with materials one finds in his early pieces, and chose instead to work *through*, not *in*, his means, as through a resistant medium.

As for Caro's colour, it too does not come easily to him. Nevertheless, it is the natural concomitant of his aspirations towards openness and weightlessness – modalities which are of no special value in their own right, but which alone make possible the construction of expressive gestures that are not simply 'abstracted from' those of figurative art. Here I want to point out a relation, which is also a distinction, between his early figurative works and the later abstract ones: in the early sculptures an almost Impressionist handling of surface tends to compromise, if not actually to dissolve, the mass of the figure; while the later works aspire toward a more fundamental mode of opticality – one which does not emphasise the texture, hence the substance of surfaces, but which attempts to divest substance itself of tactile associations. There is a precedent for these ambitions in the work of David Smith, as well as the Constructivist sculpture

in general. But even more important to Caro, I feel, have been the paintings of contemporary Americans such as Jackson Pollock, Clyfford Still, Barnett Newman, Mark Rothko, and, most of all, Morris Louis and Kenneth Noland. Louis and Noland, for example, obtain sheerly optical images by staining plastic paint into unsized canvas. This has the result of identifying the bright colour with its ground, of weaving paint and canvas into the same optical fabric. In their work – which incidentally deserves to be much better known in England – it is the paint whose substance is destroyed, largely through the agency of colour; while in much of Caro's sculpture colour is used to help render substance itself – and what could be more substantial than his massive girders? – mostly optical.

I want to stress again that, considered solely in its own right, such opticality is not necessarily desirable. It becomes a desideratum of great importance for Caro because it makes possible the construction of a kind of gesture – founded on achieved weightlessness – which figurative art can no more than gesture *toward*. But it is crucial to observe that the opticality of Caro's sculpture is, at bottom, an illusion. Whereas in painting the 'modernist "reduction"' has thrown emphasis upon the flatness and shape of the picture surface, it has left sculpture as three-dimensional as it was before. This additional dimension of physical existence is vitally important – not because it allows sculpture to continue to suggest recognisable images, or gives it a larger realm of merely formal possibilities – but because the three-dimensionality of sculpture corresponds to the phenomenological framework in which we exist, move, perceive, experience, and communicate with others. The corporeality of sculpture, even at its most abstract, and our own corporeality are the same. Modernist sculpture – but not modernist painting – can create configurations and liberate gestures, which, in their fundamental physicality, are analogous to those on which all language, all expression are ultimately founded – and which, in their illusive opticality, may overcome the customary limitations inflicted upon physical gesture by gravity.

The potential for expression in such art is clearly immense. It is also largely unrealised: within the past decades there have been no more than two sculptors whose achievements, at their best, seem to me major – David Smith and Anthony Caro. It is remarkable – but

Prospect
1964
Steel, painted red, blue,
orange and green
272 x 251.5 x 30.5 cm
Museum Ludwig, Cologne

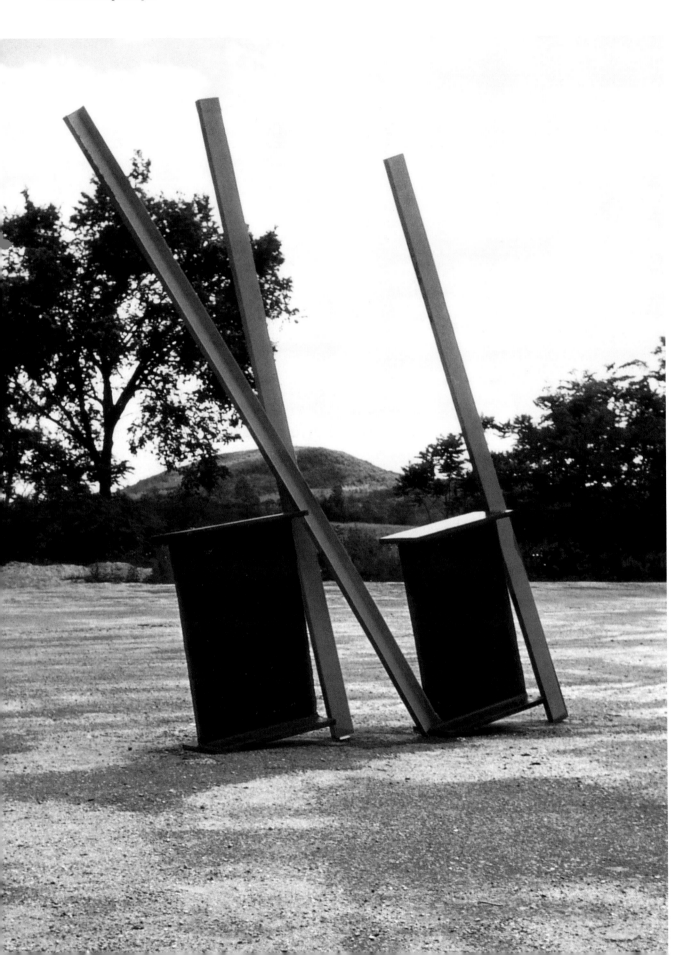

irrelevant really, except as an indication of his intelligence and the force of his passion – that Caro's entire abstract oeuvre is the result of less than four years' work. The work itself, however, is more remarkable than its biography. I don't think that an introductory essay is the proper place to attempt an assessment of the individual pieces, and I hope that such an attempt shall not be missed. What I have tried to do, as I said at the outset, is put forward a way of looking at Caro's sculptures, because it would be tragic if, though exhibited, they were not *seen*; but the task and responsibility of seeing belong to the spectator alone and ought not to be alienated by him or pre-empted by others.

Let me close, then, with a few general remarks. Caro's sculptures are bitten both by their knowledge of the beauty of the human body – which they cannot demonstrate directly – and by the intimations of those cataclysmic gestures made, in the throes of love or grief or self-hate by the naked spirit. For all their abstraction one can imagine a gifted dancer dancing Caro's sculptures. Merleau-Ponty, in a splendid phrase, wrote that what replaces the object in non-representational art is 'the allusive logic of the perceived world.'[9] In Caro's more successful sculptures one discovers the allusive syntax of our own purest and more passionate gestures used to construct gestures even more pure and passionate – and armed, beside, with what one hopes it still makes sense to speak of in our time as the durability of art.

Notes

This essay was subsequently published in *Art International 7*, 25 Sept. 1963, pp.68–72, and Michael Fried, *Art and Objecthood*, Chicago University Press, 1998, pp.269–76, from which this version is taken.

1 Stuart Hampshire, 'A Ruinous Conflict', in *Modern Writers and Other Essays*, New York 1970, p.196.
2 Rainer Maria Rilke, 'The Rodin-Book: Second Part (1907)', in *Where Silence Reigns: Selected Prose*, trans. G. Craig Houston, New York 1978, p.135.
3 Rainer Maira Rilke, 'The Rodin-Book: First Part (1903)', in Houston 1978, p.104.
4 Clement Greenberg, 'The New Sculpture', in *Art and Culture: Critical Essays*, Boston 1961, p.139.
5 I would have done better to say 'constructionist' in the sense that Greenberg speaks of 'the new construction-sculpture', ibid., p.142 – M.F., 1996.
6 Ibid., p.142.
7 In *Gazette*, no.1, 1961.
8 Ibid.
9 Maurice Merleau-Ponty, 'Le Langage indirect et les voix du silence', in *Signes*, Paris 1960, p.71.

Postscript, December 2004

I wrote this essay in the late spring of 1963, towards the end of my first year as a graduate student in art history at Harvard. As I explain in 'An Introduction to my Art Criticism' in Art and Objecthood: Essays and Reviews *(Chicago and London, 1998), it's an immature piece of work, one whose flaws are all too obvious to me now. In particular I regret the turgid prose, the appeal to authorities, the lack of discussion of specific works, the obeisance to Greenbergian opticality. But I still think that in crucial respects it gets Caro right, especially in its stress on expressive gesture, its remarks on 'achieved weightlessness', and its insistence on the primacy of the 'syntax' of his abstract sculptures. It was also the first serious piece of criticism written about Caro's early abstract work, and on those grounds alone it perhaps belongs in the present catalogue.*

To this I will add that at eighty Caro remains a truly ambitious artist in the high Modernist sense of the epithet, by which I mean that he continues to seek to challenge his own prior vision of sculptural possibility, or say of the limits of such possibility. In this regard he is one of the exemplary figures in all Modernist art, not just sculpture. His accomplishment over the past forty-five plus years has been magisterial, but (as everyone who knows him cannot but be aware) he remains unsatisfied, full of projects, a questing, creative force of undiminished magnitude.

Caro's studio, June 1979

Anthony Caro: The economies of surprise
Dave Hickey

1 / History or something like it

For most of the previous century, essays of this sort (called 'catalogue essays') presented themselves as cosy, personal introductions. In recent years, they have taken on the mantle of Teutonic, historical solemnity, but their function has not changed. Appended to public occasions that are more social and political than artistic, their job is to deal with the art – to explain away its strangeness and gentrify any wayward frisson that might disrupt the public moment. They exist to provide background music – to 'set' works of art into the larger narratives of the culture – to transform works (that have themselves had demonstrable cultural consequences) into mere effects, contingent upon other, less tangible, historical, sociological and psychological causes.

To Anthony Caro's eternal credit, a 'catalogue essay' of this sort cannot be written about his work. Even today, the works that opened his career in the 1960s remain blessedly defiant of prose description, resistant to the attribution of causes, and virtually impervious to pedagogy. By claiming no foothold in the realm of representation or concept, by opting instead for an infinitely rich field of elusive resemblance and similitude, Caro's works survive as a consequence of our having seen them. As Quintillian would have it, they survive in their eloquence, which cannot be translated or counterfeited – as opposed to their philosophy, which can be and has been. In 'Two Sculptures by Anthony Caro' in *Artforum* (February 1968), Michael Fried sums it up by observing that Caro's work 'compels us to believe what we see rather than what we know, to accept the witness of the senses against the constructions of the mind'.

Unfortunately, Professor Fried and I must testify to this compulsion toward the visible in prose, which is, before everything, a socialised construction of the mind. And prose is still required, if only to argue its

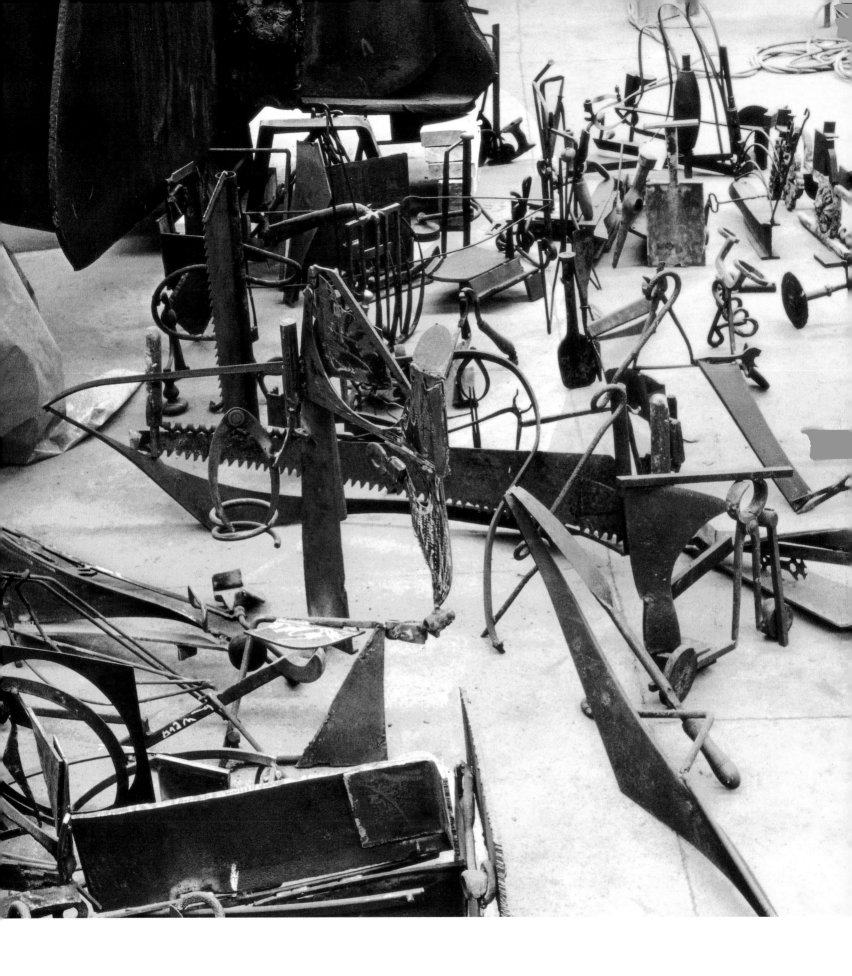

inadequacies, because we are still troubled by the fact that Caro took us by surprise. From the first morning of their public vogue, Caro's sculptures were embraced as pre-emptive icons of high modernist art. There were no overtures for the event, only fugitive precedents made visible in the light of its happening. Caro's debut work projected the beam of a revised art history into the warehouse of the past. It selected out specific sculptures 'drawn in space' by Picasso, Julio González, David Smith and others. It illuminated the exact points at which the practice of these artists (who were embarked upon their own journeys) crossed the directional vector that Caro would pursue. These spotlighted precedents, however, only told us that Caro's sculptures seemed comparable to the work of artists who declined the path that he chose. They reminded us that, by choosing the direction he did, Caro took a turn from the beaten track and demolished the fashionable currency of the practice in which he had been educated.

In that first public moment, of course, the consequences of Caro's turn were shrouded in the future. Today, less explicably, they seem shrouded in the past. What amazed us as restless beholders in the 1960s confounds us as thoughtful historians today. It shouldn't. The advent of dominant objects is always more catastrophic than benign. Such objects aren't, and then they are. Henceforth, they are givens, and, to be just, we should simply acknowledge the anomaly and see what happens next. In the historically self-conscious era in which Caro made his debut, however, the advent of modernism was presumed to have been the last catastrophe. The entire art community routinely conspired to paper over subsequent rents in the zeitgeist,

and good things that seemed to have come from nowhere were quickly accounted for. So, since Caro's work was 'constructed' and 'assembled', it was awarded a provenance in Constructivism and assemblage. The fact that Caro's work, by Constructivist standards, is very badly constructed was ignored – as was the fact that nowhere in his early work do we discover the literary 'found narratives' that have beguiled assemblageurs from Picasso to Rauschenberg.

The problem with this improvised provenance, however, is not that it was wrong or ill intentioned. In a strictly local sense, it was probably accurate enough. It simply aspires to locate Caro's work within the short history of modernism, while, from the perspective of the present, his overarching *contribution* to modernism would seem to reside in the extent to which he disrupted the modernist narrative and opened it out at both ends – in the abruptness with which he retired the isolated-figure-on-a-base as modern sculpture's predominant mimetic reference – in the speed and acuity with which he explored possibilities of its absence. At a critical juncture in Caro's early career, around 1959, he seems to have just abandoned the idea of physical 'oneness' as a criterion for sculpture – be it carved, modelled, constructed or assembled. In doing so, he dispensed with a rat's nest of literary folklore. He dispensed with 'oneness' as a modernist metaphor for the autonomous self – with 'oneness' as a Constructivist metaphor for the worker's state – with 'oneness' as a Romantic metaphor for the sublime 'oneness' of just about everything.

In its place, Caro invented a language of redeemed, acrobatic multiplicity that took sculpture out of the realm

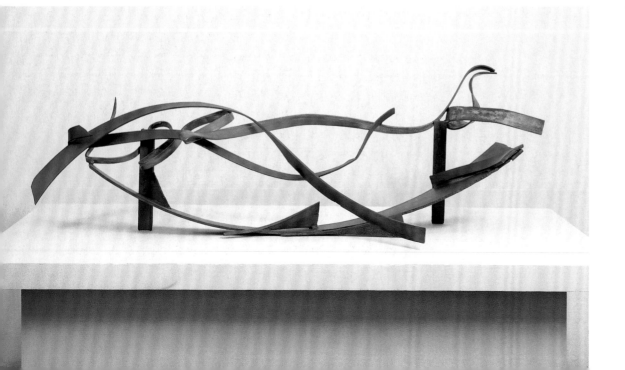

Table Piece CCLXV
1975
Steel, rusted and varnished
55.9 x 205.7 x 81.3 cm
Collection of the artist

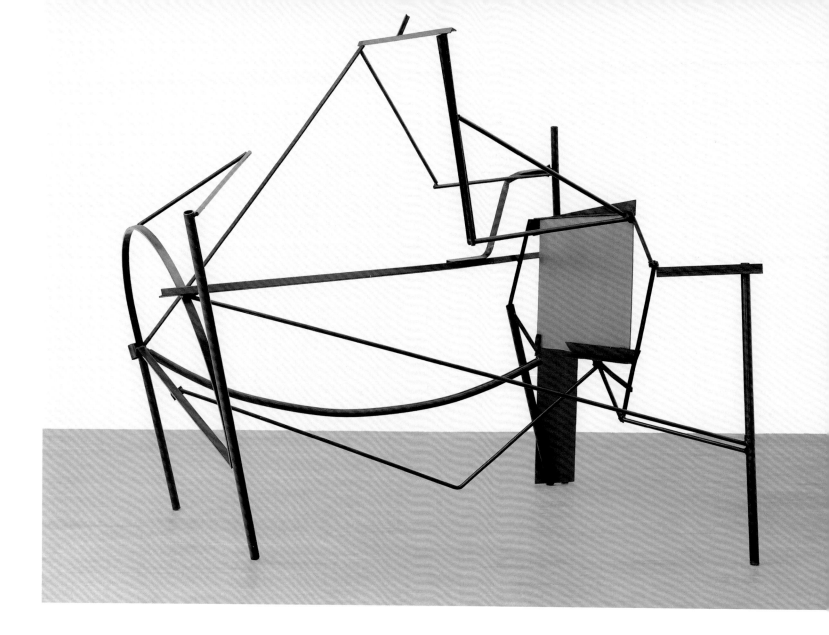

After Emma
1977–82
Steel, rusted, blacked
and painted
244 x 274.5 x 188 cm
Private collection, UK

of the personal and the political and into the domain of
dynamic social relationships. This opened modernist
practice at one end to a complex tradition of elegantly
deployed multi-unit and multi-legged sculpture that dates
back to the flowering of Hellenism. At the other end, Caro's
embrace of multiplicity and tableau prefigured the
continuing dispersal and socialisation of sculptural objects.
That said, however, calling Caro a proto-deconstructionist
is an offence comparable to calling him a late-
Constructivist and equally deceptive. Calling him the new
Canova would have made more sense, although it could
never have happened, and, in truth, the bow wave of Caro's
patricidal debut cleared a space before it, strew wreckage
in its wake, and left Caro relatively unaffected, in the eye of
this storm, to invent and ultimately retire his own early
practice. Like any artist who precipitously alters the terms
and climate of practice (like Picasso, Pollock, Warhol, Judd
and Serra) Caro leaves us to cite precedents but no
precursors, consequences but no legitimate inheritors.

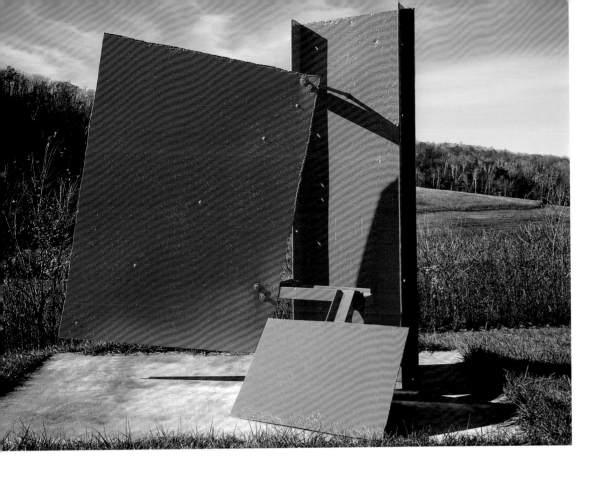

Capital
1960
Steel, painted orange
245 x 241.5 x 132 cm
Private collection

2 / Formalism without tears

For twenty-five years beginning around 1959, Anthony Caro created a body of multi-part, abstract, steel sculptures that serve as their own support. With few exceptions, these sculptures are painted in monochromes and stand on their own legs on the ground. All of them are more concerned with lightness than weight, with space rather than volume. All are more deeply engaged with the complex sociability of their parts than with the autonomous singularity of the piece itself. Beyond these primary attributes, the works are radically dissimilar – from one another, from their settings and from themselves in different aspects. They present themselves to us as 360-degree tableaux with no hard orientation and minimal redundancy. The front is not replicated on the back or reversed. The left is not replicated or reversed on the right, and the slightest shift in elevation complicates things even more. In fact, the orientation of Caro's sculptures, front and back, left and right, high and low, is always idiosyncratic and contingent upon circumstances.

Neither nature nor culture presents us with objects as dissimilar, asymmetrical and lacking in orientation as this. So, cognitively, Caro's tableaux-in-the-round are 'difficult' objects. They neither reference nor compete with the world around them in any persuasive way. In a very real sense, these abstract objects only compete and compare with one another, and then only at the second level of abstraction –

rather in the way that the novels of Dickens reference and compete with one another. All of Dickens's novels are dissimilar; their plots, characters and settings differ in every case, but the books as intellectual objects are irrevocably Dickens's books. We recognise them as being Dickens's by the dynamic, social arrangement of their disparate and dissimilar parts, but recognition is not cognition. The intellectual object we recognise remains un-named except as Dickens-ness. The same is true for Caro, and the difficulty of naming what we recognise is made all the more difficult by the fact that Dickens's novels and Caro's sculptures (once we except the eccentricity of their delicate arrangement) are virtually bereft of nuance, implacably not-mysterious, and quite straightforwardly made.

The materials Caro uses are used for that which they are intended to be used. Steel is used for the reason steel was invented, not for its weight relative to its volume, not for its lovely patina when left unpainted, but for its lightness relative to its rigidity and for the fact that it can be welded and efficiently sealed with industrial paint. Industrial paint is used to do what paint does in industry. It seals the surface of the works and 'identifies' them. It protects them from their physical setting and distinguishes them from it. According to Caro, the actual *colour* of the paint with which the sculptures are sealed is casually selected after the fact – like the titles of the sculptures, which are also chosen late and often take their cue from the colour.

The sculpture called *Prairie* 1967, for instance, is named after the trademark colour of the paint used to seal it. The fact that, once painted and named, the sculpture deftly evokes prairie machinery would seem be a fugitive effect that the artist accepts but has not really sought after – an instance of colour doing what colour does – colour being an unavoidable attribute of paint. So, Caro's colours don't aspire to 'portray' the sculptures or to invest them with the aura of some absent subject. The smooth monochrome, however, as a monochrome and not as any specific colour, does function as an integrated surrogate for the traditional sculptural base. It sets the piece apart, and, beyond this, the single 'aesthetic' effect of Caro's paint derives from the tendency of saturated colour, on account of its retinal authority, to de-emphasise the weight of that which it covers. This, however, only emphasises the 'use-value' of the steel, its lightness relative to its strength, and incorporates the prosaic exploitation of materials into the larger aesthetic of Caro's project.

From this we may infer that, since all open constructions of painted steel in this industrial culture must necessarily take on the aspect of armatures arrested in their progress toward completion or dilapidation, Caro's are probably intended to bear that attribute as well. Intended or not, they do evoke armatures, and this aura of arrest or incompletion invests Caro's work with a dynamic potential that emphasises rather than detracts from their formal equipoise. The inference of potential that accrues to the look of the armature invites us on toward some imaginary resolution. The formal stability of the physical work restrains our speculation, locking the work into its hard configuration, like a syntactical tether.

This balance of formality and potential locates Caro's sculptures in a rather special category of abstraction. Its idiom differs radically from those abstractions that simply embody abstract concepts (grids, diagonals, etc.) and from those that seek to represent that which cannot be represented (truth, soul, history, orgasm). More to the point, and unlike the vast majority of abstract art, which is simply abstracted *from* the configuration of visible reality, Caro's art seems to be abstracted *towards* something. It floats just below the radar of articulate representation, evoking some potential but never fully available absent

Cover of *Artforum*, February 1968, showing Caro's *Prairie* 1967

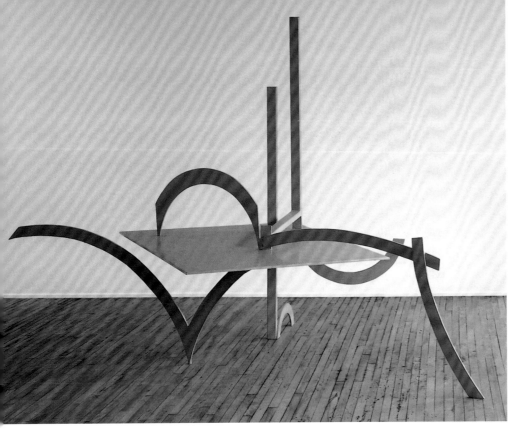

Trefoil
1968
Steel, painted matt yellow
211 x 254 x 165 cm
Private collection

signifier. David Smith's sculptures and Willem De Kooning's abstract paintings of this period are similarly energised by this opposition of formal rigour and potential meaning. In the decade of the work's fashionable cynosure, this passive-aggressive dynamic was usually read as a metaphor for a condition of 'becoming' arrested by existentialist angst – for the tragic optimism of Sisyphus pushing his rock up the hill in Camus's retelling of the myth.

In my view, this trope has always seemed to be an astonishingly effective, primary instrumentality that resides at the heart of what we call formalism (defined as an aspect of practice rather than a kind of art). For this exact reason, in February of 1968, I tore the cover off that month's *Artforum* magazine. It bore a colour reproduction of *Prairie* , and announced an essay by Michael Fried inside the magazine. I pinned the cover to the wall over my desk, where it remained for years as a talisman of the way I thought that things should look. At the time, I was writing a dissertation in field of theoretical linguistics, and Caro's sculpture appealed to me as an example of art confounding language – of art synthesising the fractured subjects and predicates of Western languages and speaking in a more atmospheric idiom.

In short, I found Caro's sculptures hard to deal with and impossible to ignore. Having seen the work, read the words written about it and attempted to write some words myself, I quickly realised that, in order to write about Caro's sculpture, it was necessary to misconstrue the relationship of their parts. In writing, one fractured the sculptural

synthesis of subject and predicate. One described 'things' as 'running across', 'springing up', 'lifting over' and 'bending down', and Caro's parts did no such thing. In their condition of arrest, they might have seemed on the verge of doing them or to have just done one of them, but they were, in fact, quite still, yet even so, the sense of potential and expended energy – of 'something-about-to-spring' or 'something-having-bent' – remained. This attribute was an undeniable part of the work as experienced and should, I felt, be a part of the work as described.

So, I tried to imagine the sort of language that would describe Caro's sculptures without misconstruing them. I imagined a language without subjects and predicates – a language that had a word for 'man-running', a word for 'man-sitting' and even a word for 'man-appearing-to-run', but no word for 'man' and no discrete concepts of running and sitting and appearing. A language like this, that spreads out and not up, that blends rather than classifies, would restore the world to us in its fullness, in all of its radical positivity. It would activate objects, embody actions and reinvest the language of actions and objects with a dynamic autonomy that extant languages shatter. It would take us out of the realm of concept and representation into the Foucaultian world of haunting, pagan similitude, into a world awash in infinite reference, a world that we can see but can't see through, that simulates the fluidity of thought yet can't be thought about.

This, I took to be the language of Anthony Caro's sculptures, because such a language of 'live objects' and

'embodied action' could describe formalism in its true function as a hedge against those live potentialities without which formalism is dead and redundant. Its task would be to evoke the dynamic, internal arrangement of things poised in perfect equanimity as alive and lively. Great art from Homer to Caro speaks to us in this language but we cannot speak it back. We cannot even name the virtue that we recognise, because its instances are unique and, thus, good form is a disjunct category, only recognisable as the absence of bad form. So, we seek the attributes of virtue where we find no fault. We speak of rhyme and rhythm, of interval and angle, of euphony and harmony, and only succeed in fracturing the indivisibility of dynamic entities.

The triumphs of formalism, then, exacerbate the tragedy of criticism. They extend to critics an invitation to do something that can't be done. Yet however grotesquely we critics try but fail do it, successful forms remain visible and recognisable to those who care to look, and this recognition constitutes the only free marker that designates things as art – the only marker that Caro has ever needed. Less successful forms in art, and particularly those forms that are willfully unsuccessful, require external prostheses and institutional imprimatur to cue our recognition. They need 'pictorial' content, hard reference, signifiers, labels, prices, kunsthalles and gallery spaces. They require governments, agencies, prizes, patronage, journalism and public occasions. Caro, in good form, has never needed anything more than a lawn and his own ravishing economy of means.

Red Splash
1966
Steel, painted
115.5 x 175.5 x 104 cm
Private collection

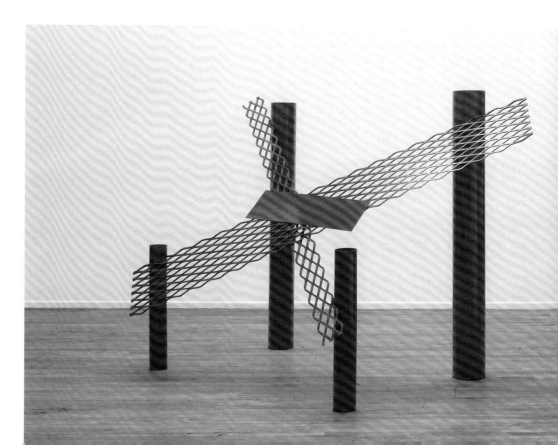

In the beginning, Caro only required steel, one colour of paint, and a variegated unmediated outdoor setting, working together – and somewhat differently apart. The variegated natural setting embodied everything the sculpture was not. The monochrome identified the work's unnaturalness, lightened it, and allowed the steel tableau to function in the landscape as an irrational, provisional icon of sheer intellectual exuberance. The intimate balance of these three attributes, I have always felt, is best inferred from the high percentage of Caro's early unpainted sculptures that seem destined for monochrome interior spaces. When sited out of doors, these unpainted works blur into their settings. They lose their lightness and abstract potential and take on an un-Caroesque aura of naturalised, Greenbergian modernism. Or so it has always seemed to me, who never comes upon an early unpainted Caro out of doors without being overcome by a desire to take it inside or, even worse, to *paint it monochrome* in a gesture of complementary idiocy to Clement Greenberg, as David Smith's executor, grinding the paint off Smith's late sculptures.

This is an inappropriate instinct, I know, but I hope to be forgiven because I have a point, which is that Caro's 'natural' works share a quality with the outsized, unframed American paintings of their period. They all demand the monochrome interiors that were ultimately provided for them. Such works spawned a metropolis of ice-white private rooms, lofts and galleries to frame them, and, Caro's 'sculptures in dishabille' distinguish themselves from these 'clean rooms' as his painted monochrome sculptures distinguish themselves from the variegated out-of-doors. In both cases, the painted monochrome, *on the walls or on the work*, signifies as a surrogate frame. It isolates the work, sets it apart but never quite 'sites' it in a sculptural sense, so the sculpture, indoors and out, always seems potentially mobile – retains the implicit mobility of painting. This reversible interplay of object and context, of monochrome and variegation, is further worth mentioning here because it seems to be the only rational justification for comparing Caro's work to American painting in the moment of its sculptural triumph – at the dawn of sculpture's new ascendancy.

There were irrational reasons for this comparison, of course. In the United States, likening Caro's work to American painting was a way of claiming him for the New World. In the United Kingdom, the comparison was more often a snarky rebuke directed at Caro for abandoning English ways, striking out for the colonies and, like some English Gauguin, going native. A more reasonable scenario would involve the artist, on a cold night in Vermont, noticing the efficiency with which a large, unframed painting by his friend Kenneth Noland was 'framed' by its white enclosure. From there to the idea that a baseless sculpture in an outdoor setting might be semiotically 'framed' by a monochrome paint job is less than a giant step. The contemporary notion that Caro's work alluded to

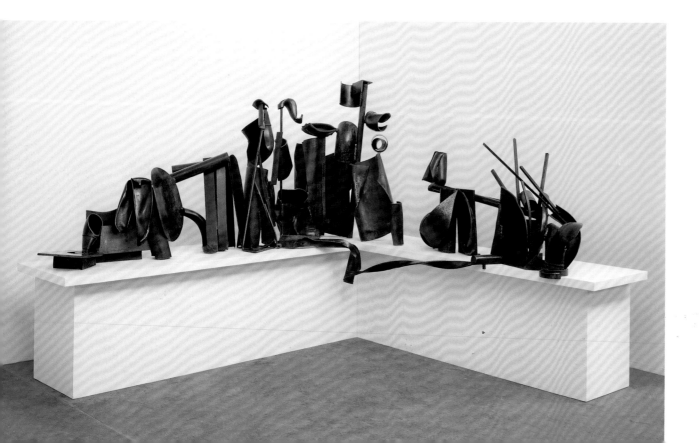

Triumph of Caesar
1987
Steel, rusted and waxed
157.5 x 343 x 198 cm
Private collection, USA

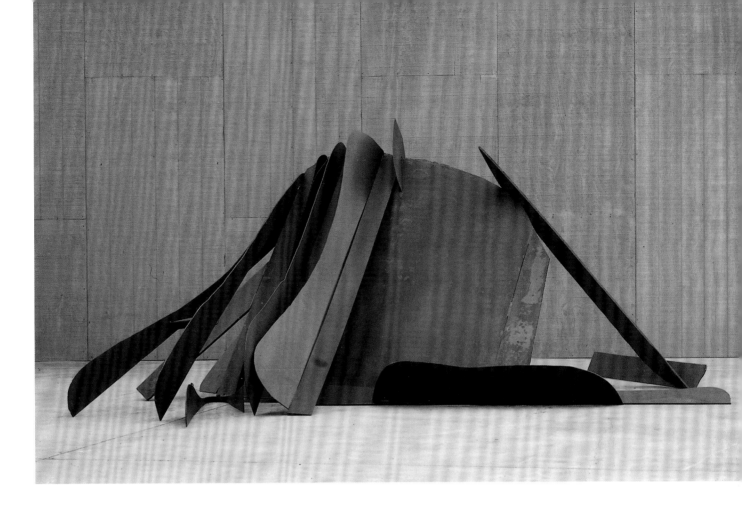

Curtain Road
1974
Steel, rusted and varnished
198 x 475.5 x 277 cm
Private collection, UK

American painting because they both dealt with 'forms in space' involves more of a trek, since it requires us to confound 'painted shapes that don't quite fill up the rectangle of the canvas' with 'forms in space'.

In any case, the idea that Caro's abandoning of the base and American painters' abandoning of the frame had similar motivations seems highly unlikely, since Caro doesn't so much dispense with the base as dispense with the narrative object that the base traditionally supports. In fact, he *apotheosises* the base, frames it, and creates works obsessively concerned with the sculptural problem of getting the objects onto the ground in dynamic relationship. This fiat is what we used to call a 'breakthrough', but nothing comes from nothing, so it should be noted that, for the young Caro studying in London, innumerable solutions to this problem were readily available in the city's great museums and public spaces. His education in sculpture would certainly have exposed him to their rhetoric, if only as a negative example. So it is not unreasonable to imagine that, knowingly or not, in the way that students gravitate toward the unfashionable, a budding young formalist like Caro would take some lessons from the complex formal tropes of the traditional multi-figure sculpture available to him, and from their traditional precursors, the Laocoön, the fountains of Bernini, the monuments of Canova.

In any case, Caro would soon embark on a career based on the spare, symphonic relationship of contiguous figures. He would refine the language of these sociable figurative objects, the cant of the elbow, the slant of the shoulder, the angle at the knee, and the curve of the back into an idiom as remote from figuration as it is from concept. There is evidence of this agenda, of course, in the manner in which the geometric language of his early bronze and terracotta pieces reappears in his first steel sculptures and in the later more pictorial works in which Rembrandt's *Descent from the Cross* and Manet's *Déjeuner sur L'herbe* 1862–3 are translated without apology into Caro's multipart language. We may even find confirmation of this agenda as an available option for subsequent practice in the work of Caro's most assiduous devotee, the Californian sculptor Charles Ray, who, in homage to Caro, reproduced *Early One Morning* 1962 on the cover of his own retrospective catalogue. Many of Ray's pieces acknowledge Caro while restoring the potential image to Caro's elusive armature. Ray's topless table sculptures come replete with 'tabled' objects deftly supported by the abstract steel armature. His *Oh, Charley, Charley* 1992 is composed of eight sculptural replicas of the naked artist deployed in auto-erotic abandon and arranged in a Caro-esque horizontal tableau of weights, curves and angles. So, if one should be required, *Oh Charley, Charley* marks the end point of an arc leading from Canova to Caro to Ray – from the pre-modern to the modern to the postmodern, or, if you will, to the neo-modern.

Aligning Caro's work with a tradition of figurative sculpture comes with several large caveats, however. First, this traditional allusion might seem to bear with it a sense of reactionary historical intention, while Caro is clearly activating an apt historical precedent to solve a contemporary problem – an option that all practitioners, be they lawyers, doctors or artists, hold a mandate to exercise. Second, associating Caro's sculpture too rigorously with the multi-figure tradition is a little like locating Mondrian in the tradition of newspaper layouts. It tells us something, but not a lot, and implicitly makes Pop artists of both. Finally, this association leaves the inference that Caro has somehow pared down pre-existing

Cover of Charles Ray's retrospective exhibition catalogue, 1998

CHARLES RAY

figurative groups to their armatures in the way that traditional sculptures pared down the stone to find the figure within, and this is demonstrably not the case. Caro is clearly 'designing' his non-designs to test as delicately as possible the dividing line between that which grows and that which is made, between that which reads and that which writes, between that which moves and that which is rooted.

This final aspect of Caro's early sculpture, its sense of always being provisionally sited, locates the ultimate aspect of his sculpture's formal potentiality. The combination of their asymmetrical orientation, their monochromatic 'frames' and their apparent lightness, almost invariably creates a sense of their being 'ready to go', an aura of situational instability, ludic mobility and good-natured imposture, that in a very real sense retards our sense of their historical 'age' in their location. In truth, a Caro monochrome that has been allowed to 'weather' in its site is not really a Caro any longer. The great Caro monochromes always seem to have just arrived in a good situation from which they are all too willing to move. As a consequence, they do not so much inhabit the world as furnish it, and this, in the moment, was something new, a primary shift in modern sculpture's domain of mimetic reference.

Before Caro, from Michelangelo to Brancusi, sculptures traditionally presented themselves to us as mimetic 'creatures' or 'vegetation' – in fugitive cases, as industrialised creatures or vegetation – rooted in or on their site. These objects, when sited, were presumed to have found their symbolic niche in the world. Caro's work, by combining domestic reference, implied mobility and industrial facture, created a new genre of non-utilitarian objects whose legibility derives from their subliminal reference to utilitarian forms – to equipment, as it were – to the tool, the appliance, the table, the bench and the chaise. All of these things fall into a category of mobile objects concerned with negotiating between human beings and the physical world when and wherever they are needed. As singular objects (whenever and wherever) they are invested with their past or potential function. Scott Burton put it shrewdly when he remarked to me in conversation that 'a chair or a bed or a table, in and of itself, is always empty and always in need'.

Antonio Canova (1757–1822)
Psyche Revived by the Kiss of Love
Louvre, Paris

Charles Ray
Oh Charley Charley
1992
Private collection

4 / The end of the beginning

The formal authority of all Caro's sculptures, then, holds the inference of potential meaning, potential figuration, potential action and potential function, frozen in a condition of provisional repose – and this, to be honest, pretty much exhausts the category of visible potential. Not surprisingly then, the sculptors who were required to work in the wake of Caro's fiat (a group, which, most prominently, includes Caro himself) felt called upon to mount some kind of dissent or divagation. Caro, of course, with an ease that betrays the rigorous limitations he imposed on his early work, simply relaxed them to explore the pictorial, architectural and material diversity previously held in abeyance. In the United States, where sculptors are notoriously disinclined to relax, the response manifested itself as a concerted attack not on Caro's works themselves but on the pre-eminent virtues to which they aspired – on the validity of abstract eloquence, radical dissimilarity, visual complexity and physical legibility as signifiers of artistic value. American Minimalists would replace sculpture in the round with sculpture in the square or in the rectangle. Caro's 360-degree tableaux were reduced to 90- and 180-degree prospects that theatricalised their shifting settings.

Donald Judd would transform Caro's idea of sculpture as ideational furniture into his own idea of sculpture as minimised furniture. He would restore the monolith by deploying serial monoliths and then, ultimately, take the logic full circle by applying Minimalist rigour to a line of designer chairs. Scott Burton would spin Caro's idea off into a practice in which the utilitarian function of the chair and its emptiness became the single constant in a sculptural endeavour that explored the permutations of 'chair-ness' through a design catalogue of forms and styles. Richard Serra would transform Caro's idea of sculpture as its own support into a kinaesthetic assault on the earth itself.

Caro himself would luxuriate in the refined, eclectic literary sensibility that had made his non-literary works possible in the first place. After decades of nuancing the interdependence of the monochrome and the allusive armature, Caro would abandon them both to stunning effect in his later works. In *After Olympia* 1986–7, he would create a dramatically transitional work that positions itself just beyond the outer limits of the territory Caro first claimed for

himself and just on the verge of the figurative and architectural territory he would explore in his later career. Constructed of rusted steel, shot-blasted and varnished, *After Olympia* is composed of five long, low tables arranged in a row that extends some seventy-five feet. The five tables are laden with a heavy feast of ominously appetising steel fragments, like a giant's buffet, stacked, tilted and piled along their full length. The raw steel banquet ascends to a height of eleven feet, nearly four times the height of the tables, and the sense of its weight bearing down on the tables is enormous, like a city bearing down on its foundations.

A nice, bright monochrome paint job for *After Olympia*, of course, would take the weight away, but since the piece is in no sense an armature, since the tables in *After Olympia* are in fact tables that support objects, this new monochrome lightness, rather than investing the work with elusive potential, would translate *After Olympia* into a three-dimensional graphic image resembling nothing so much as a large Tom Wesselmann tableau derived from an ebullient Dutch still life. Yet the work is no less recognisable as Caro's in its transgression of our expectations. The deft economy of means with which Caro always segues from one object to another, manifests itself here in his translation from one idiom to the next. Nothing much has

After Olympia
1986–7
Steel, shot-blasted, rusted
slightly and varnished
332.5 x 2342 x 170 cm
Etablissement public pour
l'aménagement de la région
de la Defense, Paris

changed; steel is steel, construction is construction, and table is table – only everything is different.

Today, of course, having set sculpture off in a new direction that he has no predisposition to follow, Caro pursues his new direction pretty much on his own. The sheer liveliness and power of works like *After Olympia*, however, should serve as a cautionary reminder about the false rigour of our teleologies. It should also remind us of just how assiduously we conspire to deny adult artists both the privileges of maturity and the permissions of youth. We expect artists to romance their youthful sweethearts ever and anon – to proceed steadily onwards through the mist of their youthful dreams. The mature artist's desire to expand the breadth of his or her practice, to look back into the historical depths of its long inheritance, seems to us a betrayal of that original romance – a divorce from that first sweetheart whom we loved so well, although we didn't really understand her at first and don't really understand her now. At the same time, the artist's youthful zest for surprising and outraging us – the very instinct that amazed us at the outset – seems to us after that first surprise to constitute a kind of impudence. We gaze in puzzlement from the bondage of the imaginary histories we have so eloquently imagined, and exhale in exasperation: how *dare* he surprise us *again*!

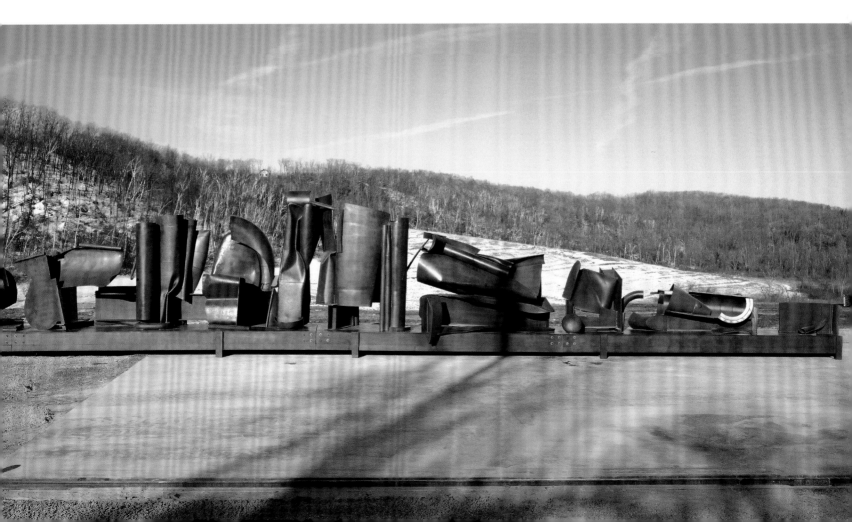

Chronology

Compiled by Rachel Tant

Caro walking in the parking lot
in Bennington, Vermont, 1965

1924 / Anthony Caro is born 8 March in New Malden, Surrey, to Alfred and Mary Caro, both originally from Norwich. Father works as a stockbroker in the City. Caro spends childhood with older brother Peter and sister Rachel in Churt, near Farnham, Surrey.

1933–7 / Attends Pinewood Preparatory School, Farnham, Hampshire. Enjoys drawing from a young age but recalls 'I never went to an art gallery as a child … It was the making [of art] that was what I wanted to do and not the looking at it. And then I found looking at it helped the making of it and that was a great pleasure.' (Artist's talk, 24 April 2002, Tate Britain)

1937–42 / Educated at Charterhouse School, Godalming, Surrey. Shows admiration for van Gogh who 'has been a hero since my early teens … I saw him then in an intensely romantic way after reading *Lust for Life*' (Caro quoted in Rachel Barnes, 'Building on Tradition', *Independent*, 26 Feb. 1998). Shows no interest in painting – 'I was not interested in colour' – but starts to model in clay.

1939 / Introduced by housemaster to sculptor Charles Wheeler and accepts the opportunity to work in his studio during school vacations learning sculptural techniques and gaining experience in enlarging small-scale models.

1942–4 / Reads engineering at Christ's College, Cambridge; 'My father was very insistent that if I wasn't going to be a stockbroker, which is what he would have liked, then I should do something sensible and useful to society like engineering. And so I did.' (Artist's talk, 24 April 2002, Tate Britain) Attends Farnham School of Art during vacations where he models clay figures and portrait busts from life.

1944–6 / Serves in Fleet Air Arm of Royal Navy working as an Air Engineer Officer; continues to attend Farnham School and Wheeler's studio at every opportunity.

1946–7 / Despite his parents' opinion that 'making art was a dilettante occupation', decides to pursue a career in sculpture and on Wheeler's advice enrols at Regent Street Polytechnic, in London, studying sculpture with Geoffrey Deeley. Encouraged to visit the British Museum; early work shows an awareness of contemporary sculptors Eric Gill and Barbara Hepworth.

1947–52 / Training at Royal Academy Schools, London, under the tuition of sculptors such as Macwilliam, Hardiman, Charoux and Lambert. Continues drawing and gains knowledge of traditional sculptural materials including plaster, stone, terracotta and wood by sculpting from the model and from antique casts. Fellow students include Frank Martin, Adrian Montford, Peter Lowe and Peter Smithson. Early interest in Carl Milles, Romanesque and Gothic art develops towards Renaissance and classical sculpture.

1948 / Royal Academy Schools award him one bronze and two silver medals for his work. First Open Air Exhibition of Sculpture held in Battersea Park, London, displaying wide range of British and European sculptors, including Auguste Rodin, Frank Dobson and Henry Moore.

Caro and Henry Moore, c.1952

Moore was a most generous teacher ... we'd have long conversations about art ... he'd look at my drawings and criticise them. He taught me how to draw. It was very good. And I actually did try very much to get into his head and to learn everything I could from him ... here I was, in a place where someone was actually making sculpture and I was seeing how it all worked; it was fabulous.
(Artist's talk, 24 April 2002)

My first knowledge of Negro art, Surrealism, Cubism, of the whole modern movement, came from Moore. You can scarcely conceive what a closed world it was then for a student in the Academy Schools. We were expected to look either at casts of Greek sculpture in the school corridors or else go upstairs to the Royal Academy Summer Exhibition. Our education was very bad, very incomplete. (Caro quoted in Peter Fuller interview, *Art Monthly*, Feb. 1979)

I owe [Moore] a great debt. The doors of a whole world of art which I had not known as a student he opened for me. (Caro, 'The Master Sculptor: Henry Moore – An Appreciation', *Observer Weekend Review*, 27 Nov. 1960)

During this period visits a wide range of exhibitions:

There were shows like The Wonder and Horror of the Human Head *and* 40,000 Years of Modern Art *... they were marvellous shows ... The Wonder and Horror of the Human Head went from Paolozzi right back to pre-historic times ... and then I was beginning to get interested in contemporary people like Dubuffet and De Kooning and so on ... so in a way art came into one's knowledge ... I saw Bacon's van Gogh series at the Hanover Galleries; I thought they were wonderful ... and I still think they're marvellous.*
(Caro interviewed by Rachel Tant, 8 July 2004)

1953–79 / Begins teaching two days a week at St Martin's School of Art, London; under the leadership of Frank Martin, Head of Sculpture, the department is reorganised and the curriculum developed. Decides 'I am not going to teach as a professor, I am going to teach as a student. So I made it clear that we were all engaged on an adventure, to push sculpture where it has never been.' (Caro in Andrew Dempsey (ed.), *Sculptors Talking: Anthony Caro, Eduardo Chillida*, 2000) Students during the period include David Annesley, Michael Bolus, Richard Deacon, Barry Flanagan, Hamish Fulton, John Gibbons, Gilbert & George, Gerard Hemsworth, Charles Hewlings, Phillip King, Richard Long, Tim Scott, Wendy Taylor, William Tucker and Isaac Witkin.

1949 / Marries painter Sheila Girling, a fellow student at the Royal Academy Schools. Works closely with his wife throughout his career, her support and criticism of his sculpture being of great importance: '[Sheila's] got a terrific eye and I trust her entirely to tell me the truth.' (Artist's talk, 24 April 2002)

1951 / First son, Timothy, is born.
Henry Moore retrospective, Tate Gallery, London.

1951–3 / Continues to draw from the model at Royal Academy but, wishing to broaden his experience, Caro calls at Henry Moore's house, without an appointment, to ask for a job. 'I had to think of other horizons. So I asked myself "Who is the best sculptor around?"' (Caro quoted in Roger Berthoud, 'Before and after Henry', *Independent on Sunday*, 6 Oct. 1991) Six months later moves his family to Much Hadham, Hertfordshire, and works as part-time assistant to Henry Moore. Helps set up small foundry, works on waxes and enlarges Moore's Time-Life bronze figure.

1954 / Moves family back to London, settling in Hampstead. Sets up studio in his one-car garage and, exploring 'what it felt like to be inside a human body' and how to make sculpture 'more real', he executes single figure sculptures in clay and plaster, sometimes cast in bronze. Figures are engaged in simple physical actions, such as *Man Holding his Foot* 1954. Experiments by dropping, punching and piercing soft clay lumps, reworking the shapes that suggest themselves. Starts to incorporate pebbles into figurative clay sculptures which are later cast in bronze, such as *Woman Waking Up* 1955.

I found it was very hard to distort a figure, to get away from that naturalism, and I tried all sorts of schemes to try to free myself up ... I felt there was something else out there I wanted to get to, and I couldn't reach it. (Caro quoted in Dorothy Gallagher, 'Anthony Caro: Pushing the Limits of Sculpture', *New York Times*, 18 May 1975)

When I left Moore to start off as a sculptor on my own in London, I was much influenced by Picasso ... reproductions of Picasso's Man Carrying a Lamb *had recently appeared in* Verve *and he had been painting cats and bulls, the art of claws and horns and cockscombs, the 'Geometry of Fear'. I tried to achieve this intensity in a figure in clay.* (Caro, 'My Own Work', in *Anthony Caro: Drawing in Space: Sculptures from 1963 to 1988*, exh. cat., Fundació Caixa Catalunya, Barcelona 2002)

1955 / Exhibits for first time in London, in group exhibition *New Painters and Painter-Sculptors* at the Institute of Contemporary Arts. His two figurative sculptures are described as 'impressive' and 'successful' and 'modelled with considerable power' in *The Times*. In the *Listener*, David Sylvester remarks: 'Of the new sculptors the most impressive on this showing seems to me to be Anthony Caro, whose hideous and rather silly "Man Holding his Foot" (picking his toes?) reveals, besides the influence of Picasso and Henry Moore, a sheer sculptural power indicative of rare promise.' ('Round the London Galleries', *Listener*, 1 Sept. 1955)

1956 / Included in summer group show at Gimpel Fils Gallery, London.

First solo exhibition, at Galleria del Naviglio, Milan; exhibits twenty figurative sculptures and heads in clay or plaster. The work is described as 'serious' and displaying a 'sense of the world'. 'His future position', remarks Lawrence Alloway in the catalogue introduction, 'may well be important'.

Modern Art in the United States at Tate Gallery, London includes work by Abstract Expressionists Jackson Pollock, Franz Kline and Willem De Kooning, whom Caro shows interest in.

1957 / First solo exhibition in London held at Gimpel Fils. Shows sixteen sculptures executed during 1954–6, described by Andrew Forge in the *Listener* as a 'tour de force'.

Anthony Caro's sculpture can make no wide appeal. Nevertheless, this young man … is a sculptor of talent and genuine feeling. He is also in the van of a rising generation of British sculptors concerned to exploit all the emotional possibilities of the rugged shell of a primitive human image. (Neville Wallis, 'Different Worlds', *Observer*, 13 Jan.1957)

Pierre Rouve writes 'his road leads in other directions: towards the revaluation of the very components of the essence of sculpture.' ('Personality', *Art News and Review*, 19 Jan. 1957)

1958 / Second son, Paul, is born.

Included in contemporary British art shows in Brussels and Arnhem; exhibits *Man Taking Off his Shirt* 1955–6, *Woman Standing* 1957 and *Cigarette Smoker 1* 1957 in international show at Venice Biennale; the latter is also shown in Pittsburgh Bicentennial International Exhibition of Contemporary Painting and Sculpture.

1959 / Dissatisfied with his 'models of people', Caro pushes his sculpture to feel 'more real' and sits *Woman's Body* 1959 on a bench directly on the ground – 'But it still wasn't right, still too much of an imitation.' (Caro quoted in Dorothy Gallagher, 'Anthony Caro: Pushing the Limits of Sculpture', *New York Times*, 18 May 1975)

Woman Waking Up 1955 purchased by Tate Gallery.

Continues to exhibit internationally in Antwerp and Carrara Biennials and is awarded the Sculpture Prize at the First Paris Biennale for Young Artists.

Challenges Clement Greenberg's opinion that 'there are no decent sculptors in England' and invites him to his studio for the first time. Their conversation prompts Caro to rethink his sculpture and he experiments in non-figurative work: 'I got to the stage where, try as I might, I was making a "pretend person" out of clay or plaster or bronze. I did not want that. Sculpture, I felt, must not be pretence. Sculpture must be itself. Anything less was not going to work for me anymore.' (Caro quoted in Peter Murray, *Caro at Longside: Sculpture and Sculpitecture*, exh. cat., Yorkshire Sculpture Park, Wakefield 2001)

[Greenberg] more or less told me my art wasn't up to the mark. He came to see me in my London studio. He spent all day with me talking about art and at the end of the day he had said a lot of things that I had not heard before. I had wanted him to see my work because I had never had a really good criticism of it. A lot of what he said hit home, but he also left me with a great deal of hope. I had come to the end of a certain way of working; I didn't know where to go. He offered some sort of pointer. (Caro quoted in Peter Fuller interview, *Art Monthly*, Feb. 1979)

Greenberg's criticism is greatly important to Caro over many years of friendship: 'Clem's eye was like a beam of light which lit up the problem areas of a painting or sculpture and brought new possibilities … he gave us direction and confidence.' (Caro, 'In the Studio', Nov. 2000, www.anthonycaro.org)

Awarded Ford Foundation English Speaking Union grant and, together with his wife, visits the United States for the first time. Visits museums, galleries and art schools on the East and West coasts and meets various critics and artists, including Greenberg, John Chamberlain, Richard Diebenkorn, Helen Frankenthaler, Jasper Johns, Ed Kienholz, Robert Motherwell, Kenneth Noland, Robert Rauschenberg and David Smith.

Particularly struck by Noland's first show of paintings of circles at French & Co. 'I thought to be a sculptor you had to be much cleverer than me. I thought you had to be able to describe your work or be poetic or intellectual about it. I didn't realise you could just make it. He worked at his paintings flat on a table in a very small space. I couldn't believe that his approach was as pedestrian as mine. That gave me a lot of confidence.' (Caro quoted in Roger Berthoud, 'Before and after Henry', *Independent on Sunday*, 6 Oct. 1991)

Caro's first solo exhibition at Gimpel Fils Gallery, London, 1957

Describing the trip as his 'conversion' Caro recalls:

America made me see that there are no barriers and no regulations … There's a tremendous freedom in knowing that your only limitations in a sculpture or painting are whether it carries its intentions or not, not whether it's "Art". (Lawrence Alloway, 'Interview with Anthony Caro', *Gazette* (London), 1961)

What America brought home to me was that in the studio, assumptions in Art are up for questioning … For my own part I realised that if I was to try to arrive at first principles in sculpture then every prop that sculpture presently relied on should be tested and if necessary cut away. (Anthony Caro, 'The British Voice in Contemporary Sculpture', Lecture at Royal Society for the Arts, London, 9 May 1995)

1960 / Heeds the advice of Greenberg – 'if you want to change your art, change your habits' – and on return to London buys oxyacetylene welding equipment and supply of scrap metal from dockyards. Eschews figurative style and makes first abstract sculpture in steel, *Twenty Four Hours* 1960, and sets it directly on the ground. The work is later owned by Clement Greenberg, before entering the Tate's collection.

The old statue was made on a base and it inhabited a world of its own, the limits of which were set by the limits of its base. Whether it was an equestrian statue or a little model on a piano or a mantelpiece, it inhabited its own world. I don't want my sculpture to relate to the spectator in this imaginary sort of way. It has to do with presence, more as one person relates to another. (Caro quoted in Phyllis Tuchman, 'An Interview with Anthony Caro', *Artforum*, June 1972)

Experiments further with welding and bolting steel sheets and girders; completes *Midday* 1960. Decides to paint this and subsequent sculptures a bright colour to reinforce the mood and to 'make it look fresh and new'.

New approach to sculpture precipitates change in teaching methods: 'when I came back, I said, my work's changing but I can't teach you the new stuff, I've got to teach you the old stuff. That lasted about four hours!' (Interview with the artist, 8 July 2004) A welding shop is set up at St Martin's and experimentation and debate is actively encouraged in a workshop situation. Relationship with 'New Generation' artists becomes 'like a little tight community … we were talking all the time about where sculpture could go and how do we get it down to the essentials.' (Artist's talk, 24 April 2002) Phillip King recalls 'he was uncertain as to where he was going and communicated a great sense of openness, discussing his own doubts. It was his enthusiasm that was the driving force in making everyone want to go their own way.' (King quoted in *Independent*, 8 Oct. 1991)

1961 / Completes first polychrome sculpture, *Sculpture Seven* 1961. Distancing his work from the 'totem', works become longer and horizontal: 'this made them less graspable, less a figure or a thing.'

Meets the American writer Michael Fried who later describes *Midday* 1960 and *Sculpture Seven* 1961 as 'the most powerful and moving pieces of sculpture I had ever seen.' (Michael Fried, 'Anthony Caro, "Midday"', *Artforum*, Sept. 1993)

Caro's affinity with painters leads to his inclusion in *New London Situation*, an exhibition of 'Situation paintings' selected by Lawrence Alloway held at Marlborough New London Gallery, where he exhibits *The Horse* 1961. This sole sculptural exhibit attracts attention in the *Observer*:

Abstraction, in one form or another, continues to prevail in London. Almost all the seventeen artists in the New London Gallery's Situation exhibition bid us empty our minds of associative ideas … Curiously striking is Anthony Caro's new two-piece girder construction, painted brown, which creates a tension by the spark gap dividing the unwieldy forms and in its stable-instability seems to give a sculptural clue to the exhibition. (*Observer*, 20 Aug. 1961)

1962 / *Early One Morning* 1962 completed. In a move away from girders and their associated heaviness, begins to incorporate aluminium tubes and sheets into sculptures. Investigation into weightlessness continues with *Month of May* 1963 and later *Prairie* 1967: 'All sculptors dream of defying gravity … of putting heavy pieces calmly up in the air and getting them to say there.' (Caro quoted in Phyllis Tuchman, 'An Interview with Anthony Caro', *Artforum*, June 1972)

1963 / Large solo exhibition of Caro's work is organised at Whitechapel Art Gallery, London, by director Bryan Robertson who comments in the catalogue: 'Caro has set a certain pace by taking a difficult and decisive step towards greater freedom and a fresh purpose in sculpture, and a new sculptural vocabulary … Above all, Caro is no longer commenting on what we already know … He is really on his own.' ('Preface', *Anthony Caro: Sculpture 1960–1963*, Whitechapel Art Gallery, London 1963) Exhibits fifteen abstract steel sculptures, including *Twenty Four Hours* 1961, *Midday* 1960, *Sculpture Seven* 1961, *Early One Morning* 1962, and *Month of May* 1963. The national press pick up on the excitement and originality of the show:

Mr Anthony Caro's sculpture, at the Whitechapel Gallery, undeniably does something new, and does it so impressively that pundits acclaim it and art students are influenced by it even while everyone is still trying to explain what it is that excites them. ([Alan Soloman], 'From our Art Critic: Mr Caro's New and Original Sculpture', *The Times*, 4 Oct. 1963)

His exhibition at the Whitechapel is one of the most talked-about events going on in the art world. It has left critics either entirely speechless, or babbling near incomprehensible torrents of polysyllabic enthusiasm. (Charles Greville, 'The Steel-welding Mr Caro is anything but a conventional sculptor', *Daily Mail*, 2 Oct. 1963)

This is an important exhibition. Caro has shown most impressively that sculpture need not be dependent on the human figure. And that not all roads lead to Moore. (Edwin Mullins, 'Time of the Modern', *Sunday Times*, 6 Oct. 1963)

Invited to teach at Bennington College, Vermont, as visiting faculty member until 1965 with painters Jules Olitski, Paul Feeley and Peter Stroud. Renews contact with Noland and Smith who live nearby and on repeated studio visits sees many of Smith's sculptures at Bolton Landing. Weekend visitors include Greenberg, Frank Stella, Larry Poons, Bill Rubin and art dealer André Emmerich. Noland interests Caro in working in series, which he takes up many times subsequently.

Included in group exhibition at Kasmin Limited, London. Kasmin continues to show Caro's work regularly until 1972 and then under the name of Knoedler Gallery until 1991.

Caro with *Atlantic*,
Hampstead, 1962

The *New Generation* exhibition of British Sculpture opens at the Whitechapel Art Gallery, London; six of the nine selected artists studied with Caro at St Martin's. His teaching influence is lauded by Bryan Robertson as triggering the 'inevitable revolution' in sculpture.

Returns to Bennington to teach for six weeks. Conversations with colleagues encourage a move away from weight; produces *Eyelit* 1965, essentially a line in space. Bennington is a stimulating counterpoint to the English scene and for the next two decades visits the United States three or four times a year, often working at Noland's studio in Shaftsbury, for about a month each time.

There's still life in English sculpture. But the pressure is on here. I think that it is important to come here even if you work in London. You get standards here, you get pressure. I couldn't stay and work all the time in my studio. It's too peaceful. I have to get that little bit of discomfort that says, wake up! You can do better. (Caro quoted in Moira Hodgson, 'An Interview with Anthony Caro, Bearer of the Picasso Tradition', *Soho Weekly News*, 15 May 1975)

First solo exhibition at Kasmin Limited, London, showing steel sculptures of reduced elements, such as *Yellow Swing* 1965 and *Slow Movement* 1965 (purchased by the Arts Council), 'is the big event of the autumn in its domain.' (John Russell, 'The Man who Gets There First', *Sunday Times*, 31 Oct. 1965). Press reaction is mixed:

The most discerning artists and critics are full of enthusiasm for this handsome, cool-looking show. Laymen, even 'with-it' ones, find it baffling. When we discussed the exhibition on The Critics last Sunday, four out of six confessed that Caro's work was above their heads. (John Richardson, 'Carissimo', *New Statesmen*, 12 Nov. 1965)

It is this attempt to create a free-standing design beyond the solid base which has limited sculpture until now that marks Caro as a resourceful experimenter in the 'marriage' of sculpture and painting. This alliance is one of the really new directions discernible in contemporary art recently. (G.S. Whittet, 'No More an Island: London Commentary, *Studio International*, Dec. 1965)

Some people have found this exhibition very boring. I find it, generally speaking, rather lame when set against my memory of other work Caro has done (Norbert Lynton, 'London Letter', *Art International*, 20 Dec. 1965)

1964 / Exhibits *Pompadour* 1963 in *1954–1964: Painting & Sculpture of a Decade* exhibition at Tate Gallery, London; *Month of May* 1963 and *Hop Scotch* 1962 displayed at Documenta III, Kassel, Germany.

Experience of working with an assistant in the United States leads to Caro engaging Charlie Hendy at Aeromat, Hampstead, to fabricate some of his sculptures.

First solo exhibition in New York at André Emmerich Gallery following acquaintance made at Bennington; exhibits five new sculptures including *Titan* 1964 and *Bennington* 1964. Exhibits are described as 'cool, efficient, very effective' in *Art News* (Jan. 1965) and despite some reservations, Donald Judd echoes the positive critical reception in *Arts Magazine* (Jan. 1965): 'this is a good show.'

Exhibits regularly with Emmerich for several decades with solo shows in New York until 1994; also shows at Galerie André Emmerich, Zurich on three occasions.

1965 / Exhibition of eleven sculptures from 1960–4 at Washington Gallery of Modern Art, Washington DC, including *Sculpture Seven* 1961 and *Midday* 1960, works which remain in United States on extended loan to Fogg Art Museum, Cambridge, Massachusetts.

Early One Morning 1962 exhibited in *British Sculpture in the Sixties* at the Tate Gallery, a group show organised by the Contemporary Art Society, who subsequently present *Early One Morning* to the Tate Gallery. John Richardson describes the show as looking 'suspiciously like a trade fair' but that *Early One Morning* 'wins out over the décor and makes the nearby Hepworths look as dead as dodo's eggs. Here at last is a statement which is as straightforward, uncompromising and true as an equation – refreshingly sparse after the sentimentality and mannerism of Herbert Read's angst-peddling sculptors of the Fifties.' (*New Statesman*, 5 March 1965)

1966 / Exhibits in *Primary Structures: Younger American and British Sculptors* at the Jewish Museum, New York; artists include Carl Andre, Dan Flavin, Donald Judd, Sol LeWitt, Morris Louis and Robert Smithson. *Titan* 1964 is singled out as a 'major work' by Andrew Hudson in the *Washington Post* ('English Sculptors Outdo Americans, 8 May 1966) and Caro is descried as 'the best of the sculptors' by Hilton Kramer in the *New York Times* ('Primary Structures: The New Anonymity', 1 May 1966).

Solo exhibition at David Mirvish Gallery, Toronto; the five-sculpture display, including *The Horse* 1961 and *Shaftsbury* 1965, is described as 'a rich and startling experience' in the *Toronto Daily Star* (13 May 1966).

Month of May 1963 is displayed in the exhibition *Sculpture in the Open Air* at Battersea Park, sponsored by the Greater London Council.

Selected for *Five Young British Artists* in the British Pavilion at the Venice Biennale with painters Bernard Cohen, Harold Cohen, Robyn Denny and Richard Smith, and is awarded the David E. Bright Foundation Prize for best sculptor under forty-five. Exhibits *Early One Morning* 1962, *Wide* 1964 and *Yellow Swing* 1965. In the catalogue introduction David Thompson describes Caro as the 'pioneer' of the revolution in British sculpture.

Questions the general acceptance that 'sculpture should not be on a base, it should be on the floor ... I said why? I always said why? What happens if we put it on the table? What is the difference?' (Caro interviewed by Rachel Tant, 8 July 2004) Discussions with Michael Fried leads to inquiry into smaller sculptures 'that could not be seen either as models for or as reduced versions of larger ones'. Achieves this by incorporating prefabricated handles, such as scissors, and, emphasising the edge, hangs at least one part of the work over the side of the table top on which they are displayed. Calls these 'Table Pieces', which Fried claims 'mark the emergence of a sense of scale for which there is no precedent in earlier sculpture' ('Anthony Caro's Table Sculptures', *Arts Magazine*, March 1977). Continues to produce wide range of table sculptures with a variety of finishes – chromed, polished, glazed, lacquered or sprayed with automobile paint – which encourages scrutiny of surface and detail, previously inappropriate for his larger works.

Starts work on *The Window* 1966–7 and with the incorporation of grills and mesh screens, explores room-like structures.

Solo exhibition at André Emmerich in New York, displaying works such as *Carriage* 1966 and *Red Splash* 1966, highlights the difference to Smith's sculpture that Caro has been striving for:

Where Mr Caro has been most original is in his exploitation of a horizontal stance for his constructions. While David Smith's sculpture tends for the most part to rise vertically, either on actual or implied vertical supports more or less on the model of upright figures, Mr Caro endows his sculpture with a characteristic horizontal reach … There are, to be sure, a good many sculptors now working along the line pursued by Mr Caro – some of them, as the result of Mr Caro's example. But at the moment, and even if the tendency exists to over praise a body of work that remains small and in some respects tentative, he seems far and away the most striking new sculptural talent to have emerged in the nineteen sixties. (Hilton Kramer 'Sculpture: Talent Unfolds on Horizon', *New York Times*, 26 Nov. 1966)

Early One Morning in Hayward Gallery exhibition, London, 1969

1967 / Charlie Hendy becomes Caro's studio assistant. Acquires stock of raw materials from estate of the late David Smith which he incorporates into later works.

Completes *Prairie*, 'probably the most abstract sculpture I've ever made'.

Profile in United States and Europe strengthens as Caro is invited to exhibit widely in *Colour, Image, Form*, Detroit Institute of Arts; *American Sculpture of the Sixties*, Los Angeles County Museum; *Guggenheim International Exhibition: Sculpture from Twenty Nations* at Solomon R. Guggenheim Museum, New York; Solo exhibition of fifteen large sculptures (1961–7) and ten table pieces at Rijksmuseum Kröler-Müller, Otterlo. Greenberg contributes to several of the catalogues and in *Studio International* he writes: 'Breakthrough is a much abused word in contemporary art writing but I don't hesitate to apply it to the sculpture in steel Anthony Caro has been doing since 1960.' ('Anthony Caro', *Studio International*, Sept. 1967)

In London, reception of Caro's two-sculpture Kasmin Gallery show is very favourable:

I believe that Prairie *is a masterpiece, one of the great works of modern art, a touchstone for future sculpture, and that* Deep Body Blue, *while less ambitious, is nevertheless beyond the reach of any other sculptor alive.* (Michael Fried, 'Two sculptures by Anthony Caro', *Artforum*, Feb. 1968)

Caro's Prairie, *the most exciting work by a living artist that I saw in any London gallery in 1967.* (Charles Harrison, 'London Commentary: British Critics and British Sculpture', *Studio International*, Feb. 1968)

I'm practically certain we are considering a masterpiece. (Bryan Robertson, 'Mixed Double', *Spectator*, 16 Oct. 1967)

At the Kasmin Gallery there is another notable piece of sculpture which all addicts should make a point of seeing before it disappears for ever into the teeming bowels of America – an important new piece by the now internationally famous Anthony Caro. (Nigel Gosling, *Observer*, 1 Nov. 1967)

1968 / *Prairie* 1967 is reproduced on the cover of the February issue of *Artforum*. Continues to develop table sculptures and completes *Table Piece LXIV – The Clock* 1968, which Michael Fried identifies as an example giving Caro 'free reign to a pictorialism which has never been entirely foreign to his art'. ('Anthony Caro's Table Sculptures', *Arts Magazine*, March 1977) He goes on to suggest a parallel between Caro's table pieces and the traditional genre of still-life painting, notably the work of Chardin, due to the suspension of elements in his composition below the edge of the table.

Noland and Louis and Caro organised at Metropolitan Museum of Art, New York, where *Titan* 1964 is exhibited.

Exhibits widely in UK group and touring exhibitions, including *New British Painting and Sculpture* organised by the Whitechapel Art Gallery for UCLA Galleries, Los Angeles, which tours for a year; participates in Venice Biennale and is guest artist at 13th Annual Exhibition of Contemporary Art Society of New South Wales.

Hilton Kramer's review of Caro's solo show at André Emmerich, New York, which showcases five works including *Table Piece LXIV – The Clock* 1968 and *Trefoil* 1968, anticipates a change in Caro's work in the following decade:

All in all this is a brilliant exhibition by one of the world's foremost living sculptors. But it leaves one musing on the questions of value in relation to originality. For Mr Caro is not really an original. He is an artist of great quality who continues a tradition, but does not create one for himself. Yet we know that in his other role, as a teacher, he has sparked a movement of considerable originality and force. At 44, he remains an important – indeed, a major – figure, but a figure of transition, marking the shift of values from one generation of artist to another. ('Anthony Caro: A Gifted Sculptor Within a Tradition', *New York Times*, 9 Nov. 1968)

Awarded Honorary Doctor of Letters, University of East Anglia.

1969 / First major retrospective exhibition at Hayward Gallery, London, consisting of fifty works made 1954–68, organised by Arts Council of Great Britain, with a catalogue essay by Michael Fried. Critical response to the show is very positive:

The six years which separate Sculpture Seven *from* The Window *are represented in this exhibition by a selection of works which are nothing less than astonishing in their beauty and in the profound differences in what I would describe as their conditions of abstractness.* (Jane Harrison Cone, 'Caro in London', *Artforum*, April 1969)

Caro is an Anglo-American phenomenon. (Robert Melville, 'Turner's Only Rival', *New Statesman*, 7 Feb. 1969)

Moves studio to former piano factory in Camden Town, London, where he still works each day.

Patrick Cunningham, a welder, becomes Caro's studio assistant in London and continues to work with him today. With increased productivity and enjoying collaboration with others, Caro employs young sculptors and students as assistants for about two years at a time:

Everybody's feeding each other. It's not a bit like a little box with your own inspiration and it's all closed in; it's much more open than that ... very much a workshop situation. I want to hear what young people think, and see how they're thinking. (Artist's talk, 24 April 2002)

In an article in *Art International*, William Feaver describes Caro's intuitive and improvisational working method:

He often spends evenings in the garage at home spot welding a small table piece. The following morning this goes to the workshop where his assistant gets to work on it, following both conversational instruction and directions chalked on the piece, like a tailor's marks on a suit in progress. Alterations proceed until everything is a perfect fit. Each change is exploratory. 'I start not from a problem but from the way things are going. I want a sense of spread, or I want to keep it moving, or to be very still, or to twist a little ... The act of moving things about and lifting is very important to me. So that although I don't weld I could never order a sculpture by telephone, because the very fact that it's awkward, or heavy, or that I've lifted it and put it down a hundred times is very much part of it for me.' ('Anthony Caro', *Art International*, 20 May 1974)

Prizewinner at Tenth São Paulo Biennale, where he exhibits in British section with John Hoyland; participates in *Stella, Noland, Caro* at Dayton's Gallery 12, Minneapolis.

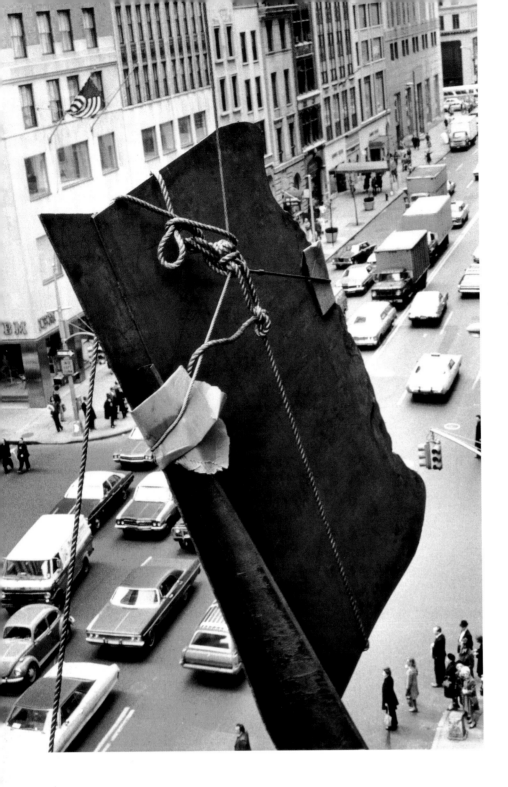

Installation of André
Emmerich exhibition in
New York, 1974

Explores horizontal planes and works with flowing shapes in sculptures such as *Orangerie* 1969 and *Sun Feast* 1969; incorporates ploughshares and aircraft propeller blades acquired from sale of agricultural machinery the previous year, which according to critic David Bourdon, writing in the *Village Voice*, 'arabesque as artfully as any shapes that Matisse might have composed'.

Appointed Commander of the Order of the British Empire.

1970 / Unsettled by the success of André Emmerich exhibition in New York, Caro turns his back on 'groundbreaking' sculpture of the 1960s and moves into a different, exploratory direction. Works for short periods at Noland's studio at Shaftsbury, Vermont, assisted by Bennington sculptor James Wolfe and later Willard Boepple. Works on heavier sculptures using I-beams and pre-cast steel pieces which remain unpainted, the rusted steel being varnished or waxed:

I stopped using colour because at the time it felt too comfortable. Colour is so emotive and you respond to it faster and more readily. (Caro quoted in Peter Murray, *Caro at Longside: Sculpture and Sculpitecture*, exh. cat., Yorkshire Sculpture Park, Wakefield 2001)

Participates in 'British Sculpture Out of the Sixties' at the ICA, London. In a review in *Studio International*, Bruce McLean comments:

Anthony Caro's piece Orangerie *does have some style about it, and it does have some beauty – the only piece in the show which is near crimble crumble. It's too easy for Mr Caro; he can do this very well. I'd like to see him do as he did before: take a few more chances, make a few more mistakes.* Month of May, *which is illustrated in the catalogue, which he made seven years ago, tremendous then. I don't think that he has gone on from there. I hope he does.* ('Not Even Crimble Crumble', *Studio International*, Oct. 1970)

Such criticism parallels a turning point in Caro's approach to sculpture and through the 1970s his work becomes more sombre.

The British Council exhibit his coloured sculpture in mixed British contemporary shows in Japan and Washington DC.

1971 / Invited to judge Perth Prize at Western Australia Art Gallery; travels around the world with his family, visiting Mexico, New Zealand, Australia, Thailand and India.

Completes *Ordnance* 1971, an example of the open, symmetrical sculptures that start at table height and extend down to the ground.

1972 / Reviewing his New York André Emmerich show, Walter D. Bannard observes:

Since about 1970 the evolution of his work has shown inconsistencies such as squared-off regularity, formal blankness, and symmetry intrudes and displaces. Apparently this is a conscious effort ("I would like to make sculptures that are more abstract"), and I venture that it is a mistake. All the evidence of the last 10 or 12 years tells us that Caro's work gets better as it is less abstract in effect and more playful, convoluted and erratic in appearance … And the Museum of Modern Art surely could improve its record with a Caro retrospective. He's the best we've got, and I mean better than Calder, Moore, Nevelson, and all the rest. We should be able to see more of his work. ('Caro's New Sculpture', *Artforum*, June 1972)

Continues to be represented in mixed shows internationally in Boston, Edmonton, Winnipeg, Toronto and Venice.

In London, makes series of seven rusted-steel sculptures – the 'Straight' series – by rearranging and altering the component parts of the first sculpture *Straight Flush* 1972.

To produce work for his Galleria dell'Ariete exhibition in Milan, works at Ripamonte factory in Veduggio, Italy, assisted by James Wolfe; for ten days works rapidly on fourteen sculptures using soft-edge steel and achieves an incongruous softness in his work. The experience highlights for Caro how the 'look' of his sculpture depends on where it was made:

It's an extraordinary thing. I couldn't do it in my own studio, but when I go abroad ... it's a whole new thing, and it's exciting and it's a challenge and you're suddenly filled with adrenalin. (William Feaver, 'Anthony Caro', *Art International*, May 1974)

1973 / Stimulated by his discovery in Italy, obtains soft-edge rolled steel from Consett, County Durham, and subsequently makes *Durham Purse* 1973–4, *Durham Steel Flat* 1973–4 and a new series of table sculptures. Of Caro's recent unpainted sculpture William Feaver writes: 'Comparison with the work of his lesser, trailing followers shows how tired and dated his achievements would have become had he been content to stick with the old colourful innovations.' ('Anthony Caro', *Art International*, May 1974)

Museum of Modern Art, New York, acquires *Midday* 1960.

1974 / André Emmerich marks Caro's fiftieth birthday in New York with two exhibitions showing table pieces, 'Veduggio' and 'Durham' pieces. In *Studio International*, Barry Martin writes:

He is an inventor, and, as with all inventions, some work and some don't. He avoids making the same mistakes twice. His style is onwards, never pedantic. It is this elusive quality of not stopping in any one place too long that captures and hypnotizes the imitators. He is free to create in the present without ties and in this way he has found freedom. ('New Work: Anthony Caro', *Studio International*, April 1974)

Works at York Steel Company in Toronto using heavy steel handling equipment and mobile cranes; makes large, powerful, upright sculpture that has a 'deceptive thrown-together look – think planks or ponderous sheets of steel leaning against one another in precarious balance or frozen in a state of sliding collapse.' (Bill Marvel, 'Caro, Steel Man and Scavenger, Enlarges a Tradition', *National Observer*, 28 June 1975); returns several times over the next two years and completes thirty-seven sculptures later known as the 'Flats' series.

That's where I learned the value of spontaneity. The working pad could support four sculptures only. The logistics of the situation forced me to try to get one work off the pad every day. So, despite the immense size of the works, during my initial work period no sculpture had more than four days work

on it. (Caro quoted in Phyllis Tuchman, 'An Interview with Anthony Caro', *Art in America*, Oct. 1984)

Kenwood House, London, holds solo exhibition of seventeen recent table sculptures made from rusted steel, including *Table Piece CLXIII* 1973, which are softer and more organic in form. The press is divided on this change of mood:

Incommunicative to a fault, these offerings do not manage either to justify or revitalise the redundant bases on which they are displayed, and no amount of sculptural gymnastics at the table's edge can persuade me that Caro's increasing conservatism is anything other than a retrograde development. (Richard Cork, 'Sculpture Back on a Pedestal', *Evening Standard*, 19 Sept. 1974)

All this makes for a most appealing, informal bunch of works in which you can retrace his decisions and the succession of delights his materials afford him. Sculpture so often consists of objects you just stand beside and stare at: Caro's tabletop pieces, by contrast, are thoroughly welcoming. They are ample confirmation of all the evidence that he is by no means past his peak. (William Feaver, 'Anthony Caro', *Financial Times*, 25 Sept. 1974)

1975 / Retrospective exhibition at Museum of Modern Art, New York – the first major exhibition of a British sculptor since Henry Moore's show in 1947 and, comments the *Guardian*, 'a very rare honour for a British Sculptor'. Exhibition also travels

Installation view of *Midday* 1960 (left) and *The Horse* 1961 (right) on sculpture terrace at Museum of Modern Art, New York, 1975

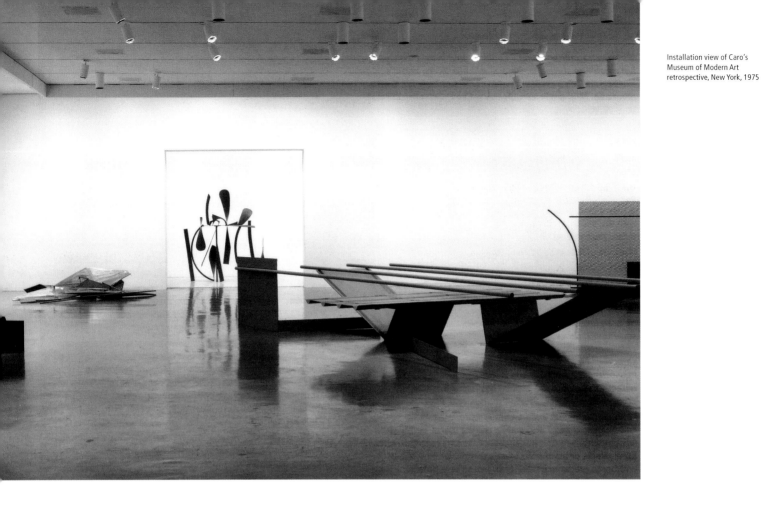

Installation view of Caro's
Museum of Modern Art
retrospective, New York, 1975

to Walker Art Center, Minneapolis, Museum of Fine Arts, Houston and Museum of Fine Arts, Boston.

American critics react against organiser William Rubin's apotheosising of Caro in his book-length monograph but most agree that 'this is, all the same an important exhibition; no one hoping to understand the art of our time can afford to miss it.' (Hilton Kramer, 'Is Caro our Best Sculptor?', *New York Times*, 11 May 1975)

'It only takes one great artist to keep the tradition alive.' So runs the first sentence of William Rubin's monograph, and one is left in no doubt which prince is coming. But now that the English dauphin has been so well anointed with the oil of consecration, one may step back and reflect that after all, his work does not have the immense flawed vitality of David Smith's; that it is an intelligent, distinguished but sometimes only decorative addition to the short history of constructed sculpture. (Robert Hughes, 'Caro: Heavy Metal', *Time*, 5 May 1975)

Anthony Caro is by any rational count the most remarkable sculptor to have appeared anywhere in the world during the last 25 years. (John Russell, 'Art: Fine Caro Sculptures', *New York Times*, 3 May 1975)

Caro has got over Smith for sure, to become his own, impressive man. (Emily Genauer, *New York Post*, 3 May 1975)

That Caro has been a valuable, important contributor to the expansion of the constructionist tradition cannot be in doubt. Whether, on the other hand, his blend of (steadily less evident) intellectual radicality and tasteful, accomplished conservatism has the fecundity of energy that will project this tradition further, is an open question. (Kirk Varnedoe, 'Intellectual Subtlety in Constructed Steel', *Art News*, Summer 1975)

The heat of this controversy is obscuring the merit of an immensely interesting exhibition … On any level, it is a major

event, and Caro deserves the tribute, whether his friends have oversold him or not … Most important, MOMA shows that Caro is even now taking a sharp – and largely overlooked – turn away from the bright-hued 'painterly' form that dominated his work in the 1960s … That none of the naked '70s pieces are completely successful proves – paradoxically – that the critics are wrong. Caro is no 'king'. He is a sculptor still in mid-career, and still in search of himself. (Douglas Davis, 'King Caro?', *Newsweek*, 21 July 1975)

In an interview in *Soho Weekly News*, Caro comments: 'I'm older and I find that more ways of working are open to me now than they were ten years ago. I feel freer now.' (Caro quoted in Moira Hodgson, 'An Interview with Anthony Caro', *Soho Weekly News*, 15 May 1975). Accepts invitation to work with ceramic clay at Syracuse University, New York, with Margie Hughto.

1976 / Presented with key to the City of New York by Mayor Abraham Beame.

1977 / Displays *Orangerie* 1969 with a personal selection of Old Masters in *Artist's Eye* at the National Gallery, London; the first time a living artist has been invited to exhibit in this way.

Retrospective exhibition of table sculptures organised by the British Council tours to Israel, Australia, New Zealand and Germany until 1979.

Artist-in-residence at Emma Lake summer workshop, University of Saskatchewan, Saskatoon. Produces the 'Emma' series, linear works made from lightweight tubular steel, including *Emma Dipper* 1977 and *Emma Dance* 1977–8, in response to the site:

You have to use limitations as a plus … [at the Emma Lake] I knew I couldn't work on heavy sculpture because I was in an inaccessible place. So, before I left for Canada I decided to work with lightweight elements and I made linear sculptures different from any I had made previously, and these came out precisely as a response to the limitations. (Caro quoted in Phyllis Tuchman, 'An Interview with Anthony Caro, *Art in America*, Oct. 1984)

1978 / Embarks on 'writing pieces': small, linear, calligraphic sculptures made rapidly in steel, often including tools or other utensils.

Undertakes large 'Ledge Piece' commission for architect I.M. Pei's new East Wing building of the National Gallery of Art, Washington, DC, despite constraints of working to schedule and on site in 'real size'.

Forthright interview with Peter Fuller published in *Art Monthly* in which Caro and the author clash on many points:

My job is making sculpture; and by that I mean using visual means to say what I, a man living now in 1978, feels like ... But in my art my job is not the discussion of social problems ... My job is to do with art, with pure delight, with the communication of feeling, with the enrichment for a short time of those who look at it, just as I myself am enriched for a while when I read a sonnet of Shakespeare's. I cannot hope for more. I cannot hope to change the injustice in the world, and in my art I am not overtly concerned with that or with anything like that.
(Caro quoted in Peter Fuller interview, *Art Monthly*, Feb. 1979)

1979 / Dieter Blume commences work on Caro's extensive catalogue raisonné.

Awarded Honorary Member of American Academy and Institute of Arts & Letters and Honorary Doctor of Letters, York University, Toronto.

1980 / Participates in *Skulpturen der Moderne: Julio Gonzalez, David Smith, Anthony Caro, Tim Scott, Michael Steiner*, shown in Paris and then touring Germany.

Returns to Syracuse University, New York, to participate in Bronze workshop; produces 'Can Co.' and 'Water Street' series. In London begins series of lead and wood sculptures.

I try always to stay open, to open myself to the unexpected. That's how new possibilities reveal themselves. I love to discover a new material. Each material demands its own way of working and always I try to use it in as direct and

straightforward a manner as I treat steel. (Caro in Andrew Dempsey (ed.), *Sculptors Talking: Anthony Caro, Eduardo Chillida*, 2000)

1981 / Exhibits recent bronze works at Acquavella Gallery, New York, and at Kenwood House, London.

Caro is at a dangerous age. Unfashionable, with no perceptible relation to a British avant-garde, he can choose to put on carpet slippers and be Caro-esque for the rest of his life. Or he could take a few chances. Of course, there is a critical problem. What is the place of formalism in a post-modern inclusive world view? ... His latest pieces are accomplished, interesting even, but a little eccentric [casting egg boxes in bronze] and overwhelmingly safe, the playthings of a Grand Old Man. Dear Mr Caro, put your shoes on. Sell your foundry. Go out there and be great. Grow old disgracefully. What have you got to lose?
(Stuart Morgan, 'Anthony Caro, Kenwood House', *Artforum*, Dec. 1981)

Further enjoys the freedom of new materials and makes large series of relief sculptures in handmade paper, with Ken Tyler at Tyler Graphics, New York: 'I don't want any assumptions ... if I could make sculpture with water, I'd have a shot.' (Artist's talk, 24 April 2002)

Receives Honorary Degree, Brandeis University, Massachusetts; becomes Honorary Fellow, Christ's College, Cambridge University, England.

1982 / Reviewing Caro's New York André Emmerich display of bronze screens, inspired by Indian stone reliefs, Drew Fitzhugh writes:

He has totally avoided the traditional use of bronze as a way of translating into metal work originally conceived and executed

Caro and assistants at Emma Lake Workshop, 1977

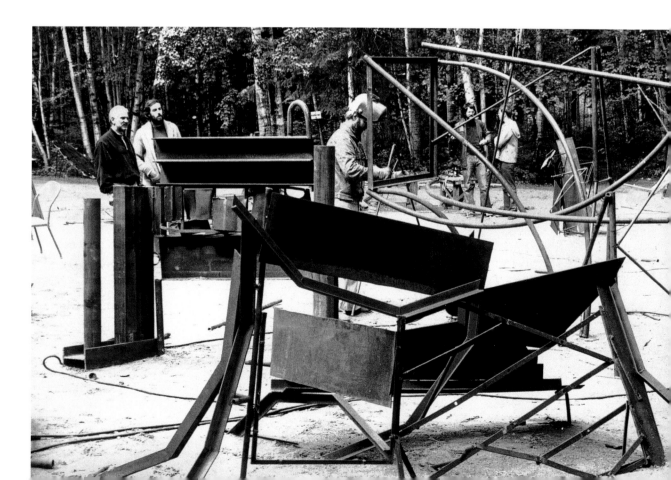

Caro's US studio at Ancram,
New York state

*in another material, like clay, plaster, wax ... Instead he has
used bronze to enlarge enormously the range and choice of
forms available to him in the making of his sculpture ... the
use of bronze has allowed Caro an enormous enrichment of his
art by giving him practically unlimited access to any form,
shape, or object to which his fancy would direct him ... In
these new Bronze Screens he exploits the rich possibilities of
the material in an entirely new manner and he makes it his
own. Caro's quintessential grace in transforming pedestrian
industrial objects into exhilarating forms has never been more
beautifully revealed.* ('Anthony Caro's Bronzes', *Arts Magazine*,
Feb. 1982)

Appointed Trustee of Tate Gallery, London, serving as member
of the board for seven years until 1989, and Member of
Council, Slade School of Art, London, until 1992.

Delivers William Townsend Memorial Lecture on sculpture at
University College London.

To establish a collaborative working situation, organises with
Robert Loder the first Triangle Artists' Workshop for thirty
sculptors and painters from the United States, Britain and
Canada at Pine Plains, New York, to promote exchange of
ideas, broaden personal vision and stimulate experimentation.

*I get a tremendous buzz from working with other people ... I
get something from them. I get a lot from workshops and
things of that sort and it gets me out of being stuck in my own
studio and my own head and I'm able to respond to things that
other people are doing.* (Artist's talk, 24 April 2002)

Over the years artists from many countries attend the intense
but informal two week sessions with visitors such as Terry
Fenton, Fried, Frankenthaler, Greenberg, Noland, Stella and
Karen Wilkin giving critiques of the work. Caro participates
annually thereafter until 1991, when leadership passes to
Willard Boepple, Jon Isherwood and Wilkin.

Experiments with painting in acrylic at Helen Frankenthaler's
studio in New York: 'It was terrifying ... didn't work for me one
bit. I couldn't move the colour about!' (Artist's talk, 24 April
2002)

1983 / Included in *Aspects of British Art* at Solomon R.
Guggenheim Museum, New York.

1984 / Continues to extend his art into new directions and
accepts Arts Council invitation to create a room for *Four Rooms*,
displayed in Liberty's department store in London and on
European tour; completes *Child's Tower Room* 1983–4 in
Japanese oak, which he describes as 'a completely crazy thing
and completely new for me.' (Caro quoted in Phil Patton,
'Unpublic Sculpture', *Art News*, April 1984); this is the first
sculpture with an architectural dimension where the spectator
is invited to enter the work and experience its inner space.

Arts Council organises sixtieth birthday solo exhibition at
Serpentine Gallery, London, displaying works made since his
Hayward show (1979–84) and previously unseen in Britain; later
tours to Whitworth Art Gallery, Manchester, Leeds City Art
Gallery, Ordrupgaard, Copenhagen, Kunstmuseum Düssseldorf,
and Fundació Joan Miró, Barcelona. In the *New Statesman* John
Spurling remarks: 'Caro's mature work has never looked so
authoritative and beguiling as it does at the Serpentine'
('Saved!', *New Statesman*, 27 April 1984) and the *Guardian*
asserts '[he] must be recognised again as our greatest
practicing sculptor.' (Waldemar Januszczak, 'Hard Truths Told in
Metal', *Guardian*, 14 April 1984)

In the United States, Acquavella and André Emmerich galleries
stage commemorative shows presenting four phases of work
made between 1982 and 1984.

*Most artists work toward a show; Caro needs four floors of two
galleries just to accommodate what he's done recently as a
matter of course. The man's energy is boundless, and so is his
importance to us. I think he's been the best sculptor in the
world for the past couple of decades. That his sixtieth, and
these shows, are not at the center of art-world honors and
media ballyhoo tells me that my opinion is not shared by the
'artocracy'.* (Walter Darby Bannard, 'Anthony Caro's New
Sculpture', *Arts Magazine*, Summer 1984)

Appointed as Trustee of Fitzwilliam Museum, Cambridge.

1985 / Looking for somewhere to store his sculptures, buys
field at Ancram, New York state, and builds a barn for his own
and his wife's use as US studio, which he keeps for twelve years;
Jon Isherwood becomes Caro's US studio assistant.

Delivers Delia Heron Lecture, Falmouth School of Art.

Guest leader of sculptors' workshops at Jan van Eyck Academie,
Maastricht; works with crushed, bent steel which lends a 'soft'
quality to his sculptures.

Awarded Honorary Doctor of Letters, Cambridge University.

Visits Greece for the first time: 'it knocked me out, absolutely
knocked me out'.

1986 / Completes *Scamander* 1985–6 and *Rape of the Sabines*
1985–6, in a series of sculptures inspired by Greek pediments
seen the previous year. Exhibits them at Waddington Galleries,
London, together with selection of table sculptures and cast
bronze pieces entitled 'Variations on an Indian Theme' at
Knoedler Gallery, London.

*It's a brave attempt not just to incorporate historical references
but also to link the heavy female forms of his early expressionist
work with his later abstraction. At the moment it doesn't
succeed – the two languages jarringly conjoin – but who cares?
As Schnabel said of Picasso 'He was not afraid of failing, only of
not trying.' At least Anthony Caro is travelling in promising new
directions.* (Sarah Kent, 'Anthony Caro', *Time Out*, 8–15 Oct.
1986)

Made an Honorary Fellow, Royal College of Art, London.

1987 / Participates in special Triangle Workshop in Barcelona
and starts 'Barcelona' series incorporating curly balustrades and
balconies to explore the idea of drawing in sculpture; later
returns to Spain to complete the series.

*In Barcelona, the light is different; the shadows are strong, the
whole approach and thinking is different. So at the workshop
we all found ourselves thinking afresh. I like that.* (Caro quoted
in Pep Subirós, 'A conversation with Anthony Caro' in *Anthony
Caro: Drawing in Space: Sculptures from 1963–1988*, exh. cat.,
Fundació Caixa Catalunya, Barcelona 2002)

The scope of the Triangle Workshop is broadened by the inclusion of architects: 'Sculptors can learn from architects because architects have a feeling for scale and the open air.' (Caro quoted in Peter Murray, *Caro at Longside: Sculpture and Sculpitecture*, exh. cat., Yorkshire Sculpture Park, Wakefield 2001) Works with Frank Gehry on architectural/sculptural 'village' and the idea of exploring the relationship between architecture and sculpture takes off.

Delivers the Contemporary Art Society's Fourth Annual Lecture, 'The Artist's Method', at Tate Gallery, London.

Makes the seventy-six feet long *After Olympia* 1986–7 in London in response to visiting the Temple of Zeus at Olympia and in tribute to the frieze sculptures that originally adorned the temple pediments.

Breaking Modernist rules about self-contained works of art, some critics feel Caro has betrayed his early achievements. He responds:

Rules exist to be broken, particularly artist ones ... at the beginning of the sixties we were trying to find ways to make art with clarity and economy, to establish our grammar. Now we can write fuller sentences. (Caro quoted in Tim Marlow, 'Man of Steel', *Cambridge Alumni Magazine*, Lent term 1997)

Included in *Current Affairs: British Painting and Sculpture in the 1980s*, Museum of Modern Art, Oxford, and tour to Budapest, Prague and Warsaw.

Awarded Honorary Degree, University of Surrey.

Knighted in the Queen's Birthday Honours.

1988 / *After Olympia* 1986–7 installed on roof garden of Metropolitan Museum of Art, New York, throughout the summer.

Starts 'Catalan' series, thirty-three table sculptures made from steel elements brought back from the Barcelona workshop to London studio.

Made Honorary Foreign Member, American Academy of Arts and Sciences.

Architectural/sculptural 'village' made with Frank Gehry, Sheila Girling and Jon Isherwood on Triangle workshop, 1987

1989 / Begins working on the 'Cascades' series of fourteen large table sculptures, which often involve the floor and the wall.

First solo show at Annely Juda Fine Art, London, entitled *Aspects of Anthony Caro*, displaying a broad range of recent work including paper sculptures, 'Catalan' and other table pieces, *Elephant Palace* 1989 – which marks a real change in his work in presenting a 'skin' – and *The Moroccans* 1984–7. Five subsequent solo exhibitions held with Annely Juda.

The exhibition re-affirms Caro's status as one of the handful of leading international sculptors at work today ... This is Caro's first London show for several years, and it comes after decades of ceaseless experimentation, expanding the vocabulary of sculpture. (Marina Vaizey, 'Sailing Off into a Space of his Own', *Sunday Times*, 1 Oct. 1989)

Caro milks that old modernist tradition of finding unlikely possibilities in ordinary objects ... it all seems to signify Caro's own restlessness, his openness to every urging of a wandering imagination. (Andrew Graham-Dixon on Anthony Caro's return to sensual narrative at Knoedler and Annely Juda: 'The Naming of Parts', *Independent*, 3 Oct. 1989)

The exhibition extends to a display of 'source' sculptures such as *Descent from the Cross III – After Rembrandt* 1989–90 and *Déjeuner sur l'herbe* 1989 at the Knoedler Gallery which are well received:

Some of Caro's past works are magnificent and autonomous sculpture that will keep a lasting presence in the history of the art. I have no doubt that these will now be joined by his new Descent from the Cross, *which is a fine example of his enormous aesthetic ability, exercised within prescribed confines, and I hope that this will bring a new, wider appreciation of Caro's work.* (Glynn Williams, 'Anthony Caro', *Modern Painters*, Autumn 1989)

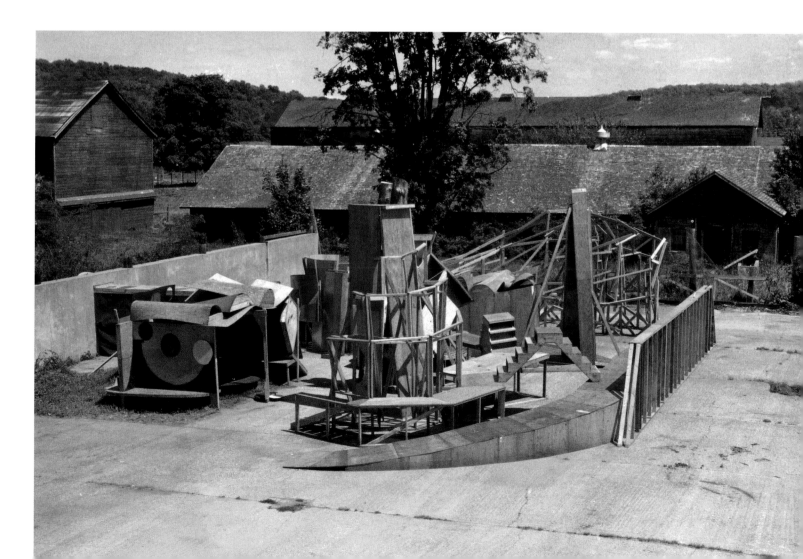

After Olympia 1996 (middle) and *Early One Morning* 1962 (top) at Trajan Markets, Rome, 1992

Retrospective exhibition of thirty-five sculptures at Walker Hill Art Centre, Seoul, the first time a living British sculptor has exhibited in Korea; travels to Korea and India.

Awarded Honorary Fine Arts Degree, Yale University, Connecticut.

1990 / Completes work on *Night Movements* 1987–90, his first work comprising four separate parts.

Retrospective exhibition at the Musée des Beaux-Arts, Calais.

Visits Japan for opening of several exhibitions of his work. Arranges visit to Mr Ohé's paper workshop in village of Obama and starts series of 'paper sculptures' using impressions made in and around the workshop, later completed in England, such as *Obama High* 1990–2.

Awarded Honorary Fine Arts Degree, University of Alberta, Edmonton.

1991 / Completes two architectural pieces, *Sea Music* 1991, a four-metre-high sculpture with integral lookout platforms for the quayside in Poole, Dorset, and the larger *Tower of Discovery* 1991 for the Sackler Octagon at the Tate Gallery, London.

It was the idea of being able to get right in the tower, to touch it and climb around inside it, which was exciting. Why shouldn't a sculptor sculpt an interior such as an opera house or church? That would be like making sculpture from the inside. It's a small part of what the 'Sea Music' piece is about. The viewer finds the form in there for him or herself simply because it's there beside them. (Caro quoted in Tim Marlow interview, *Tate: The Art Magazine*, Spring 1992)

First major exhibition in Britain since 1984 at Tate Gallery, London; exhibits four large recent sculptures in the Duveen Galleries: *After Olympia* 1986–7, *Tower of Discovery* 1991, *Xanadu* 1986–8 and *Night Movements* 1987–90. *Tower of Discovery* is a popular success but critical reviews are mixed:

Caro's continuing strength lies in the articulation of objects experienced through reference to the body – either by association or through a more immediate, physical empathy. His heavy-metal pieces remain insistently separate from their architectural environment – that is one of their most enduring features – and, as the Tate tower indicates, aiming for the architectonic (mixing the metaphors as it were), just doesn't work. (Sarah Kent, 'Art of Steel', *Time Out*, 23–30 Oct. 1991)

One of the horrors of the past year was the piece by Sir Anthony Caro called Octagon Tower. *This enormous 'sculptecture' at the Tate, instantly became my least favourite artwork of all time.* (Robyn Denny, 'Hang-Ups', *Independent*, 4 Feb. 1992)

The Tower is ingenious, a way of turning sculpture inside out. In its desire to please it may be a bit over-fiddly but is undoubtedly good fun, a quality in short supply in modern art. (John McEwen, 'Better Going Up than Sideways', *Sunday Telegraph*, 20 Oct. 1991)

Caro is no more capable of stagnation than is his most flamboyant work. Risk-taking fires him still, and his continuing ability to extend the boundaries of sculpture suggests that his development will be peppered with further surprises in the years ahead. (Richard Cork, 'Steely Vessels in a Marble Sea', *The Times*, 18 Oct. 1991)

Exhibits 'Cascades' table pieces 1989–90 at Annely Juda Fine Art, London, and Emmerich Gallery, New York.

Awarded the Henry Moore Grand Prize: First Nobutaka Shikanai Prize, Hakone Open Air Museum, Tokyo, and becomes Honorary Fellow, Wolfson College, Oxford.

1992 / 'Caro triumphs in Rome' declares the *Financial Times* headline on 23 May 1992 after the opening of retrospective exhibition in the ancient Trajan Markets, organised by Giovanni Caradente and the British Council; Caro is the only contemporary artist to be shown at the ancient site. The show is well received and 'comes at a critical point in Caro's career. He's a household name in the United States [where he works part of the year]. At one time he was seen as a dinosaur, still welding these things. But all that is now being revalued.' (Henry Meyric Hughes quoted in Paul Barker, 'Magic Toys in a Roman Market', *Daily Telegraph*, 1 June 1992)

Tower of Discovery 1991 shown at the World Expo Fair, Seville.

'Obama' paper works shown at Fuji Television Gallery, Tokyo.

Accepts major French commission for new extension at Musée de Grenoble; makes *Chant des montagnes* 1993–4 which straddles the old city walls.

On the recommendation of Eduardo Chillida, works with ceramicist Hans Spinner at his workshop near Grasse, on the Côte d'Azur. Makes series of heavy and solid ceramic elements, which are later combined with wood and steel in London to form the multi-part figurative work *The Trojan War* 1993–4.

Bit by bit these works began to come out like heads. It was like creating a dream. We shipped them to England and when we took them out in the studio here, they seemed like old friends. That moment was very important. Some were warriors but others were shadowy, ghostly spirits like the gods in Greek myths. It became this very theatrical thing: the Trojan war … a narrative. (Caro quoted in Tim Marlow interview, *Tate: The Art Magazine*, Spring 1992)

With a return to figuration, Caro responds to suggestions that the language of abstraction has run its course: 'I think we had

won the battle to make abstract sculpture, or non-figurative sculpture … and we could do what we liked.' (Caro interviewed by Rachel Tant, 8 July 2004)

I don't feel now that I have to establish this thing, that sculpture doesn't look like an insect, like a person. It can be much wider now. Somehow, that battle is won. Now, we have to extend it, and we can allow all sorts of things to come into sculpture. Why shouldn't it be narrative for example? … The battle to make abstract sculpture is over. So, we can do that or something much more literal, more narrative. (Caro, *Desert Island Discs*, BBC Radio 4)

Awarded Praemium Imperiale Prize for Sculpture, Japan Art Association, Tokyo.

Becomes Honorary Member, Accademia delle Belle Arte di Brera, Milan.

1993 / The British Council tours the 'Cascades' series (1989–90) to museums in Hungary, Romania, Turkey, Cyprus, Greece, Germany, Holland, Slovenia and Slovakia.

Appointed Honorary Doctor of Letters, Winchester School of Art, University of Southampton.

1994 / Exhibits *The Trojan War* 1993–4 at Kenwood House, London, and Yorkshire Sculpture Park, Wakefield. Caro describes the work as 'a kind of narrative … It's something I've never done. I've always said that I wanted sculptures not to be that. Yet it seems to me now that my abstraction is strong enough in itself to bear a lot of strain.' (Caro quoted in Iain Gale, 'King of the Dead and Destroyed', *Independent*, 19 March 1994). Critical response to his new direction and figurative vocabulary varies:

Credit is due to English Heritage for daring to deal with a living artist, but the exhibition shows Caro near his worst … It seems that all Caro's roads now lead to Greece and Rome. (James Hall, 'Testing the Metal of Caro', *Guardian*, 11 March 1994)

Caro has confounded all expectations … Caro surely wants his Trojan series to have an open-ended bearing on the equally savage internecine conflicts which persist in plaguing the world today. That is why I cannot see the Trojan work as a manifestation of sculptural decline. Some reviewers have dismissed the show, deploring Caro's retreat from abstraction into apparent nostalgia and conservatism. But in my view, he should be applauded for his determination to extend himself and take risks. Far from resting on his reputation and lapsing into predictability, he refuses to stand still. The Kenwood show is infused with toughness and rigour of his abstract period, but it also attempts to emphasise human fragility with a pathos which his abstract work never encompassed. (Richard Cork, 'Memorials to an Age of Conflict', *The Times*, 22 March 1994)

The Trojan War is a triumph … It results in the richest sculpture, both in materials and emotional content, of his career – the most vibrant entry into old age that any modern British artist has achieved … As always with Caro the material does the talking … This is not illustration but interpretation. (John McEwen, 'Tacking to the Windward of Fashion', *Sunday Telegraph Review*, 20 March 1994)

Installation view of retrospective exhibition at Trajan Markets, Rome 1992

Installation view of Caro's
retrospective exhibition at
Museum of Contemporary Art,
Tokyo, 1995

Several other exhibitions organised to celebrate the artist's
seventieth birthday, including *Sculpture through Five Decades*
at Annely Juda Fine Art, London, later shown at Galerie Hans
Mayer, Düsseldorf, and (a reduced version) Kukje Gallery, Seoul.

Solo exhibitions open at André Emmerich Gallery, New York,
Richard Gray Gallery, Chicago, and Constantine Grimaldis
Gallery, Baltimore.

Exhibition of table sculptures organised by Kettle's Yard
Gallery, Cambridge; later tours to Manchester and Sheffield.

Caro, Noland, Olitski workshop, symposium and exhibition
held at Hartford Art School, Connecticut.

Undertakes commission from Henry Moore Sculpture Trust for
the Henry Moore Studio at Dean Clough, Halifax. Installs
Halifax Steps: Ziggurats and *Spirals* 1994 and, integrating the
building's pillars into his sculpture, further investigates the
connections between sculpture and architecture.

*Halifax Steps at Dean Clough is a totally new, site-specific
work which is one of the largest and most magical works Caro
has ever produced ... it is extraordinarily exciting to see the
70-year-old sculptor responding so freshly and inventively to
new spaces.* (John Russell Taylor, 'How a War Takes Shape',
Times, 1 Dec. 1994)

Receives Honorary Doctorate, Royal College of Art, London.

1995 / Caro's largest retrospective exhibition, of 114 works,
opens the new Museum of Contemporary Art, Tokyo; curated by
Yasuyoshi Saito with architectural settings specially designed
by Tadao Ando; it is well received:

*With the whole extent of his work laid our like this, it is
enthralling to see a major artist constantly making and
remaking himself over more than 40 years, while always
remaining perceptibly the same artist.* (John Russell Taylor, 'At
Home Indoors and Out', *The Times*, 21 July 1995)

*This grand retrospective must alter our view of Caro's career
... Internationalism is an important aspect of Caro's work. In
the Sixties he was the first British artist of any consequence to
be simultaneously an American artist ... There really ought to
be more discussion of Caro. He's so obviously the world's
foremost artist. Why, in England, do we merely take him for
granted?* (Tim Hilton, 'World's Foremost Artist Goes East',
Independent on Sunday, 9 July 1995)

*That the museum has chosen to dedicate its inaugural solo
show to a foreigner is an extraordinary compliment. Quite right
too, we might say, but it remains true that Caro is more widely
acknowledged abroad than he is at home ... The wheel comes
full circle, which is no contradiction or recantation. It is, rather,
a confirmation and a renewal. Caro in his 70s is working with
an undiminished vigour and invention. It is wonderful to see.*
(William Packer, 'Sculptor Bestrides the World', *Financial Times*,
11 July 1995)

1996 / Closes studio at Ancram in the United States.

Goodwood Steps 1996 displayed at Hat Hill Sculpture Foundation, West Sussex, until 1998.

Shown along with Chillida, Robert Jacobsen and Bernhard Luginbühl in *Plätze und Platzzeichen* at Museum Würth, Künzelsau, and Stadtische Museum, Helibronn.

Makes new multi-part work, *Promenade* 1996, for display in Tuileries Gardens, Paris, for exhibition *Un siècle de sculpture anglaise* at Jeu de Paume.

Together with architect Norman Foster and engineer Chris Wise wins the competition for a new footbridge spanning the Thames from St Paul's to Tate Modern at Bankside, London. As the project progresses Martin Gayford remarks:

In the initial proposals, Caro contributed marvellously flamboyant steps at the end of the bridge; now he is restricted to sculptural punctuation on the approaches. It is a shame, because Caro possesses a tremendous formal imagination in search of a suitable theme. Gian-Lorenzo Bernini, another sculptor with architectural ideas, found great opportunities in the public edifices of baroque Rome. Caro might be able to do similar things for London, but so far no one has given him the chance. ('Passion Is Lost in Translation', *Daily Telegraph*, 25 Feb. 1998)

Appointed Chevalier des Arts et Lettres, France, Doctor Honoris Causa, University of Charles de Gaulle, Lille, and Honorary Doctor of Letters, Durham University.

1997 / British Council tours *The Trojan War* 1993–4 to Thessalonika and National Gallery in Athens.

Retrospective exhibition at Middleheim Sculpture Park, Antwerp, comprising forty sculptures from 1960s–90s.

Receives Lifetime Achievement Award from International Sculpture Center, Washington DC, as well as Honorary Fine Arts Degree, Florida International University, Honorary Fellow, Royal Institute of British Architects, London, and Honorary Fellow, Royal Society of British Sculptors, London.

1998 / *Anthony Caro: Sculpture from Painting* opens at the National Gallery, London – the first occasion any sculptor has been invited to hold a solo show there; display includes *Van Gogh Chair IV* 1997 and *Arena Piece 'Beginning'* 1995, works in which he responds to the forms of Old Master paintings and translates them into his own sculptural language. Again, critics are divided on this venture:

Exhibitions like this help to show that there is no real break in continuity between old figurative art and abstract art. In every period the artist has to find a way through to a visual truth that works for him in the times he lives. (Caro quoted in Rachel Barnes, 'Building on Tradition', *Independent*, 26 Feb. 1998)

The resulting works are not so dramatic, nor so eloquent, as Caro's reinventions of Greek history and myth. They strike me as mute and unhappy … I think Caro's relationship to painting may be most potent when it is least recognizable. (Tim Hilton, 'Lunchtime on the Grass with Caro', *Independent on Sunday*, 8 March 1998)

It is the first time sculpture has been displayed in the gallery and perhaps it will be the last, because it only partially succeeds. (John McEwen, 'The Good, the Bad and the Smelly', *Sunday Telegraph*, 1 March 1998)

New works displayed at Annely Juda Fine Art, including hand-sized, ceramic 'book sculptures', integrated with steel or brass elements. Followed by exhibitions in Amsterdam, Seoul and New York.

The Juda exhibition is that of a restlessly creative artist: here is the work of a man who seems to give an aesthetic spark to whatever material comes beneath his hands … [the 'book sculptures'] are delectable … The books remind us that Caro is a miniaturist as well as a monumental sculptor. (Tim Hilton, 'Lunchtime on the Grass with Caro', *Independent on Sunday*, 8 March 1998)

The proliferation of small 'book' pieces ranged on Annely Juda's shelves show him at his most irresistible. Thriving on an interplay between warm, bread-like lumps of stoneware

Installation view of *Night Movements* in retrospective exhibition at Museum of Contemporary Art, Tokyo, 1995

and wriggling, thrusting, puncturing steel, they testify to the fertility of his inventiveness. If Caro continues to perform with as much acrobatic zest as he displays here, his late period will be prodigious and full of surprises. (Richard Cork, 'From One Old Master to Another', *The Times*, 3 March 1998)

Promenade 1996 is displayed in Holland Park, London. Brian Sewell describes the sculpture as 'graceless assaults on the aesthetic sense.' ('Picture This: Anthony Caro's Promenade', *Evening Standard*, 2 July 1998)

The Trojan War 1993–4 exhibited at the Marlborough Gallery, New York.

Joins Honorary Board of Trustees, International Sculpture Center, and becomes Honorary Fellow, Glasgow School of Art, and Honorary Fellow, Bretton Hall College, University of Leeds.

1999 / *The Last Judgement* 1995–9 is unveiled at 48th Venice Biennale in the Antichi Granai; a twenty-five part sculpture in terracotta, wood and steel, made in response to present-day atrocities that 'had a resonance of what was happening in the world'.

It was, in a sense, the first time I felt oppressed by the political and moral bankruptcy of people's attitudes. With the loss of religion, the loss of values, we tend to see life as rather pointless perhaps. I don't want to preach, but I just felt the need to do it, although it's quite different from my normal work. (Caro quoted in Lynn Barber, 'The Scrap Merchant', *Observer Magazine*, 6 June 1999)

Today we see him combining with the utmost authority, whatever he needs or cares to use to achieve his ends – clay, timber, metal – and the found or given image with the contrived. If he wishes to shove in a bell or trumpet, model a skull, build a door or flight of steps, make a bare-faced clay caricature (here Greed for example), or by abstract formal suggestion evoke the Elysian Fields, he simply gets on and does so. And it is in this that he remains so true both to his art and to himself, bringing it at last together, all of a piece. It is not yet a Last Judgement, perhaps, but not bad an Interim Report. (William Packer, 'Parts Add Up to a Coherent Whole', *Financial Times*, 22 July 1999)

Begins work on 'Duccio Variations' series after accepting an invitation from the National Gallery, London, to make work in response to its collection. Caro chooses Duccio's *The Annunciation* 1311 but points out that 'the Duccio painting is not a blueprint. I keep a respectful distance. I don't want my sculptures to be illustrative in any way. I aim to capture the spirit; get a feeling of tenderness and protection.' (Caro quoted in Clare Henry, 'Symphony in Brass, Steel and Wood', *Financial Times*, 20 Jan. 2001)

Returns to Ken Tyler's paper workshop in New York and makes the 'paper book' series.

New Marlborough Gallery in Boca Raton, Florida, shows 'Arena' pieces.

Awarded Honorary Doctor of Letters, University of Westminster, London.

2000 / Order of Merit conferred by HM Queen Elizabeth. The award is restricted to twenty-four living members, and Caro is the first sculptor to be awarded this special distinction since Henry Moore in 1963.

Exhibition at Venice Design Gallery of works from the 'Concerto' series 1999–2000, sculptures incorporating parts of musical instruments and, a new material, cast brass.

Three works from the 'Duccio Variations' series 1999–2000, made in different materials from steel and wood to iron and Perspex, included in *Encounters: New Art from Old* at the National Gallery, London.

The Last Judgement inaugurates the new wing of Museo des Bellas Artes, Bilbao.

2001 / 'Duccio Variations', 'Gold Blocks' and 'Concerto' pieces exhibited at the Marlborough Gallery, New York.

The Last Judgement is exhibited at the Johanniter Kirche, a disused church in Schwäbisch Hall, Germany, to coincide with the opening of the new Kunsthalle Würth.

An educational exhibition, *A Sculptor's Development: Anthony Caro*, is shown in Lewes, Sussex, the first regional retrospective in the UK, touring to Millfield School, Somerset and Château-Musée de Dieppe (2002).

Caro at Longside: Sculpture and Sculptitecture, exhibition of large architectural inspired works – including *Elephant Palace* 1989 and *Night and Dreams* 1990–1 – opens new gallery space at Yorkshire Sculpture Park, Wakefield.

2002 / Included in *Blast to Freeze: British Art of the 20th Century* at Kunstmuseum, Wolfsburg, and travelling to Les Abattoirs, Toulouse. Exhibitions at Galeria Metta, Madrid, Galleria Lawrence Rubin, Milan, Galeria Altair, Palma de Mallorca, and Galerie Besson, London.

Anthony Caro: Drawing in Space: Sculptures from 1964 to 1988 & The Last Judgement, 1995–99, is shown at Gaudi's 'La Pedrera' building in Barcelona, organised by Fundació Caixa Catalunya.

The Barbarians 1999–2002, a group of mythical horsemen assembled from stoneware, wood and steel, is first shown at Mitchell-Innes & Nash, New York.

Many may feel betrayed that this stalwart abstract warrior would turn into a purveyor of pastiched soldiers – a scrap-heap battalion fighting against time – but Caro also takes the long view, back to antiquity and mythology. He is a veteran warrior, here assuming a heroic posture against those who consider miscegenation between abstraction and representation a heresy, just as he fought early on against the tyranny of the base, considering it an arbitrary intrusion in sculpture … These new sculptures, though narrative and figurative, are really abstract composites that we visually deconstruct and reassemble … and they have successfully provided Caro a way to extend his concerns and objectives without falling too far out of character. (Barbara A. MacAdam, 'Anthony Caro: Mitchell Innes & Nash', *Art News*, March 2003)

2003 / Exhibits selection of paper sculptures and *The Barbarians* 1999–2002 at Annely Juda Fine Art, London, alongside another figurative, stoneware and steel construction, *Europa and the Bull* 2000–2.

Exhibits works on paper at Galerie Joan Prats, Barcelona. A selection of 'Emma' sculptures and related later work is shown at Frederik Meijer Sculpture Park, Grand Rapids, Michigan, touring to Meadows Museum, Dallas.

2004 / Eightieth birthday marked with display of *Sculpture Two* 1962 outside Tate Britain and other exhibitions across the world: *Caro in Focus* is the inaugural exhibition at the new Sudhaus galleries at Kunsthalle Würth, Schwäbisch Hall; *The Way It Is* presents sixteen new works including a large terracotta figure and Caro's first monumental sculpture in stone, at Kenwood House, London; *The Barbarians* 1999–2002 is displayed at Museum of Art in Seoul.

In the studio, works on galvanised, abstract sculptures which incorporate real objects.

Becomes Senior Academician at Royal Academy, London, and receives Honorary Fellowship, University of Arts, London, and International Award for Visual Arts, Cristobal Gabarron Foundation, Spain.

2005 / Major retrospective exhibition at Tate Britain, London, covering all principal phases of Caro's career from 1950s to the present, including the huge, new architectural commission for the South Duveen gallery, *Millbank Steps* 2004.

I think it's my job to try to push sculpture forward, to keep it moving, keep it alive. And you don't keep it alive just by doing what you can do; you keep it alive by trying to do things which are difficult. For 400 years, British sculpture was pretty sleepy. We have to make sure it doesn't get sleepy again. (Caro quoted in Lynn Barber, 'The Scrap Merchant', *Observer Magazine*, 6 June 1999)

Making art is one's life. There's always the next masterpiece you're going to make tomorrow. You may not – but there's always the hope. (Caro quoted in Clare Henry, 'Symphony in Brass, Steel and Wood', *Financial Times*, 20 Jan. 2001)

It's funny; you look back and you say 'Did I do it?' … I do like the very early pieces because they were breaking through and it was a new thing … even the 'man holding his foot' and then the early steel pieces. I think that it was so new for me, it was discovery – and it's discovery that does get you … you just make it at the time, make it the best, make it as good as you can. (Caro interviewed by Rachel Tant, 8 July 2004)

Caro's Camden Town studio

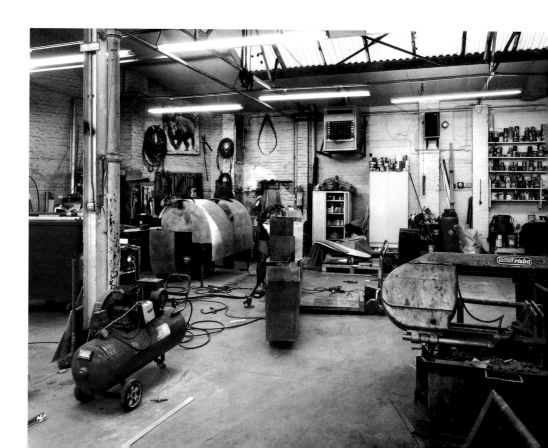

List of exhibited works

1
Seated Figure
1951
Terracotta clay
72 x 39 x 66 cm
Collection of the artist

2
Seated Man (with corrections by Henry Moore)
1951–2
Charcoal and pencil on paper
56 x 38.5 cm
Collection of the artist

3
Man Holding his Foot
1954
Bronze
65 x 90 x 81 cm
Collection of the artist

4
Man Walking
1955
Brush and ink on paper
157.2 x 53.1 cm
The British Museum, London

5
Figure
1955–6
Brush and ink on paper
85 x 54 cm
Private collection, London

6
Figure/Face
1955–6
Brush and ink on paper
84 x 53 cm
Collection of the artist

7
Man Taking Off his Shirt
1955–6
Bronze
78 x 46 x 47 cm
Collection of Professor and Mrs King

8
Smiling Head III – Smiling Woman
1956
Bronze
32 x 18 x 19 cm
Collection of the artist

9
Cigarette Smoker I – Lighting a Cigarette
1957
Bronze
32 x 19 x 27 cm
Collection of the artist

10
Pulling on a Girdle
1958–9
Bronze
62 x 23 x 23 cm
Collection of the artist

11
Twenty Four Hours
1960
Steel, painted dark brown and black
138.4 x 223.5 x 83.8 cm
Tate. Purchased 1975

12
The Horse
1961
Steel, painted dark brown
203.5 x 96.5 x 427 cm
Audrey and David Mirvish, Toronto

13
Sculpture Seven
1961
Steel, painted green, blue and brown
178 x 537 x 105.5 cm
Private collection, UK

14
Early One Morning
1962
Steel and aluminium, painted red
289.6 x 619.8 x 335.3 cm
Tate. Presented by the Contemporary Art Society 1965

15
Month of May
1963
Steel and aluminium, painted magenta, orange and green
279.5 x 305 x 358.5 cm
Private collection, UK

16
Eyelit
1965
Steel, painted blue
286 x 168 x 7.5 cm
Collection of William S. Ehrlich

17
Table Piece VIII
1966
Steel, polished
68.5 x 33 x 50.8 cm
Private collection, UK

18
The Window
1966–7
Steel, painted green and olive
217 x 374 x 348 cm
Tate. Lent by a private collector 1994

19
Table Piece XXII
1967
Steel, sprayed jewelescent green
25.4 x 80 x 68.6 cm
Private collection, UK

20
Table Piece XLII
1967
Steel, polished and sprayed green
59.7 x 39.4 x 73.7 cm
Private collection, UK

21
Prairie
1967
Steel, painted matt yellow
96.5 x 582 x 320 cm
Collection of Lois and Georges de Menil

22
Table Piece LIX
1968
Steel, sprayed silver grey
29.2 x 43.2 x 48.3 cm
Private collection, UK

23
Table Piece LXIV – The Clock
1968
Steel, painted yellow
76.2 x 129.5 x 81.3 cm
Private collection, Paris

24
Table Piece LXXV
1969
Steel, sprayed matt tan
29.2 x 99.1 x 71.1 cm
Private collection, UK

25
Table Piece LXXX
1969
Steel, painted deep blue
34.3 x 134.6 x 50.8 cm
Private collection, UK

26
Orangerie
1969
Steel, painted Venetian red
225 x 162.5 x 231 cm
Kenneth Noland

27
Sun Feast
1969–70
Steel, painted yellow
181.5 x 416.5 x 218.5 cm
Private collection

28
Ordnance
1971
Steel, rusted and varnished
129.5 x 193 x 636 cm
Collection of the artist

29
Table Piece CLXIII
1973
Steel, varnished
125.7 x 83.8 x 58.8 cm
Collection of the artist

30
Table Piece CCLXVI
1975
Steel, rusted and varnished
79.5 x 205.5 x 125 cm
Tate. Presented by the artist 2000

31
Tundra
1975
Steel, waxed
272 x 579 x 132 cm
Tate. Purchased 1982

32
Emma Dipper
1977
Steel, rusted and painted grey
213 x 170 x 320 cm
Tate. Presented by the artist 1982

33
Writing Piece 'Whence'
1978
Steel, rusted, painted and blacked
31.7 x 86.4 x 16.5 cm
Private collection, UK

34
**Paper Sculpture
No. 48 – Bandit**
1981
Pencil, chalk, acrylic, corrugated
board, handmade paper on Tycore
in wooden box
83.2 x 68.6 x 12.7 cm
Collection of the artist

35
Late Quarter – Variation G
1981
Bronze and brass, cast and welded
37 x 58.5 x 45.5 cm
Private collection

36
Xanadu
1986–8
Steel, waxed
240 x 622 x 160 cm
Tate. Lent by a private collector
1994

37
**Table Piece Y–87
'Knave's Measure'**
1987
Steel, waxed
118 x 99 x 40.5 cm
Mr and Mrs Eva and John Usdan

38
**Table Piece
'Catalan Maid'**
1987–8
Steel, rusted and fixed
134.5 x 68.5 x 39.5 cm
Collection of the artist

39
Night Movements
1987–90
Steel, stained green, varnished
and waxed
276 x 1077 x 335 cm
Tate. Purchased with funds
provided by the Kreitman
Foundation 1994

40
Déjeuner sur l'herbe II
1989
Steel, rusted and fixed
97 x 187 x 252 cm
Tate. Presented by the artist 2000

41
Elephant Palace
1989
Brass, welded
188 x 303.5 x 190.5 cm
Collection of the artist

42
**Descent from the Cross III
– After Rembrandt**
1989–90
Bronze and brass, cast and welded
221 x 119.5 x 111.5 cm
Musée d'art contemporain
Val-de-Marne/Vitry
Conseil général du Val-de-Marne

43
Night and Dreams
1990–1
Steel, bolted, welded and waxed
104 x 223.5 x 188 cm
Collection of the artist

44
Obama High
1990–2
Washi paper, tissue paper and
gouache
78.5 x 99 x 12.5 cm
Colección Marqués de la Romana

45
Arena Piece 'Beginning'
1995
Wood and steel, painted black,
red and viridian
72 x 54 x 38 cm
Michael Harris Spector and Dr Joan
Spector

46
The Last Judgement
1995–9
Stoneware, wood, steel, brass,
bronze, concrete and plaster
Dimensions variable
Collection Würth, Künzelsau,
Germany

47
Gold Block I
1997
Stoneware, steel and tin,
rubbed with paint
57 x 64 x 23 cm
Private collection

48
Millbank Steps
2004
Corten steel, rusted
534 x 780 x 2307.2 cm
Courtesy the artist

Lenders

The British Museum, London

Anthony Caro

William S. Ehrlich

Professor and Mrs King

Lois and Georges de Menil

Audrey and David Mirvish, Toronto

Kenneth Noland

Marqués de la Romana

**Michael Harris Specor
and Dr Joan Spector**

Tate

Mr and Mrs Eva and John Usdan

**Musée d'art contemporain Val–de–Marne, Vitry
Conseil général du Val–de–Marne**

Collection Würth, Künzelsau, Germany

**And other private lenders who wish
to remain anonymous**

Bibliography

Compiled by Krzysztof Cieszkowski

The Bibliography is divided into six sections:

1 / Books on the artist
2 / Sections of books
3 / Selected articles and reviews
4 / Writings by the artist
5 / Solo exhibition catalogues
6 / Selected group exhibition catalogues

Entries are listed chronologically within each section.

1 / Books on the artist

Richard Whelan: *Anthony Caro*. Harmondsworth: Penguin, 1974; New York: E.P. Dutton Paperbacks, 1975; incl. essays by Michael Fried, Clement Greenberg, John Russell, Phyllis Tuchman.

William Rubin: *Anthony Caro*. New York: Museum of Modern Art; London: Thames & Hudson, 1975 (published on the occasion of retrospective exh. at Museum of Modern Art, New York, 30 Apr.–6 July 1975).

Dieter Blume: *Anthony Caro: catalogue raisonné I–XIII*. Cologne: Verlag Galerie Wentzel (vol.VII: Cologne: Galerie Wentzel, London: Annely Juda Fine Art, New York: André Emmerich Gallery; vol.VIII: New York: Acquavella Contemporary Art; vol. IX: Cologne: Galerie Wentzel, London: Annely Juda Fine Art; New York: André Emmerich Gallery), 1981–2001 (contents: vol.I: *Table and related sculptures 1966–1978*. vol.II: *Table and related sculptures 1979–1980, Miscellaneous sculpture 1974–1980, Bronze sculpture 1976–1980*. vol.III: *Steel sculpture 1960–1980*. vol.IV: *Student work 1942–1953, Figurative sculptures 1954–1959*. vol.V: *Table and related sculptures 1981–1983, Miscellaneous sculptures 1980–1983, Bronze sculptures 1980–1983, Steel sculptures 1981–1983*. vol.VI: *Table and related sculptures 1984–1986, Miscellaneous sculptures 1984–1986, Bronze sculptures 1984–1986, Steel sculptures 1984–1986*. vol.VII: *Table and related sculptures 1986–1988, Miscellaneous sculptures 1987–1988, Bronze sculptures 1986–1987, Steel sculptures 1987–1989*. vol.VIII: *Figurative sculptures 1984–1989*. vol.IX: *Table and related sculptures 1987–1989, Miscellaneous sculptures 1987–1989, Bronze sculptures 1989–1990, Steel sculptures 1989–1990, General index 1942–1990*. vol.X: *Table and related sculptures 1990–1993, Miscellaneous sculptures 1991–1992, Bronze sculptures 1990–1993, Steel Sculptures 1989–1993*. vol.XI: *Table and related sculptures 1993–1995, Clay and related sculptures 1994–1996, Miscellaneous sculptures 1993–1996, Bronze sculptures 1993–1994, Steel sculptures 1993–1996*. vol XII: *A survey of student drawings 1951, Monotypes 1953–1955, Figurative drawings 1954–1956*. vol.XIII: *Table and related sculptures 1996–2000, Steel, wood and clay sculptures 1996–2000, Clay and related sculptures 1996–2000, Miscellaneous sculptures 1996–2000, Bronze sculptures 1996–2000, Steel sculptures 1996–2000*)

Diane Waldman: *Anthony Caro*. Oxford: Phaidon Press; New York: Abbeville Press, 1982.

Terry Fenton: *Anthony Caro*. London: Thames and Hudson; Barcelona: Ediciones Poligrafa; New York: Rizzoli, 1986; French edition, Paris: Albin Michel, 1990.

John Spurling: *Anthony Caro: in conversation with John Spurling: a sculptor and his discontents* [audio-tape and booklet of 24 slides]. London: Lecon Arts, c.1988 (Artists Talking, LA 14).

Karen Wilkin, ed. Ian Barker: *Caro*. Munich: Prestel, 1991.

Shigeo Anzai: *Caro by Anzai: photo-essay*. Tokyo: Fuso Publishing, 1992.

Giovanni Carandente, ed. by Ian Barker: *Caro at the Trajan Markets*. London: Lund Humphries, 1993.

Terry Fenton: *Anthony Caro*. London: Academy Editions, 1993 (1st publ. by Ediciones Poligrafa, 1986)

Robert Hopper: *Caro in Yorkshire* [text based on interviews on the occasion of exhibs. at the Henry Moore Studio, Dean Clough, Halifax, and Yorkshire Sculpture Park, West Bretton, 1994–5]. Halifax: Henry Moore Sculpture Trust, 1994.

Peter Baelz, Hans Magnus Enzensberger, Nadine Gordimer, Robert Hinde, Philip Rylands, John Spurling: *The Last Judgement by Anthony Caro*. Künzelsau: Verlag Paul Swindorff, Museum Wurth, 1999 (published on the occasion of British exh. at 48th Biennale di Venezia).

Giovanni Carandente, preface by Reinhold Würth: *Anthony Caro and Twentieth-Century sculpture*. Künzelsau: Verlag Paul Swidorff, Museum Würth, 1999 (published on the occasion of British exh. at 48th Biennale di Venezia).

Ian Barker: *Anthony Caro: quest for the new sculpture*. Aldershot: Lund Humphries, 2004.

Julius Bryant: *Anthony Caro: a life in sculpture*. London, New York: Merrell, 2004.

2 / Sections of books

Michel Seuphor: *Sculpture de ce siècle: dictionnaire de la sculpture moderne*. Neuchatel: Editions du Griffon, 1959; translated as *The sculpture of this century*. New York: Braziller, London: Zwemmer 1961; pp.147, 150, 248

Edward Trier: *Figur und Raum: die Skulptur des XX. Jahrhunderts*. Berlin 1961; translated as *Form and space: sculpture of the Twentieth Century*. London: Thames & Hudson, 1961; New York: Praeger, 1968 pp.44, 280–1, 326

Robert Maillard (ed.): *Dictionary of modern sculpture*. New York: Tudor, London: Methuen 1962, p.51 Britain (chapter 'Moderns in sculpture'). New York: Time Inc. (Life World Library), 1963, p.141 (reprint 1967)

Britain (chapter 'Moderns in sculpture'). New York: Time Inc. (Life World Library), 1963, p.141 (reprint 1967)

Alan Bowness: *Modern sculpture*. London: Studio Vista, New York: Dutton, 1965, p.155

Bryan Robertson, John Russell and Lord Snowdon: *Private view*. London: Nelson, 1965, pp.152–8, 202–5, 242–5

A.M. Hammacher: *Modern English sculpture*. London: Thames and Hudson, New York: Harry N. Abrams, 1967

George Rickey: *Constructivism: origins and evolution*. London: Studio Vista, New York: George Braziller, 1967, p.226; new ed. 1995

Jack Burnham: *Beyond modern sculpture: the effects of science and technology on the sculpture of this century*. London: Allen Lane, New York: George Braziller, 1968

Gregory Battcock (ed.): *Minimal Art: a critical anthology*. New York: E.P. Dutton & Co., 1968; London: Studio Vista, 1969; reprints 1967 articles by Michael Benedikt, pp.61–91; Michael Fried, pp.116–47; Clement Greenberg, pp.180–6

Rosalind Krauss: *Passages in modern sculpture*. New York: Grossman/Viking Press, London: Thames and Hudson, 1977, pp.187–95

Colin Naylor and Genesis P-Orridge (eds.): *Contemporary artists*. London: St James Press, New York: St Martin's Press, 1977, pp.169–70; updated in 2nd ed., 1983, and 3rd ed., 1989

F. David Martin: *Sculpture and enlivened space: Aesthetics and History*. University Press of Kentucky 1978

John Russell: 'The meanings of Modern Art'. New York: Museum of Modern Art, Harper & Row; London: Thames and Hudson, 1981, pp.380–91

Nicholas Wegner: 'Caro-Wilding: shifts in British sculpture', in (ed.) Nicholas Wegner: *Small histories*. London: Visual Arts Research, 1996

[interview], in Nicholas Wegner, Sarah Batiste (eds.): *Interviews with the artists*. London: Visual Arts Research, 1996

Michael Fried: *Art and objecthood: essays and reviews*. Chicago: University of Chicago Press, 1998 (reprints Fried's reviews and articles on AC)

Mel Gooding: *Public: art: space: a decade of Public Art Commissions Agency 1987–98*. London: Merrell Holberton, 1998; p.49

Andrew Dempsey (ed.), with a contribution from Hans Spinner: *Sculptors talking: Anthony Caro, Eduardo Chillida*. [s.l.]:Art of this Century, 2000

H. Peter Stern [et al.]: *Earth, sky and sculpture*: Storm King Art Center. Mountainville (NY): Storm King Art Center, 2000; pp.203–4

Sarah Clark-Langager: *Sculpture in place: a campus as site*: Western Washington University, Bellingham. Bellingham (WA): Western Washington University, 2002; pp.12–14.

Judy Collischan: *Welded sculpture of the twentieth century*. London: Lund Humphries; Purchase (NY): Neuberger Museum of Art, 2002; pp.65–6, 71–6

John Tusa: 'I don't know where I am and I love it', in *On Creativity: interviews exploring the process*. London: Methuen, 2003, pp.69–86

3 / Selected articles and reviews

'Young men's sculpture: a curator's problem' [incl. review of ICA exh.], *Times,* 12 Aug. 1955, p.7

David Sylvester: 'Round the London galleries' [incl. review of ICA exh.], *Listener*, 1 Sept. 1955, p.340

Basil Taylor: 'Art' [incl. review of ICA exh.], *Spectator*, 2 Sept. 1955, pp.307–8

Theo Crosby: 'Anthony Caro at Galleria Naviglio, Milan', *Architectural Design*, Mar. 1956, vol.26, p.107

Stephen Bone: 'Artists' contrast: Redvers Taylor and Anthony Caro', *Manchester Guardian* [review of Gimpel Fils exh.], 9 Jan. 1957

Neville Wallis: 'Different worlds', *Observer*, 13 Jan. 1957

[Alan Solomon]: 'Sculpture in a big way: Anthony Caro's show' [review of Gimpel Fils exh.], *Times*, 15 Jan. 1957, p.9

Andrew Forge: 'Round the London galleries' [incl. review of Gimpel Fils exh.], *Listener*, 17 Jan. 1957, p.102

Pierre Rouve: 'Personality' [review of Gimpel Fils exh.], *Art News and Review*, 19 Jan. 1957, vol.8 no.26, p.5

Lawrence Alloway: 'Art news from London', *Art News*, Mar. 1957, vol.56 no.1, p.21

Lawrence Alloway: 'Interview with Anthony Caro', *Gazette* (London), 1961, no.1, p.1

Lawrence Alloway: 'Artists as consumers', *Image*, Feb. 1961, no.3, pp.14–17

Lawrence Alloway: 'Upstairs and downstairs at St Martins', *Architectural Design*, May 1961, pp.212–13

David Sylvester: 'Aspects of contemporary British art: image of Britain 2', *Texas Quarterly* (University of Texas, Austin), Autumn 1961, pp.118–28

David Sylvester: 'Against sensibility', *New Statesman*, 8 Sept. 1961, pp.318

Robert Melville: 'Exhibitions: painting' [incl. review of New London Gallery exh.], *Architectural Review,* Nov. 1961, vol.130 no.777, pp.351–3 (ref. p.352)

Lawrence Alloway: 'Notes from London: Painted sculpture by Anthony Caro', *Metro*, 1962, pp.102, 104–7

John Rydon: 'Toddler's eye view of 35 tons of modern shapes and sizes', *Daily Express*, 30 May 1963

John Russell: 'Overture and beginners' [incl. review of Kasmin Gallery exh.], *Sunday Times*, 11 Aug. 1963

Alan Solomon: 'Out and out originality in our contemporary sculpture', *Times*, 20 Aug. 1963, p.11

John London: 'Mr Caro makes music out of uglies', *Evening News & Star*, 17 Sept. 1963, p.C3

Richard Walter: 'Wanted: new words for Caro', *Daily Mail*, 19 Sept. 1963

Eric Newton: 'Anthony Caro's sculpture at the Whitechapel Gallery', *Guardian*, 19 Sept. 1963, p.9

Charles S. Spencer: 'Caro at the Whitechapel Gallery', *Arts Review*, 21 Sept.–5 Oct. 1963, vol.15 no.18, p.5

John Russell: 'New areas of awareness', *Sunday Times*, 22 Sept. 1963, p.33

Mario Amaya: 'The dynamics of steel', *Financial Times*, 24 Sept. 1963

David Storey: 'When artists sell out', *Observer*, 29 Sept. 1963

Jasia Reichardt: 'Caro and environmental sculpture', *Architectural Design*, Oct. 1963, p.76

Charles Greville: 'The steel-welding Mr Caro is anything but a conventional sculptor', *Daily Mail,* 2 Oct. 1963, p.4

Neville Wallis: 'Anthony Caro' [interview and review of Whitechapel exh.], *Spectator,* 4 Oct. 1963, p.418

[Alan Solomon]: 'Mr Caro's new and original sculpture' [review of Whitechapel exh.], *Times*, 4 Oct. 1963, p.16

Bryan Robertson: [response to letter by David Storey, 29 Sept. 1963], *Observer*, 6 Oct. 1963

Edwin Mullins: 'Time of the Modern', *Sunday Telegraph*, 6 Oct. 1963

Robert Wraight: 'The girder man', *Tatler*, 9 Oct. 1963, p.133

Norbert Lynton: 'Two radicals' [incl. review of Whitechapel exh.], *New Statesman*, 11 Oct. 1963, pp.500–1

John Farleigh, Alexander Gross, Douglas Cooper, Charles S Spencer: [letters in response to articles by David Storey and Bryan Robertson, 29 Sept. and 6 Oct.], *Observer*, 13 Oct. 1963

Gene Baro: 'International reports: London: A look at reminiscence' [incl. review of Whitechapel exh.], *Arts Magazine*, Nov. 1963, vol.38 no.2, pp.44–7 (ref. pp.45–7)

Robin Martin: 'The sculpture of Anthony Caro', *Peace News*, 22 Nov. 1963

Robert Melville: 'Exhibitions: painting and sculpture'[incl. review of Whitechapel exh.], *Architectural Review*, Dec. 1963, vol.134 no.802, pp.431–3 (ref. pp.431–2)

John Russell: 'England: the advantage of being thirty', *Art in America*, Dec. 1963, pp.92–7

Norbert Lynton: 'London letter', *Art International*, 5 Dec. 1963, vol.7 no.9, pp.69–71 (ref. pp.69–70)

John Russell: 'Art news from London', *Art News*, Dec. 1963, vol.62 no.8, p.49

David Thompson: 'A decade of British sculpture', *Cambridge Opinion*, 1964

Charles S. Spencer: 'An introduction to Abstract Art III: sculpture', *The Artist,* Feb. 1964, vol.66 no.6, issue 396, pp.122–5

Charles S. Spencer: 'Sculptor for humanity', *Jewish Chronicle* (London), 14 Feb. 1964

Norbert Lynton: 'Latest developments in British sculpture', *Art and Literature*, Summer 1964, no.2, pp.195–211 (ref. pp.195–7, 201–2)

Charles S. Spencer: 'Documenta III', *Studio International*, Sept. 1964, vol.168 no.857, pp.110–17 (ref. pp.113–14)

Clement Greenberg: 'Anthony Caro', *Arts Yearbook 8: Contemporary Sculpture*, 1965, pp.106–9; repr. in *Studio International*, Sept. 1967, vol.174 no.892, pp.116–17; repr. in Clement Greenberg: *Modernism with a vengeance, 1957–1969*, vol.4 of Clement Greenberg: *The collected essays and criticisms*, ed. John O'Brian, Chicago 1993, pp.205–8; repr. as foreword to catalogues of exhibitions at Rijksmuseum Kröller-Müller, Otterlo, 1967 (Dutch/English text); at Iglesia de San Esteban, La Lonja, Galeria Soledad Lorenzo, 1986 (Spanish text); in *Britannica: trente ans de sculpture*, Le Havre,1988 (French/English text); in *Anthony Caro: oeuvres 1961–1989*, Calais 1990 (French text, extract), pp.40–2

J.P. Hodin: 'The avant-garde of British sculpture and the liberation from the liberators', *Quadrum*, 1965, no.18, pp.55–70 (ref. pp.56–7, 70)

Jasia Reichardt: 'Colour in sculpture', *Quadrum*, 1965, no.18, pp.71–8 (ref. p.75)

Lawrence Campbell: 'Reviews & previews: Anthony Caro', *Art News*, Jan. 1965, p.19

D.J. [= Donald Judd]: 'In the galleries: Anthony Caro' [review of Emmerich Gallery exh.], *Arts Magazine*, Jan. 1965, vol.39 no.4, pp.53–4

Leslie Cheek III: 'Sculptor achieves tonnage', *Washington Post*, 21 Feb. 1965

David Thompson: 'After the twisted iron, the girder sections', *Sunday Times*, 28 Feb. 1965, pp.26–33

Elisabeth Stevens: 'Caro has a way with steel and bends it to his will', *Washington Post*, 28 Feb. 1965, p.G7

John Richardson: 'Early one morning' [review of Tate exh.], *New Statesman*, 5 Mar. 1965, p.372

Bryan Robertson: 'A revolution in British sculpture' [review of Whitechapel exh.], *Times*, 9 Mar. 1965, p.15

'Sculpture: intellectuals without trauma', *Time*, 12 Mar. 1965, p.66

David Thompson: 'British sculpture up', *New York Times*, 28 Mar. 1965

John Russell: 'London/NYC: the two-way traffic', *Art in America*, Apr. 1965, vol.53 no.2, pp.126–36 (ref. p.127)

Andrew Forge: 'Some new British sculptors' [review of Whitechapel exh.], *Artforum*, May 1965, vol.3 no.8, pp.31–5 (ref. pp.31–2)

Michael Fried: 'Anthony Caro and Kenneth Noland: some notes on not composing', *Lugano Review*, Summer 1965, vol.3 no.4, pp.198–206

Gene Baro: 'Britain's new sculpture', *Art International*, June 1965, vol.9 no.5, pp.26–31 (ref. pp.27–30)

Alan Solomon: 'Moore, Caro, and after', *Times*, 30 Sept. 1965, p.16

John Russell: 'The man who gets there first', *Sunday Times*, 31 Oct. 1965

Emma Booker: 'Anthony Caro', *Vogue* (London), Nov. 1965, vol.122 no.15, pp.94–5

Ian Dunlop: 'Sculpture you look down at – and admire', *Evening Standard*, 4 Nov. 1965

Nigel Gosling: 'Cairo to Caro', *Observer*, 7 Nov. 1965

Edwin Mullins: 'Art', *Sunday Telegraph*, 7 Nov. 1965

Peter Stone: 'New mysticism', *Jewish Chronicle*, 12 Nov. 1965

John Richardson: 'Carissimo' [review of Kasmin Gallery exh.], *New Statesman*, 12 Nov. 1965, p.760

Kenneth Coutts-Smith: 'Anthony Caro' [review of Kasmin Gallery exh.], *Arts Review*, 13 Nov. 1965, vol.17 no.22, p.9

Paul Grinke: 'Caro's achievement', *Financial Times*, 15 Nov. 1965, p.16

Norbert Lynton: 'Anthony Caro exhibition', *Guardian*, 16 Nov. 1965

John Dunbar: 'Anthony Caro: the experience is the thing', *Scotsman*, 20 Nov. 1965

John Russell: '*Art News* from London' [review of Kasmin Gallery exh.], *Art News*, Dec. 1965, vol.64 no.8, pp.36, 54–5

Gene Baro: 'Britain's young sculptors', *Arts Magazine*, Dec. 1965, vol.40 no.2, pp.13–17

G.S. Whittet: 'No more an island: London commentary' [incl. review of Kasmin Gallery exh.], *Studio International*, Dec. 1965, vol.170 no. 872, pp.242–5

Norbert Lynton: 'London letter', *Art International*, 20 Dec. 1965, vol.9 nos.9–10, pp.23–30 (ref. pp.23–4, 26)

J.P.Hodin: 'Documentation: Anthony Caro', *Quadrum*, 1966, no.20, pp.142–3

Andrew Forge: 'Anthony Caro interviewed by Andrew Forge', *Studio International*, Jan. 1966, vol.171 no.873, pp.6–9 (first broadcast on BBC Third Programme)

'Anthony Caro', *London Life*, 26 Mar. 1966, p.39

Robert Hughes: 'Caro generation', *Sunday Times*, 10 Apr. 1966

Polly Devlin: 'The merchants of Venice', *Vogue* (London), May 1966, pp.112–13

Hilton Kramer: 'Primary structures – the new anonymity', *New York Times*, 1 May 1966

Andrew Hudson: 'English sculptors outdo Americans', *Washington Post*, 8 May 1966

Robert Fulford: 'When sculptor Caro works … everybody works', *Toronto Daily Star*, 13 May 1966, p.24

Harry Malcolmson: [review of David Mirvish Gallery, Toronto, exh.], *Toronto Telegram*, 21 May 1966

Edward Lucie-Smith: 'Anthony Caro at Venice', *Art & Artists*, June 1966, vol.1 no.3, pp.24–7

Charles S. Spencer: 'Hat-trick at Venice Biennale', *Jewish Chronicle*, June 1966

David Thompson: 'Venice Biennale: the British five', *Studio International*, June 1966, vol.171 no.878, pp.233–43

Harry Malcolmson: 'A chasm between artistic points of view', *Toronto Telegram*, 4 June 1966

'Sculpture: The girder look', *Time*, 22 July 1966, p.40

Ann Turner: 'Working title – "Sunday night: Venice"', *Studio International*, Aug. 1966, vol.172 no.880, pp.82–3

Alan Solomon: 'The Green Mountain Boys', *Vogue* (New York), 1 Aug. 1966, pp.104–9, 151–2

Kathryn Metz: 'The 33rd Venice Biennale of Art', *Arts & Architecture*, Sept. 1966, pp.32–4

John Russell: 'Portrait: Anthony Caro', *Art in America*, Sept.–Oct. 1966, pp.80–7

Bryan Robertson: 'Raspberry ripple' [incl. review of exh.], *Spectator*, 9 Sept. 1966, pp.320–1

Gene Baro: 'British sculpture: the developing scene', *Studio International*, Oct. 1966, vol.172 no.882, pp.171–81

Andrew Hudson: 'Bellwether of a really new sculpture', *Washington Post*, 2 Oct. 1966

W.A.L. Beeren: 'De 33e Biennale van Venetië', *Museumjournaal*, [Nov.] 1966, vol.11 no.6, pp.144–55

Emily Genauer: 'Anthony Caro', *World Journal Tribune*, 25 Nov. 1966

Hilton Kramer: 'Sculpture: talent unfolds on horizon', *New York Times*, 26 Nov. 1966

Andrew Hudson: 'Caro's four sculptures seem just like a crowd' [review of Emmerich Gallery exh.], *Washington Post*, 27 Nov. 1966

C.N. [= Cindy Nemser]: 'In the galleries: Anthony Caro' [review of Emmerich Gallery exh.], *Arts Magazine*, Dec. 1966–Jan. 1967, vol.41 no.3, p.60

'News of Art: Anthony Caro's sculpture', *Horizon* (New York), Winter 1967, pp.76–7

L.C. [= Lawrence Campbell]: 'Reviews & previews: Anthony Caro' [review of Emmerich Gallery exh.], *Art News*, Jan. 1967, vol.65 no.9, p.11

Paul Russell: 'Caro, Noland at David Mirvish Gallery, Toronto', *Arts Canada*, Jan. 1967, Supplement, p.6

Rosalind Krauss: 'On Anthony Caro's latest work', *Art International*, 20 Jan. 1967, pp.26–9

Michael Benedikt: 'New York letter: some recent British and American sculpture' [incl. review of Emmerich Gallery exh.], *Art International*, 20 Jan. 1967, pp.56–62 (ref. p.56); repr. in (ed.) Gregory Battcock: *Minimal Art: a critical anthology*, New York: E.p.Dutton, 1968, pp.61–7

Kay Kritzwiser: 'Sculptures by Caro', *Toronto Globe and Mail*, 21 Jan.1967

Barrie Hale: 'Massive Caro, delicate Caro', *Toronto Telegram*, 21 Jan. 1967

Michael Fried: 'New York by Anthony Caro', *Artforum*, Feb. 1967, pp.46–7; repr. in *Art & Objecthood*, Chicago University Press 1998, pp.173–5

Clement Greenberg: 'Recentness of sculpture', *Art International*, 20 Apr. 1967, pp.19–21; originally publ. in exh. cat. *American sculpture of the Sixties*, Los Angeles County Museum of Art, 1967, pp.24–6; repr. in Gregory Battcock (ed.): *Minimal Art: a critical anthology*, New York: E.p.Dutton, 1968, pp.180–6.

P.H. Hefting: 'Twee in een, Paolozzi en Caro in Kröller-Müller', *Museumjournaal*, [May] 1967, vol.12 no.2, pp.49–56, 63

Mario Amaya: 'Caro and Paolozzi in Holland', *Financial Times*, 17 May 1967

Michael Fried: 'Art and objecthood', *Artforum*, Summer 1967, vol.5 no.10, pp.12–23 (ref. pp.12, 17, 20, 23); repr. in (ed.) Gregory Battcock (ed.): *Minimal Art: a critical anthology*, New York: E.p.Dutton, 1968, pp.116–47; repr. in exh. cat. *The great decade of American Abstraction*, Museum of Fine Art, Houston, 1974; repr. in George Dickie and Richard J Sclafani (eds.): *Aesthetics: a critical anthology*, New York 1977, pp.438–60; repr. in Amy Baker Sandback (ed.): *Looking critically: 21 years of Artforum*, Ann Arbor 1984, pp.61–8; repr. in *Artstudio 6*, Autumn 1987, pp.11–27 (French trans.); excerpt repr. in Charles Harrison and Paul Wood (eds.): *Art in theory 1900–1990*, Oxford and Cambridge (MA), 1992, pp.822–34; repr. in Gregor Stemmrich (ed.): *Minimal Art: Eine kritische Retrospektive*, Dresden and Basel 1995, pp.334–74 (German trans.); repr. in *Art & Objecthood*, Chicago University Press 1998, pp.148–72.

Clement Greenberg: 'Anthony Caro', *Studio International*, Sept. 1967, vol.174 no.892, pp.116–17 (repr. from *Arts Yearbook 8: Contemporary Sculpture*, 1965, pp.106–9)

Edward F. Fry: 'Sculpture of the Sixties', *Art in America*, Sept.–Oct. 1967, vol.55 no.5, pp.26–43 (ref. pp.27, 33)

Jean-C. Ammann: 'Anthony Caro und die junge englische Skulptur', *Werk*, Oct. 1967, pp.641–6

Norbert Lynton: 'Anthony Caro exhibition', *Guardian*, 3 Nov. 1967, p.9

Peter Stone: 'Sculpture that floats with tension', *Jewish Chronicle*, 3 Nov. 1967

Nigel Gosling: 'Moore comes to roost', *Observer*, 5 Nov. 1967, p.25

Guy Brett: 'Anthony Caro's new sculpture', *Times*, 9 Nov. 1967

Bryan Robertson: 'Mixed double' [incl. review of Kasmin Gallery exh.], *Spectator*, 10 Nov. 1967, p.583

John Russell: 'Strength made visible', *Sunday Times*, 12 Nov. 1967

Marjorie Bruce-Milne: 'Constructed, built, assembled, arranged …', *Christian Science Monitor*, 20 Nov. 1967

Denis Bowen: 'Anthony Caro' [review of Kasmin Gallery exh.], *Arts Review*, 25 Nov. 1967, vol.19 no.23, p.442

W.S. Taylor: 'Anthony Caro', Sheffield *Morning Telegraph*, 27 Nov. 1967

Andrew Hudson: 'The 1967 Pittsburgh International', *Art International*, Christmas 1967, vol.11 no.10, pp.57–64

Norbert Lynton: 'London letter' [incl. review of Kasmin Gallery exh.], *Art International*, Christmas 1967, vol.11 no.10, pp.65–70

John Russell: 'London' [incl. review of Kasmin Gallery exh.], *Art News*, Jan. 1968, vol.66 no.9, pp.22, 62–3

Edward Lucie-Smith: 'An interview with Clement Greenberg', *Studio International*, Jan. 1968, vol.175 no.896, pp.4–5

Michael Fried: 'Two sculptures by Anthony Caro', *Artforum*, Feb. 1968, vol.6 no.6, cover and pp.24–5; repr. in Richard Whelan: *Anthony Caro*, Penguin 1974, and *Art & Objecthood*, Chicago University Press 1998, pp.180–4

Patrick Heron: 'A kind of cultural imperialism', *Studio International*, Feb. 1968, vol.175 no.897, pp.62–4

Charles Harrison: 'London commentary: British critics and British sculpture', *Studio International*, Feb. 1968, vol.175 no.897, pp.86–9

David Hall: 'Critical syndrome' [letter in response to article by Charles Harrison in issue of Feb. 1968], *Studio International*, Mar. 1968, vol.175 no.898, p.113

Hilton Kramer: 'The Metropolitan takes another step forward', *New York Times*, 25 May 1968

R.S. [= Rita Simon]: 'Kenneth Noland, Morris Louis, and Anthony Caro' [review of Metropolitan Museum of Art exh.], *Arts Magazine*, June/Summer 1968, vol.42 no.8, pp.56–7

William Rubin: 'New acquisitions: painting and sculpture – 1967–8', *Members Newsletter*, Museum of Modern Art, New York, Oct. 1968, p.10

Hilton Kramer: 'Anthony Caro: a gifted sculptor within a tradition', *New York Times*, 9 Nov. 1968

Christopher Andrea: 'Light defiance of gravity', *Christian Science Monitor*, 13 Nov. 1968

K.K. [= Katherine Kline]: 'Reviews & previews: Anthony Caro' [review of Emmerich Gallery exh.], *Art News*, Dec. 1968, vol.67 no.8, p.15

James R. Mellow: 'New York letter' [incl. review of Emmerich Gallery exh.], *Art International*, 20 Dec. 1968, vol.12 no.10, pp.62–8, 108 (ref. pp.66–7)

'Anthony Caro's work: a symposium by four sculptors: David Annesley, Roelof Louw, Tim Scott, William Tucker', *Studio International*, Jan. 1969, vol.177 no.907, pp.14–20

Rosalind Krauss: 'New York' [incl. review of Emmerich Gallery exh.], *Artforum*, Jan. 1969, vol.7 no.5, pp.53–5

Charles Harrison: 'Some recent sculpture in Britain', *Studio International*, Jan. 1969, vol.177 no.907, pp.26–33

Bryan Robertson: 'Caro and the passionate object' [review of Hayward Gallery exh.], *Spectator*, 24 Jan. 1969, pp.115–16

Merete Bates: 'Caro at the core', *Guardian*, 25 Jan.1969, p.6

Nigel Gosling: 'International father', *Observer*, 26 Jan. 1969, p.5

Edwin Mullins: 'Removing the barriers', *Sunday Telegraph*, 26 Jan. 1969, p.15

John Russell: 'The triumph of Anthony Caro', *Sunday Times*, 26 Jan. 1969, p.49

Ian Dunlop: 'Caro: new language of modern sculpture', *Evening Standard*, 27 Jan. 1969

Guy Brett: 'Elegance of Caro's sculpture', *Times*, 27 Jan. 1969

Christopher Neve: 'A new kind of sculpture: Anthony Caro at the Hayward Gallery', *Country Life*, 30 Jan. 1969, p.231

Christopher Salvesen: 'Anthony Caro's iron idylls' [review of Hayward Gallery exh.], *Listener*, 30 Jan. 1969, p.157

James Burr: 'Mystery in full daylight' [review of Hayward Gallery exh.], *Apollo*, Feb. 1969, vol.89 no.84, pp.147–8

Michael Dempsey: 'The Caro experience', *Art and Artists*, Feb. 1969, vol.3 no.11, pp.1, 16–19

Charles Spencer: 'Caro – functional art', *Fashion* (London), Feb. 1969, p.44

Paul Overy: 'Anthony Caro', *Financial Times*, 4 Feb. 1969

Barbara Niven: 'Fine assertion of space', *Morning Star*, 5 Feb. 1969

Robert Melville: 'Turner's only rival' [review of Hayward Gallery exh.], *New Statesman*, 7 Feb. 1969, p.200

Winefride Wilson: 'This week in the arts: adventure playground', *Tablet*, 8 Feb. 1969

Margaret Richards: 'Art: Poetic engineer', *Tribune*, 8 Feb. 1969

Ian Dunlop: 'Is this Caro's secret?', *Evening Standard*, 10 Feb. 1969

Eddie Wolfram: 'Anthony Caro' [review of Hayward Gallery exh.], *Arts Review*, 15 Feb. 1969, vol.21 no.3, pp.79, 87

Oliver Beckett: [response to review by Bryan Robertson in issue of 24 Jan. 1969], *Spectator*, 15 Feb. 1969

David Thompson: 'Intimately related to us?', *New York Times*, 16 Feb. 1969

Frank Giles: 'Groping among the girders', *Sunday Times*, 16 Feb. 1969

Norbert Lynton: 'Sculpture on the table', *Guardian*, 17 Feb. 1969, p.8

Andrew Causey: 'Art: Shaped in steel', *Illustrated London News*, 22 Feb. 1969, pp.20–1

[eight replies to review by Frank Giles in issue of 16 Feb. 1969], *Sunday Times*, 23 Feb. 1969

Frank Bowling: 'Letter from London: Caro at the Hayward', *Arts Magazine*, Mar. 1969, vol.43 no.5, p.20

Tony Bottell: 'Sculpture at St Martin's' [letter in response to article by Charles Harrison in issue of Jan. 1969], *Studio International*, Mar. 1969, vol.177 no.909, p.110

Charles Harrison: 'London commentary' [review of Hayward Gallery exh.], *Studio International*, Mar. 1969, vol. 177 no.909, pp.130–1

W.S. Taylor: 'Caro, sculptor of the building site', *Morning Telegraph* (Sheffield), 3 Mar. 1969

Christopher Gotch: 'The measure of a man's achievement', *Hampstead & Highgate Express,* 14 Mar. 1969

R.C. Kenedy: 'London letter', *Art International*, 20 Mar. 1969, vol.13 no.3, pp.46–51

Jane Harrison Cone: 'Caro in London' [review of Hayward Gallery exh.], *Artforum*, Apr. 1969, vol.7 no.8, pp.22–6

Charles Spencer: 'Private view: Caro and Oiticica: object and environment' [editorial], *Art and Artists*, Apr. 1969, vol.4 no.1, p.4

David Russell: 'London: Magritte, Caro, Environments' [incl. review of Hayward Gallery exh.], *Arts Magazine*, Apr. 1969, vol.43 no.6, pp.49–50

Anthony Fawcett: 'Sculpture in view: Off the mark', *Sculpture International*, Apr. 1969, vol.2 no.4, pp.36–9

Reg Langford: 'Caro's influence' [letter in response to letter by Tony Bottell in issue of Mar. 1969], *Studio International*, Apr. 1969, vol.177 no.910, p.162

John Russell: '1000 makers of the Twentieth Century: Anthony Caro', *Sunday Times Magazine*, 15 June 1969, p.62

Frederic Tutin: 'Brazil Saõ Paolo 10', *Arts Magazine*, Nov. 1969, pp.50–1

R.H. Fuchs: 'Omtrent Anthony Caro', *Museumjournaal*, Feb. 1970, vol.15 no.1, pp.24–30 (English summary pp.54–5)

Christopher Andreae: 'The home forum', *Christian Science Monitor*, 14 April 1970

W.D. [= Willis Domingo]: 'In the galleries: Anthony Caro at Emmerich', *Arts Magazine*, May 1970, vol.44 no.7, p.66

John Russell: 'Closing the gaps' [review of Emmerich Gallery exh.], *Art News*, May 1970, vol.69 no.3, pp.37–9; repr. in Richard Whelan: *Anthony Caro*, Penguin 1974

Gene Baro: 'Caro', *Vogue* (New York), May 1970, pp.208–11, 276

'Contrasts by Caro', *Observer Magazine*, 15 May 1970, p.11

Hilton Kramer: 'A promise of greatness from Anthony Caro', *New York Times*, 17 May 1970; repr. in *International Herald Tribune*, 22 May 1970

Paul Overy: 'British sculptors and American reviewers', *Financial Times*, 21 Aug. 1970

Michael Fried: 'Caro's Abstractness', *Artforum*, Sept. 1970, vol.9 no.1, pp.32–34; repr. in Richard Whelan: *Anthony Caro*, Penguin 1974; repr. in *Art & Objecthood*, Chicago University Press 1998, pp.189–92

Bruce McLean: 'Not even crimble crumble' [review of ICA exh. *British sculpture out of the Sixties*], *Studio International*, Oct. 1970, vol.180 no.926, pp.156–9

Norbert Lynton: 'British art today', *Smithsonian*, Nov. 1970, pp.38–47

Neil Marshall: 'Anthony Caro's "Clearing", The David Mirvish Gallery, Toronto', *Artscanada*, Feb.–Mar. 1971, no.152–3, p.61

Charles Harrison: 'Virgin soils and old land', *Studio International*, May 1971, vol.181 no.933, pp.201–5

James R. Mellow: 'How Caro welds metal and influences sculpture', *New York Times*, 18 July 1971, p.D21

Edward Lucie-Smith: [incl. review of Kasmin Gallery exh.], *Sunday Times*, 6 Sept. 1971

Hilary Spurling: 'Art' [incl. review of Kasmin Gallery exh.], *Observer*, 26 Sept. 1971

Edward Henning: 'Anthony Caro: Wending back', *Bulletin of the Cleveland Museum of Art*, Oct.1971, vol.58, no.8, pp.239–43

W. Neil Marshall: 'Anthony Caro at David Mirvish', *Studio International*, Dec. 1971, vol.182 no.939, pp.254–5

Kay Kritzwiser: 'A high quality package of old & new', *Toronto Globe & Mail*, 29 Jan. 1972

David Shirey: 'Caro's steel constructions on view', *New York Times*, 26 Feb. 1972, p.25

J.S. [= Jeanne Siegel]: 'Reviews and previews: Anthony Caro', *Art News*, Apr. 1972, vol.71 no.2, p.12

Joseph Masheck: 'A note on Caro influence: five sculptors from Bennington', *Artforum*, April 1972, vol.10 no.8, pp.72–5

Barbara Rose: 'Through modern sculpture, from Matisse to Caro', *Vogue* (New York), April 1972, p.30

Irving Sandler: 'Anthony Caro at Emmerich', *Art in America*, May–June 1972, vol.60 no.3, p.35

Phyllis Tuchman: 'An interview with Anthony Caro', *Artforum*, June 1972, vol.10 no.10, pp.56–8; repr. in Richard Whelan: *Anthony Caro*, Penguin 1974; French extract repr. in exh. cat. *Anthony Caro: oeuvres 1961–1989*, Calais 1990, pp.43–5; repr. in *Likovne sveske*, no.8, University of Belgrade 1985, pp.130–7

Walter D. Bannard: 'Caro's new sculpture', *Artforum*, June 1972, vol.10 no.10, pp.59–64

Kay Kritzwiser: 'Sleek shapes in the Sculpture Courts', *Toronto Globe & Mail*, 22 July 1972

Jane Harrison Cone: 'Smith and Caro: Sculptures at Museum', *Baltimore Museum of Art Record*, Nov. 1972, p.4

John Russell: 'A sense of order' [review of Kasmin Gallery exh.], *Sunday Times*, 12 Nov. 1972

Peter Stone: 'Serene and subtle', *Jewish Chronicle*, 17 Nov. 1972

Guy Brett: [incl. review of Kasmin Gallery exh.], *Times*, 21 Nov. 1972

Marina Vaizey: 'Carpets and Caro', *Financial Times*, 30 Nov. 1972

'Uneasy' [review of Kasmin Gallery exh.], *Evening Standard*, 1 Dec. 1972

John McLean: 'Through the screen' [review of Kasmin Gallery exh.], *Guardian*, 5 Dec. 1972

Nigel Gosling: [incl. review of Kasmin Gallery exh.], *Observer*, 9 Dec. 1972

John Elderfield: 'New sculpture by Anthony Caro' [review of Kasmin Gallery exh.], *Studio International*, Feb. 1973, vol.185 no. 952, pp.71–4

Hilton Kramer: 'Anthony Caro', *New York Times*, 26 May 1973

E.A.C. [= E.A. Carmean, Jr.]: 'Anthony Caro's Night Road', *Museum of Fine Arts, Houston, Bulletin*, Fall 1973, vol.4 no.3, pp.46–51

Peter Frank: 'Anthony Caro' [review of exh. at Emmerich Gallery], *Art News*, Sept. 1973, vol.72 no.7, pp.85–6

Jeremy Gilbert-Rolfe: 'Anthony Caro, André Emmerich Gallery uptown', *Artforum*, Sept. 1973, vol.12 no.1, pp.87–8

Kenneth Baker: 'Anthony Caro: meaning in place', *Arts Magazine*, Sept.–Oct. 1973, vol.48 no.1, pp.21–7

Richard Findlater: 'Signposts through the labyrinth', *Observer Magazine*, 2 Sept. 1973, pp.19–27

Hamilton Wood: 'Weighty sculptures on the terrace', *Eastern Evening News*, 22 Oct. 1973

Richard Cork: 'Make mine a double sculpture', *Evening Standard*, 1 Dec. 1973

B. Diamonstein: 'Caro, De Kooning, Indiana, Motherwell and Nevelson on Picasso's influence', *Art News*, Apr. 1974, pp.44–6

Barry Martin: 'New work: Anthony Caro', *Studio International*, Apr. 1974, vol.187 no.965, pp.202–3

Hayden Herrera: 'Anthony Caro' [review of Emmerich Gallery exh.], *Art News*, May 1974, vol.73 no.5, pp.92, 95

William Feaver: 'Anthony Caro', *Art International*, 20 May 1974, pp.24–5, 33–4

Rolf-Gunter Dienst: 'Anthony Caro' [review of Zürich exh.], *Das Kunstwerk*, July 1974, vol.27 no.4, p.33

Terry Grimley: 'The evolution of Anthony Caro', *Birmingham Post*, 3 Aug. 1974

Joseph Masheck: 'Reflections on Caro's Englishness', *Studio International*, Sept. 1974, vol.188 no.969, pp.93–6

Matthew Lewin: 'Steel in Adam style', *Hampstead & Highgate Express*, 13 Sept. 1974, p.42

Marina Vaizey: 'Contemporary celebrations' [review of Kenwood exh.], *Sunday Times*, 15 Sept. 1974

Caroline Tisdall: 'Caro' [review of Kenwood exh.], *Guardian*, 17 Sept. 1974

Richard Cork: 'Sculpture back on a pedestal', *Evening Standard*, 19 Sept. 1974, p.30

Oswell Blakeston: 'Anthony Caro' [review of Kenwood exh.], *Arts Review*, 20 Sept. 1974, vol.26 no.19, p.563

Peter Stone: 'For the top of the table', *Jewish Chronicle*, 20 Sept. 1974

Sarah Kent: 'Hanging around', *Time Out*, 20–26 Sept. 1974, pp.21–2

Evan Anthony: 'Acts of Caro' [review of Kenwood exh.], *Spectator*, 21 Sept. 1974

Michael Shepherd: 'Inside yourself' [review of Kenwood exh.], *Sunday Telegraph*, 22 Sept. 1974

William Feaver: 'Anthony Caro' [review of Kenwood exh.], *Financial Times*, 25 Sept. 1974

Margaret Richards: 'Caro's coffee-table sculptures', *Tribune*, 27 Sept. 1974

Sarah Kent: 'Why make 'em?', *Time Out*, 25–31 Oct. 1974, p.18

Lynda Morris: 'The 'Garage' enterprise', *Studio International*, Nov. 1974, vol.188 no.971, pp.196–197

Suzi Gablik: 'Anthony Caro at Kenwood', *Art in America*, Nov.–Dec. 1974, vol.62 no.6, p.126

John McLean: 'Table sculptures by Anthony Caro', *Art Spectrum*, Jan. 1975

Roald Nasgaard: 'Simultaneous activity: the current work of Anthony Caro', *Arts Magazine*, Jan. 1975, vol.49 no.5, pp.71–3

Hilary Chapman: 'Anthony Caro's table top sculptures', *Arts Magazine*, Feb. 1975, vol.49 no.6, pp.64–6

Barbara Rose: 'Anthony Caro: the last great Cubist sculptor', *Vogue* (New York), April 1975

Alan G. Artner: 'Two shows rate a place in Britain's top drawer', *Chicago Tribune*, 20 Apr. 1975

Amei Wallach: 'A show that makes Anthony Caro free to be nutty', *Newsday*, 27 Apr. 1975, pp.21–2

Kenneth Baker: 'Morality in steel', *Atlantic*, May 1975, vol.235 no.5, pp.91–4

Lawrence Alloway: [review of monograph by William Rubin], *Nation*, May 1975

R.F.: 'The sculpture of Anthony Caro', *Pictures on Exhibit*, May–June 1975

Barry Martin: 'On the occasion of Anthony Caro's retrospective exhibition' [review of New York exh.], *Studio International*, May–June 1975, vol.189 no.975, pp.233–5

John Russell: 'Art: Fine Caro sculptures', *New York Times*, 3 May 1975

Robert Hughes: 'Caro: heavy metal', *Time*, 5 May 1975, pp.58–9

Hilton Kramer: 'Is Caro our best sculptor?', *New York Times*, 11 May 1975, p.31

Julian Weissman: 'Anthony Caro: metal heavyweight', *The Press*, 12 May 1975, vol.3 no.7, p.16

John Gruen: 'On art: Anthony Caro', *Soho Weekly News*, 15 May 1975

Moira Hodgson: 'An interview with Anthony Caro', *Soho Weekly News*, 15 May 1975

William Rubin: 'Kramer on Caro', *New York Times*, 18 May 1975, p.D35

Dorothy Gallagher: 'Anthony Caro – pushing the limits of sculpture', *New York Times*, 18 May 1975, pp.D1, D35

John Russell: 'Grand scale' [review of New York exh.], *Sunday Times*, 18 May 1975

David Bourdon: 'Anthony Caro', *Village Voice*, 19 May 1975

Kirk Varnedoe: 'Intellectual subtlety in constructed steel', *Art News*, Summer 1975, pp.38–40

Barbaralee Diamonstein: 'The reluctant modernist', *Art News*, Summer 1975, vol.74 no.6, pp.40–1

Emmie Donadio: 'Anthony Caro', *Arts Magazine*, June 1975, p.31

Guy Northrop: 'Living with art', *Memphis Commercial Appeal*, 8 June 1975, p.14

Thomas B. Hess: 'Monumental privacy', *New York Magazine*, 9 June 1975, pp.76, 79

Judith Helfer: 'Caros abstrakte Skulpturen', *Augbau*, 13 June 1975

Carter Ratcliff: 'New York', *Art International*, 15 June 1975, pp.36–42, 101–5 (ref. pp.102–5)

Ingeborg Hoesterey: 'Caro im MOMA', *Art International*, 15 June 1975, pp.78–9, 108

John Daxland: 'Metal sculpture at Art Museum', *New York Daily News*, 15 June 1975, p.20

Bill Marvel: 'Caro, steel man and scavenger, enlarges a tradition', *National Observer*, 28 June 1975

Nigel Gosling: 'British stars and Scythian gold', *Observer*, 29 June 1975

Harold Rosenberg: 'Lyric steel', *New Yorker*, 7 July 1975, pp.72–4

Douglas Davis: 'King Caro?', *Newsweek*, 21 July 1975, p.43

Caroline Tisdall: 'In the genius tradition', *Guardian*, 24 July 1975

Judy Ruenitz: 'Anthony Caro', *Vogue* (Australia), Aug. 1975

Roy M. Close: 'Remolded self led to constructed art', *Minneapolis Star*, 12 Sept. 1975, p.B2

Dorothy Gallagher: '"Dreamy Kid" became heir to modernists', *Minneapolis Tribune*, 14 Sept. 1975, p.D4

Charlotte Moser: 'Britain's Caro sitting on top sculpture 'ship'', *Houston Chronicle*, 16 Sept. 1975

Roy M. Close: 'Sculptor Caro's exhibition bares weight of excellence', *Minneapolis Star*, 17 Sept. 1975

Mimi Crossley: 'In Caro's corner', *Houston Post*, 21 Sept. 1975, p.8

'Kunst: Caros späte Deutschland-Premiere', *Der Spiegel*, 24 Nov. 1975, no.48

Herbert Albrecht: 'Hamburg: Anthony Caro', *Die Welt*, 10 Dec. 1975

Petra Kipphoff: 'Hamburg: Anthony Caro', *Die Zeit*, 12 Dec. 1975, no.51

Peter Winter: 'Anthony Caro' [review of Hamburg exh.], *Das Kunstwerk*, Jan. 1976, vol.29 no.1, p.60

Timothy Hilton: 'Re-inventing sculpture' [review of monograph by William Rubin], *Times Literary Supplement*, 27 Feb. 1976, p.237

'Boston Museum exhibits works of Anthony Caro', *Rochester Argus & Jamaica Plain Citizen*, 4 Mar. 1976; repr. in *Antiques & The Arts Weekly & The Bee*, 12 Mar. 1976

'The floor is part of the composition', *Whitman Times*, 13 Mar. 1976

Kenneth Baker: 'Anthony Caro: pushing beyond Picasso', *Boston Phoenix*, 30 Mar. 1976, section 2, p.9

'Sculpture of Caro exhibit salutes Britain', *Whitman Times*, 8 Apr. 1976

[review of Lefevre Gallery exh.], *Observer*, 25 Apr. 1976

[review of Lefevre Gallery exh.], *Sunday Times*, 25 Apr. 1976

Paul Overy: 'Anthony Caro: the soft option' [review of Lefevre Gallery exh.], *Times*, 4 May 1976

John McEwen: 'Steel pastries' [review of Lefevre Gallery exh.], *Spectator*, 8 May 1976, p.27

Peter Winter: 'Anthony Caro: Galerie von Wentzel, Hamburg', *Das Kunstwerk*, Jan. 1976, vol.29 no.1, p.60

Tim Hilton: 'Re-inventing sculpture', *Times Literary Supplement*, 27 Feb. 1976

Robert Taylor: 'British sculptor Caro brilliant at MFA', *Boston Sunday Globe*, 28 Mar. 1976, pp.A8, A15

Robert Garrett: 'A one-man movement of his own', *Boston Sunday Herald Advertiser*, 28 Mar. 1976, pp.A25, A29

Bonny Saulnier: 'Anthony Caro: his work is really worth the fanfare', *Patriot Ledger*, 31 Mar. 1976, p.52

Ann Philips: 'Caro's sculptures: junk piles turned to art', *Cambridge Chronicle*, 22 Apr. 1976

William Feaver: 'Signals from a lost world', *Observer*, 25 Apr. 1976

Marina Vaizey: 'Private faces, public faces', *Sunday Times*, 25 Apr. 1976, p.35

Paul Overy: 'Anthony Caro: the soft option', *Times*, 4 May 1976

John McEwen: 'Steel pastries', *Spectator*, 8 May 1976, p.27

Kay Kritzwiser: 'Beautiful but brutal steel on the grasslands at York', *Toronto Globe & Mail*, 11 June 1976

Michael Greenwood: 'Caro and the picturesque', *Artscanada*, Oct.–Nov. 1976, no.208/209, pp.50–2

Karen Wilkin: 'Anthony Caro and Bernini', *New Lugano Review*, Nov.–Dec. 1976

Peter White: 'Caro's new language in abstract sculpture', *Toronto Globe & Mail*, 26 Nov. 1976

Peter Fuller: 'Anthony Caro' [review of monograph by William Rubin], *Studio International*, Jan.–Feb. 1977, vol.193 no.985, pp.70–3

Jacques Michel: 'Le fer en direct d'Anthony Caro', *Le Monde*, 24 Feb. 1977, p.15

Gilles Plazy: 'Caro à l'horizontale', *Le Quotidien de Paris*, 24 Feb. 1977

Michael Fried: 'Anthony Caro's table sculptures', *Arts Magazine*, Mar. 1977, vol.51 no.7, pp.94–7; previously publ.in exh. cat. *Table sculptures 1966–1977*, London: British Council 1977; repr. in Dieter Blume: *Anthony Caro: catalogue raisonné*, vol.I, Cologne: Galerie Wentzel 1981, pp.21–35

Pierre Faveton: 'Caro', *Connaissance des Arts*, Mar. 1977

Serge Bramly: 'Anthony Caro à Paris', *Echo Thérapie*, Mar. 1977

Sylvain Lecombre: 'Une sculpture par assemblage', *Info Artitude*, Mar. 1977

M.–Cl. V.: 'Anthony Caro', *Les nouvelle litteraires*, 3 Mar. 1977

Georgina Oliver: 'Caro and Hernandez: the swastika connection between a spaced-out Hell's Angel and a visionary apostle', *Metro*, 5 Mar. 1977, p.20

O.H.: 'Anthony Caro', *L'Express*, 7–13 Mar. 1977

Ann Hindry: 'Anthony Caro: un abstraction maximale: interview', *Art Press*, Apr. 1977, no.6 (n.s.), pp.12–13

Gil Goldfine: 'Caro's table sculptures', *Jerusalem Post*, 22 Apr. 1977

Hilton Kramer: 'Art: Anthony Caro adds new forms', *New York Times*, 6 May 1977

'Contrasts by Caro' [on National Gallery exh.], *Observer Magazine*, 15 May 1977, p.11

Marina Vaizey: 'All the fun of the fair', *Sunday Times*, 29 May 1977

Linda Talbot: 'A masterly selection', *Hampstead & Highgate Express*, 3 June 1977

Paul Flather: 'The artist's eye' [review of National Gallery exh.], *Arts Review*, 10 June 1977, p.398

John Spurling: 'Anything you can do …' [review of Battersea Park exh.], *New Statesman*, 10 June 1977, p.781

[Max Wykes-Joyce]: 'The artist's eye', *International Herald Tribune*, 11–12 June 1977

Marina Vaizey: 'The greatness of Henry Moore', *Sunday Times*, 12 June 1977

[review of National Gallery exh.], *Sunday Times*, 12 June 1977, p.39

Paul Overy: 'Henry Moore – a time to reassess', *Times*, 14 June 1977

William Packer: 'Caro's choice' [review of National Gallery exh.], *Financial Times*, 18 June 1977

Dominique Fourcade: 'Anthony Caro', *Art International*, July–Aug. 1977, vol.21 no.4, pp.9–13

John Spurling: 'Skittish' [review of National Gallery exh.], *New Statesman*, 1 July 1977, pp.30–1

W. Stephen Gilbert: 'Aquarius', *Observer*, 10 July 1977, p.29

Kenneth Eastaugh: 'Aquarius – The artist's eye', *Times*, 16 July 1977

Kenneth Robinson: 'Not Caro mio' [review of 'Aquarius' documentary programme on London Weekend Television, 17 July 1977], *Listener*, 21 July 1977, pp.74–5

John Russell: 'A Caro amid the masters', *New York Times*, 21 July 1977

Noel Frackman: 'Anthony Caro' [review of Emmerich Gallery exh.], *Arts Magazine*, Sept. 1977, vol.52 no.1, pp.16–17

Harold Osborne: 'Anthony Caro: Waddington and Tooth Gallery', *Arts Review*, 16 Sept. 1977, pp.566–7

Robert Taylor: 'Caro's work remains inventive, provocative', *Boston Sunday Globe*, 19 Mar. 1978

Gordon Rintoul: 'Creating unity out of the junk culture', *The Australian*, 10 Apr. 1978

'Anthony Caro, Ben Nicholson: Galerie André Emmerich', *Neue Zürcher Zeitung*, 10 Apr. 1978, no.82

Mary Eagle: 'Caro sitting at the head of the table', *The Age*, 10 May 1978

Memory Holloway: 'Caro lays that macho image to rest', *The Australian*, 10 May 1978

Ian McKay: 'Caro table sculptures', *Art and Australia*, Winter, June 1978, vol.15 no.4, p.354

Lutz Haufschild: 'Conversations with Anthony Caro, I: At Emma Lake: Douglas Bentham, Terry Fenton, Anthony Caro and Lutz Haufschild', *Artmagazine*, June 1978, no.38/39, pp.30–2

Andrew Hudson: 'Conversations with Anthony Caro, II: London and Washington: Anthony Caro and Andrew Hudson', *Artmagazine*, June 1978, no.38/39, pp.33–5

Alan Artner: 'Caro fashions show of sculptural might', *Chicago Tribune*, 25 June 1978

Camilla Snyder: 'Q&A: working with steel', *Los Angeles Herald Examiner*, 12 Aug. 1978, pp.A–1, A–9

Michael Ritzer-Andres: 'Abstrakte Stahlskulpturen von Anthony Caro', *Hamburger Abendblatt*, 3 Oct. 1978

Karen Wilkin: 'Anthony Caro's Emma Lake sculptures', *Arts Magazine*, Nov. 1978, vol.53 no.3, pp.152–3

Eric Gibson: 'Anthony Caro' [review of Emmerich exh.], *Art International*, Nov.–Dec. 1978, vol.22 no.7, pp.70–1

Hilton Kramer: 'Anthony Caro', *New York Times*, 10 Nov. 1978

Tim Hilton: 'Case of astonishing fertility' [review of Knoedler Gallery exh.], *Observer*, 17 Dec. 1978, p.18

William Packer: 'Two sculptors – Flanagan and Caro' [incl. review of Knoedler Gallery exh.], *Financial Times*, 19 Dec. 1978, p.13

Peter Fuller: 'Anthony Caro' [interview], *Art Monthly*, Feb. 1979, no.23, pp.6–15; repr. in Dieter Blume: *Anthony Caro: catalogue raisonné*, vol.3, Cologne: Galerie Wentzel 1981, pp.7–47; repr. in Likovne sveske, no.8, University of Belgrade 1985, pp.137–66

Wade Saunders: 'Anthony Caro at Emmerich', *Art in America*, Mar.–Apr. 1979, vol.67 no.2, pp.151–2

Colin Booth: 'The Caro/Fuller "duel"' [letter in response to interview in issue of Feb. 1979], *Art Monthly*, May 1979, no.26, p.23

Jürgen Schilling: 'Anthony Caro: Versuch einer Bestimmung', *Heute-Kunst International Arts Review*, June–July 1979, no.25, pp.12–13

Pat Gilmour: 'The art that doesn't play to the gallery', *Guardian*, 26 Sept. 1979, p.12

Peter Fuller: 'Stockwell Depot', *Art Monthly*, Oct. 1979, no.30, pp.14–17

John Russell: 'André Emmerich', *New York Times*, 16 Nov. 1979, p.C20

'Anthony Caro, Emmerich Gallery', *Art World*, 17 Nov.–15 Dec. 1979, p.10

Emmie Donadio: 'David Smith's legacy: the view from Prospect Mountain', *Arts Magazine*, Dec. 1979, vol.54 no.4, pp.154–7

Richard Whelan: [review of Emmerich Gallery exh.], *Art News*, Feb. 1980, vol.79 no.2, p.196

Madeleine Deschamps: 'Julio Gonzalez, David Smith, Anthony Caro, Tim Scott, Michael Steiner : la sculpture de fer ou la fuite du centre', *Art Press*, Mar. 1980, no.35, pp.5–7

Robert Taylor: 'A first for sculpture in Boston', *Boston Globe*, 17 Aug. 1980

Christopher Andreae: 'On the edge of the impossible', *Christian Science Monitor*, 18 Aug. 1980, pp.20–1

Theodore F. Wolff: 'Art that speaks for itself: the Caro sculptures', *Christian Science Monitor*, 21 Aug. 1980, pp.13, 15

Phyllis Tuchman: 'Recent Caro', *Bennington Review*, Sept. 1980, pp.58–62

John Russell: 'Anthony Caro's show – a historic event', *New York Times*, 7 Sept. 1980, p.D33

Günther Wirth: 'Vermählung mit dem Raum', *Stuttgart Zeitung*, 18 Sept. 1980

John Izbicki: '"Cycle-rack"' sculpture defended by artist', *Daily Telegraph*, 24 Oct. 1980, p.19

Jean-Marie Benoist: 'L'art du fer', *Connaissance des arts*, Nov. 1980, no.345, pp.72–7

Hilton Kramer: [review of Acquavella exh.], *New York Times*, 5 Dec. 1980

Deanna Petherbridge: 'A sculpture for all seasons', *Architectural Review*, Feb. 1981, vol.169 no.1008, pp.98–103

Kenneth Baker: 'Heavy metal' [review of installation at Christian Science Center, Boston], *Art in America*, Mar. 1981, vol.69 no.3, pp.81–87

Laurel Enright: 'Anthony Caro: tradition and innovation', *Artswest*, June 1981, vol.6 no.6, pp.36–7

Waldemar Januszczak: 'Unnatural practices' [incl. review of Kenwood exh.], *Guardian*, 9 June 1981, p.9

Graham Hughes: 'Anthony Caro' [interview], *Arts Review*, 19 June 1981, p.248

William Feaver: 'Shimmers, stripes and sherds' [incl. review of Kenwood exh.], *Observer*, 21 June 1981, p.35

William Packer: 'Caro and Pietsch' [incl. review of Kenwood exh.], *Financial Times*, 30 June 1981, p.17

John Roberts: 'Reviews' [incl. review of *Objects and sculptures* exh. at Arnolfini and ICA], *Artscribe*, Aug. 1981, no.30, p.50–3

Carola Hahn: 'Riesenspielzeuge aus dem Stahlbaukasten', *Frankfurter Allgemeine Zeitung*, 29 Aug. 1981, no.199, p.25

John McEwen: 'Conjuror' [review of Kenwood exh.], *Spectator*, 29 Aug. 1981, pp.26–7

Kay Larson: 'The steel-plated theories of Anthony Caro', *New York Magazine*, 7 Sept. 1981, pp.58–9

Yorick Blumenfeld: 'Artist's dialogue: a conversation with Anthony Caro', *Architectural Digest*, Sept. 1981, pp.64–72

Felicity Redgrave: 'Sculpture '81 at Halifax/Dartmouth Sites', *Artmagazine*, Nov.–Dec. 1981, no.56, pp.57–8

Stuart Morgan: 'Anthony Caro, Kenwood House', *Artforum*, Dec. 1981, vol.20 no.4, pp.80–1

Terry Friedman: 'Introducing Caro and Paolozzi', *Leeds Arts Calendar*, 1982, no.91, pp.21–7

Lorenz Dittmann: 'Die Skulpturen Anthony Caros', *Neue Saarheimat*, 1982, no.12, pp.331–4

John Russell: 'Anthony Caro', *New York Times*, 15 Jan. 1982

Drew Fitzhugh: 'Anthony Caro's bronzes', *Arts Magazine*, Feb. 1982, vol.56 no.6, pp.83–5

Ruth Bass: 'Anthony Caro' [review of Emmerich Gallery exh.], *Art News*, Apr. 1982, vol.81 no.4, p.215

Matthew Collings: 'Anthony Caro' [review of monograph by Diane Waldman], *Artscribe*, June 1982, no.35, p.68

Tim Hilton: 'A profusion of steel' [review of monograph by Diane Waldman], *Times Literary Supplement*, 4 June 1982, pp.599–600

Tim Scott: 'Anthony Caro' [review of monograph by Diane Waldman], *Art Monthly*, July–Aug. 1982, no.58, p.32

Peter Fuller: 'Emperor unclothed' [review of monograph by Diane Waldman], *Art Book Review*, [Oct.] 1982, vol.1 no.3, pp.60–2

Bernhard Kerber: 'Skulptur und Farbe', *Kunstforum International*, 1983, vol.60 no.4, pp.25–104 (ref. pp.48, 64–5)

Alexandra Anderson: 'The new Bronze Age', *Portfolio*, Mar.–Apr. 1983, vol.5 no.2, pp.78–83

Waldemar Januszczak: 'Anthony Caro' [review of Waddington and Knoelder exhs., *Guardian*, 4 Mar. 1983, p.11

Marina Vaizey: 'How Caro makes his world go round' [review of Waddington and Knoedler exhs.], *Sunday Times*, 6 Mar. 1983, p.43

Roger Berthoud: 'Chipping away at the old block' [interview], *Times*, 11 Mar. 1983, p.13

William Feaver: 'Whitechapel all-sorts' [incl. review of Waddington and Knoedler exhs.], *Observer*, 13 Mar. 1983, p.30

John McEwen: 'Carissimoore' [review of Waddington and Knoedler exhs.], *Spectator*, 19 Mar. 1983, pp.30–1

D.C.P.[= Deborah Phillips]: 'New editions: Anthony Caro', *Art News*, Apr. 1983, vol.82 no.4, pp.89–90

Michael Billam: 'Anthony Caro at Waddington's & Knoedler', *Artscribe*, Apr. 1983, no.40, pp.44–5

Peter Fuller: 'A black cloud over the Hayward' [review of *The sculpture show*], *Art Monthly*, Oct. 1983, no.70, pp.12–13

Robert Ayers: 'Sculpture placed', *Artscribe*, Oct. 1983, no.43, pp.63–6

Karen Wilkin: 'David Smith and Anthony Caro', *Harper's Bazaar*, Mar. 1984, p.62

Phil Patton: 'Unpublic sculpture', *Art News*, Apr. 1984, vol.83 no.4, pp.82–7

Waldemar Januszczak: 'Hard truths told in metal' [review of Serpentine Gallery exh.], *Guardian*, 14 Apr. 1984, p.10

Michael Shepherd: 'Subtlety of steel' [review of Serpentine Gallery exh.], *Sunday Telegraph*, 15 Apr. 1984, p.13

Marina Vaizey: 'The master of heavy metal' [review of Serpentine Gallery exh.], *Sunday Times*, 15 Apr. 1984, p.35

William Feaver: 'Senior sculptor' [review of Serpentine Gallery exh.], *Observer*, 22 Apr. 1984, p.20

John Russell Taylor: 'Anthony Caro: sculpture 1969–84' [review of Serpentine Gallery exh.], *Times*, 24 Apr. 1984, p.8

Mary Rose Beaumont: 'Anthony Caro, Serpentine Gallery', *Arts Review*, 27 Apr. 1984, p.201

John Spurling: 'Saved!' [review of Serpetine Gallery exh.], *New Statesman*, 27 Apr. 1984, p.24

Kate Singleton: 'Anthony Caro, from scrap steel to "Sun Feast"', *Wall Street Journal*, 27 Apr. 1984

John Glaves-Smith, Peter Fuller: 'Caro's sculpture – two viewpoints' [reviews of Serpentine Gallery exh.], *Art Monthly*, May 1984, no.76, pp.3–5

'Anthony Caro's market', *Art Newsletter*, 1 May 1984, pp.5–6

William Packer: 'Anthony Caro at the cross-roads' [review of Serpetine Gallery exh.], *Financial Times*, 1 May 1984, p.19

Terence Mullaly: 'Caro's cold logic' [review of Serpentine Gallery exh.], *DailyTelegraph*, 23 May 1984, p.15

Walter Darby Bannard: 'Anthony Caro's new sculpture', *Arts Magazine*, Summer 1984, vol.58 no.10, pp.128–30

Mike Westlake: 'Outstanding sculpture exhibition', *The Artful Reporter*, June 1984, no.69

John Russell: 'Art: Anthony Caro commuting British sculptor', *New York Times*, 1 June 1984, p.C23

James E. Cooper: 'Caro invests power and beauty in his huge steel sculpture', *New York Tribune*, 8 June 1984, p.B7

Jack Harris: 'Rust is beautiful' [review of Serpentine Gallery exh.], *Guardian*, 9 June 1984, p.9

Ram Ahronov, Sarah Kent: 'High-tech: craft and Caro', *Architectural Review*, July 1984, vol.176 no.1049, pp.19–23

Robert Ayers: 'Anthony Caro at the Serpentine, John Davies at Marlborough', *Artscribe*, July–Aug. 1984, no.47, pp.62–3

Christopher Andreae: 'When steel floats', *Christian Science Monitor*, 17 July 1984, p.34

John Robinson: 'Anthony Caro' [review of Emmerich Gallery exh.], *Arts Magazine*, Sept. 1984, vol.59 no.1, p.33

Irene McManus: 'King of table mountain' [review of Leeds exh.], *Guardian*, 4 Sept. 1984, p.9

Phyllis Tuchman: 'An Interview with Anthony Caro', *Art in America*, Oct. 1984, vol.72 no.9, pp.146–53; Spanish trans. in cat. of exh. in Iglesia de San Esteban, La Lonja and Galeria Soledad, 1986

Jeanne Silverthorne: 'Anthony Caro' [review of Acquavella exh.], *Artforum*, Nov. 1984, vol.23 no.3, pp.96–7

Michael Brenson: 'A lively renaissance for sculpture in bronze', *New York Times*, 4 Nov. 1984, p.H29

David Matlock: 'Sculpture by experience', *Sculptors International*, Dec. 1984–Jan. 1985,vol.3, no.6, pp.3, 8–9, 28

Renate Puvogel: 'Anthony Caro: Skulpturen 1969–84' [review of Dusseldorf and Cologne exhs.], *Das Kunstwerk*, Apr. 1985, vol.38 no.2, pp.62–64

Ernst-Gerhard Güse: 'Anthony Caro: "Shade", *Das Kunstwerk des Monats* (Westfalisches Landesmuseum für Kunst und Kulturgeschichte, Münster), June 1985, pp.1–3

Michael Brenson: 'How sculpture freed itself from the past', *New York Times*, 15 Dec. 1985, p.H39

Kenworth Moffett: 'Anthony Caro: André Emmerich Gallery', *Moffett's Artletter*, 1986, vol.I no.2, p.8

Roland Bothmer: 'Anthony Caro – "Carriage" und "Source"', *Pantheon*, 1986, pp.164–70

John Russell: 'Art: Anthony Caro at Emmerich Gallery', *New York Times*, 21 Mar. 1986, p.C24

John Daxland: 'Artist "steeling" the show', *New York Daily News*, 27 Mar. 1986, p.M14

James F. Cooper: 'Caro's Expressionist sculpture does more with more', *New York City Tribune*, 28 Mar. 1986, p.12

Michael Brenson: 'An Abstract sculptor returns to the figure', *New York Times*, 18 May 1986, p.H31

Jack Flam: 'Abstract master embraces the figure', *Wall Street Journal*, 20 May 1986, p.26

Kenworth Moffett: 'Anthony Caro: from the figure', *Moffett's Artletter*, June 1986, vol.I no.4, pp.2–3

Ellen Lee Klein: 'Anthony Caro' [review of Acquavella exh.], *Arts Magazine*, Oct. 1986, vol.61 no.2, p.124

John Russell Taylor: 'A phantasmal presence after the old master' [incl. review of Waddington and Knoedler exhs.], *Times*, 7 Oct. 1986, p.23

Sarah Kent: 'Anthony Caro' [review of Waddington and Knoedler exhs.], *Time Out*, 8–15 Oct. 1986, p.45

William Packer: 'Creators of the shape and space' [incl. review of Waddington and Knoedler exhs.], *Financial Times*, 14 Oct. 1986, p.19

Peter Fuller: 'Modern sculpture: a contradiction in terms', *Art & Design, Sculpture Today*, 1987, vol.3 nos.11/12

Milton Grundy: 'Looking at sculpture' [interview], *Warwick Arts Trust Review*, Spring–Summer 1987

Alistair Hicks: 'Caro', *Antique*, Summer 1987, pp.48–9

Hilton Kramer: 'A rare sculptor who succeeds with color', *New York Observer*, 13 Mar. 1988, p.12

John Russell: 'A Greek temple that inspired steel sculptures', *New York Times*, 29 May 1988, pp.29, 38

Catherine Ferbos: 'Sculpture "in between" – le paysage', *Artstudio*, Autumn 1988, no.10, pp.20–5

Peter Fuller: 'Anthony Caro talks about Henry Moore' [interview], *Modern Painters*, Autumn 1988, vol.1 no.3, pp.6–13

Karen Wilkin: 'At the galleries' [review of exh. in Emmerich Gallery], *Partisan Review*, 1989, no.3

Martin Filler: 'Sir Anthony Caro creates a new and startling version of the English garden folly: sculpitecture', *House & Garden* (US ed.), Mar. 1989, pp.174–5

Deyan Sudjic: 'Caro in the round' [cover-title: 'Anthony Caro turns architect'], *Blueprint*, Apr. 1989, no.56, pp.1, 48–51

Karen Wilkin: 'Caro country', *Architectural Digest*, Aug. 1989, vol.46 no.8, pp.192–7, 218–20

Glynn Williams: 'Anthony Caro' [review of Annely Juda and Knoedler exhs.], *Modern Painters*, Autumn 1989, vol.2 no.3, pp.89–91

'Looking at Anthony Caro, reading Anthony Caro', *Space* (Korea), Sept.–Oct. 1989

Mark Stevens: 'Sculpted essences', *New Republic*, 4 Sept. 1989

David Lee: 'Galleries' [review of Annely Juda & Knoedler exhs.], *Times*, 23 Sept. 1989, p.48

Tim Hilton: 'A double first for Caro', *Guardian*, 27 Sept. 1989

James Yood: 'Anthony Caro – Richard Gray Gallery', *Artforum*, Oct. 1989, vol.28 no.2, p.180

Peter Fuller: 'Drawing away from the revolution' [review of Annely Juda and Knoedler exhs.], *Daily Telegraph*, 1 Oct. 1989, p.42

Marina Vaizey: 'Sailing off into a space of his own' [review of Annely Juda add Knoedler exhs.], *Sunday Times*, 1 Oct. 1989, p.C9

Andrew Graham–Dixon: 'The naming of the parts' [review of Annely Juda and Knoedler exhs.], *Independent*, 3 Oct. 1989, p.17

Dalya Alberge: 'Building from scrap metal' [interview], *Independent*, 3 Oct. 1989, p.35

Sacha Craddock: 'The metal manipulator' [review of Annely Juda and Knoedler exhs.], *Guardian*, 9 Oct. 1989, p.37

Richard Cork: 'Weld disposed' [review of Annely Juda and Knoedler exhs.], *Listener*, 12 Oct. 1989, p.37

Matthew Lewin: 'Caro breaks the language barrier', *Hampstead & Highgate Express*, 13 Oct. 1989, p.95

Tom Lubbock: 'Celebrating nature in steel and leaves' [incl. review of Annely Juda and Knoedler exhs.], *Sunday Correspondent*, 15 Oct. 1989, p.38

Brian Sewell: 'Crucified in cold steel' [incl. review of Annely Juda and Knoedler exhs.], *Evening Standard*, 19 Oct. 1989, p.29

Larry Berryman: 'Anthony Caro: recent sculpture 1981–89' [review of Annely Juda and Knoedler exhs.], *Arts Review*, 20 Oct. 1989, vol.41 no.21, pp.735, 738

Barry Fealdman: 'Steeling the imagination', *Jewish Chronicle*, 20 Oct. 1989

John Russell Taylor: 'Generous spirit of imagination' [review of Annely Juda and Knoedler exhs.], *Times*, 20 Oct. 1989, p.18

Heidi Burklin: 'Eiserne Zwitterwesen – Wenn Stahl über Tische kriecht: Anthony Caro in London', *Die Welt*, 21 Oct. 1989

Giles Auty: 'Feeling in form' [incl. review of Annely Juda and Knoedler exhs.], *Spectator*, 21 Oct. 1989, pp.40–1

Vincent McGourty: 'Caro: sculpture and space', *Newsline*, 28 Oct. 1989

Tim Marlow: 'Anthony Caro' [review of Annely Juda and Knoedler exhs.], *Art Monthly*, Nov. 1989, no.131, pp.25–26

Andrew Wilson: 'Sculpture post Caro' [incl. review of Annely Juda and Knoedler Gallery exhs.], *Galleries*, Nov. 1989, vol.7 no.6, p.18

David Lillington: 'Aspects of Anthony Caro' [review of Annely Juda and Knoedler exhs.], *Time Out*, 1–8 Nov. 1989, p.31

Yasuyoshi Saito: 'Anthony Caro: the grace and savagery of iron', *Mizue*, Winter 1990, no.957, pp.23–9

Caroline Smulders: 'Anthony Caro – l'apesanteur accomplie', *Art Press*, Apr. 1990, no.146, pp.26–9

Serge Sautreau: 'Anthony Caro: Le tain sur le miroir / The silvering in the mirror', *Cimaise*, Apr.–May 1990, vol.36 no.205, pp.129–32

Tim Marlow: 'Iconic and iconoclastic: Anthony Caro', *Tema Celeste*, Apr.–June 1990, no.25, pp.40–3

Philippe Sprang: 'Une sculpture arrive de New York' and 'Caro le sculpteur de la realité', *Le Figaro La Defense*, 2 Apr. 1990

Tim Hilton: 'Anthony Caro, gentleman ferrailleur', *Beaux Arts*, May 1990, no.79, pp.72–9

Marielle Ernould-Gandouet: 'Paris: Anthony Caro' [review of Galerie Lelong exh.], *L'Oeil*, May 1990, no.418, p.89

Christopher Hume: 'Light shines through sculptor's heavy metal', *Toronto Star*, 15 June 1990

Tim Hilton: 'Soul in the iron' [review of Calais exh.], *Guardian*, 27 June 1990, p.38

Philippe Piguet: 'Anthony Caro: entre deux continents', *Le Quotidien de Paris*, 16 Aug. 1990

Alice Aycock: 'Anthony Caro', *Mizue*, Autumn 1990, no.956

Anthony O'Hear: 'Anthony Caro talks about Eduardo Chillida with Anthony O'Hear' [interview], *Modern Painters*, Autumn/Sept. 1990, vol.3 no.3, pp.56–7, 61

Catherine Fayet: 'Anthony Caro: oeuvres 1961–1989' [review of Calais exh.], *Arte Factum*, Nov.–Dec. 1990–Jan. 1991, vol.7 no.36, p.38

Nigel Reynolds: 'Top sculptor rejects election to Royal Academy', *Daily Telegraph*, 5 Nov. 1990

John Skelton: 'Great artist's quandary over standards at RA' [letter], *Daily Telegraph*, 6 Nov. 1990

David Lister: 'Sculptor's decision on Royal Academy election "a sad loss"', *Independent*, 6 Nov. 1990, p.3

Joe Joseph, Simon Tait: 'Sculptor blames "ill-chosen" shows for snub to RA', *Times*, 6 Nov. 1990

'Caro and Piccadilly Circus', *Guardian*, 7 Nov. 1990

Nick Kettles: 'Anthony Caro: my working day', *Network Magazine* (Polytechnic of Central London), Winter 1991

Hugh Pearman: 'Restless figure on a private mission' [interview], *Sunday Times*, 10 Mar. 1991, pp.52–3

Anthony O'Hear: 'At issue: Caro on teaching: education or training?', *Modern Painters*, Autumn 1991, vol.4 no.3, pp.77–9

Tim Marlow: 'Man of steel on his mettle' [preview of Tate exh.], *RA Magazine*, Autumn 1991, no.32, p.14

Paul Overy: 'Lions & unicorns: the Britishness of postwar British sculpture', *Art in America*, Sept. 1991, vol.79, no.9, pp.104–11, 153–5 (ref. pp.107, 153–54)

Gabriele Magnani: 'Sulle due rive dell'Atlantico ;a scultura si chiama Anthony Caro. Nel 1993 un tour mondiale' [review of Tate and Emmerich Gallery exhs.], *Arte*, Oct. 1991, p.37

R.B.: 'Caro's sculpitecture' [review of Tate exh.], *Art Newspaper*, Oct. 1991

Roger Berthoud: 'Before and after Henry' [interview], *Independent on Sunday*, 6 Oct. 1991, pp.14–15

Laurence Marks: 'Right a bit into the jaws of hell, please' [review of Tate and Annely Juda exhs.], *Observer Review*, 6 Oct. 1991, p.56

James Hall: 'Heavy metal' [review of Tate, Annely Juda and Knoedler exhibs.], *New Statesman & Society*, 11 Oct. 1991, p.20

'Chips off an old block: Key notes: Sir Anthony Caro', *Weekend Times*, 12 Oct. 1991, p.3

Hugh Pearman: 'Caro's adult adventure playground steels the scene' [review of Tate exh.], *Sunday Times*, 13 Oct. 1991, pp.10–11

Richard Cork: 'The man who built a tower for the Tate' [interview], *Times*, 14 Oct. 1991, p.13

Tim Hilton: 'Symphonies of ruin' [review of Tate exh.], *Guardian*, 16 Oct. 1991, p.38

Richard Cork: 'Steely vessels in a marble sea' [review of Tate and Annely Juda exhs.], *Times*, 18 Oct. 1991, p.12

Tom Lubbock: 'Heavy metal and the elder statesman' [review of Tate, Annely Juda and Knoedler exhs.], *Independent on Sunday*, 20 Oct. 1991

John McEwen: 'Better going up than sideways' [incl. review of Tate and Annely Juda exhs.], *Sunday Telegraph*, 20 Oct. 1991, p.xvi

William Packer: 'Sculpture married to architecture' [review of Tate exh.], *Financial Times*, 22 Oct. 1991, p.17

'Anthony Caro: Sculpture towards architecture – "no barriers and no regulations"' [review of Tate exh.], *News Line*, 22 Oct. 1991, p.9

Sarah Kent: 'Art of steel' [review of Tate, Annely Juda and Knoedler exhs.], *Time Out*, 23–30 Oct. 1991, p.41

Sarah Kent: 'Steel plates' [review of Tate exh.], *Time Out*, 23–30 Oct. 1991, p.49

Richard Dorment: 'Of course it's clever, but is it art?' [review of Tate exh.], *Daily Telegraph*, 24 Oct. 1991, p.15

Matthew Collings: 'Art reviews' [incl. review of Tate exh.], *City Limits*, 24–31 Oct. 1991, p.18

Giles Auty: 'Beings versus Behemoths' [incl. review of Tate exh.], *Spectator*, 26 Oct. 1991, pp.46–8

Rebecca Hubbard: 'Beauty and the beasts' ['Relative values' series, interview with Anthony and Tim Caro], *Sunday Times*, 26 Oct. 1991

Daniel Farson: 'Folly good fun at the steel works', *Mail on Sunday*, 27 Oct. 1991

William Feaver: 'Let there be light fittings', *Observer*, 27 Oct. 1991, p.58

Andrew Graham-Dixon: 'Piecing it together' [review of Tate exh.], *Independent*, 29 Oct. 1991, p.18

James Dunnett: 'Processed Caro' [review of Tate, Annely Juda and Knoedler exhs.], *Architects Journal*, 30 Oct. 1991, pp.82–3

'Can Opener sculpture arrives at Quay', *Bournemouth Evening Echo*, 30 Oct. 1991

Tim Marlow: 'Caro' [review of Tate, Annely Juda and Knoedler exhibs.], *Art Monthly*, Nov. 1991, no.151, p.23

Conor Joyce: 'Non troppo Caro', *Artscribe*, Nov.–Dec. 1991, no.89, p.117

Linda Talbot: 'Tower of strength' [incl. review of Tate and Annely Juda exhs.], *Hampstead & Highgate Express*, 1 Nov. 1991

Geraldine Norman: 'Works fuel debate on meaning of "sculpture"', *Independent*, 4 Nov. 1991

Brian Sewell: 'Bursting point' [review of Tate exh.], *Evening Standard*, 7 Nov. 1991, p.30

'Man of steel', *Poole & Dorset Advertiser*, 7 Nov. 1991

Clare Henry: 'Tramway sees a Caro on the horizon', *Glasgow Herald*, 12 Nov. 1991

Charles Hall: 'Caro' [review of Tate, Annely Juda and Knoedler exhs.], *Arts Review*, 15 Nov. 1991, vol.43 no.23, p.572

'Arts chief to unveil quayside sculpture', *Evening Echo* (Bournemouth and Poole), 18 Nov. 1991

John Jacob: 'Substance of an abstract artist' [review of monograph by Karen Wilkin], *Hampstead & Highgate Express*, 22 Nov. 1991

Peter Fischer: 'Architektur und Skulptur kreuzen sich' [review of Tate exh.], *Hannoversche Allgemeine Zeitung*, 25 Nov. 1991

'Rusty clutter or art?', *North Londoner*, 28–9 Nov. 1991, p.20

Paul Overy: 'Tate shows Anthony Caro's "Sculpitecture"', *Journal of Art*, 9 Dec. 1991

Robin Dutt: 'Tower of strength' [review of Tate exh.], *What's on in London*, 11–18 Dec. 1991, p.16

Tom Roberts & Anthony Caro: 'Caro sculpture, Poole Quay – history of the making', *Bulletin* (Poole Arts Council Magazine), Winter 1992

Ennio Pouchard: 'Caro, l'archiscultore: alla Tate Gallery di Londra le opera dell'artista piu amato in Inghilterra, ex assistente di Moore', *Giornale di Sicilia*, 22 Jan. 1992

Robyn Denny: 'Hang-ups: why Robyn Denny finds Caro's "Octagon Tower" so "English, pompous and vain"', *Independent*, 4 Feb. 1992, p.15

Michael Corris: 'Sir Anthony Caro and his critics', *Artforum*, Mar. 1992, vol.30 no.7, pp.62–5

Tom Roberts, AC: 'Sea music', *Arts Review*, Mar. 1992, vol.44 no.3, pp.70–2

Lidia Lombardi: 'I Mercati Traianei dal letargo alla Rinascita', *Il Tempo*, Mar. 1992

Emma Dexter: 'Anthony Caro, Tate Gallery, London', *Sculpture*, Mar.–Apr. 1992, vol.11 no.2, p.70

Roger Bevan: 'Caro on up the Forum, dear' [review of Rome exh.], *Art Newspaper*, May 1992, vol.3 no.18, p.5

David Cohen: 'The apotheosis of Caro' [review of Dieter Blume catalogue raisonné and monograph by Karen Wilkin], *Art Newspaper*, May 1992, vo.3 no.18, p.15

David Cohen: 'Breaking the mould that Moore broke', *Times Saturday Review*, 16 May 1992, pp.28–9

Franco Simongini: 'Acciaio e antichita: Anthony Caro, il piu grande scultore inglese vivente, espone ai Mercati Traianei', *Il Tempo*, 21 May 1992

William Packer: 'Caro triumphs in Rome', *Financial Times Weekend*, 23 May 1992, p.xvii

Adachiara Zevi: 'Caro: 'Dipingere l'acciaio. Per dargli luce.' [interview], *Corriere della Sera*, 24 May 1992

Silvia Dell'Orso: 'Trent'anni di sculture firmate da Caro', *La Repubblica*, 28 May 1992

Richard Cork: 'New light in an ancient setting' [review of Rome exh.], *Times*, 29 May 1992, p.3

Giuseppe Selvaggi: 'La scultura di Anthony Caro rovescia la Torre di Babele', *Il Giornale d'italia Arte*, 31 May 1992, p.19

Paul Barker: 'Magic toys in a Roman market' [review of Rome exh.], *Daily Telegraph*, 1 June 1992, p.17

Claudio Spandoni: 'Visioni di fine millennio in puro acciaio dipinto' [review of Rome exh.], *Il Resto del'Carlino*, 11 June 1992

Celia Lyttleton: 'Iron test of art in the market place' [review of Rome exh.], *The European*, 11–14 June 1992, p.22

Marina De Stasio: 'Le forme metalliche dipinte ed assemblate di Anthony Caro', *L'Unita*, 14 June 1992

Mary Rose Beaumont: 'Caro a Roma: sculpture by Anthony Caro', *Arts Review*, July 1992, vol.44 no.7, pp.286–7

Marina Vaizey: 'Public sculpture aired' [incl. review of Rome exh.], *RSA Journal*, Aug.–Sept. 1992, pp.633–4

Heathman: 'Italian summer's lease of life: Caro', *Hampstead & Highgate Express*, 14 Aug. 1992

Michael Dibdin: 'From Canova to Caro' [incl. review of exh. in Rome], *Modern Painters*, Autumn 1992, vol.5 no.3, pp.42–5

Rosanna Greenstreet: 'Anthony Caro' [questionnaire], *Guardian Weekend*, 31 Oct. 1992, p.54

Michael Gibson: 'Caro entre le chaud et le froid', *Connaissance des Arts*, Nov. 1992, no.489, pp.102–9

Gabriella Grasso: 'Rome: Anthony Caro' [review of exhs.in Mercati Traianei and Galleria Oddi Baglioni], *Tema Celeste*, Autumn 1992, no.37–8, p.100

Massimo Carboni: 'Anthony Caro, Mercati di Traiano', *Artforum*, Dec. 1992, vol.31 no.4, p.102

Geordie Greig: 'Heavy metal man', *Sunday Times*, 25 July 1993, p.12

Michael Fried: 'Anthony Caro: "Midday"', *Artforum*, Sept. 1993, vol.32 no.1, pp.138–9

Armelle Cloarec: '14 questions posées à des sculpteurs: réponses d'Anthony Caro', *Saxifrage*, Dec. 1993, no.3, pp.68–73

Tim Hilton: 'Out of the darkness came the light' [incl. review of monograph by Carandente], *Independent on Sunday*, 5 Dec. 1993, p.31

'Heathman': 'A busy 70th year for Caro', *Hampstead & Highgate Express*, 11 Feb. 1994

Elizabeth Lambert: 'Artist's dialogue: Sir Anthony Caro', *Architectural Digest*, Mar. 1994, pp.36–48

Anthony Thorncroft: 'Anthony Caro at Annely Juda', *Art & Auction*, Mar. 1994

Frank Whitford: 'Ups and downs of the birthday boys', *Daily Telegraph*, 4 Mar. 1994

James Hall: 'Testing the metal of Caro' [review of Kenwood and Annely Juda exhs.], *Guardian*, 11 Mar. 1994, p.6

William Packer: 'Bolted together in totemic splendour' [review of Kenwood and Annely Juda exhs.], *Financial Times*, 12 Mar. 1994, p.xvi

Tim Hilton: 'Still reckless after all these years', *Independent on Sunday*, 13 Mar. 1994, pp.24–5

Iain Gale: 'King of the dead and destroyed' [review of Kenwood exh.], *Independent*, 19 Mar. 1994, p.31

John McEwen: 'Tacking to the windward of fashion' [incl. review of Kenwood exh.], *Sunday Telegraph Review*, 20 Mar. 1994, p.27

Richard Cork: 'Memorials to an age of conflict' [review of Kenwood and Annely Juda exhs.], *Times*, 22 Mar. 1994, p.39

William Feaver: 'Warriors in the Orangery' [incl. review of Kenwood exh.], *Observer Review*, 27 Mar. 1994, p.8

Waldemar Januszczak: 'New ground for old battles' [review of Kenwood and Annely Juda exhs.], *Sunday Times*, 27 Mar. 1994, p.28

John Spurling: 'Heroes and Gods of Troy' [review of Kenwood and Annely Juda exhs.], *RA* (Royal Academy Magazine), Spring 1994, no.42, p.20

Tim Marlow: 'Anthony Caro' [interview], *Tate: The Art Magazine*, Spring 1994, no.2, pp.38–41

Marjorie Crossley: 'Artistic *times*' [letter], *Independent*, 1 Apr. 1994, p.15

Julia Weiner: 'Precious metal' [interview], *Jewish Chronicle*, 22 Apr. 1994, p.3

Nicholas Wegner: 'Anthony Caro', *What's on in London*, 4–11 May 1994

Alan G. Artner: 'Caro builds zones from architectural blocks', *Chicago Tribune*, 20 May 1994

William Zimmer: 'When colour and shape were a formal pair', *New York Times*, 22 May 1994

Anthony O'Hear: 'The Trojan War', *Modern Painters*, Summer 1994, vol.7 no.2, pp.90–1

Richard Shone: 'London: Spring exhibitions' [incl. review of Annely Juda exh.], *Burlington Magazine*, July 1994, vol.136 no.1096, pp.471–3

Barry Schwabsky: 'Irreplaceable hue', *Artforum*, Sept. 1994, vol.33 no.1, pp.90–7, 127 (ref. pp.96–7)

Lilly Wei: 'The prime of Sir Anthony Caro' [review of Emmerich Gallery exh.], *Art in America*, Sept. 1994, vol.82 no.9, pp.94–7

Nicholas Wegner: 'Steel Eye Span', *Art Monthly*, Dec. 1994–Jan. 1995, no.182, pp.20–2

John Russell Taylor: 'How a war takes shape' [incl. review of Yorkshire Sculpture Park exh.], *Times*, 1 Dec. 1994, p.38

Giles Smith: 'The sculpitect at home', *Independent*, 6 Dec. 1994, p.23

Karen Wilkin: 'Anthony Caro: The Trojan War', *American Ceramics*, 1995, vol.11 no.4, pp.18–27

David Cohen: 'The last Modernist: Sir Anthony Caro', *Sculpture*, Jan.–Feb. 1995, vol.14 no.1, pp.20–27

Robert Clark: 'Lightening up heavy metal' [review of Whitworth exh.], *Guardian*, 4 Jan. 1995, pp.6–7

Andrew Mead: 'Revealing the intimate side of Caro', *Architect's Journal*, 24 Apr. 1995

Deyan Sudjic: 'House, horse or hearse?' [review of Tokyo exh.], *Guardian*, 30 June 1995, p.11

Tim Hilton: 'World's foremost artist goes east' [review of Tokyo exh.], *Independent on Sunday*, 9 July 1995, p.23

William Packer: 'Sculptor bestrides the world' [review of Tokyo exh.], *Financial Times*, 11 July 1995, p.15

John Russell Taylor: 'At home, indoors and out' [incl. review of Tokyo exh.], *Times*, 21 July 1995, p.32

Bryan Robertson: 'A match for Matisse' [review of Tokyo exh.], *Spectator*, 29 July 1995, pp.34–5

Karen Wilkin: 'Smith and Caro', *Modern Painters*, Winter 1995, vol.8 no.4, pp.38–43

Tim Hilton: 'Artist of the year: Tokyo story', *Independent on Sunday*, 24 Dec. 1995, p.18

David Cohen: 'Caro East' [review of Tokyo exh.], *Art in America*, Jan. 1996, vol.84 no.1, pp.57–8

Dennis Duerden: 'Anthony Caro', *Contemporary Art*, Spring 1996, vol.3 no.2, pp.42–46

Katja Blomberg: 'Muscheln zu Metallschrott', *Frankfurter Allgemeine Zeitung*, 21 May 1996, no.117, p.39

Itzhak Goldberg: 'Henry Moore & Co' [review of Jeu de Paume exh.], *Beaux Arts*, June 1996, no.146, pp.56–76 (ref. pp.62–3, 65)

Maiten Bouisset: 'Promenade avec Anthony Caro', *L'Oeil*, July–Aug. 1996, no.481, pp.97–101

Mark Finch: 'A century of British sculpture' [review of Jeu de Paume exh.], *Contemporary Art*, Autumn 1996, no.13 [vol.4 no.1], pp.34–9

Karen Wilkin: 'British sculptors invade Paris', *Hudson Review,* Autumn 1996, vol.49 no.3, pp.457–62

Norbert Lynton: 'British sculpture in Paris' [review of Jeu de Paume exh.], *Modern Painters*, Autumn 1996, vol.9 no.3, pp.56–61

Tim Marlow: 'Man of steel', *Cam Magazine*, Lent Term 1997

Claude Laurent: 'Anthony Caro : structures sculpturales dans le paysage', *La Libre Culture*, 30 May 1997

Denis Gielen: 'Anthony Caro : la modernite retournée comme un gant', *Art et Culture*, 19 June 1997

'Anthony Caro to receive ISC Lifetime Achievement Award', *Sculpture*, Sept. 1997, vol.16 no.7, p.88

Phyllis Tuchman: 'Anthony Caro: sculpting space', *Sculpture*, Oct. 1997, vol.16 no.8, pp.18–23; repr. in exh. cat. *Anthony Caro: new sculptures*, Annely Juda Fine Art 1998, pp.9–17

Elisa Turner: 'Eminent sculptor's secret: living art night and day', *Miami Herald*, 21 Dec. 1997, p.41

Isabel Carlisle: 'Profile: Anthony Caro' [interview], *Blueprint*, Feb. 1998, no.147, pp.10–11

Hugh Pearman: 'The man who paints with steel', *Sunday Times*, Culture Section, 8 Feb. 1998, cover and pp.10–11

David Cohen: 'Anthony Caro invites you to lunch', *Independent* Saturday magazine, 21 Feb. 1998 pp.32–5

Joanna Pitman: 'No rules for the scrap metal man', *Times*, 23 Feb. 1998, p.18

Martin Gayford: 'Passion is lost in translation', *Daily Telegraph*, 25 Feb. 1998, p.18

Rachel Barnes: 'Building on tradition', *Independent*, 26 Feb. 1998, pp.4–5

William Packer: 'Classical austerity meets romance', *Financial Times*, 3 Mar. 1998, p.20

Richard Cork: 'From one old master to another', *Times*, 3 Mar. 1998, p.37

'Caro at the National Gallery – sculpture from painting', *Newsline*, 6 Mar. 1998, pp.6–7

Tim Hilton: 'Lunchtime on the grass with Caro', *Independent* on Sunday, 8 Mar. 1998, pp.20–21

Brian Sewell: 'Turning history into junk', *Evening Standard*, 12 Mar. 1998, pp.28–29

Russell Bingham: 'Interview: Anthony Caro', *Edmonton Review*, Spring 1998, vol.4 no.2, pp.1–8, 11

John Spurling: 'Spirit of optimism', *RA* (Royal Academy Magazine), Spring 1998, no.58, pp.16–17

Philip Henscher: 'Anthony Caro: new sculptures', *Mail on Sunday*, 12 Apr. 1998

Bill Bace: 'The greatest sculptural achievement of the 20th century', *Review* (New York), 15 Apr. 1998, cover and p.5

J. Bowyer Bell: 'Sir Anthony Caro: The Trojan War sculptures', *Review* (New York), 15 Apr. 1998, p.33

Karen Wilkin: 'Anthony Caro: National Gallery, Annely Juda', *Art News*, Summer 1998, vol.97 no.7, p.165

Isabel Carlisle: 'Fantasy in steel goes up in Holland Park', *Evening Standard*,16 June 1998, p.14

Brian Sewell: 'Picture this: Anthony Caro's promenade', *Evening Standard Hot Tickets magazine*, 7 July 1998, p.45

Nigel Spivey: 'Lord of the elves with a passion for the abstract', *Financial Times*, 8 Aug. 1998, p.3

Nonie Niesewand: 'Will Norman Foster and Anthony Caro cross the Thames in a blaze of glory', *Independent*, 25 Sept. 1998

Juliet Hardwicke: 'Sir Anthony Caro reflects on the work that first inspired his love of art', *Art Quarterly,* Summer 1999, p.80

Agi Katz: 'An artist's protest against atrocity', *Jewish Quarterly*, Summer 1999, pp.17–19

Lynn Barber: 'The scrap merchant', *Observer magazine*, 6 June 1999, pp.20–3

Dalya Alberge: 'Why art today is shocking – by our greatest sculptor', *Times*, 10 June 1999, p.19

Richard Cork: 'It's big, but it's not very clever', *Times*, 16 June 1999

John McEwen: 'War's shadow darkens Venice', *Sunday Telegraph*, 20 June 1999, p.9

William Packer: 'Parts add up to a coherent whole', *Financial Times*, 22 June 1999, p.20

Martin Gayford: 'The best is British' [review of Venice Biennale], *Spectator*, 26 June 1999, pp.46–7

Sarah Greenberg: 'The Marco Polo Biennale', *Art Newspaper*, July–Aug. 1999, vol.10 no.94, pp.30–3

Anna Maria Positano: 'Anthony Caro', *Ars*, Oct. 1999

Bryan Robertson: 'Colour as form: British sculpture in the '60s', *Modern Painters*, Winter 1999, vol.12 no.4, pp.30–4

James Hall: 'Clement Greenberg on English sculpture and Englishness', *Sculpture Journal*, 2000, vol.4, pp.172–7

Margaret Somerville: 'Sea Music: a sculpture on Poole Quayside by Sir Anthony Caro', *Dorset*, Apr. 2000, pp.22–3

Bryan Robertson: 'Britain gives the world its greatest', *Sunday Telegraph*, 30 Apr. 2000, p.8

Andrew Graham-Dixon: 'The art of success', *Vogue* (London), May 2000, pp.178–91

Martin Newman: 'Caro: man of steel', *Camden New Journal*, 25 May 2000, p.21; repr. in *West End Extra*, 26 May 2000 p.13

Helen Smithson: 'A tension span', *Hampstead & Highgate Express*, 16 June 2000, p.40

Eva Larrauri: 'El escultor británico Anthony Caro reinventa "El juicio final" en Bilbao', *El Pais*, 27 June 2000, p.53

Kosme De Baranano: 'Anthony Caro: El Juicio Final', *El Cultura (El Mondo)*, 28 June–4 July 2000, pp.26–7

José Luis Merino: 'La expresividad de AnthonyCaro', *El Pais*, 17 July 2000, p.8

Oliver Finegold: 'Artist's heartache over bridge of sighs', *Camden New Journal*, 23 Nov. 2000, p.19; repr. in *West End Extra*, 24 Nov. 2000, p.11

Jon Cronin: 'A bridge too far for Sir Anthony', *Hampstead & Highgate Express*, 24 Nov. 2000, p.17

Clare Henry: 'Symphony in brass, steel and wood' [interview], *Financial Times*, 20 Jan. 2001, p.vi

Mark Daniel Cohen: 'Sir Anthony Caro: Duccio Variations, Gold Blocks and Concerto Pieces', *Reviewny.com*, 1 Feb. 2001

'The commission that straitjacketed Caro', *New York Observer*, 5 Feb. 2001

Lawrence Weschler: 'The Duccio Variations', *Metro*polis, June 2001, pp.88–9

Elaine Williams: 'Sculpture: Sir Anthony Caro is coming to town', *Times Educational Supplement*, 29 June 2001, pp.19–20

Maev Kennedy: 'Caro lends weight to Regency rooms', *Guardian*, 2 July 2001, p.7

William Packer: 'A small but perfectly formed show', *New York Times*, 10 July 2001, p.20

John Spurling: 'Sculpture's message' [incl. review of Lewes exh.], *Spectator*, 28 July 2001, p.38

Richard Cork: 'Moving images: profile of Sir Anthony Caro', *Saturday Times Magazine*, 22 Sept. 2001, p.23

Paul Gough: 'Anthony Caro' [review of Atkinson Gallery, Millfield exh.], *Galleries*, Oct. 2001, vol.19 no.5, issue 222, p.21

Sebastian Smee: 'Sculpitecture: Sir Anthony Caro talks about pushing sculpture in the direction of architecture', *Art Newspaper*, Oct. 2001, vol.12 no.118, p.45

Karen Wilkin: 'Life after Formalism', *Art in America*, Nov. 2001, vol.89 no.10, pp.110–15, 159 (ref. pp.110–12)

Jeremy Hunt: 'Sir Anthony Caro: Sculpture and Sculpitecture', *Art & Architecture*, 2002, no. 56, pp.40–1

Brian McAvera: 'Influence, exchange, and stimulus: a conversation with Sir Anthony Caro', *Sculpture*, Mar. 2002, vol.21 no.2, pp.24–31

Paola F. Tavazzani: 'Anthony Caro: Galleria Lawrence Rubin', *Arte Critica*, Apr.–Sept. 2002, no.30–31, p.77

David Galloway: 'Anthony Caro: Hans Mayer', *ArtNews*, May 2002, vol.101 no.5, p.178

Carol Vogel: 'Caro's full circle', *New York Times*, 14 June 2002

Carly Berwick: 'Art talk: Anthony Caro' [replies to questionnaire], *ArtNews*, Oct. 2002, vol.101 no.9, p.38

Therese Nolan: 'Anthony Caro: The Barbarians', *Antiques & Collecting*, Nov. 2002

Adrian Dannatt: 'Caro lands in Manhattan', *Art Newspaper*, Nov. 2002, vol.13 no.130

Alberto Ruiz de Samaniego: 'La moral del arte' [interview], *Lapiz*, Nov.–Dec. 2002, vol.21 no.187–8, pp.48–53

Andrew Mead: 'Making a marriage', *Architect's Journal*, 14 Nov. 2002, pp.80–81

Roberta Smith: 'Art in review: Anthony Caro – Barbarians', *New York Times*, 13 Dec. 2002

Karen Wilkin: 'Late style Anthony Caro', *New Criterion*, Jan. 2003, vol.21 no.5, pp.40–5

Dalya Alberge: 'Anti-war feelings demonstrated through art', *Times*, 26 Feb. 2003, p.33

Barbara A. MacAdam: 'Anthony Caro: Mitchell-Innes & Nash', *Art News*, Mar. 2003, vol.102 no.3, p.115

Ann Elliott: 'Barbarians at the gate' [review of Annely Juda exh.], *Galleries*, Mar. 2003, vol.20 no.10, issue 239, p.21

Deirdre Fernand: 'The man with the golden horde', *Sunday Times Magazine*, 2 Mar. 2003, pp.40–43

Sarah Hemming: 'Anthony Caro: The Barbarians, Europa & The Bull and Paper Sculptures', *Daily Express*, 7 Mar. 2003

Helen Smithson: 'Caro on sculpting', *Hampstead & Highgate Express*, 7 Mar. 2003, pp.i–ii

John McEwen: 'Barbarians at the gates', *Evening Standard*, 11 Mar. 2003, p.39

Gerald Isaaman: 'Battle stations for men of war', *Camden New Journal*, 20 Mar. 2003, p.25

Morgan Falconer: 'Anthony Caro: The Barbarians, Europa and the Bull & Paper Sculptures', *What's on in London*, 26 Mar. 2003, p.25

Jonathan Goodman: 'New York: Anthony Caro: Mitchell-Innes & Nash', *Sculpture*, Apr. 2003, vol.22 no.3, pp.78–9

Sally O'Reilly: 'Anthony Caro: Annely Juda', *Time Out*, 2–9 Apr. 2003

Edward Leffingwell: 'Anthony Caro at Mitchell-Innes & Nash', *Art in America*, June 2003, vol.91 no.6, pp.120–1

Maev Kennedy: 'Caro is 80 – and still working', *Guardian*, 8 Mar. 2004

Tim Adams: 'Soldering on' [review of Kenwood exh.], *Observer*, 4 July 2004

Michael Glover: 'His stark materials' [interview], *Times*, 7 July 2004, p.15

Morgan Falconer: 'Weight-watching' [review of Kenwood exh.], *Architects' Journal*, 15 July 2004, vol.220 no.3, p.44

Karen Wright: 'Anthony Caro : metal guru' [interview], *Independent*, 18 July 2004

4/ Writings by the Artist

'The master sculptor: Henry Moore – an appreciation', *Observer Weekend Review,* 27 Nov. 1960, p.21

Anthony Caro, Kenneth Noland and Jules Olitski: 'Some excerpts from a conversation at Bennington, Vermont, USA', *Monad* (Chelsea Arts School Union), Jan. 1964, no.1, pp.18–22

[statement] in *Art Now:* New York, Sept. 1969, vol. 1 no.7, p.2

'Some thoughts after visiting Florence', *Art International,* 20 May 1974, pp.22–3; Italian trans. publ. in Giovanni Carandente: *Anthony Caro, Sonzogno:* Fabbri Editori 1992, pp.84–6

'Sculptors' replies' [incl. AC's response to a series of 5 questions dated 20 May 1976], *Artscribe,* Summer 1976, no.3, pp.8–10 (ref. p.8)

[preface], in *Anthony Caro,* Osaka: Gallery Kasahara, 1979 (cat. of exh.29 Jan.–17 Feb. 1979)

'Stockwell Depot' [letter in response to review by Peter Fuller in issue of Oct. 1979], *Art Monthly,* Dec. 1979–Jan. 1980, no.32, p.27

'It all depends …' [reply to survey asking about issues of particular relevance and the most important artists currently working], *Artscribe* No.27, Feb. 1981,pp.34–48 (ref. p.36)

[brief text], in Biennale 17, Middelheim, Antwerpen. Openluchtmuseum voor Beeldhouwkunst Middelheim, Antwerp (cat. of exh., 12 June–2 Oct. 1983), p.68

'How sculpture gets looked at', *A sense of place: sculpture in landscape,* Sutherland Arts Centre, Tyne and Wear,1984, p.42

[text], in *Four rooms: Howard Hodgkin, Marc Camille Chaimowicz, Richard Hamilton, Anthony Caro.* London: Arts Council 1984 (cat. of exh. at Liberty's, London; travelling to Wolverhampton, Southampton, Newport, Aberdeen and Sheffield)

'Art in jeopardy' [letter on proposed cuts in art education funding], *Times,* 12 Oct. 1984, p.14

'How artists are losing their 'made in England' cachet' [letter on proposed cuts in art education funding], *Guardian,* 13 Oct. 1984, p.14

[introduction], in *From the figure: bronzes and drawings by Anthony Caro,* cat. of exh. at Acquavella Contemporary Art, New York, 1986, p.4

[letter in response to review by Waldemar Januszczak in issue of 26 Feb.], *Guardian,* 20 Mar. 1986, p.14

'Artists on art: Anthony Caro: an appetite for art', *Update* (Edmonton Art Gallery), Summer 1986, vol.7 no.3, pp.13–14

[introduction], in *Triangle Artists Workshop Yearbook 1988,* Mashomac Fish & Game Preserve, Pine Plains, NY, p.4

[introduction], in *Anthony Caro: major new work,* exh. cat., Richard Gray Gallery, Chicago, 1989, p.5

'A lesson from the first King Charles', *Guardian,* 1 Jan. 1989

'The architecture of sculpture', *Blueprint,* June 1991, no.78, p.36

'Sea music', *Arts Review,* Mar. 1992, vol.44 no.3, pp.70–2 (ref. p.71)

'Michelangelo and Donatello: scale and presence', *Modern Painters,* Spring 1993, vol.6 no.1, pp.36–40

'Show prefers the trivial to the visual' [letter], *Independent,* 17 Sept. 1993

'The cube root' [review of *Picasso sculptor/painter* exh. at Tate Gallery], *Independent,* 11 Feb. 1994

'Anthony Caro, Robert Rosenblum and David Sylvester on Picasso as sculptor' [text of BBC Third Programme discussion broadcast on occasion of 1967 Picasso exh. at Tate Gallery], *Independent,* 11 Feb. 1994, vol.7 no.1

'The sculptural moment' [in series 'Sculptors on sculpture'; adapted from lecture given at Sotheby's Annual Conference of the Association of Art Historians, Leeds, 1992], *Sculpture,* Jan.–Feb. 1995, vol.14 no.1, pp.28–31

'When British sculptors found their voice' [abridged version of RSA lecture], *Daily Telegraph,* 20 May 1995

[text] in (introd.) David Mitchinson: *Celebrating Moore: works from the collection of the Henry Moore Foundation.* London: Lund Humphries, 1998

'Sculpture from painting', *Art News and Review,* 19 Feb. 1998, *Hot Tickets* magazine, pp.46–7

'Sir Anthony Caro's picture choice', *National Gallery News,* Mar. 1998, p.1

'My greatest ever …', *High Life* (British Airways magazine), May 1998

'Sculpture's new spaces', in Andrew Guest and Ray McKenzie (eds.) : *Dangerous ground: sculpture in the city* [text of papers presented at conference at Glasgow School of Art in Oct. 1997]. Edinburgh: Sculpture Trust, 1999; pp.13–15

'"Duccio Variations Nos 1 to 6"', *Tate,* Summer 2000, no.22, pp.52–3

'True colours' [interview with Hilly Janes about the work of Helen Frankenthaler], *Observer* Magazine, 4 June 2000, pp.26–9

'In the studio', in Karen Wilkin and Bruce Guenther: *Clement Greenberg: a critic's collection,* Portland Art Museum and Princeton University Press 2001 (published on the occasion of exh. at Portland Art Gallery, 14 July–16 Sept. 2001), p.13

'"Veduggio Light"', in Germano Celant (ed.): *Madly in love: the Luigi and Peppino Agrati Collection, Milan:* Skira Editore, 2002, pp.24–5

'Artist statement' [on the work *India* 1976, based on interview from 1991, revised 2001], in Sarah Clark-Langager: *Sculpture in place: a campus as site:* Western Washington University, Bellingham, Bellingham (WA): Western Washington University, 2002, pp.13–14

'The sculptural architecture of Mughal India', *World of Interiors,* Apr. 2002, pp.198–201

'Eduardo Chillida: lives remembered', *Times,* 30 Aug. 2002, p.33

'Art and the moral imperative', in Stephen Newton (ed.): *The Kingston & Winchester Papers* (London: Oneiros Books, 2003, pp.203–5

5 / Solo Exhibition Catalogues

1956
Galleria del Naviglio, Milan; introd. by Lawrence Alloway ('Caro and gravity', repr. in vol.4 of catalogue raisonné by Blume)

1957
Jan. *Paintings by Redvers Taylor, sculpture by Anthony Caro.* Gimpel Fils, London. 3p.

1963
Sept.–Oct. *Anthony Caro: sculpture 1960–1963.* Whitechapel Art Gallery, London; introd. by Michael Fried. 36p, illus.

1964
2–19 Dec. *Anthony Caro: first New York exhibition.* André Emmerich Gallery, New York. 4p, illus.

1965
24 Feb.–28 Mar. *Anthony Caro.* Washington Gallery of Modern Art, Washington; incl. reprint of text by Clement Greenberg. 4p, illus.

29 Oct.–. *Anthony Caro: recent sculpture.* Kasmin Limited, London. 4p, illus.

1966
David Mirvish Gallery, Toronto

8 Oct.–4 Nov. *Anthony Caro: Neue Skulpturen.* Galerie Bischopfberger, Zürich. 4p, illus.

André Emmerich Gallery, New York

1967
7 May–2 June. *Anthony Caro.* Rijksmuseum Kroller-Müller, Otterlo. 10p, illus.

Kasmin Limited, London

1968
André Emmerich Gallery, New York

1969
X Bienal de São Paulo: Gra-Bretanha 1969: Anthony Caro, John Hoyland. São Paulo (organised by British Council). 28p, illus.

24 Jan.–9 Mar. *Anthony Caro.* Hayward Gallery, London (organised by Arts Council of Great Britain). 80p, illus.

1970
2–21 May. *Anthony Caro: new sculpture.* André Emmerich Gallery, New York. 8p, illus.

1971
12 June–31 June. *Anthony Caro.* David Mirvish Gallery, Toronto. 8p, illus.

Kasmin Limited, London

1972
19 Feb.–8 Mar. *Anthony Caro: new sculpture.* André Emmerich Gallery, New York. 8p, illus.

Kasmin Limited, London

1973
25 May–29 June. *Anthony Caro: a special showing of the new table pieces.* André Emmerich Gallery, New York. 8p, illus.

13 Oct.–11 Nov. *Anthony Caro: exhibition of sculpture.* County Hall, Norwich (Norfolk and Norwich Triennial Festival). 8p, illus.

1974
André Emmerich Gallery, New York

4 May–9 June. *Anthony Caro: Neue Eisenplastiken / recent sculpture.* Galerie André Emmerich, Zürich. 8p, illus.

11 Sept.–20 Oct. *Anthony Caro: Table top sculptures 1973/4.* Iveagh Bequest, Kenwood, London. 20p, illus.

David Mirvish Gallery, Toronto

Galleria dell'Ariete, Milan

1975
30 Apr.–6 July. *Anthony Caro.* Museum of Modern Art, New York; text by William Rubin (republ. by Thames and Hudson, 1975). 196p, illus.

Walker Art Gallery, Minneapolis

Museum of Fine Arts, Houston

1976
Museum of Fine Arts, Boston

Watson de Nagy Gallery, Houston

Galerie Wentzel, Hamburg

Richard Gray Gallery, Chicago

22 Apr.–15 May. *Anthony Caro: new sculpture.* Lefevre Gallery, London. 8p, illus.

1977
Galerie Pfitzer-Rheims, Paris

Waddington and Tooth Galleries, London

12 Apr.–17 June. *Anthony Caro: Table sculptures 1966–1977.* Tel Aviv (touring exh. organised by British Council). 28p, illus.

30 Apr.–21 May. *Anthony Caro: new sculpture.* André Emmerich Gallery, New York. 8p, illus.

1 June–24 July. *The artist's eye: an exhibition selected by Anthony Caro.* National Gallery, London; incl. interview with AC. 6p, illus.

1978
31 Mar.–13 May. *Anthony Caro: Neue Plastiken.* Galerie André Emmerich, Zürich. 12p, illus.

27 Sept.–4 Nov. *Anthony Caro.* Galerie Wentzel, Hamburg; incl. extract from text by William Rubin, 1975. 12p, illus.

28 Oct.–15 Nov. *Anthony Caro: Emma Lake sculptures.* André Emmerich Gallery, New York. 8p, illus.

Harcus Krakow Gallery, Boston

15 Nov. *Writing pieces, by Anthony Caro.* Knoedler Gallery, London. 8p, illus.

Ace Gallery, Venice (CA)

Richard Gray Gallery, Chicago

1979
29 Jan.–17 Feb. *Anthony Caro.* Gallery Kasahara, Osaka. 20p, illus.

9 Feb.–4 Mar. *Anthony Caro: Tisch-Skulpturen 1966–1977.* Stadtische Kunsthalle Mannheim; text by Michael Fried. 60p, illus.

Kunstverein Frankfurt, Frankfurt-am-Main

18 May–1 July. *Anthony Caro: Table and related sculptures 1966–1977.* Kunstverein Braunschweig, Brunswick; introd. by Jürgen Schilling, Michael Fried; incl. catalogue raisonné. 268p, illus.

Stadtische Galerie im Lenbachhaus, Munich

Ace Gallery, Vancouver

André Emmerich Gallery, New York

1980

Anthony Caro: The York sculptures. Christian Science Center, Boston (organised by Museum of Fine Arts, Boston); incl. interview with AC. 40p, illus.

20 Nov.–31 Dec. *Anthony Caro: Bronze sculpture*. Acquavella Contemporary Art, New York. 48p, illus.

1981

27 Mar.–Apr. 1982. *Anthony Caro: 12 Skulpturen*. Stadelsches Kunstinstitut, Frankfurt-am-Main; introd. by Hannelore Kersting-Bleyl; incl. *Steel sculptures 1960–1980*: catalogue raisonné III. 250p, illus.

20 May–31 Oct. *Anthony Caro: sculptures*. Storm King Art Center, Mountainville (NY); introd. by Karen Wilkin. 16p, illus.

3 June–31 Aug. *Anthony Caro: recent bronzes 1976–81*. Iveagh Bequest, Kenwood, London; introd. by John Jacob. 28p, illus.

Waddington Galleries, London

Downstairs Gallery, Edmonton

Harcus Krakow Gallery, Boston

1982

9–30 Jan. *Anthony Caro: Bronze screens and Table sculptures*. André Emmerich Gallery, New York. 8p, illus.

27 Feb.–10 Apr. *Five sculptures by Anthony Caro*. Hunterian Art Gallery, Glasgow (organised by Arts Council; travelling to Huddersfield, Stoke-on-Trent, Hull, Rochdale and Colchester); introd. by Norbert Lynton. 32p, illus.

6 Mar.–29 May. *Anthony Caro: Bronzeskultpuren*. Galerie Wentzel, Cologne. 6p, illus.

Moderne Galerie im Saarland-Museum, Saarbrücken

Knoedler Gallery, London

13 Nov.–2 Dec. *Anthony Caro: recent bronze sculpture*. Gallery One, Toronto; introd. by Karen Wilkin. 8p, illus.

1983

2–26 Mar. *Anthony Caro: recent sculptures: steel and bronze*. Knoedler Gallery and Waddington Galleries, London; introd. by Christopher Andreae. 40p, illus.

Galerie de France, Paris

1984

10 Apr.–May. *Anthony Caro*. Knoedler Gallery, London. 2p, illus.

12 Apr.–28 May. *Anthony Caro: sculpture 1969–84*. Serpentine Gallery, London (organised by Arts Council; travelling to Whitworth Art Gallery, Manchester, 9 June–28 July 1984; Leeds City Art Gallery. 10 Aug.–23 Sept. 1984; Copenhagen, Düsseldorf and Barcelona); introd. by Tim Hilton. 84p, illus.

24 May–29 June. *Anthony Caro: an exhibition in honor of the artist's 60th birthday – 1982–1984: four phases: Bronze sculptures, The Pine Plains series, Steel sculptures, Painted lead & wood pieces*. Acquavella Galleries and André Emmerich Gallery, New York; introd. by André Emmerich. 48p, illus.

9 June–15 July. *Anthony Caro: sculpture and drawings*. Castlefield Gallery, Manchester; introd. by Mike Lyons. 6p, illus.

12 Oct.–18 Nov. *Anthony Caro: skulpturer 1969–1984*. Ordrupgaard, Copenhagen (organised by Arts Council of Great Britain, London; previously at Serpentine Gallery, London, 1984, Manchester and Leeds); introd. by Hanne Finsen, Tim Hilton. 48p, illus.

Martin Grand Gallery, Edmonton

Galerie Wentzel, Cologne

1985

27 Jan.–3 Mar. *Anthony Caro: Skulpturen 1969–84*. Kunstmuseum Düsseldorf (organised by Arts Council, London; previously at Serpentine Gallery, London, 1984, travelling to Manchester, Leeds and Copenhagen); introd. by Tim Hiton, Christiane Vielhaber. 108p, illus.

28 Jan.–20 Apr. *Anthony Caro: Skulpturen, Zeichnungen*. Galerie Wentzel, Cologne. 6p, illus.

21 Mar.–12 May. *Anthony Caro*. Fundació Joan Miró, Centre d'Estudis d'Art Contemporani, Barcelona (organised by British Council, London; previously in Serpentine Gallery, London, travelling to Manchester, Leeds, Copenhagen and Düsseldorf); introd. by Tim Hilton. 79p, illus.

23 Apr. –. *Anthony Caro: Skulpturen 1972–1984*. Galerie André Emmerich, Zürich. 6p, illus.

Constantine Grimaldis Gallery, Baltimore

Galerie Blanche, Stockholm

Galerie Lang, Malmö

Galerie Artek, Helsinki

Galleria Stendhal, Milan

Gallery One, Toronto

Norrkopings Museum

1986

26 Apr.–24 May. *From the figure: bronzes and drawings by Anthony Caro*. Acquavella Contemporary Art, New York: introd. by AC. 32p, illus.

6–29 Mar. *Anthony Caro: painted sculpture 1983–1985*. André Emmerich Gallery, New York. 28p, illus.

1–25 Oct. *Anthony Caro: recent sculptures*. Knoedler Gallery and Waddington Galleries, London; introd. by David Sylvester. 56p, illus.

14 Nov.–10 Dec. *Anthony Caro: escultures 1971–1985*. Iglesia de San Esteban, Murica (travelling to La Llonja, València); introd. by Clement Greenberg; incl. interview with AC. 48p, illus.

Commune di Bogliasco, Genoa

Galeria Joan Prats, Barcelona

1987

Mar.–Apr. *Anthony Caro: obra 1971–1985*. Galeria de Arte Soledad Lorenzo, Madrid; introd. by Clement Greenberg. 45p, illus.

1 Sept.–17 Oct. *Anthony Caro: sculpture and drawings*. Northern Centre for Contemporary Art, Sunderland. 6p, illus.

Constantine Grimaldis Gallery, Baltimore

1987–1988

Anthony Caro: bronzes and drawings from the figure. Gallery One, Toronto. introd. by Karen Wilkin

1988

29 Apr.–4 June. *Anthony Caro: neue Skulpturen*. Galerie Renée Ziegler, Zürich. 6p, illus.

30 Apr.–10 June. *Anthony Caro: The Greek series*. André Emmerich Gallery, New York; introd. by John Dorsey. 28p, illus.

Sylvia Cordish Fine Art, Baltimore

Elisabeth Franck Gallery, Knokke

Galerie Wentzel, Cologne

1989

14 Apr.–31 May. *Anthony Caro: major new work*. Richard Gray Gallery, Chicago; introd. by AC. 17p, illus.

23 May–30 June. *Anthony Caro: new sculpture*. André Emmerich Gallery, New York. 30p, illus.

29 Sept.–4 Nov. *Aspects of Anthony Caro: recent sculpture 1981–89*. Annely Juda Fine Art and Knoedler Gallery, London; introd. by Richard Rogers. 96p, illus.

Kathleen Laverty Gallery, Edmonton

Nabis Gallery, Seoul

Rutgers Barclay, Santa Fe (NM)

Galeria Sebastia Jané, Gerona

Anthony Caro: esculturas das séries Barcelona e Catalã. Fluxus Gallery, Porto; introd. by B. Pinto de Almeida

Galeria Acquavella, Caracas

Kasmin Limited, London

Anthony Caro 1963–1989. Walker Hill Art Centre, Seoul; introd. by Park Kae Hee, Um Tai Jung

Sala de Exposiciones de Banco Bilbao Vizcaya, Barcelona; introd. by Gloria Moure; incl. text by AC

Anthony Caro: works of the 1980s. Constantine Grimaldis Gallery, Baltimore; introd. by Charles Millard

1990

Anthony Caro: oeuvres 1961–1989. Musée des Beaux-Arts, Calais; introd. by Patrick Le Nouene

Galeria Charpa, Gandia, Valencia

Night movements. Galerie Lelong, Paris; introd. by Bernard Blistène

Paribas Bank, Huis Osterreich, Antwerp; introd. by Florent Bex.

Fuji Television Gallery, Tokyo; introd. by Seiji Oshima

Gallery Auka, Tokyo

29 Oct.–17 Nov. *Anthony Caro*. Gallery Kasahara, Osaka; introd. by Tadayasu Sakai. 40p, illus.

Anthony Caro: Barcelona sculpture. Gallery One, Toronto; introd. by Goldie Konopny, Karen Wilkin, David Mirvish

1991

16 Oct. –26 Jan. 1992. A*nthony Caro: Sculpture towards architecture*. Tate Gallery, London; text by Paul Moorhouse. 55p, illus.

Knoedler Gallery, London

22 Oct.–30 Nov. *Anthony Caro: The Cascades*. Annely Juda Fine Art, London; concurrently at André Emmerich Gallery, New York, 22 Oct.–16 Nov. 1991. 43p, illus.

16 Nov.–15 Jan. 1992. *Anthony Caro: Skulpturen*. Galerie Hans Mayer, Düsseldorf. 6p, illus.

Galerie Wentzel, Cologne

Nabis Gallery, Seoul

Kasmin Limited, London

1992

20 May–31 Aug. *Anthony Caro*. Mercati di Traiano, Rome (publ. Milan: Fabbri Editori); text by Giovanni Carandente. 119p, illus.

Anthony Caro. Veranneman Foundation, Kruishoutem; introd. by Hugo Brutin

Galleria Oddi Baglioni, Rome

Studio Marconi, Milan

Fuji Television Gallery, Tokyo

1993

Anthony Caro: The Cascades sculptures. British Council, London; text by Tim Marlow. 23p, illus.

Mucsarnok, Budapest

Museum of Art, Constanta (travelling to National Galleries, Bucharest)

1994

25 Jan.–25 Feb. *Anthony Caro*. Aksanat, Aktbank Kültür Sanat Eqilim Merkezi, Istanbul (organised by British Council); 25p, illus.; introd. by Tim Marlow; travelling to Devlet Güzel Sanatlar Galerisi, Ankara, 15–30 Mar. 1994; and to Devlet Resim ve Heykel Müzesi, Izmir, 4–14 Apr. 1994. 25p, illus.

Nicosia Municipal Art Centre, Nicosia

6 Mar.–6 Apr. *The Trojan War: sculptures by Anthony Caro*. Iveagh Bequest, Kenwood, London (publ. by Lund Humphries, London, in association with British Heritage and Yorkshire Sculpture Park); texts by John Spurling, Julius Bryant; travelling to Yorkshire Sculpture Park, West Bretton, Wakefield, Nov. 1994; 88p, illus.; enlarged 2nd ed. publ. 1997, 96p, illus.

8 Mar.–7 May. *Anthony Caro: Sculpture through five decades, 1955–1994: an exhibition to celebrate the artist's seventieth birthday*. Annely Juda Fine Art, London; introd. by Bryan Robertson. 104p, illus.

14 Apr.–27 May. *Anthony Caro: an exhibition of recent sculpture on the occasion of the artist's seventieth birthday*. André Emmerich Gallery, New York; introd. by Michael Fried. 24p, illus.

11 May–30 July. *Anthony Caro: The Zone series: bronzes*. Richard Gray Gallery, Chicago. 32p, illus.

31 May–15 Aug. *Anthony Caro: Skupturen: Fünf Jahrzehnte 1955–1994*. Galerie Hans Mayer, Düsseldorf. 4p, illus.

1995

30 June–3 Sept. *Anthony Caro*. Museum of Contemporary Art, Tokyo. 165p, illus.

Nov.–Mar. 1996. *Anthony Caro: Halifax steps*. Henry Moore Sculpture Trust Studio, Dean Clough, Halifax (publ. by Henry Moore Institute, Leeds); interview with Robert Hopper. 44p, illus.

1996

The Caros: a creative partnership: Sheila Girling and Anthony Caro. Chesil Gallery, Portland (Dorset); introd. by Margaret Somerville. 30p, illus.

1997

24 May–17 Aug. *Anthony Caro*. Openluchtmuseum voor Beeldhouwkunst, Antwerp; text by Tim Marlow. 78p, illus.

1998

25 Feb.–18 Apr. *Anthony Caro: new sculptures: a survey.* Annely Juda Fine Art, London; text by Phylis Tuchman. 144p., illus.

25 Feb.–4 May. *Caro at the National Gallery: sculpture from painting.* National Gallery, London; text by John Golding. 56p, illus.

2000
Atkinson Gallery, Millfield

2001
A sculptor's development: Anthony Caro. (publ. by Sculpture Exhibitions Ltd., Lewes); revised French version, Chateau-Musée de Dieppe, 2002

11 Jan.–9 Feb. *Anthony Caro: Duccio variations, Gold blocks, Concerto pieces.* Marlborough Gallery, New York. 39p, illus.

2002
Anthony Caro: drawing in space: sculptures from 1963–1988, The Last Judgement 1995–1999. Fundacio Caixa Catalunya, Barcelona; texts by Enrique Juncosa, Pepe Subiros, Eugenio Trias; incl. texts of 2 essays by AC.

1 Nov.–20 Dec. *Anthony Caro: The Barbarians.* Mitchell-Innes and Nash, New York; text by David Hickey; travelling to Annely Juda Fine Art, London, 5 Mar.–17 Apr. 2003. 57p, illus.

Anthony Caro. Metta Galeria, Madrid; introd. by F. Calvo Serraller

2003
6 Mar.–17 Apr. *Anthony Caro: Europa and the Bull, & Paper book sculptures.* Annely Juda Fine Art, London; text by Ian Barker. 35p, illus.

Anthony Caro: Escultures i obra sobre paper. Galeria Joan Prats, Barcelona; introd. by Joan De Muga

Anthony Caro: The Emma series and after. Frederik Meijer Gardens & Sculpture Park, Grand Rapids; introd. by Terry Fenton

Caro at Longside: Sculpture and Sculpitecture. Yorkshire Sculpture Park, Wakefield; interview by Peter Murray

6 / Group catalogues

1962
Joven escultura inglesa. Ateneo de Madrid.

1965
7 sculptors: Anthony Caro, John Chamberlain, Donald Judd, Alexander Liberman, Tina Malkovic, David Smith, Anne Truitt. Institute of Contemporary Art, Philadelphia

25 Feb.–4 Apr. *British sculpture in the Sixties.* Tate Gallery, London (organised by Contemporary Art Society)

Mar.–Apr. *The new generation 1965.* Whitechapel Gallery, London

1966
5 young British artists: Bernard Cohen, Harold Cohen, Robyn Denny, Richard Smith, Anthony Caro. 33rd Biennale di Venezia, British Pavilion.

Works by Anthony Caro, Bernard Cohen, Robyn Denny, Richard Smith. Kasmin Gallery, London

1967
14 Oct.–10 Nov. *Englische Kunst.* Galerie Bruno Bischofberger, Zürich.

1968
8 Jan.–11 Feb. *New British painting and sculpture.* UCLA Galleries, Los Angeles (organised by Whitechapel Art Gallery, London

1969
6 Nov.–6 Dec. *Stella, Noland, Caro.* Dayton's Gallery 12, Minneapolis

1974
6 Sept.–31 Oct. *Sculpture in steel.* Edmonton Art Gallery; travelling to David Mirvish Gallery, Toronto

1978
15 Dec.–10 Feb. 1979. *Sculpture.* Richard Hines Gallery, Seattle

1980
10–31 Oct. *The Poole Arts Centre modern art exhibition: Douglas Abercrombie, Anthony Caro, John Hoyland, Peter Lanyon, Fred Pollock, Alistair Michie.* Seldown Gallery, Poole Arts Centre.

5 Feb.–29 Mar. *Skulpturen der Moderne: Julio González, David Smith, Anthony Caro, Tim Scott, Michael Steiner.* Galerie de France, Paris (travelling to Bielefeld, Berlin, Hamburg, Ludwigshafen).

10 May–14 Sept. *Skulptur im 20. Jahrhundert.* Wenkenpark Riehen, Basel.

1981
11 Sept.–24 Jan. 1982 *British sculpture in the 20th Century.* Whitechapel Art Gallery, London

1982
18 Jan.–27 Feb. *Mixed show.* Knoedler Gallery, London.

27 Feb.–11 Apr. *Aspects of British art today.* Metropolitan Museum of Art, Tokyo (organised by British Council)

7 Sept.–2 Oct. *Six artists at the Brewhouse*: Abi Kremer, Charotte Moore, Carole Gibbons, Geoffrey Rigden, Alastair Michie, Anthony Caro. Brewhouse Theatre and Arts Centre, Taunton.

1983
12 June–2 Oct. *Biennale 17, Middelheim, Antwerpen.* Openluchtmuseum voor Beeldhouwkunst Middelheim, Antwerp; incl. brief text by AC.

1984
15 Jan.–26 Feb. *Six in bronze: Anthony Caro, Sandro Chia, Nancy Graves, Bryan Hunt, George Segal, Isaac Witkin.* Williams College Museum of Art, Williamstown (MA) (travelling to Pittsburgh and Columbus (OH)).

10 Feb.–10 Mar. *Four rooms: Howard Hodgkin, Marc Camille Chaimowicz, Richard Hamilton, Anthony Caro.* Liberty's, London (organised by Arts Council; travelling to Wolverhampton, Southampton, Newport, Aberdeen and Sheffield); incl. text by AC.

1985
22 Nov.–16 Feb. 1986. *Transformations in sculpture: four decades of American and European art.* Solomon R. Guggenheim Museum, New York.

1986
19 Feb.–27 Apr. *Forty years of modern art 1945–1985.* Tate Gallery, London.

29 Apr.–15 June. *Bodenskulptur.* Kunsthalle Bremen.

22 May–5 July. *British sculpture 1950–1965.* New Art Centre, London

3 July–13 Oct. *Qu'est-ce que la sculpture moderne?* Musee National d'Art Moderne, Centre Georges Pompidou, Paris.

1987
15 Jan.–5 Apr. *British Art in the 20th century: the Modern Movement.* Royal Academy of Arts, London (incl. essay by Susan Compton, 'Anthony Caro and Sixties Abstraction', pp.356–7)

23 Jan.–5 Apr. *A quiet revolution: British sculpture since 1965.* Museum of Contemporary Art, Chicago (travelling to San Francisco, Newport Beach (CA), Washington (Hirshhorn Museum and Sculpture Garden, 10 Nov. 1987–10 Jan. 1988) and Buffalo)

1988
16 July–28 Aug. *Made to measure.* Kettle's Yard, Cambridge.

1990
5–28 Apr. *The great decade: the 1960s: a selection of paintings and sculpture.* André Emmerich Gallery, New York.

1991
6–30 Nov. *Sculpture and sculptors' drawings.* William Jackson Gallery, London.

1992
Acquavella 1992. Acquavella Galleries, New York.

1992
A selection of works by Caro, Hull, Nevelson, Nicholson, Pomodoro, Rickey. Sigrid Freundorf Fine Art, New York.

1993
Partners. Annely Juda Fine Art, London.

Images of Christ. St Matthew's Church, Northampton.

1994
A changing world: fifty years of sculpture from the British Council Collection. State Russian Museum, St Petersburg

(publ. by British Council, London); travelling to Prague Castle Riding School, 28 June–3 Sept. 1995.

1995
Sculpture at Goodwood: 1. Sculpture at Goodwood, Goodwood (West Sussex)

19 June–2 July. *Here & now.* Serpentine Gallery, London.

7 Sept.–5 Nov. *Escultura Britanica contemporanea de Henry Moore a los años 90.* Fundaçao Serralves, Porto.

1996
British contemporary sculpture 96/97. Sculpture at Goodwood, Goodwood (West Sussex)

6 June–15 Sept. *Un siècle de sculpture anglaise.* Jeu de Paume, Paris.

29 June–29 Sept. *Platz und Platzzeichen: Anthony Caro, Eduardo Chillida, Robert Jacobsen, Bernhard Luginbühl.* Museum Würth, Küznelsau, and Stadtische Museum, Heilbronn.

28 Sept.–24 Nov. *Les champs de la sculpture.* Museum of Contemporary Art, Tokyo.

1997
A changed world: sculpture from Britain. British Council, London; in Pakistan, travelling to South Africa in 1998.

British contemporary sculpture 97/98. Sculpture at Goodwood, Goodwood (West Sussex)

1998
British figurative art, part two: sculpture. Flowers East, London (publ. by Momentum, London).

British contemporary sculpture. Sculpture at Goodwood, Goodwood (West Sussex)

British contemporary sculpture: drawings and models 94/98. Sculpture at Goodwood, Goodwood (West Sussex).

24 Nov.–7 Feb. 1999. *Forjar el espacio: la escultura forjada en el siglo XX [Forging space: 20th Century wrought iron sculpture].* Centro Atlántico de Arte Moderna, Las Palmas; travelling to IVAM Centre Julio González, Valencia, 4 Apr.–30 May 1999; and Musée des Beaux-Arts et de la Dentelle, Calais, 23 June–30 Sept. 1999.

1999
A dance of stillness (1 work). Sculpture at Goodwood, Goodwood (West Sussex)

1 Feb.–11 Apr. *Picasso, Léger, Nolde, Arp i inni: sztuka wspólczesna z Kolekcji Würth* [Picasso, Léger, Nolde, Arp and others: art of our century from the Würth Collection]. Muzeum Narodowe w Krakowie, Krakow.

1 July–27 Aug. *A line in painting, part one: British art.* Gallery Fine, London.

6 Oct.–6 Nov. *Colour sculpture: Britain in the Sixties.* Waddington Galleries, London.

13 Nov.–9 Jan. 2000. *'45–99: a personal view of British painting and sculpture.* Kettle's Yard, Cambridge; introd. by Bryan Robertson; travelling to Leicester Art Gallery, 15 Jan.–26 Feb. 2000.

2000
14 June–17 Sept. *Encounters: new art from the old.* National Gallery, London; text by Richard Morphet.

7 Oct.–12 Nov. *The eye of the storm.* Villa dei Laghi, Turin.

2001
14 July–16 Sept. *Clement Greenberg: a critic's collection.* Portland Art Museum, Portland (OR) (publ. by Portland Art Museum and Princeton University Press 2001); incl. text by AC, 'In the studio', p.13.

2002
14 Sept.–19 Jan. 2003. *Blast to Freeze: British art of the 20th century.* Kunstmuseum Wolfsburg; travelling to Les Abattoirs, Toulouse, 24 Feb.–11 May 2003.

2003
25 Oct.–18 Jan. 2004. *Einbildung: das Wahrnehmen in der Kunst / Imagination: perception in art.* Kunsthaus Graz am Landesmuseum Joanneum; text ed. by Peter Pakesch.

2004
Winter–Spring. *Turning points : 20th century British sculpture.* Tehran Museum of Contemporary Art (organised by British Council, London)

British art of the 20th century. Kunstmuseum Wolfsburg; travelling to Les Abattoirs, Toulouse, 24 Feb.–11 May 2003.

Index of works illustrated

Photographic credits

David Buckland; John Goldblatt; Annely Juda Fine
Art; Jorge Lewinski; Richard Davies; Kim Lim; John
Riddy; Tate Photography; Shigeo Anzai; John Webb

Photographs courtesy Anthony Caro/Barford
Sculptures Ltd, except:

© *Artforum*, February 1968, p.131
© Museum of Fine Arts, Houston, Texas, USA/
 www.bridgeman.co.uk, p.16
Private collection/ www.bridgeman.co.uk, p.16
Courtesy Regen Projects, Los Angeles/ Joshua
 White, pp.136, 137
© Photo SCALA, Florence, Museum of Modern Art
 (MOMA), New York, 2005, p.92

Supporting Tate

Tate relies on a large number of supporters – individuals, foundations, companies and public sector sources – to enable it to deliver its programme of activities, both on and off its gallery sites. This support is essential in order to acquire works of art for the Collection, run education, outreach and exhibition programmes, care for the Collection in storage and enable art to be displayed, both digitally and physically, inside and outside Tate. Your donation will make a real difference and enable others to enjoy Tate and its Collections both now and in the future. There are a variety of ways in which you can help support the Tate and also benefit as a UK or US taxpayer. Please contact us at:

The Development Office
Tate
Millbank
London SWIP 4RG
Tel: 020 7887 8945
Fax: 020 7887 8738

Tate American Fund
1285 Avenue of the Americas (35th fl)
New York
NY 10019
Tel: 001 212 713 8497
Fax: 001 212 713 8655

Donations

Donations, of whatever size, from individuals, companies and trusts are welcome, either to support particular areas of interest, or to contribute to general running costs.

Gifts of Shares

Since April 2000, we can accept gifts of quoted share and securities. These are not subject to capital gains tax. For higher rate taxpayers, a gift of shares saves income tax as well as capital gains tax. For further information please contact the Campaigns Section of the Development Office.

Tate Annual Fund

A donation to the Annual Fund at Tate benefits a variety of projects throughout the organisation, from the development of new conservation techniques to education programmes for people of all ages.

Gift Aid

Through Gift Aid, you can provide significant additional revenue to Tate. Gift Aid applies to gifts of any size, whether regular or one-off, since we can claim back the tax on your charitable donation. Higher rate taxpayers are also able to claim additional personal tax relief. Contact us for further information and a Gift-Aid Declaration.

Legacies

A legacy to Tate may take the form of a residual share of an estate, a specific cash sum or item of property such as a work of art. Legacies to Tate are free of Inheritance Tax.

Offers in lieu of tax

Inheritance Tax can be satisfied by transferring to the Government a work of art of outstanding importance. In this case the rate of tax is reduced, and it can be made a condition of the offer that the work of art is allocated to Tate. Please contact us for details.

Tate American Fund and Tate American Patrons

The American Fund for the Tate Gallery was formed in 1986 to facilitate gifts of works of art, donations and bequests to Tate from United States residents. United States taxpayers who wish to support Tate on an annual basis can join the American Patrons of the Tate Gallery and enjoy membership benefits and events in the United States and United Kingdom (single membership $1000 and double $1500). Both organisations receive full tax exempt status from the IRS. Please contact the Tate American Fund for further details.

Membership Programmes

Tate Members enjoy unlimited free admission throughout the year to all exhibitions at Tate Britain, Tate Liverpool, Tate Modern and Tate St Ives, as well as a number of other benefits such as exclusive use of our Members' Rooms and a free annual subscription to *Tate etc.* Whilst enjoying the exclusive privileges of membership, you are also helping secure Tate's position at the very heart of British and modern art. Your support actively contributes to new purchases of important art, ensuring that the Tate's Collection continues to be relevant and comprehensive, as well as funding projects in London, Liverpool and St Ives that increase access and understanding for everyone.

Tate Patrons

Tate Patrons are people who share a strong enthusiasm for art and are committed to giving significant financial support to Tate on an annual basis. The Patrons support the Tate Collection, helping Tate acquire works from across its broad collecting remit: historic British art, modern international art and contemporary art. Tate welcomes Patrons into the heart of its activities. The scheme provides a forum for Patrons to share their interest in art and to exchange knowledge and information in an enjoyable environment.

Corporate Membership

Corporate Membership at Tate Modern, Tate Liverpool and Tate Britain, and support for the Business Circle at Tate St Ives, offer companies opportunities for corporate entertaining and the chance for a wide variety of employee benefits. These include special private views, special access to paying exhibitions, out-of-hours visits and tours, invitations to VIP events and talks at members' offices.

Corporate Investment

Tate has developed a range of imaginative partnerships with the corporate sector, ranging from international interpretation and exhibition programmes to local outreach and staff development programmes. We are particularly known for high-profile business to business marketing initiatives and employee benefit packages. Please contact the Corporate Fundraising team for further details.

Charity Details

The Tate Gallery is an exempt charity; the Museums & Galleries Act 1992 added the Tate Gallery to the list of exempt charities defined in the 1960 Charities Act. The Friends of the Tate Gallery is a registered charity (number 313021). Tate Foundation is a registered charity (number 1085314).

The Anthony Caro Exhibition Supporters Group

Sarah and Gerard Griffin
Mr and Mrs David Mirvish
Paul and Alison Myners
Hugh and Catherine Stevenson
Mark Weinberg and Anouska Hempel

Tate Britain Donors to the Centenary Development Campaign

Founder

The Heritage Lottery Fund

Founding Benefactors

Sir Harry and Lady Djanogly
The Kresge Foundation
Sir Edwin and Lady Manton
Lord and Lady Sainsbury of Preston Candover
The Wolfson Foundation

Major Donors

The Annenberg Foundation
Ron Beller and Jennifer Moses
Alex and Angela Bernstein
Ivor Braka
Lauren and Mark Booth
The Clore Duffield Foundation
Maurice and Janet Dwek
Bob and Kate Gavron
Sir Paul Getty K B E
Nicholas and Judith Goodison
Mr and Mrs Karpidas
Peter and Maria Kellner
Catherine and Pierre Lagrange
Ruth and Stuart Lipton
William A Palmer
John and Jill Ritblat
Barrie and Emmanuel Roman
Charlotte Stevenson
Tate Gallery Centenary Gala
The Trusthouse Charitable Foundation
David and Emma Verey
Clodagh and Leslie Waddington
Mr and Mrs Anthony Weldon
Sam Whitbread

Donors

The Asprey Family Charitable Foundation
The Charlotte Bonham Carter Charitable Trust
The CHK Charities Limited
Sadie Coles
Giles and Sonia Coode-Adams
Alan Cristea
Thomas Dane
The D'Oyly Carte Charitable Trust
The Dulverton Trust
Tate Friends
Alan Gibbs
Mr and Mrs Edward Gilhuly
Helyn and Ralph Goldenberg
Richard and Odile Grogan
Pehr and Christina Gyllenhammar
Jay Jopling
Howard and Lynda Karshan
Madeleine Kleinwort
Brian and Lesley Knox
Mr and Mrs Ulf G Linden
Anders and Ulla Ljungh
Lloyds TSB Foundation for England and Wales
David and Pauline Mann-Vogelpoel
Nick and Annette Mason
Viviane and James Mayor
Anthony and Deidre Montague
Sir Peter and Lady Osborne

Maureen Paley
Mr Frederik Paulsen
The Pet Shop Boys
The P F Charitable Trust
The Polizzi Charitable Trust
Mrs Coral Samuel CBE
David and Sophie Shalit
Mr and Mrs Sven Skarendahl
Pauline Denyer-Smith and Paul Smith
Mr and Mrs Nicholas Stanley
The Jack Steinberg Charitable Trust
Carter and Mary Thacher
Mr and Mrs John Thornton
Dinah Verey
Gordon D Watson
The Duke of Westminster OBE TD DL
Mr and Mrs Stephen Wilberding
Michael S Wilson
and those donors who wish to remain anonymous

Tate Collection

Founders

Sir Henry Tate
Sir Joseph Duveen
Lord Duveen
The Clore Duffield Foundation
Heritage Lottery Fund
National Art Collections Fund

Founding Benefactors

Sir Edwin and Lady Manton
The Kreitman Foundation
The American Fund for the Tate Gallery
The Nomura Securities Co Ltd

Benefactors

Gilbert and Janet de Botton
The Deborah Loeb Brice Foundation
National Heritage Memorial Fund
Patrons of British Art
Patrons of New Art
Dr Mortimer and Theresa Sackler Foundation
Tate Members

Major Donors

Aviva plc
Edwin C Cohen
Lynn Forester de Rothschild
Kathy Fuld
Noam and Geraldine Gottesman
Mr and Mrs Jonathan Green
The Leverhulme Trust
Hartley Neel
Richard Neel
New Opportunites Fund
Ophiuchus SA
Tate Patrons

Donors

Abstract Select Limited
Howard and Roberta Ahmanson
Lord and Lady Attenborough
Mr and Mrs A Ben-Haim
The Charlotte Bonham-Carter Charitable Trust
Veronica Borovik Khilchevskaya
Mrs John Chandris
Ella Cisneros and Guido Alba-Marini
Sir Ronald and Lady Cohen
Mr and Mrs Zev Crystal
Danriss Property Corporation Plc
Linda and Ronald Daitz
Mr and Mrs Guy Dellal
Brooke Hayward Duchin
GABO TRUST for Sculpture Conservation
The Gapper Charitable Trust
The Getty Grant Program
Mr and Mrs Fisher
Mimi Floback
Mr and Mrs Koenraad Foulon
Mr and Mrs G Frering
Glenn R Fuhrman

Liz Gerring and Kirk Radke
Mr and Mrs Zak Gertler
Marian Goodman
Calouste Gulbenkian Foundation
Mimi and Peter Haas
Birgid and Richard Hanson
Mr and Mrs Stanely Hollander
HSBC Artscard
Leili and Johannes Huth
Angeliki Intzides
Lord and Lady Jacobs
Ellen Kern
The Samuel H Kress Foundation
Leche Trust
Robert Lehman Foundation
Mr and Mrs Diamantis M Lernos
William Louis-Dreyfus
Mr and Mrs Brett Miller
Lucy Mitchell-Innes
The Henry Moore Foundation
Mary Moore
Friends of the Newfoundland Dog and Members of the Newfoundland Dog Club of America
Peter and Eileen Norton, The Peter Norton Family Foundation
Mr and Mrs Maurice Ostro
Outset Contemporary Art Fund
William Palmer
Mr and Mrs Stephen Peel
The Honorable Leon B and Mrs Cynthia Polsky
Karen and Eric Pulaski
The Radcliffe Trust
The Rayne Foundation
Julie and Don Reid
Mr Simon Robertson
Barrie and Emmanuel Roman
Lord and Lady Rothschild
Ken Rowe
Mrs Jean Sainsbury
Claire and Nicola Savoretti
Debra and Dennis Scholl
Michael and Melanie Sherwood Charitable Foundation
Harvey S Shipley Miller
Peter Simon
John A Smith and Vicky Hughes
Mr and Mrs Ramez Sousou
The Foundation for Sports and the Arts
Stanley Foundation Limited
Kimberly and Tord Stallvik
David Teiger
Mr and Mrs A Alfred Taubman
Inna Vainshtock
Mr and Mrs Pyrros N Vardinoyannis
Andreas Waldburg
Ziba and Pierre de Weck
Angela Westwater
Poju and Anita Zabludowicz
and those donors who wish to remain anonymous

Tate Britain Donors

Major Donors

The Bowland Charitable Trust
Mr and Mrs James Brice
The Henry Luce Foundation
The Henry Moore Foundation
The Horace W Goldsmith Foundation
John Lyon's Charity

Donors

Howard and Roberta Ahmanson
Blackwall Green (Jewellery & Fine Art)
Mr and Mrs Robert Bransten
The Cadogan Charity
The Calouste Gulbenkian Foundation
The John S Cohen Foundation
Ricki and Robert Conway
The Glass-House Trust
The Hite Foundation

ICAP plc
ICI
The Stanley Thomas Johnson Foundation
Kiers Foundation
The Kirby Laing Foundation
London Arts
The Paul Mellon Centre for Studies in British Art
The Mercers' Company
The Peter Moores Foundation
Judith Rothschild Foundation
Keith and Kathy Sachs
Safeway
Karsten Schubert
The Wates Foundation
and those donors who wish to remain anonymous

Tate Britain Corporate Members

Accenture
American Express
Aviva plc
Bank of Ireland UK
The Bank of New York
BNP Paribas
Clifford Chance
Drivers Jonas
EMI
Ernst & Young
EDF Energy
Freshfields Bruckhaus Deringer
GAM
GLG Partners
HSBC – Corporate, Investment Banking and Markets
Kohlberg Kravis Roberts & Co. Ltd.
Lehman Brothers
Linklaters
Microsoft Limited
Nomura
Paragon Business Furniture
Pearson
Reckitt Benckiser
Simmons & Simmons
Standard Chartered
Tishman Speyer Properties
UBS

Tate Britain Sponsors

Founding Sponsors

BP
Campaign for the creation of Tate Britain (1998–2000)
BP Displays at Tate Britain (1990–2007)
Tate Britain Launch (2000)

BT
Tate Online (2001–2006)

Channel 4
The Turner Prize (1991–2003)

Ernst & Young
Picasso: Sculptor/Painter (1994)
Cézanne (1995)
Bonnard (1998)
Art of the Garden (2004)
Turner, Whistler, Monet (2005)

Benefactor Sponsors

Egg Plc
Tate & Egg Live (2003)

GlaxoSmithKline
Turner on the Seine (1999)
William Blake (2000)
American Sublime: Landscape Painting in the United States, 1820–1880 (2002)

Gordon's gin
The Turner Prize (2004–2006)

Prudential plc
The Age of Rossetti, Burne-Jones and Watts: Symbolism in Britain 1860–1910 (1997)
The Art of Bloomsbury (1999)
Stanley Spencer (2001)

Tate & Lyle plc
Tate Members (1991–2000)
Tate Britain Community Education (2001–2004)

Major Sponsors

Barclays PLC
Turner and Venice (2003)

The British Land Company PLC
Joseph Wright of Derby (1990)
Ben Nicholson (1993)
Gainsborough (2002)

The Daily Mail
Media Partner for *Turner and Venice* (2003)

The Daily Telegraph
Media Partner for *American Sublime* (2002)
Media Partner for *Pre-Raphaelite Vision: Truth to Nature* (2004)
Media Partner for *In-A-Gadda-Da-Vida* (2004)

The Guardian
Media Partner for *Intelligence* (2000)
Media Partner for *Wolfgang Tillmans if one thing matters, everything matters* (2003)
Media Partner for *Bridget Riley* (2003)
Media Partner for Tate & Egg Live Series (2003)
Media Partner for 20 Years of the *Turner Prize* (2003)
Media Partner for *Turner Prize* 2004 (2004)

The Independent Newspapers
Media Partner for *William Blake* (2000)
Media Partner for *Stanley Spencer* (2001)
Media Partner for *Exposed: The Victorian Nude* (2001)

Morgan Stanley
Visual Paths: Teaching Literacy in the Gallery (1999–2002)

The Sunday Times
Media Partner for *Art and the 60s: This Was Tomorrow* (2004)

Tate Members
Exposed: The Victorian Nude (2001)
Bridget Riley (2003)
A Century of Artists' Film in Britain (2003–2004)
In-A-Gadda-Da-Vida (2004)
Art Now: Nigel Cooke (2004)
Gwen John and Augustus John (2004)

UBS
Lucian Freud (2002)

Volkswagen
Days Like These: Tate Triennial of Contemporary Art (2003)

Sponsors

Classic FM
Media Partner for *Thomas Girtin: The Art of Watercolour* (2002)

Diesel
Late at Tate Britain (2004–2005)
Art Now (2004–2005)

Häagen Dazs
Turner Prize Dinner (2003)

Hiscox plc
Tate Britain Members Room (1995–2001)

John Lyon's Charity
Constable to Delacroix: British Art and the French Romantics (2003)